Digital Landscape Photography

Digital Landscape Photography

John and Barbara Gerlach

AMSTERDAM • BOSTON • HEIDELBERG • LONDON • NEW YORK • OXFORD • PARIS
SAN DIEGO • SAN FRANCISCO • SINGAPORE • SYDNEY • TOKYO
Focal Press is an imprint of Elsevier

Focal Press is an imprint of Elsevier
30 Corporate Drive, Suite 400, Burlington, MA 01803, USA
Linacre House, Jordan Hill, Oxford OX2 8DP, UK

Library of Congress Cataloging-in-Publication Data
Application submitted

British Library Cataloguing-in-Publication Data
A catalogue record for this book is available from the British Library.

ISBN: 978-0-240-81093-5

For information on all Focal Press publications
visit our website at www.elsevierdirect.com

10 11 12 13 5 4 3 2 1

Printed in China

Working together to grow
libraries in developing countries

www.elsevier.com | www.bookaid.org | www.sabre.org

ELSEVIER BOOK AID
 International Sabre Foundation

Contents

About the Author

John and Barbara Gerlach have been professional nature photographers for more than 25 years. Their beautiful nature photographs are publish in magazines, calendars, and books worldwide. They travel the globe leading photographic safaris to terrific wildlife destinations and teach field workshops on landscape, close-up, and hummingbird photography. More than 50,000 people have attended their intensive 1-day nature photography instructional seminars. Both love to teach others how to make their own fine photographs. They enjoy living in the mountains near Yellowstone National Park and frequently ride their horses in the backcountry to photograph. For details about their instructional nature photography field programs, please go to www.gerlachnaturephoto.com.

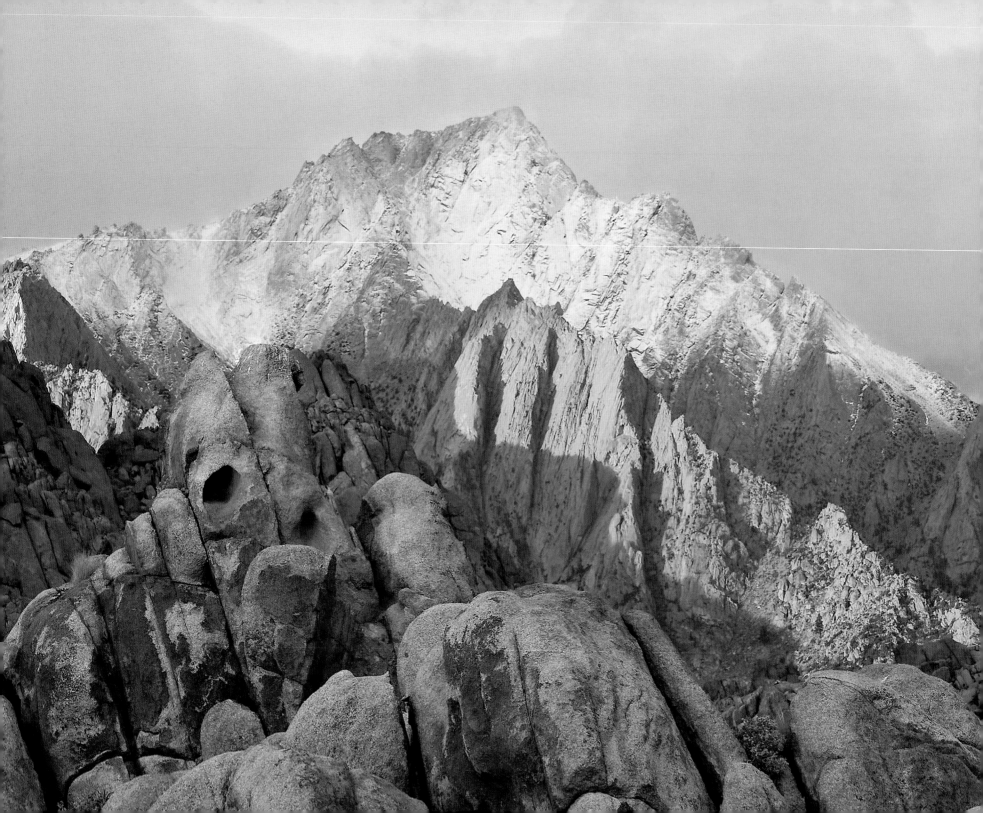

Acknowledgments

We dedicate this book to a fantastic group of skilled landscape photographers whom we know personally or vicariously through their photo books that find a home on our bookshelves. This list includes Ansel Adams, Ian Adams, Craig Blacklock, Willard Clay, Carr Clifton, Jack Dykinga, John Fielder, Tim Fitzharris, David Muench, William Neill, Pat O'Hara, Galen Rowell, John Shaw, Tom Till, Larry Ulrich, and many others. Their wonderful images of the landscape inspired us to visit many of the places they photographed. We know it was seeing so many awesome landscape images, especially of the American West, that encouraged us to settle close to Yellowstone National Park in 1993.

You wouldn't be holding this book were it not for the help and encouragement of the super staff at Focal Press. Paul Gottehrer, a Senior Project Manager at Elsevier, attended our one-day photo seminar. At the end of the seminar he asked us to send a book proposal to his company, which we did shortly thereafter. That proposal led to our first book, *Digital Nature Photography — The Art and the Science*. Cara Anderson, Carlin Reagan, and Valerie Geary at Focal Press were our primary contacts throughout the process of creating this book. They deserve special thanks for putting up with us spending way too much time in the mountains far away from e-mail and cell phones. They somehow kept us on schedule, even though we were impossible to reach most of the time.

Many of the images in this book were taken around our Idaho mountain home and in nearby Yellowstone National Park. We wish to thank Bill Howell and Clyde Seely for hiring us in 1995 to lead winter photo tours by snowmobile in the park. Over the years, we've thoroughly enjoyed hundreds of winter days in fabulous Yellowstone National Park. Some of the images we captured appear in this book.

Terry and Angie Search who own Yellowstone Mountain Guides helped us pursue our passion for riding horses in the wilderness by hiring us to be their photo wranglers. For several years, we've enjoyed guiding photographers on extended overnight horseback photo trips into the backcountry of Yellowstone National Park and the Lee Metcalf wilderness.

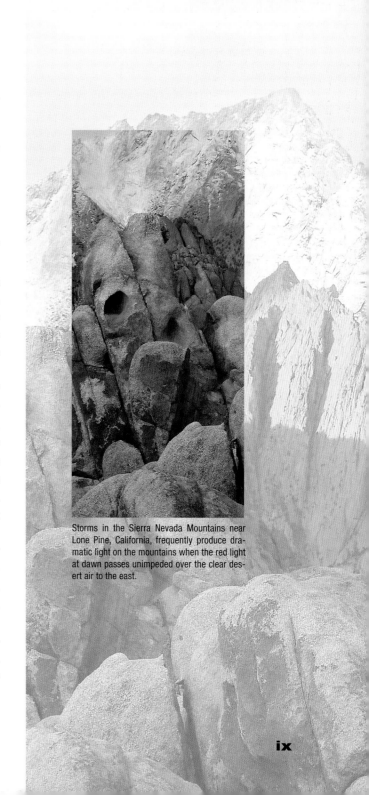

Storms in the Sierra Nevada Mountains near Lone Pine, California, frequently produce dramatic light on the mountains when the red light at dawn passes unimpeded over the clear desert air to the east.

Mike and Mary Sue, Jan and Terry, the two Nolan couples who collectively own the Timber Ridge Lodge, deserve more thanks than we can possibly bestow on them. Since 1988 we have taken over their small motel and lodge that's nestled in the gorgeous northern Michigan woods for weeks at a time. Mary Sue and Jan never once protested when we completely rearranged everything in the lodge to make it more suitable for our photography workshops. When we ask Mary Sue if we can move all of her furniture just one more time, she always cheerfully responds with the most beautiful Yooper accent by saying, *you betcha, I need to clean under the couches anyway, eh?*

Writing a book is a daunting task with long and lonely hours. One of the hardest parts is finding typos that are obvious when pointed out but nearly impossible to see if you wrote them yourself. A couple of our best photography students offered to read the text over to spot typos, errors, omissions, or anything that wasn't clear. Al Hart and Dan Pater both helped considerably in finding these errors. Al spent incredible amounts of time reworking much of my original writing to make it far more understandable and precise, so we all owe him a huge debt of gratitude. Dan did his best to help control our comma chaos and contributed numerous important advisory comments. Together, these two fine writers helped enormously in making this text so much better for you to read. Edited chapters flew back and forth across the country via e-mail at all hours of the day and night. We all laughed a lot and learned a lot and hope these fine editing commandos will join us for future books! Since both of these excellent photographers shoot Nikon, more Nikon details made it into the text, too. If you do find typos or other problems, I (John) accept responsibility and beg your forgiveness.

Two professional photographers read this manuscript, too. Many thanks to Craig Carlson and Tony Sweet for offering suggestions that make this book better. We appreciate your time and effort greatly!

The fifty thousand or so students who have passed through our photo classes over the decades deserve the most recognition of all. Many have offered advice on where to find magical landscape opportunities and their probing questions have forced us to find crucial answers to questions we haven't ever considered. Teaching has always been a two-way street for us. We help our students improve their knowledge and photo skills in the field and they help us deepen our own depth of understanding, too. It's a win–win situation for all. We feel truly blessed for all of the wonderful folks we have met over thirty years of teaching nature photography!

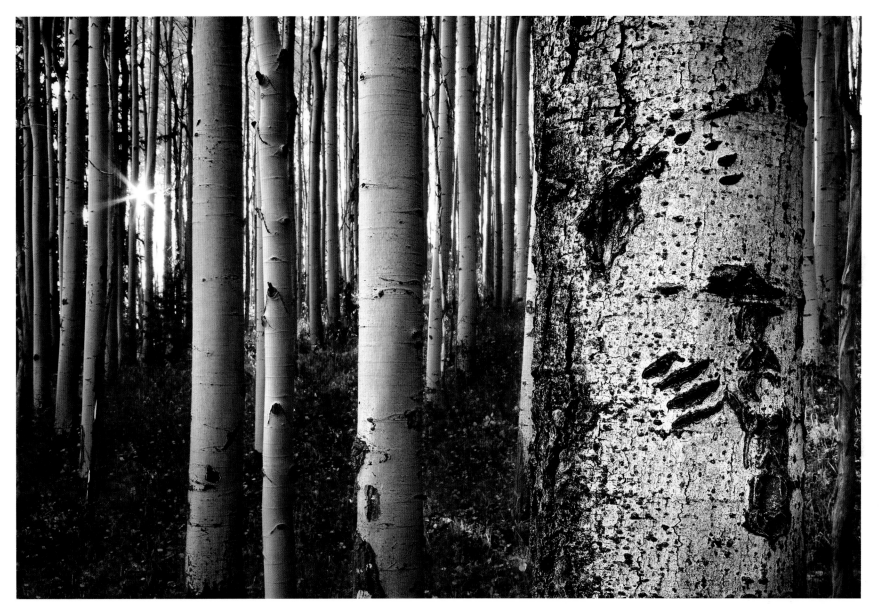

Cindy Koch, one of our gifted students, made this fine image of a New Mexico aspen grove. Remembering our advice, she turned the sun into a star by stopping the lens down to f/22. We love how she balanced the sun with the bear claw marks on the nearest tree!

Introduction

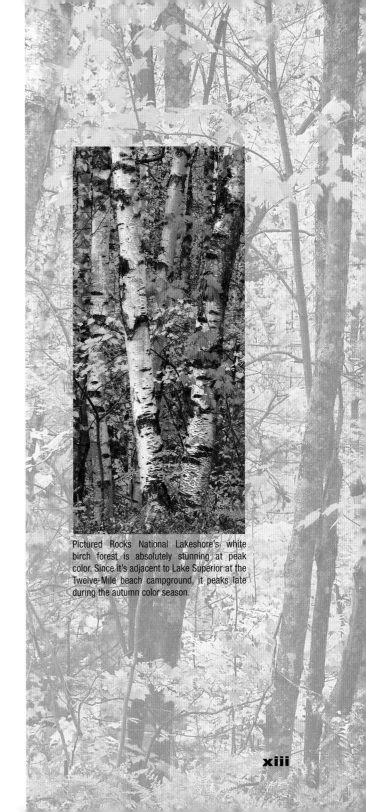

Everyone can easily find wonderful landscapes to photograph no matter where he or she lives. Even city dwellers have backyards and nearby parks where perhaps a small stream offers interesting images. Many live near an ocean, a mountain range, or a national park that was set aside to preserve scenic features. Each of these places offers the landscape photographer endless possibilities.

Landscape photographers can buy and carry less gear than other photographers, such as wildlife or macro photographers. You can do quite well with a couple of zoom lenses and a few other accessories. Two advantages landscape photographers have are the ability to approach their subject rather easily in most cases, and the ease of finding magnificent landscapes in protected and well-publicized parks.

However, natural landscapes are by no means easy to photograph well. Humans have put their mark on the landscape, too. Man-made distractions such as telephone wires, fences, litter, and signs may be difficult to keep out of your images. Even in the most remote locations, jet contrails often streak across a blue sky and smog may obscure the Grand Canyon.

Landscapes tend to be huge subjects, so natural light is crucial to getting the best images. The macro photographer's tactics of modifying light with reflectors, diffusers, and fill flash just don't work on a distant and massive mountain! You must be present when the best light is illuminating the landscape. This means photographing at dawn and dusk whenever possible. However, there are times when middle of the day light works well for landscapes, too.

We've been most fortunate to live most of our lives in northern Michigan and, since 1993, at 7000 feet in the picturesque mountains of Idaho near Yellowstone National Park. Both of these wonderful places offer fabulous landscapes to photograph. We live in the mountains to enjoy wonderful views on a daily basis, to feel and hear the storms as they crash into the mountain peaks, and to live with the mountain wildlife.

Pictured Rocks National Lakeshore's white birch forest is absolutely stunning at peak color. Since it's adjacent to Lake Superior at the Twelve-Mile beach campground, it peaks late during the autumn color season.

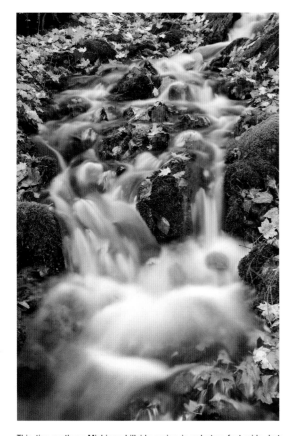 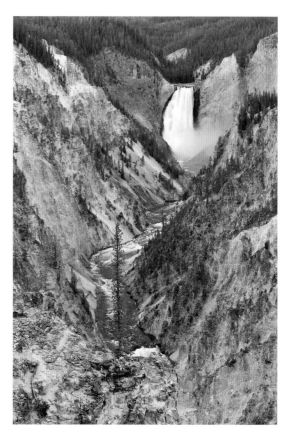

This tiny northern Michigan hillside spring is only two feet wide, but offers rich photo opportunities when autumn leaves litter the scene.

(a, b) The Lower Falls from Artist Point in Yellowstone National Park is a splendid landscape during all seasons of the year.

Some people think landscapes are static and don't change, but they are mistaken. Landscapes change as seasons come and go. Drought or torrential rain can drastically change their appearance. Landscapes change rapidly as the light illuminating them changes. Often, fabulous light is fleeting, so you must be able to quickly and efficiently use your camera gear to capture the light before it disappears behind a cloud or drops below the horizon. The landscape is dynamic and always changing its mood.

As in our first book on digital nature photography, this book will also stress shooting the highest quality images possible in the field. We'll do little with the digital darkroom (Capture NX, Photoshop, Aperture, Lightroom) because so many books already cover that topic and those applications. Sadly, we see too many photographers taking short-cuts, such as shooting landscapes hand-held, when it would be easy to get sharper images by using a tripod. Too many photographers are taking short-cuts because they think they can fix most problems in the digital darkroom. Perhaps they can minimize the problems later, but making wonderful landscape images is so much easier if you adopt superb shooting techniques and make them a habit. We stress these techniques throughout this book and, with practice, they will become a habit that allows

you to shoot outstanding landscape images shot after shot.

However, we must explore at least a few things that you can easily do in the digital darkroom, because the power of image-editing software may significantly affect the way you shoot images in the field. Shooting a series of overlapping images so that later you can use software to stitch them together into a stunning panorama is just one important example.

Another example is the power of digital capture and high dynamic range (HDR) software to successfully record a scene that is so contrasty that it could never before be successfully photographed. HDR photography can produce truly awesome results! We'll be discussing how to shoot an HDR scene that can be computer-assembled into an image that preserves the detail and color of the original scene's brightest highlights and darkest shadows. We've devoted a whole chapter to this powerful new technique that you surely will want to use and master.

In the interest of full disclosure, I'm (John) on uneasy terms with the computer, so I know how you feel if the computer frightens you, too. I struggles with the computer more than most. If it weren't for Barbara, who easily makes computers do her bidding, I would be absolutely lost. I have developed certain Photoshop skills, though. I'm an expert at starting the program, a guru with the crop tool, and a master at stopping for lunch — the three easiest things one can do in Photoshop. Oh, one more thing: I can convert RAW images with the Photoshop RAW converter quite well, so that must be easy, too, but I know little beyond that. Fortunately, Barbara is a whiz

Pristine Lake Ha Hand in the Lee Metcalf wilderness is at the edge of the alpine zone at 9000 feet. We used HDR techniques to capture color and detail in both the sunlit mountains and the heavily shadowed foreground.

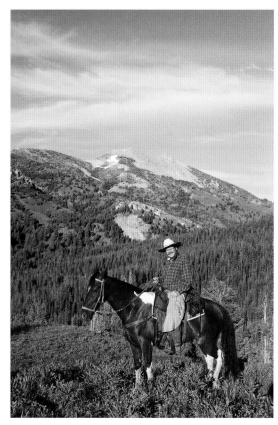

We love riding horses over the mountain peaks around our Idaho home. Here's John riding Teton, his well-behaved (usually) Tennessee Walker. We frequently use our horses to explore the wilderness where magnificent photo subjects abound.

with computers, remembers all of the short-cut keys that make Photoshop dance to her commands, excels at making wonderful prints, and continues to expand her knowledge by practicing and attending advanced printing classes taught by master printers such as Charles Cramer.

It isn't that I don't want to know a lot more about the digital darkroom, but my time is criti-

cally limited. I love shooting outdoor images and teaching field workshops. Both of these interests permit me to spend massive amounts of time in wild places, which suits me perfectly. In my *spare* time, I do enjoy trout fishing, bird watching, kayaking, cross-country skiing, and riding Tennessee Walking Horses in the rugged mountains surrounding my home. I spend most of my

time outdoors, but I do enjoy writing because it can be done at night, on rainy days, or when buckled into an airplane seat.

We never get tired of learning new ways to use cameras and lenses to shoot better images. It's exciting to buy a new camera so all of the new features can be explored to see if they're useful for taking better images. We meticulously go through every custom function to figure out what each one does and then carefully consider how it might help us shoot nice images. Many custom functions aren't that useful for landscape photography, but some are critical and are covered in detail later in this book.

Our goal is to always shoot quality images because we have no use for snapshots. We hope you're reading this book because you, too, want quality images, but don't want to struggle with camera gear or use methods that are unnecessarily complicated or aren't especially effective. We shoot landscapes with digital cameras quite differently than we did when shooting film. That's why every image in this book comes from original digital capture. Although we've shot film all over the world for most of our careers, we feel images captured with a digital camera (not scanned slides) should be used to illustrate a book about digital photography. That's why you won't see any Antarctica images, even though we've led two photo tours before going digital to that magnificent part of the world. In some cases our recommendations differ from those of other photographers, but everyone is entitled to an opinion. Often, there's more than one way to achieve excellent results. We explain why our shooting strategies are what they are and hope

you'll try them. Ultimately, you must decide for yourself what works best for you.

We have more than three decades of experience seriously photographing landscapes. (Could that much time have flown by?) We enjoy being productive, so we carefully choose what to photograph, because weather conditions and light are critical to making spectacular images. In addition, we've led hundreds of field workshops that we always strive to make successful for our students. When you have a dozen students expecting you to lead them to outstanding subjects, it adds pressure to selecting worthwhile destinations. We want our workshop students to shoot images they'll cherish. The key to accomplishing this goal is to make sure the students have wonderful subjects to photograph in good weather and bad, and are guided in using their camera equipment in the most efficient manner they can.

This book is unlike many photography books because the emphasis is on the process of capturing outstanding images in the field. We concentrate on perfecting shooting techniques and developing strategies for dealing with the weather and light. We emphasize thoroughly working various subjects, such as fall color, waterfalls, and snow scenes. We spend a lot of time on using camera gear effectively, shooting perfect exposures, making sharp images, and creating pleasing compositions. We don't spend much time on the digital darkroom, nor do we go into detail about how lenses focus light, the pros and cons of different imaging sensors, or the inner workings of cameras. While some of this information might be interesting to know about (or not), knowing how a lens is assembled does little to

help you shoot outstanding images. We simply don't have space in this book to cover topics that really don't help you shoot pleasing images.

The methods we use to shoot landscape images are simple and fairly straightforward. They work for us and we know they work for the thousands of students who have attended our field workshops over the past 30 years. Our students do extremely well in our field workshops and many have gone on to make nature photography a part- or full-time activity for fun or profit. We're thrilled by the enormous success our students have enjoyed and love seeing their images published all over the place. Once they develop superb shooting habits, learn to spot photogenic subjects, and make good decisions about where to go, given weather and light conditions, excellent landscape photography is easy to achieve.

This book is intended for those who want to learn to shoot solid and exciting landscape images efficiently, easily, and quickly. We stress the factors that really matter for achieving that goal. We wish you the best of luck in the wonderful journey that awaits you in shooting your own special landscape images. Take your time while enjoying that journey and we hope you'll share your fine images with others!

May fabulous light lead you to magical subjects!

John and Barbara Gerlach

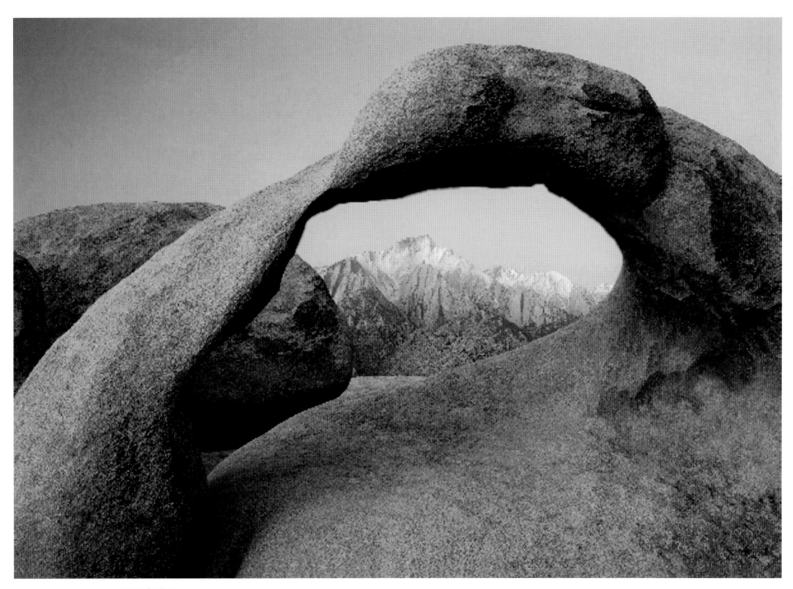

Natural arch in the Alabama Hills in California.

Landscapes are Everywhere

John and I love photographing landscapes and we're thrilled to share our strategies with you in this book. We live in the mountains bordering Yellowstone National Park, so fabulous natural landscapes are all around us. At first, we considered landscapes to be geysers, waterfalls, rugged mountain peaks, seashores, sand dunes, and other natural features. But landscapes are really more than that. We don't photograph a lot of man-made landscapes, but they are certainly legitimate subjects. Old buildings, barns, bridges, farms, lighthouses, and a massive field of sunflowers are all landscape subjects. We tend to avoid big cities which, in our opinion, are any towns with more than one restaurant, but city images are surely and often opportune, urban landscapes.

Landscapes include such an enormous variety of subjects that everyone can enjoy photographing them. They are everywhere. Regrettably, however, this book isn't big enough to cover every possible landscape situation, so we'll narrow the focus down to the landscapes we know best — natural scenes and old buildings. Fortunately, the techniques and strategies we highlight in this book cover most landscape possibilities quite well.

FINDING NATURAL LANDSCAPES

Landscape photographers enjoy a huge advantage compared to action, sports, and wildlife photographers because most of the finest natural landscapes were preserved years ago by law. They still exist in a fairly pristine state and they're public property. The national parks and national monuments of the United States, and those of some other countries, probably have the best known and best preserved landscapes. These parks encompass a fabulous collection of opportunities, from the geysers of Yellowstone and the sand dunes of Death Valley to the waterfalls in Great Smoky Mountains National Park. We have been privileged to visit most of them over the years, and they're wonderful. You could easily spend the rest of your life making exquisite landscape images without ever leaving the national park system.

The undulating sand dunes of Death Valley test your compositional skills to make sense out of endless patterns of form and light.

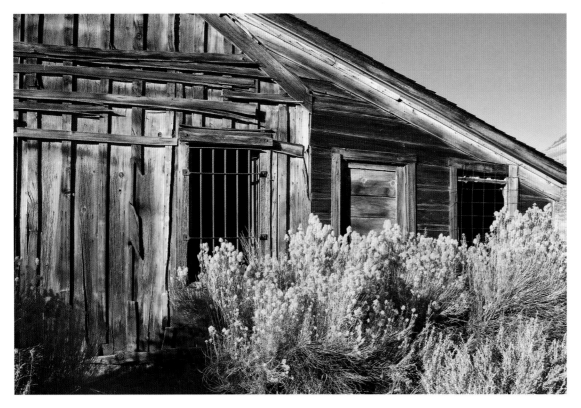

Old buildings like these found in the well-preserved ghost town of Bodie in eastern California always make us wonder who lived there and what did they think and do.

However, don't overlook the opportunities on other public lands that are less well known. City and state parks preserve smaller landscapes, which may be superb for photography. Tahquamenon Falls, flowing the second highest volume of water of any falls east of the Mississippi River, lies in a northern Michigan state park. It's easy to access and photograph. And a city park might offer a small pond reflecting a riot of color when the surrounding maple trees become brilliantly colored in the autumn.

Vast amounts of public land are available to photograph in the state and national forest systems. These lands are filled with photogenic streams, ponds, fields of wildflowers, and waterfalls. Especially in the western states, the Bureau of Land Management (BLM) oversees millions of acres of wild land. Fortunately, public land is well mapped, so it's easy to find the special places that make enchanting landscape images. In the eastern states, where public land isn't as plentiful, some land may be set aside as state game areas for hunting purposes. These lands also offer many gorgeous scenes to photograph, and it can be done quite safely if you wear hunter orange and take other appropriate precautions. If the ongoing hunting activity makes you nervous, you can avoid those lands during the short hunting seasons, and still have the state game areas largely to yourself throughout most of the year.

Another huge amount of public land is set aside in the National Wildlife Refuge (NWR) system. These lands were purchased primarily with the money that hunters paid for duck stamps or with special taxes on guns and ammunition that were earmarked for conservation. The NWR system protects wildlife-rich areas, especially the wetlands so critical to migratory birds such as ducks and geese. These lands are widely used by wildlife photographers because of the many small bodies of water that attract wildlife. Reflections in these ponds and lakes can be quite beneficial to landscape photographers, too. Call ahead to learn if the refuge will be open when you plan to visit. Some refuges have seasonal restrictions during hunting seasons and many areas may be closed during the nesting season to prevent disturbing wildlife at that critical time. One of the more scenic refuges is Montana's Red Rock Lakes National Wildlife Refuge, which is only 25 miles from our home. On calm mornings and evenings during the summer, the Centennial

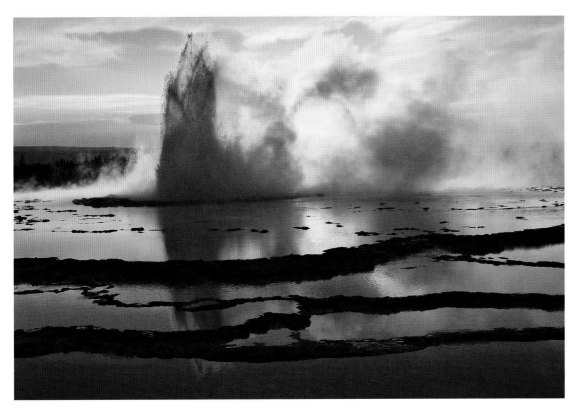

Yellowstone's Great Fountain geyser is a sight to behold when it erupts at sunset. It's a predictable geyser (sort of) as it erupts about every 12 hours plus or minus 2 hours. It's well worth the wait, though.

to their land, especially if you become a member, by simply asking, and sharing your images.

SEASONAL CONSIDERATIONS

It's always pleasant and convenient if you can find some wonderful landscapes near your home. Near home, you can easily photograph them at dawn when the scene is drenched in dew, when kissed by a hard frost, or perhaps blanketed by snow or fog, or whenever you have only a short time available for shooting. As everyone knows, many landscapes photograph best at dawn and dusk, so easy and quick access is highly desirable.

The time of the day isn't the only variable, however. The photo opportunities of a marsh, small pond, or waterfall are quite different throughout the year. Imagine a waterfall surrounded by peak autumn color, blanketed with a fresh layer of snow, swollen by spring rains, or fringed with summer wildflowers. Many landscapes change dramatically with the seasons, and provide exciting new photo opportunities.

Mountain Range is beautifully reflected in the small lakes that make up the refuge.

PRIVATE LAND

Private land also offers plenty of possibilities for nice landscape images. Always get permission before entering. Entering without permission is trespassing, and may have both civil and criminal consequences. It's often tough to get permission to hunt with a gun on private land, but gaining access to photograph on private ground is usually quite easy. Landowners are often thrilled that you find their special place to have worthwhile photo subjects, and may even help you find what you're looking for. Giving landowners a few prints of images made on their land is a nice gesture, and keeps the welcome mat out for you.

Nature centers are often built where special landscapes are found. Normally, you can get access

ELEVATION ADVANTAGES

We live in the mountains, so we understand their photographic advantages well. Spring begins at the lower elevations first and gradually climbs up the slopes to the alpine zone on top. The progression could take several weeks to several months, depending on the latitude and especially on how high the mountain peaks tower above the low valleys. When we lived in California, we saw that spring started in the foothills around Fresno in February, but didn't reach the tops of the Sierras

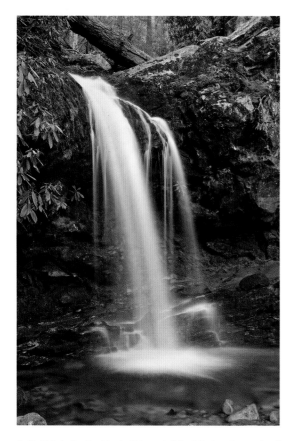

Grotto Falls in the Smokies isn't huge, but its delicate nature makes it highly photogenic. We used a long shutter speed to nicely blur the water and to properly expose the scene in the dim light of an early spring morning.

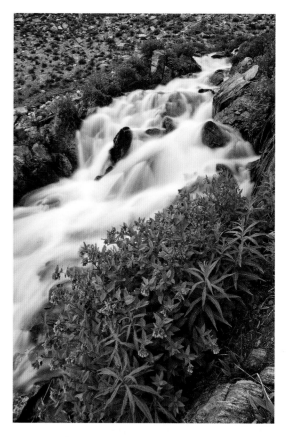

We used a DeLorme map book covering Montana to look for small lakes and creeks on the east side (hoping to get dawn reflections) of the mountain peaks in the Lee Metcalf wilderness. This small mountain creek is lined with mountain bluebells during late July as it tumbles by our campsite at Lake Ha Hand.

instance, in California, driving from the foothills around Fresno to Tuolumne Meadows in Yosemite National Park is just like driving thousands of miles north in terms of seeing plants and animals that are indigenous to the individual zones. The unique subjects of the different zones offer a photographer's potpourri of landscape opportunities.

In the eastern United States, truly high mountains are in short supply, so changing your altitude doesn't work as well. However, we know many professional nature photographers and retired nature photography enthusiasts who follow the seasons. For example, it's quite effective to begin photographing autumn colors in the Upper Peninsula of Michigan in late September and follow the color south through November in Georgia or South Carolina. It's also easy to begin spring photography in the south and follow it into Canada.

Finding wonderful landscape prospects is easy today. Guides such as the DeLorme map books have led us to wonderful photo subjects. You can now buy software that provides detailed maps of your entire state, including nearly all trails, waterfalls, mountain peaks, and other special points of interest. Also, don't overlook all of the guidebooks that are available. You would be amazed how many books have been produced on the scenic wonders around your home. Some of these books are quite specific, such as *A Guide to 199 Michigan Waterfalls.* Some are less specific. Search the Web for information, too! If you live in Maine and love lighthouses and waterfalls, searching the Internet for *Maine* and *lighthouse* or *waterfalls* will bring up plenty of leads.

until July. Of course, mountains stretch out all of the seasons, so you have more time to capture the unique images each season offers. Mountains offer another crucial advantage for landscape and nature photography in general. The elevation changes make it possible to drive up and down the mountainsides, changing ecological zones as you go. For

We sometimes meet photographers who won't go to a well-known landscape hotspot like Arches National Park in Utah. They want to shoot original images, but this park has been extensively photographed for decades. Those photographers skip Arches because they think it is difficult to find

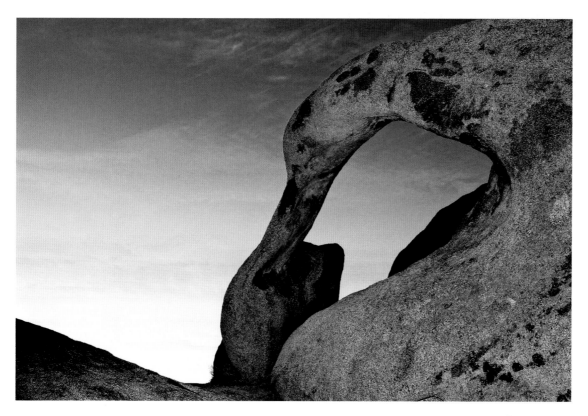

slide film ever permitted — even with split ND filters. Shooting wonderful panoramas is easy and straightforward with digital capture. Surely you could find a veritable smorgasbord of nice panoramas in Arches National Park that have never been done before. And even if it has been done before, does it really matter? Now that electronic flash is so easy with through-the-lens metering, perhaps you can make some unique images by lighting a dark foreground with flash while allowing a long shutter speed to properly expose a brighter background such as the sky. Always remember the light — often the essence of the image — is always changing. We're limited only by our own imagination when making unique images.

We used electronic flash to light up this natural arch in the Alabama Hills of California. Combining flash with natural light is a powerful technique that is easy to do. Use manual exposure and determine the sky background exposure using the histogram. Then use your automatic dedicated flash and flash compensation control to light the arch.

unique images. To each his or her own, but we feel you'll miss out on some of the most dramatic landscapes by avoiding the well-known spots. We don't care how many photographers may have been to the same spot before us. If we enjoy photographing the magnificent landscapes of the park, that's all that matters. While our images may look like many others, they're now *our* images, so we can enjoy them and share them with others.

Even in Arches National Park, it's possible to make unique images. The quality of images from high-end DSLRs is now much better than film images ever were, so you're using the best technology that has ever existed. Remember that digital photography offers techniques that were difficult or impossible to do with film. High dynamic range (HDR) methodologies make it possible to expand the brightness range of your images more than

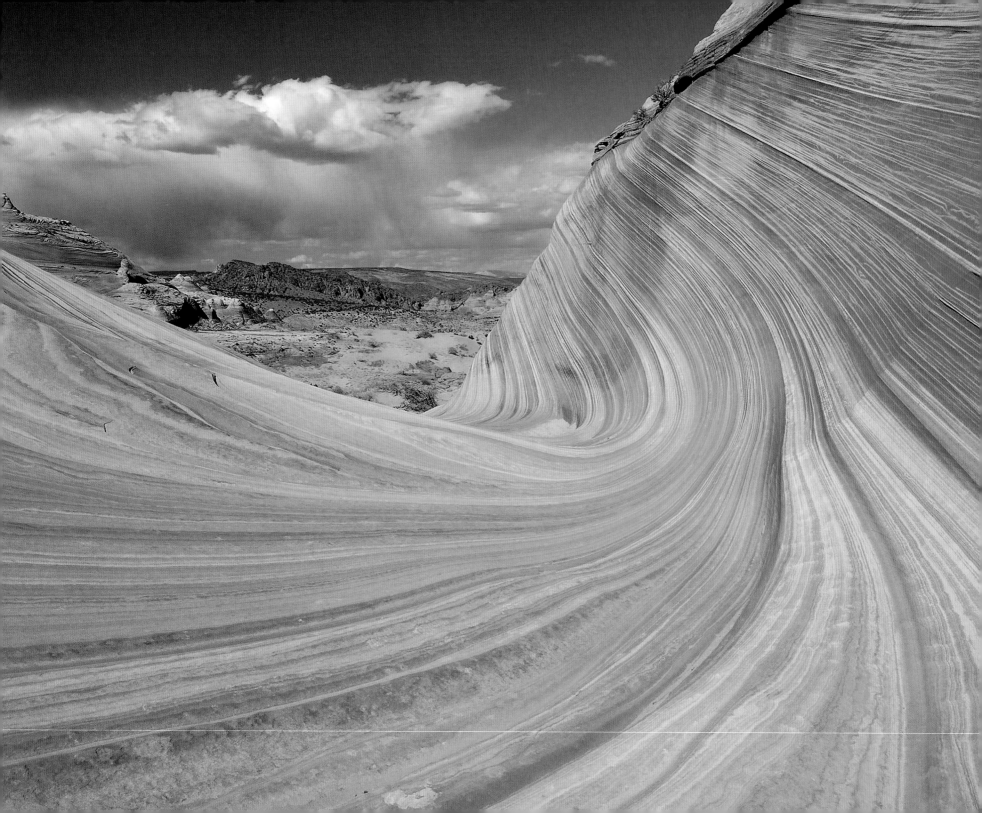

Cameras and Accessories

Lying west of Page, Arizona, the Coyote Buttes encompass an area of spellbinding beauty. The crown jewel is the "wave," an area of polished and twisted colorful sandstone. Access is by permit only and requires a six-mile round-trip hike, but it's a "must do" spot for any land-scape photographer. Our one-day, dawn-to-dusk visit remains one of the highlights of our careers and we hope to return soon.

SELECTING YOUR CAMERA

Chances are you already own the camera you'll be using to shoot landscapes, but do read this anyway, so you know what to look for when it's time to upgrade. Unlike the bygone days of film cameras, in which you might have used the same camera for several years, the rapid advances in digital technology and stunning improvements in image quality offered by the latest camera models encourage digital photographers to upgrade every two or three years.

NIKON AND CANON CAMERAS ARE SUPERB!

All digital cameras can produce fine landscape images, but some models are clearly better for landscapes than others. Just for the record, John has used Canon cameras for more than 30 years while Barbara shoots Nikon. You might be surprised to hear we shoot two different systems, but it makes perfect sense to us. We always know our Nikon gear is Barbara's and Canon items belong to John, so we never get mixed up. This makes things simple, keeps peace in the family, and we each shoot what we like. Effectively teaching over a thousand photo students each year is important to us, too. Thoroughly knowing both the Canon and Nikon systems helps us teach, because the vast majority of our photography students also shoot Canon or Nikon.

If you're deciding on a camera system to buy, what is the best choice? We really do mean buying into a *system*, because once you buy several lenses, accessories such as a dedicated electronic flash and, perhaps, software that is specific to your camera system, it's very expensive to later switch to another camera manufacturer. No, this isn't a decision to be taken lightly. We feel you can't go wrong with either the Nikon or Canon system. Both systems offer many equipment choices, and each company is rapidly improving their products and adding useful features.

Both Canon and Nikon offer superb cameras and wide choices of lenses, including high-quality prime (non-zoom) lenses, tilt-shift lenses that control depth of field and convergence of vertical lines, zoom lenses with image-stabilization, and specialized macro lenses. Canon and Nikon

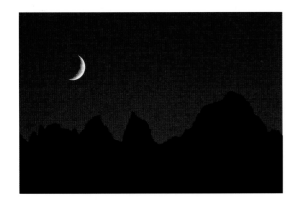

Some digital cameras like Barbara's Nikon D3 (and many other Nikons) can shoot double exposures. She photographed the peaks of Mt. Whitney in silhouette first. Then she changed the exposure to properly expose the bright crescent moon that was floating high above the mountains. This process enabled her to move the moon closer to the mountain peaks, eliminating a large expanse of empty sky while retaining detail and color in both the night sky and the moon.

each have cameras with a *full-frame* sensor that gives the full effect of wide-angle lenses.

OTHER EXCELLENT CAMERA SYSTEMS

Several other companies build digital camera systems and they make fine equipment. The major players include Sigma, Fujifilm, Pentax, Sony, Panasonic, Samsung, and Olympus. Their cameras are perfectly capable of shooting superb landscape images, but their overall systems are considerably smaller than the Canon and Nikon systems, leaving nature photographers with far fewer choices of lenses and accessories.

All of these companies are expanding their lines of equipment, but they often lack long macro lenses in the 200 mm range and good choices of long telephoto lenses for wildlife photography. If you wish to seriously pursue close-up photography, you would miss not using a long macro lens. If you decide to photograph wildlife, then having the opportunity to use long lenses in the 500mm range is desirable. Both Canon and Nikon have 500 mm f/4 and 600 mm f/4 prime lenses. However, this book is about landscape photography, and long macros and super telephoto lenses are seldom used by most landscape photographers.

If you primarily want to shoot landscape images, then any of these camera systems can provide what you need, unless you love tilt/shift (T/S) lenses like us. As long as the system you select covers the focal length range of 16 to 400 mm with fixed focal length or zoom lenses, your landscape imaging needs are well covered. Sony is known for fine products, and seems determined to dominate the digital single-lens reflex (DSLR) camera market, so keep an eye on them. They are still behind Canon

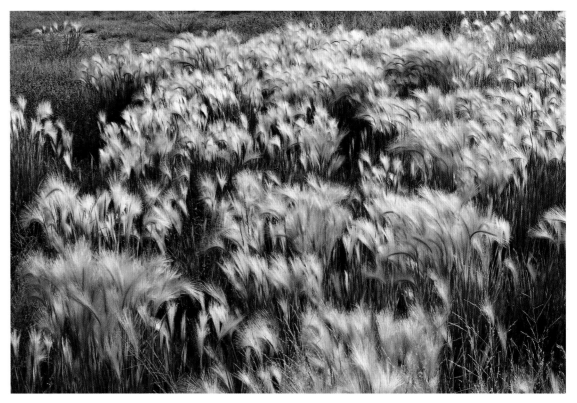

The dawn sun wonderfully highlights the back-lit foxtail grass that flourishes in the meadows around Mono Lake. By using the tilt features of a Canon 45 mm T/S lens and waiting for a lull in the light breeze, these grasses were sharply focused throughout the image.

and Nikon in early 2009, but they may close the distance in the future. We hope all of the other camera companies challenge Canon and Nikon, because this encourages everybody to produce better products at lower prices, a situation that substantially benefits all photographers.

MEDIUM-FORMAT CAMERAS

Medium- and large-format film cameras were the tools favored by most serious landscape photographers before the digital revolution. By 2005, DSLR cameras were producing better images than medium-format film cameras, so the popularity of medium-format cameras declined quickly, soon losing out to digital capture. However, medium-format digital cameras are beginning to regain lost ground among landscape photographers. These cameras offer huge megapixel counts; for example, the Hasselblad H3D has 31 megapixels. This camera produces a fine digital image with low noise, increased dynamic range, great color, and has so many megapixels that huge images of 4 × 6 feet or larger can be made while retaining excellent detail. Unfortunately, in early 2009, this fine camera costs more than $20,000, and you still have to buy some lenses for it! Few nature photographers can afford it, including your authors. If, however, you want to specialize in landscape photography and have the money to spend, you might consider checking out digital medium-format options. The major players are Hasselblad and Mamiya. We haven't gone to digital medium-format because they are so expensive, especially when you consider how rapidly the present state of digital technology goes out of date. Furthermore, it would

be terribly detrimental to our teaching capability if we shot camera systems that none of our students used. Still, digital medium-format cameras are a viable option for the wealthy among us.

IMPORTANT CAMERA FEATURES
MEGAPIXELS

The camera's digital imaging sensor is made up of tiny pixels (short for *picture elements*) that record and quantify the light that strikes them. Pixels are all the same size in a given sensor (in most cases), but vary in size among different sensors. Larger or smaller pixels; they're all very tiny. If you multiply the number of pixels in the width of an imaging sensor by the number of pixels in the height, you find the total number of pixels in the sensor. For example, the Canon 1Ds Mark II has a sensor with a width of 4992 pixels and a height of 3328 pixels. Multiplying those two numbers gives a total of 16,613,376 pixels. The number is rounded off and the camera is called a 16.7 megapixel camera, where *mega* is a prefix meaning *millions*. Nikon's D3 has 12.1 megapixels while Canon's 1Ds Mark III has 21.1 megapixels.

The number of megapixels can be increased by making pixels smaller or making the imaging sensor larger. Both the Nikon D3 and the Canon 1Ds Mark III have a full-frame sensor with no crop factor. A full-frame sensor is a sensor with a size approximating that of a single frame of 35mm film, and *crop factor* describes the relationship between the size of a full-frame sensor and the size of some smaller sensor. Meanwhile, the Canon 1D Mark III has a smaller sensor (1.3× crop factor) and 10.2

megapixels (MP). The imaging sensor is smaller and it contains fewer pixels. Both of these Canon cameras were introduced in 2007 and both were aimed at the advanced amateur and professional markets. Why would a professional photographer, who can buy either camera, select the Canon 1D Mark III with 10.2 MP over the Canon 1Ds Mark III with 21.1 MP?

DISADVANTAGES OF MORE MEGAPIXELS

Having more megapixels isn't always an advantage and is sometimes detrimental to shooting fine images. First of all, cameras with a lot of megapixels and a full-frame sensor are much more costly than cameras with a smaller sensor, so price is significantly affected by the pixel count. Secondly, a high-megapixel camera shoots larger image files and operates more slowly because it takes longer to transfer the sensor's data to the memory card. Thirdly, the memory card will hold fewer of the larger images so it takes longer to download the large files to the computer and hard drives will reach capacity more quickly. Most of these problems can be solved by using larger capacity storage devices and by being a bit more patient waiting for the files to be written.

The more important drawback to shooting images with large megapixel counts is that you can miss images altogether, because either the camera's buffer is full or the shooting speed is too low for fast action. While this is more of a consideration for action (wildlife and sports) photographers than landscape shooters, we rarely meet folks who are

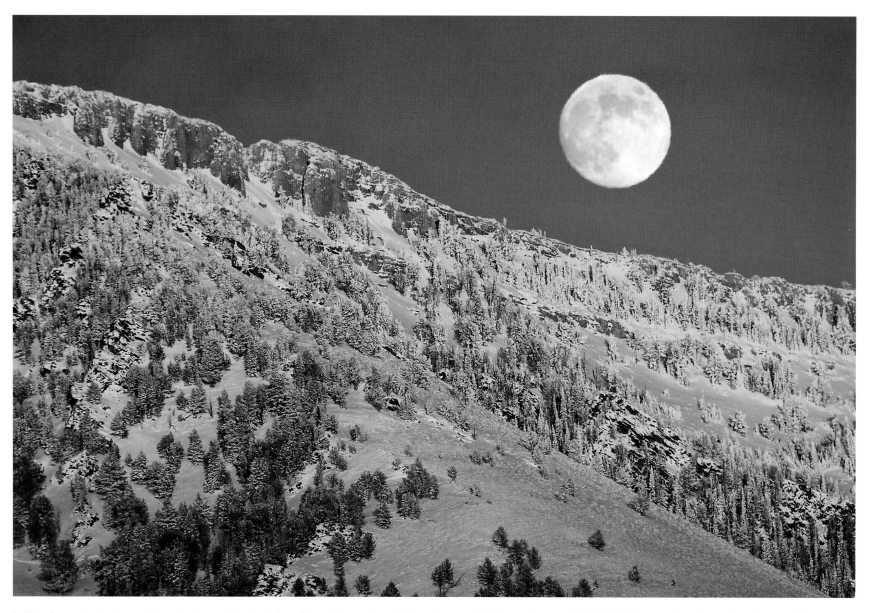

A 500 mm lens captured this moon rising over Black Mountain in Idaho. Since the mountain was still lit by the setting sun, a single image easily captured detail in both the mountain and the moon. We often use telephoto lenses to make landscape images.

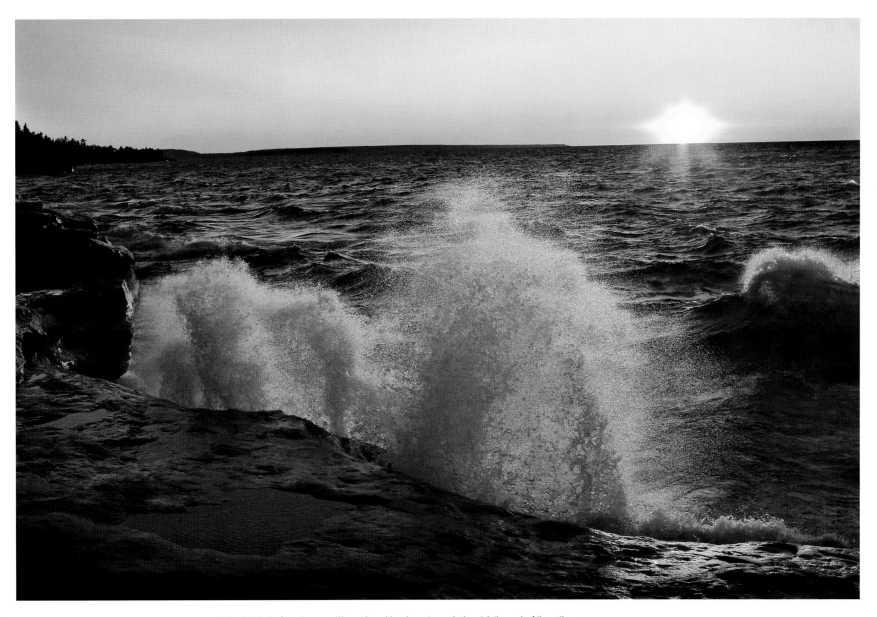

We love how the red light at sunset beautifully colors this back-lit Lake Superior wave. We used a cable release to precisely catch the peak of the action.

exclusively one or the other. So let's look at each of these factors in detail because they're critical to getting or missing images in some circumstances. Canon's 1Ds Mark II, for example, shoots 16.7 megapixel files. The large amount of data requires more time to be transferred to the camera's buffer so the fastest speed at which this camera can shoot images is four frames per second. When shooting, data from the sensor are sent to a temporary storage area called a *buffer* and then written to the memory card. Let's consider an analogy. As you put water into a bucket having a hole in the bottom, it's leaking out, but if you put water in faster than it leaks out, you'll eventually have a filled bucket. So it is with your digital camera's buffer writing to card memory!

When shooting, every shutter press causes picture data to leave the sensor and move into the storage buffer, which is faster. These data reside in the buffer while being written to the memory card, which is slower. Thus, when shooting too fast, the buffer can become filled (just like the bucket!), which prevents any more data from entering and temporarily shuts down the camera.

On this particular camera, the buffer can store ten 16.7 megapixel RAW images before it fills. As said, once the buffer is full, you can't shoot another image until enough data have been written to the memory card and buffer space becomes available for at least one more image. At a shooting rate of 4 frames per second (fps), you can see that holding the shutter button down during peak action will disable the camera in 2.5 seconds because the buffer fills to capacity with 10 images. Photographers define the *burst depth* of a camera as the number

of images you can shoot continuously before the buffer is full.

As we said above, having a large burst depth is clearly advantageous for action, but not as critical for landscape photographs. Shooting 4 fps sounds fast, but it's actually slow for some action photography, so you might miss a lot of good images. It isn't nearly fast enough for birds in flight or running cheetahs, even if it's plenty fast enough for nearly all landscape images. However, sometimes action and landscape shooting coincide: If you were photographing a tornado zigzagging across the prairie or a wave crashing into a rocky shoreline, you might wish to shoot faster than 4 fps.

Landscape photographers aren't often concerned with a camera's shooting speed or burst depth. They tend to shoot relatively static subjects. So, if you're exclusively a landscape photographer, you don't need to put too much emphasis on either factor as you evaluate cameras. However, since many landscape photographers often train their cameras on subjects other than landscapes, firing speed and burst depth might be important to you.

ADVANTAGES OF MORE MEGAPIXELS

The landscape photographer's limited concern with shooting speed and burst depth allows him to benefit from having more megapixels available. More megapixels are an advantage in making larger prints. Indeed, having more megapixels is more about size than about quality. For an 8 × 10 inch print, you probably couldn't see a difference in print quality between the average 8 MP DSLR and the 21.1 MP Canon EOS 1Ds Mark III. But, if your print will be 4 × 6 feet in size, the 21.1 MP

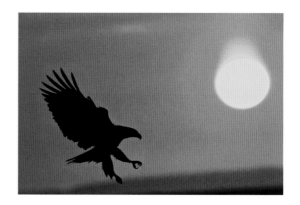

The 500 mm lens is perfect for capturing this wildlife landscape of a white-tailed eagle dropping its legs to land on sea ice in northern Japan.

image file will easily produce a sharper image. For example, remember that the pixel dimensions of the Canon 1Ds Mark II sensor are 4992 × 3328 pixels. Limitations in ink technology and the inability of our eyes to resolve very fine detail seldom warrant making prints with resolutions greater than 300 pixels per inch (ppi). Most people couldn't see the difference if higher ppi values were used. If 4992 pixels and 3328 pixels are divided by 300 pixels per inch, the resultant print size for 300 ppi is 16.64 × 11.09 inches. This is called the *native resolution* for 300 ppi. Computers, though, can use an interpolation process to synthesize additional pixels that lie between native pixels and allow even larger prints. Interpolation works well, but at some size, you start to seriously lose detail.

As a landscape photographer, you must consider your needs and budget. An 8 MP DSLR easily produces a beautiful 16 × 20 inch print. With a colored border added to the print, you could go 20 × 24 inches. Do you want to make larger prints?

If you don't, the 8 MP camera is all you need and anyway, most consumer-level cameras have more than 8 megapixels. You can buy an 8 MP DSLR for well under $1000. If you want to make huge prints and you have the money to spend, then more megapixels give an advantage to the landscape photographer. If you want to sell landscape images for calendars or books, or you want to enlist a stock photo agency to sell your images, it doesn't hurt to shoot the high-end cameras if you can handle their hefty price, which falls into the $4000–8000 range. Of course, DSLRs of any price range involve no incremental film or processing costs, so they end up cheaper to use than the initially less expensive film cameras. That's dramatically true for high-volume shooters. At least we look at it that way and it works for us.

Having more megapixels is again an advantage if you must substantially crop the image. Perhaps you took a beautiful reflection at a lake near your home, but the strip of sky at the top was grossly overexposed and had no detail at all. You could still make a nice print by cropping out the overexposed sky and leaving in the enchanting reflection. If you cut 25% of the pixels out of a 12 megapixel file, you still have 9 megapixels left, which are perfectly capable of making a 16 × 20 inch print. If you started with only a 6 megapixel file, cropping out 25% of the pixels or 1.5 megapixels leaves you a little short for making a super sharp 16 × 20 inch print.

(a, b) Micah is our good friend who packs the mules and cooks the meals on our backcountry photo tours. Having a larger 16.7 megapixel camera is a huge advantage if you must crop the image. We didn't want the boring sky, but knew it could be successfully eliminated later.

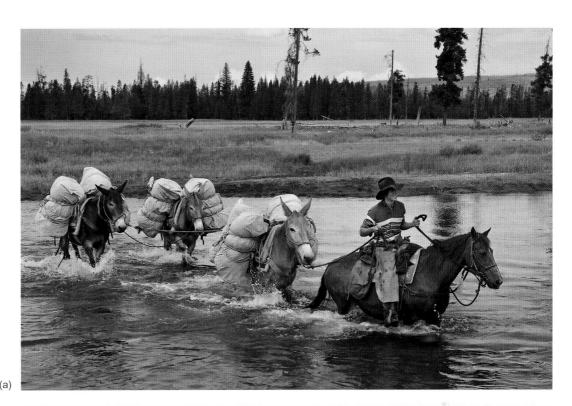

(a)

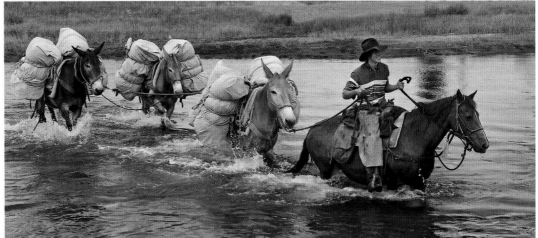

(b)

HIGH MEGAPIXEL COUNTS AREN'T EVERYTHING

All pixels aren't created equal. Most point-and-shoot pocket cameras have 7 megapixels or more, but a large print from these files won't have near the quality as an equally sized print from a 6 MP DSLR. The DSLR has a bigger imaging sensor, so its pixels are larger than those of the point-and-shoot cameras. Larger pixels count photons better, thus offering far better noise performance than point-and-shoot cameras with their very small pixels. (Yes, digital noise in your image can be reduced not only by using a camera with larger pixels, but also with any camera, by properly exposing the scene, and by using noise-reduction software such as Nik's Dfine, Noise Ninja, and Noiseware in your post-capture editing.) However, noise reduction software isn't our focus here: We're interested in suitable camera equipment for the best landscape photography.

The lower noise of cameras with larger pixels means the camera can be used at higher ISO values with less noise-related image degradation. Higher ISOs make shooting in low light easier while maintaining good image quality. Was there ever a dedicated landscape photographer who didn't welcome the occasional opportunity for improved dim-light shooting?

Digital noise is caused by pixel errors that show up primarily in the dark areas of an image. Pixel errors generally appear as unexpected bright or dark pixels (luminance noise) or as specks of red, green, and blue color (chrominance noise). Of the two types, chrominance noise is a greater problem,

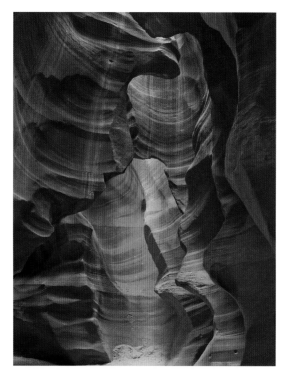

A sensor with large pixels is better able to accurately capture the color and detail when photographing in extremely dim light, as is often the case in slot canyons like this one near Page, Arizona.

but both should be minimized whenever possible. When you make a print, digital noise looks a little like film grain, but as we saw above, noise can be minimized by choosing a camera with larger pixels, by properly exposing the scene, and by using noise-reduction software.

SENSOR SIZE

Imaging sensors in different cameras aren't standardized sizes. For example, Canon offers the full-frame sensor on the EOS 5D, 1Ds Mark II, and the 1Ds Mark III. This sensor size is equivalent to the size of a 35mm slide image. The Canon EOS 30D, 40D, 50D, and Digital Rebel XSi all use a smaller sensor with a 1.6× crop factor. The Canon EOS 1D Mark III uses an in-between sensor size with a crop factor of 1.3×. Nikon also builds both full-frame cameras (these presently include the D3x, D3, and D700) and cameras with a smaller sensor, such as D300, D200, D80, etc. Nikon refers to the smaller sensor as the *DX* format, and even manufactures some lenses specifically for that format. We photographers benefit enormously from the manufacturers' ability to vary sensor sizes to suit various purposes.

First, let's wrap our brains around just what the crop factor is really all about. Some call it the magnification factor while others call it the lens conversion factor. Everyone is referring to the same thing, but we prefer to use the term crop factor because calling it a magnification or lens conversion factor isn't really accurate. A 300mm lens on a 35mm film SLR and on a digital camera with a full-frame sensor will record images of the same size. If you switch to a camera with a 1.5× crop factor, such as most of the Nikon DX cameras, the imaging sensor is smaller. A smaller portion of the subject fills that smaller sensor, giving a specious sense of magnification that falsely implies an increase in the focal length of the lens, as if the image was the same as that taken by a 450mm lens on a full-frame sensor. However, the focal length of 300mm is a fixed attribute of the lens, and can't be converted by changing sensor sizes. However, the lens does appear to

give you the framing that you might enjoy with a 450 mm lens. Yes, the size of the subject appears to be larger in the viewfinder, but the magnification isn't really greater. If everything else remains the same, such as shooting distance and focal length, a camera with a smaller sensor is merely cropping the image that would be recorded with the same lens on a full-frame sensor. The image really isn't magnified, nor is the lens magically converted into a longer focal length. If distance and lens type caused a picture of you to just fit in a full-frame sensor, and if that distance and lens type were maintained, your image on a smaller sensor would have your visible body the same size as before, but your hat and legs might be missing! It's just as if the full-frame image had been cropped.

The crop factor of most DSLRs isn't the same as greater magnification, but with a given lens, a given subject fills more of the sensor and fills more of the viewfinder; both are a gratifying illusion when you're wishing for a longer lens.

SMALL SENSOR ADVANTAGES

Be aware that the considerations here aren't really photographic advantages, but rather cost-related ones:

1. Smaller sensors are much cheaper to build. Additionally, if the smaller sensor has correspondingly fewer pixels, then all of the camera's other electronics are simplified, battery requirements are lessened, the camera can be smaller, weight is lower, lenses are simpler and cheaper, and the simpler camera has lower warranty costs, packaging and shipping costs, and on and on and on. It all results in a much lower camera cost.

2. The seemingly greater magnification caused by the crop factor of a small sensor is helpful when you wish to fill the frame with a distant landscape but don't have a full-frame camera with a longer focal-length lens. Again, this is primarily a cost advantage rather than a photographic one: You still get a cropped image.

3. The viewing angle of the lens is smaller when the image is focused on a small sensor, so it's easier to keep distractions out of the background.

4. Many companies design and manufacture special lenses for use on camera bodies that have a crop factor, because those bodies form the largest

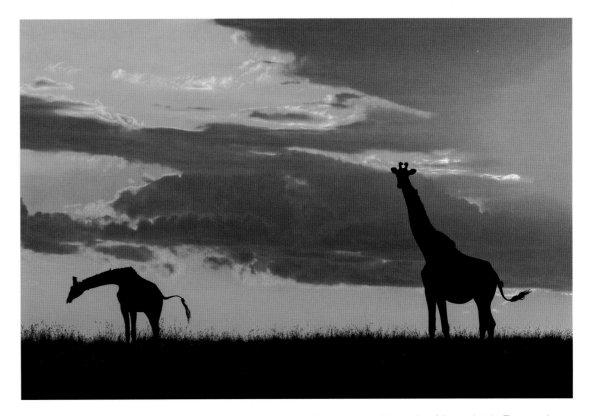

We used a longer focal length from below the hill to isolate these Maasai giraffes against the reddest portion of the evening sky. The camera's crop factor helped us exclude unwanted elements from the image.

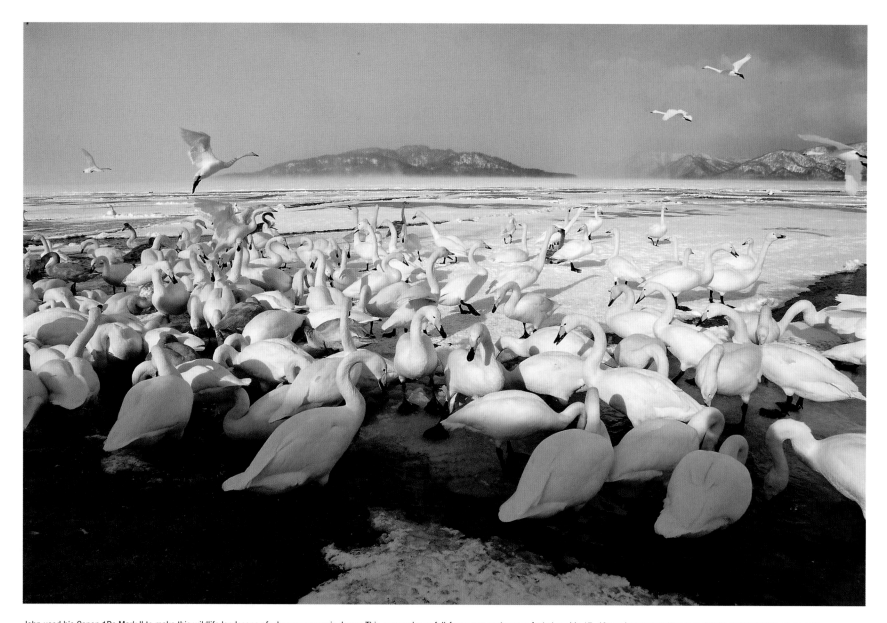

John used his Canon 1Ds Mark II to make this wildlife landscape of whooper swans in Japan. This camera has a full-frame sensor (no crop factor), so his 17–40 mm lens set at 17 mm maintained a true wide-angle view.

market segment of digital cameras. The lenses don't have to produce as large an image circle as lenses for full-frame sensors, so they can be smaller, lighter, and less expensive.

5. Small sensors seem to attract less dirt, and are easier to clean than a full-frame sensor.

6. The small sensor, when used with a lens designed for full-frame sensors (the overwhelming majority of lenses), uses only a portion of the lens' image circle. It's the portion nearer to the center of the image circle, an area often called the *sweet spot* because it's the area of optimal lens performance. The bottom line is that the image on a small sensor may be sharper overall than a full-frame image made with the same lens.

SMALL SENSOR DISADVANTAGES

1. The sensor contains fewer light-sensitive receptors, called photo sites, or pixels, so the camera's megapixel count is lower.

2. If a small sensor has a larger number of pixels, the individual pixels must be smaller. Smaller pixels don't record light as well, resulting in reduced color accuracy and increased digital noise.

3. Small sensors normally have fewer pixels than full-frame sensors, so you can't crop their images as much and still maintain the high resolution you may want for your large prints.

4. Probably the most serious problem for the landscape photographer is the crop factor of the small sensor when the image will require use of a wide-angle lens. A crop factor of 1.5× will cause a 20 mm wide-angle lens to act like a 30 mm lens (20 mm × 1.5 = 30), so you lose the wide field

of view of the 20 mm lens. Wide-angle lenses are enormously effective for many landscape images, but they won't seem as wide with the crop factor of a small sensor.

LARGE LCD MONITOR

Photographers prefer large LCD monitors on the backs of their cameras. Early digital cameras had small monitors, but later monitors have gradually grown. A 2.5-inch (diagonal) monitor is the minimum you should accept today, although we think that a 3-inch monitor is much better. Also, a monitor that displays more pixels produces a sharper image that's easier to check for sharpness and content. We use the monitor primarily to view our menus when changing settings and to check the histogram and highlight alert when determining proper exposure. Many photographers use the monitor to check their composition, lighting, and sharpness. We don't use the monitor for these things because we know the composition and lighting before we shoot the image. Our shooting habits enable us to easily get perfectly crisp images, so in most situations, there's no need to check for sharpness either.

The greatest irritant to LCD monitor use is the difficulty seeing its image clearly in high ambient light levels. Stated simply, the sun wipes out the image! Our solution is to use a viewing device called the HoodLoupe. It hangs from a thin, lightweight strap worn around the neck and, when needed, is placed against the monitor. The

user examines his image by looking through the HoodLoupe eyepiece while the loupe blocks out the irritating ambient light. The loupe can be adjusted for the user's eyesight and permits him to examine the image's finest details.

LUMINANCE AND RGB HISTOGRAMS

All digital cameras offer a histogram to check the exposure. Using the histogram is the best way to ensure the very best exposure, so be sure to activate it. In most cameras, it can be turned on somewhere in the menu and viewed on the LCD screen. The typical histogram is the *luminance histogram*, although Canon calls it the *bright histogram* in some of their camera manuals and others just call it the *histogram*. This histogram charts your pixel values from pure black with a value of zero to pure white at the 255th value. Most digital cameras have three color channels (red, green, and blue), although some systems offer slightly different schemes. The luminance histogram averages the three color channels and charts the results. Once you understand how to interpret the histogram (discussed in Chapter 4, Mastering Exposure), shooting terrific exposures is easy.

There's a problem with the luminance histogram, though. It's possible to clip one and even two color channels, yet when the three color channels are averaged together, no clipping is shown. Clipping a single color channel could cause a loss of detail in important areas of the subject, so it's normally avoided. For example, photographing a

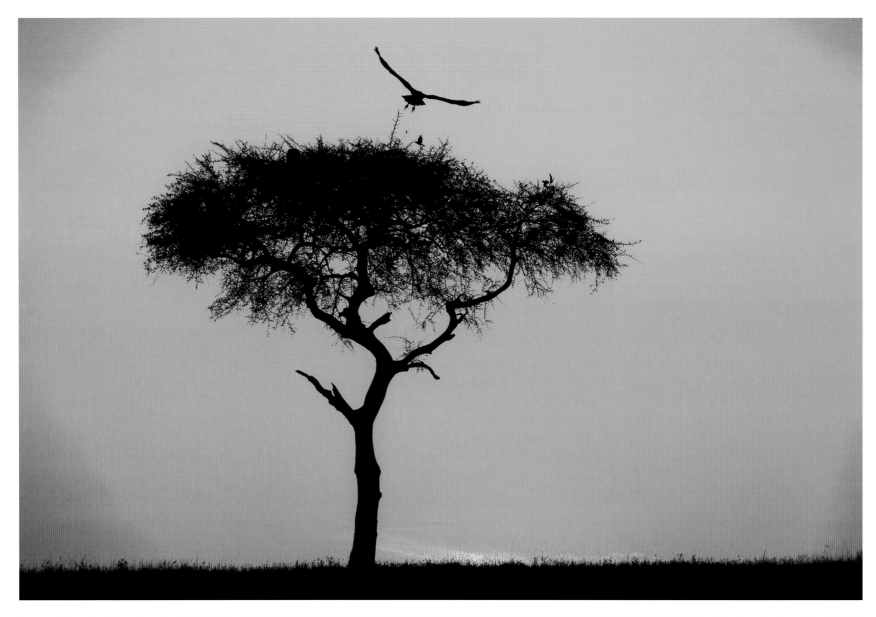

Any scene with an abundance of one color like this red dawn background is prone to clipping a color channel. Using the RBG histogram option provides an individual histogram of each color channel, so clipping can be avoided. The white-backed vulture lifting off this acacia tree is a typical scene at dawn in Kenya's Maasai Mara Game Reserve.

subject with a lot of red, such as a scene full of red maple trees during autumn, could easily clip the red color channel because so much red light is striking the sensor. This leads to a loss of detail in the red leaves. (By the way, Barbara finds that clipping the red color channel is especially problematic when making her fine art prints because red objects lose their detail so completely. So if nothing else, don't overexpose the reds!)

Many cameras now have another histogram choice that goes by a variety of names. Some call it the color channel histogram. We prefer to call it the RGB histogram for the red, green, and blue channels mentioned above. This histogram display shows an individual histogram for each separate color channel along with an overall luminance histogram. The RGB histogram is simple to use, and will help you capture the optimum exposure for most scenes. It displays the histogram for each individual color channel and can be used to avoid overexposing any of the color channels, so no important detail is lost in the image. The RGB histogram is a powerful feature, so make sure your camera has it before buying a new DSLR.

MIRROR LOCKUP

A DSLR mirror, in its normal movement, causes the camera to vibrate ever so slightly, which can cause a slight loss of image sharpness when shooting at shutter speeds in the 1/4 to 1/60 second range. Accordingly, many cameras allow the mirror to be locked before shutter release to reduce camera vibration. Make sure your intended camera purchase has the mirror lockup feature and, if your present camera has it, be sure to use it whenever appropriate.

Some cameras have their mirror lockup switch on the camera body, but most digital cameras with mirror lockup offer a custom function to set it. Mirror lockup is especially useful to landscape and close-up photographers, so it's well worth having and using. We'll discuss strategies for using this feature in more detail in Chapter 5.

SELF-TIMER

A self-timer is a useful accessory for landscape photographers. All cameras have a self-timer, and the default setting is typically ten seconds. One example of self-timer use is when the photographer mounts the camera on a tripod, activates the self-timer, pushes the shutter button, and runs around the camera to enter the scene to be photographed within it. The typical default ten-second delay works great for that scenario, but isn't very useful for some other purposes. Fortunately, many cameras allow user adjustment of the delay time. Landscape and close-up photographers often prefer a shorter self-timer delay. A two-second delay is often used to obtain sharper images by reducing camera shake. Suppose, on your tripod-mounted camera, you push the shutter-release button very gently. That gentle push and the resulting mechanical motion of the mirror join to cause a slight vibration in the camera. In turn, that vibration can cause a certain unsharpness when shooting at shutter speeds from 1/4 second to 1/60 second. The self-timer eliminates vibration caused by that button push and, as said before, mirror lockup eliminates

that vibration caused by the mirror. When using vibration reduction the photographer generally wouldn't want to wait and waste the default ten seconds and would prefer to set her self-timer to a more convenient two seconds.

CABLE RELEASES

The cable release is another important aid to image sharpness. Camera vibration and resulting image softness are reduced by isolating the photographer's hand from the camera. You should always be using a camera that can be fired by a cable release. Older cameras used a mechanical cable release and modern cameras use an electrical cable release. The modern electrical release comprises a hand-held push button, a flexible connecting wire, and a mating connector for the camera.

Some of today's cameras eliminate the cost and reliability issues of an on-camera connector by using a cable-free remote release that operates by infrared light or by wireless radio, just like your TV remote. Infrared and radio releases share the upside of allowing greater distances between the camera and photographer. One downside with some models is that the remote release can only fire from in front of the camera, since that's where the infrared sensor is. They also need batteries and are easily lost. Come to think of it, cable releases are easily lost, too! We once found a cable release in a meadow where we had been taking photo students for many years. It had obviously been lost years earlier because it was badly rusted, but it still had the red ribbon that had been tied around it to help the owner see it. Mechanical or electrical,

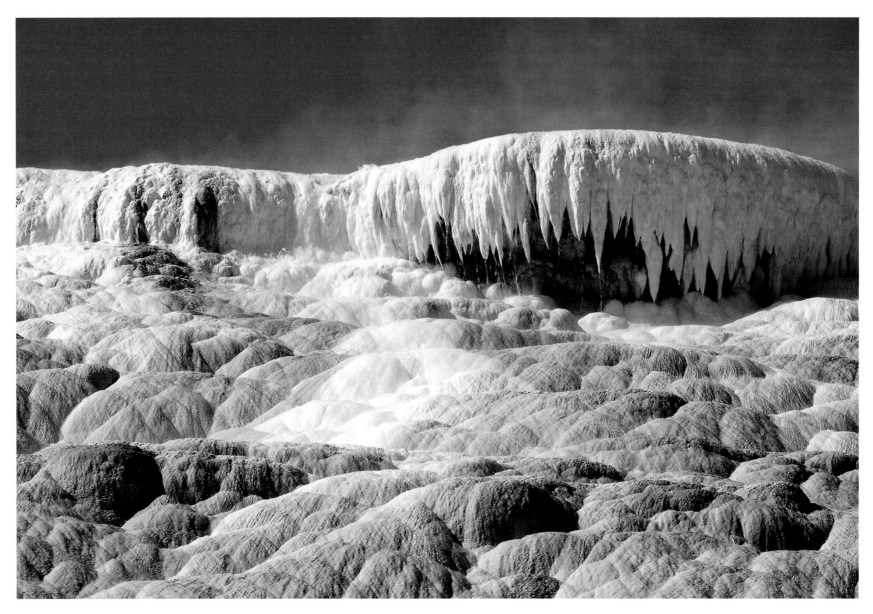

Palette Spring at Mammoth Hot Springs in Yellowstone offers wonderful patterns. Since wind can't wiggle the subject, this is the perfect time to use mirror lockup, f/16 depth of field, and the 2-second self-timer to trip the shutter for maximum sharpness.

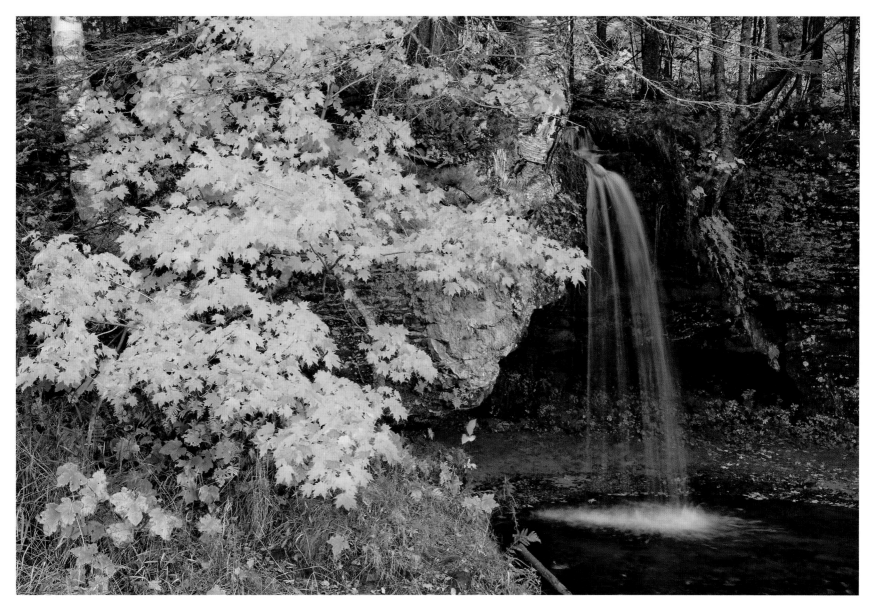

Scott Falls is an adorable tiny waterfall, especially after a recent rainstorm. The orange and red maple leaves nicely fill in the foreground. Steady breezes tend to be common during Michigan's autumn season, so use a cable release to fire the camera when the leaves are motionless. We call this "catching the peak of stillness."

cable-attached or remote, optical or radio, an off-camera release is an important weapon in the never-ending battle for sharper images.

SPOT METER

A spot meter measures the light reflected from a very tiny 2 or 3% of the scene. In the past, we used manual exposure, spot-metered some part of a scene, adjusted the exposure for the tonality (reflectance) of the metered area, and shot. This was a very effective way to expose slide film, and works every bit as well for digital capture. However, we've recently modified our exposure techniques to take advantage of the digital histogram and the highlight alerts (*blinkies*), so spot-metering isn't nearly as valuable to us now.

CUSTOM FUNCTIONS

Sadly, far too many photographers never take advantage of the custom functions that nearly all cameras have. Custom functions let you program the camera to reflect your personal shooting techniques and styles. You probably won't use the majority of the custom functions — few photographers do — but some of the functions can be very important to the enjoyment of your camera and to your photographic success. Make sure that any camera you buy has custom functions and diligently check each one to see if it might be helpful to you. We'll go over custom functions in detail in Chapter 5.

MEMORY CARDS

Digital images are first sent from the sensor to the camera's internal buffer and then written to a

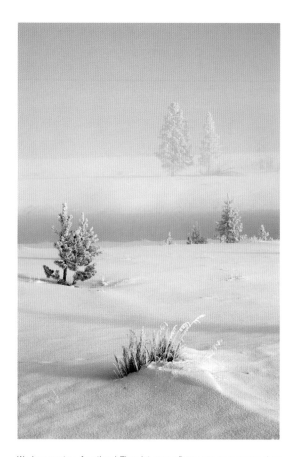

We love custom functions! They let us configure our cameras so they work the way we want them to. Here, we used custom functions to set mirror lockup, back-button focusing, highlight tone priority, and live view exposure simulation. These frosted plants grow along the Madison River in Yellowstone.

memory card. There are several configurations of cards, and depending on your camera, you may require a CompactFlash (CF) card, a Secure Digital card, a Memory Stick Pro Dual, or some other type of card. Some cameras have slots for two different types of cards, and some, like the Nikon D3, have slots for two cards of the same type. Four of the best known manufacturers of memory cards are Delkin, Kingston, Lexar, and SanDisk. We've used SanDisk CF cards for all of our digital shooting, have never had a problem with them, and we can recommend them from several years of personal experience.

The prices of memory cards, like prices of most digital equipment, have decreased over the years while the card speed, capacity, and reliability have increased. A one gigabyte (1 GB) CompactFlash card was considered huge only a few years ago. Today, though, even low-end DSLRs shoot image files upwards of 10 megabytes (10 MB), so it's more convenient to routinely use memory cards with greater capacity. We currently (early 2009) use SanDisk Extreme IV cards that hold 8 GB and 16 GB of data. A 16 GB card can hold around 1600 10 MB files. It's surely a lot smaller, lighter, and cheaper than the 45 rolls of film needed for 1600 images! These big cards can be purchased for less than $250, a price likely to drop in the future. Notice that all memory cards of a given capacity aren't the same. Some cards can be written to, and can write, faster than other cards. We strongly recommend that you use the higher speed memory cards that permit faster camera operation. We freely admit that card speed isn't critical for landscape photographers, but you'll certainly appreciate that increased speed if you shoot action images. Additionally, the larger file sizes of many newer cameras will make you appreciate the larger capacity and faster memory cards.

Some argue that it's better to use more smaller capacity cards than fewer larger capacity cards so you won't have all of your image eggs in one card basket. But, goes the counter-argument, by using a greater quantity of the smaller capacity cards, you increase the statistical likelihood of card failures and of misplacing a card. The more relaxed pace of landscape photography makes it less critical but, in wildlife photography, we find that smaller cards always seem to become filled at the most inopportune times and that increases our chances of missing a good shot. There's no right or wrong choice here. It depends on your needs and how you feel.

USE MEMORY CARDS PROPERLY

Knock on wood, we've never lost an image from the malfunction of a SanDisk card. Some of our students have, so we know it's always a risk. We do know that using cards properly will reduce your risk of lost images. How do you use a card properly?

1. Never let the camera's battery go completely dead while you're photographing. Losing power while data are written to the card can easily corrupt not only the image written, but all the other images already on the card. Always keep your camera batteries as near to fully charged as practicable.
2. Never delete individual images from the card, and download all of the images on the card to your main storage device as soon as practicable. We download the images to our computer's hard drive and then download a backup copy to an external hard drive.
3. Once you have a backup of your images, re-insert the memory card into its camera. Erase the images, not by using the camera's erasing option, but by formatting the card. *Do not* format the card in your computer, it might cause the card to malfunction in the camera. *Format only in the camera!*
4. Don't permit the ingress of dirt. Certain card types, such as the popular CF card, have scores of tiny holes in the card into which even tinier pins of the camera are inserted for electrical contact. These itsy-bitsy holes in the card are easily plugged by pocket and purse lint and debris and can cause very expensive camera damage when the card is inserted into a camera. Our point? Don't put these cards into your pocket or purse without protection by some kind of card case!

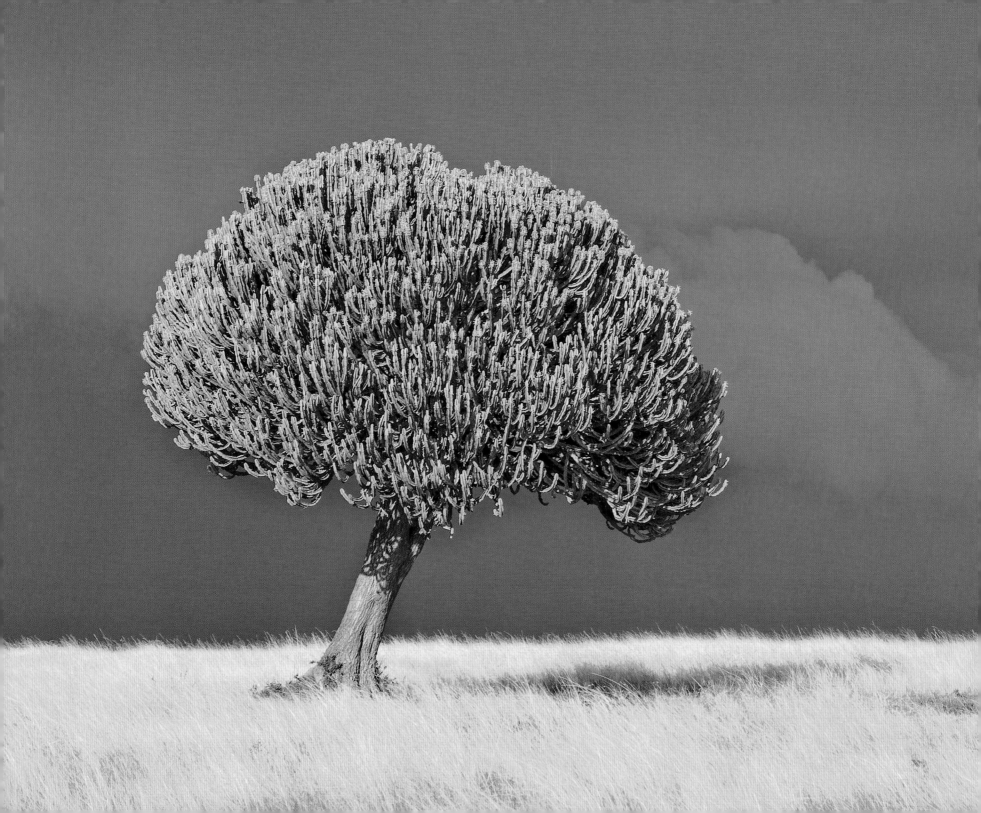

Choosing and Using Lenses

This isolated euphorbia tree in the Maasai Mara of Kenya is nicely illuminated with golden light near sunset. The awesome black storm clouds to the east are a wonderful added bonus.

THE IMPORTANCE OF QUALITY

Lenses are critically important to the quality of your images because, among other things, they focus the light that's recorded by the imaging sensor. Some lenses do this better than others. We believe that it's more important to buy the best lenses you can afford instead of the most expensive camera. Quality lenses excel at focusing light, so the images are sharper (assuming the photographers do their part), provide good contrast, and deliver accurate colors. A good lens is easy to use and rugged enough to not break easily. You might think all lenses should meet these standards, but lenses built for serious photographers who use their equipment a lot tend to be far more durable than the vast majority of lenses, which are made for consumers who don't use their gear very much. Lens manufacturers know how to make high-quality lenses, but quality pushes the cost up, and many manufacturers build lenses for those who don't want to spend too much money on their hobby, as well as the lenses for those who demand quality. No matter what price range, all lenses we've seen in our workshops lately have done a good job.

AMATEUR VS. PRO QUALITY LENSES

What lenses you should buy depends on your budget and demand for quality. If you don't need the absolute best quality, you can save a bundle on lenses. If you're a stickler for quality, consider the lenses built for serious photographers.

However, many times a much higher price has more to do with added features that you may or may not need. For example, Canon offers EF, EF-S, and the L series lenses. The EF lenses are their less expensive line of lenses. These are quite good and we use some of them with fine results. The L series lenses are made with special lens elements that deliver extremely sharp images, they tend to be faster than EF lenses, and may have other features such as image-stabilization. Of course you pay a price for all of this. The Canon EF 35 mm f/2.0 lens is about $230 while the Canon 35 mm f/1.4L USM costs $1120, a difference of $890! Whether the price

difference is worth it really depends on your needs. The 35 mm f/1.4L USM lens is one stop faster than the non-USM lens, so the glass elements are larger, making the lens weigh more. The letter "L" indicates this lens uses the best optical elements, so you can expect it to be a tiny bit sharper than the other lens, especially when shooting it wide open at f/1.4. If you stop both lenses down to f/8 or f/11, the sharpness difference isn't really significant. Lens elements of high-optical-quality glass are especially critical to the design of zoom lenses to ensure the lenses are satisfactorily sharp throughout their focal-length ranges. The faster speed of an f/1.4 lens does make it a bit easier to shoot hand-held in dim light, so it would appeal to street and sports photographers. The term *USM* means the f/1.4L lens has an interior ultrasonic motor that makes for speedier autofocus, something very important for action photos, if not for landscapes. In this case, we don't feel the difference in price is worth it to landscape photographers who tend to stop down the lens to f/16 for greater depth of field and who use a tripod most of the time.

The other lens category is the Canon EF-S lenses. These lenses are made lighter and smaller because they're designed for the smaller image circle appropriate to cameras with small sensors, i.e., cameras with a crop factor. However, the smaller image circle won't fully cover a full-frame sensor, so the EF-S lenses are generally not used on full-frame cameras. The whole point of this discussion is to show that it's futile to compare lenses by price alone. You must read about the lenses you're considering and carefully determine why some are more expensive than others, even though they are the same focal length. Glass quality, and features such as image-stabilization, fast autofocus, and lens speed all play a part in determining the price of a lens.

LENS SPEED

This has nothing to do with how fast a lens can run or how fast it can deplete your bank account.

Lens speed refers to how much light a lens can pass. A 300 mm lens with a maximum speed of f/8 is considered a slower lens, while a 300 mm f/2.8 lens is faster because it passes three additional stops of light. Action photographers appreciate fast lenses because the reciprocity principle allows the faster shutter speeds needed to freeze action. This is especially true if they must photograph in dim light, such as during a night football game. If

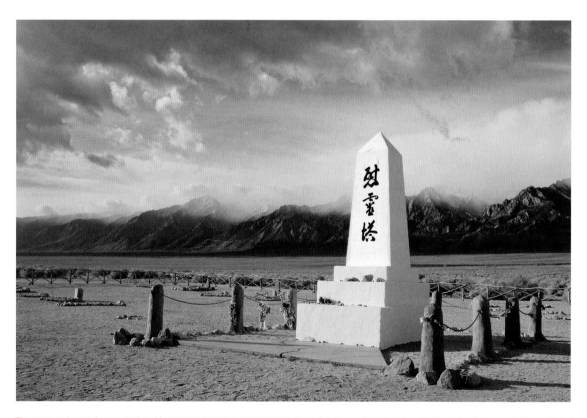

The warm early morning sun bathes this monument while a snowstorm begins to break over the Sierra Nevada Mountains to the west. It's erected at the Manzanar National Historic site where Japanese and Japanese-Americans were interred during WW II. Since nothing is moving, use f/16 depth of field to capture detail in the distant mountains. In this instance, lens speed isn't important.

proper exposure at ISO 400 is 1/60 at f/8 and the lens used is a 300 mm f/8, you won't be stopping the action of many running backs. If your lens speed is f/2.8 (three stops faster than f/8), then you can now use an exposure combination of f/2.8 at 1/500, making sharp images far more likely.

Faster lenses need larger optical-glass elements, so these lenses are bigger, heavier, and more expensive than slower lenses. On the other hand, a fast lens allows higher shutter speeds more easily, the viewfinder is brighter, and the autofocus may also be quicker. What makes the most sense for a landscape photographer? We wish a definite answer was forthcoming, but the right answer depends on your own needs and budget.

We were recently faced with this choice when John decided he needed a Canon lens that covered the 70–200 mm range. Our logic in deciding which one to buy might help you decide, too. Canon makes three 70–200 mm zooms and all of them are L lenses. The three lenses we had to choose from were the 70–200 mm f/4.0L USM, the 70–200 mm f/4.0L USM IS, and the 70–200 mm f/2.8L USM. All three lenses were USM lenses with the ultrasonic motor for fast autofocusing, so that wasn't a factor. The f/2.8L lens was the biggest and most expensive of the three. John's lens would be used primarily for landscapes, and carrying heavy gear a long distance is a problem, so we dropped this one from consideration. Now we could choose between the two 70–200 mm f/4.0L lenses. One has image-stabilization (IS) and one doesn't. The IS lens is twice as expensive. Image-stabilization is useful in hand-held photography because it helps get sharp images

when slower shutter speeds are used. We nearly always use a solid tripod when shooting landscapes, so image-stabilization wasn't important, so we bought the 70–200 mm f/4.0L lens that was half the price of the other one and a lot lighter to carry. We have used that lens for two years and know we made the right choice for our particular needs.

Landscape photographers have an advantage over action photographers because expensive lens features are usually unnecessary for serious landscape work done slowly and carefully on a sturdy tripod. This means you don't need to spend nearly as much money or carry as much weight to be well equipped for your landscape work. We agree your choices are more difficult if you love to shoot landscapes and also like making close-ups or photographing wildlife. We photograph all types of nature (except underwater — John can't swim!), so we often have to make trade-offs in our lens choices. If you, too, do other kinds of photography, then you must decide if perhaps you really do need a faster lens or image-stabilization.

PROS AND CONS OF FAST LENSES

We like them because:

1. A fast lens passes more light, so it's easier to use fast shutter speeds.
2. A fast lens gives a brighter viewfinder, improving the ease of focusing and composing.
3. A fast lens is generally built with the best optical glass, so it's sharper, especially wide open.
4. A fast lens has a larger aperture, such as f/2.8, giving less depth of field when wide open, making it easier to defocus an objectionable background.

5. A fast lens does autofocus faster and more accurately.

But, on the other hand:

1. A fast lens is more expensive than a slower lens of the same focal length.
2. A fast lens is heavier, so hand-held shooting will be more difficult.
3. A fast lens is heavier, so just lugging it around may be a problem.
4. A fast lens is bulkier, so it takes up more room in your camera bag.
5. A fast lens generally requires larger filters, which add to the weight and cost.

IMAGE-STABILIZATION

Canon has offered image-stabilized lenses for many years. Other manufacturers have only recently introduced lenses incorporating moveable elements that compensate to some degree for wiggling cameras and reduce the apparent movement. Canon calls these *image-stabilized* (IS) lenses, and Nikon calls them *vibration reduction* (VR) lenses. Whatever the terms used, they do similar things to deliver sharper images. Some companies have built an anti-shake mechanism right into the camera body. Sony's *Super Steadyshot* is built into the camera body and, like VR and IS, reduces the negative effects of camera movement. Moreover, it works with any lens that can be used by the Sony camera.

These anti-shake mechanisms do help photographers who shoot hand-held get sharper images

at lower shutter speeds. A common rule of thumb states you can safely shoot hand-held if the shutter speed used is 1/(focal length) or faster. For example, if you're using a 200 mm lens, plugging the 200 mm focal length into the formula shows you need a shutter speed of at least 1/200 second to ensure sharp images. Naturally, this depends greatly on how steady a shooter you are to begin with. Using an anti-shake lens or camera body, photographers can shoot at two shutter speeds slower than the formula suggests, and sometimes more, but this is debatable. With the 200 mm lens, using anti-shake technology can deliver sharp hand-held images at 1/50 second shutter speed. It's clear that anti-shake helps deliver sharp images, but don't overly rely on it. Too many photographers shoot hand-held at shutter speeds far too slow for hand-held photography, with or without anti-shake.

We find limited use for anti-shake features in our landscape photography because we shoot on a sturdy tripod whenever possible to have complete control over focus, depth of field, and image sharpness. Anti-shake technology might, in a very few cases, eliminate the need for the stabilization benefits of our sturdy tripods, but we'd continue to faithfully use the tripods because of their value as aids to composition. That doesn't mean there's little use for anti-shake technology in landscape photography. There are times when it's awkward or impossible to use a tripod. It's difficult to use a tripod in mounds of powdery snow, so anti-shake systems do help deliver crisp images there. However, we normally pack the snow down with our feet and still use a tripod. We have often used Canon's IS lenses

It's difficult to use a tripod in several feet of soft snow, so John used a Canon 24–105 mm f/4 IS lens hand-held to capture these "ghost trees" on Two Top Mountain. He used ISO 200 for more shutter speed, sat down in the snow, rested his elbows on his knees, and gently tripped the shutter to achieve excellent sharpness.

and Nikon's VR lenses to photograph the gorgeous rock formations along the Lake Superior shoreline between Munising and Grand Marais on Michigan's beautiful Upper Peninsula. Anti-shake technology is terrific for photographing from boats! We've been to Antarctica twice (awesome trips!), and we know we could make good use of anti-shake lenses while photographing icebergs from our Zodiacs, the inflatable boats perfect for cruising the ice fields.

The anti-shake systems of some (but not all) lenses should be turned off when shooting on a tripod. Even if the camera isn't moving, the anti-shake mechanism may activate to look for shake and cause some of its own. However, there are times when you have camera movement even on a tripod. Anyone who has used a tripod in a howling wind knows what we mean, so if it's a windy day, use your anti-shake even when using a tripod. It can help!

The number of focal lengths contained in a single zoom lens is enormously helpful to landscape photographers. Barbara used her Nikon 70–200 mm lens to isolate these dead lodgepole pines in the fog.

But always follow the maker's recommendations about whether to use anti-shake when on a tripod.

ZOOM LENSES

WHAT'S A ZOOM LENS?

The Canon 17–40mm f/4.0L USM, the Nikon 18–35mm f/3.5–4.5, the Sony 24–105mm f/3.5–4.5, and the Tokina 19–35mm f/3.5–4.5 are all wide-angle zoom lenses that work well for landscape photography. A zoom lens can change its focal length over a certain range. For example, the Nikon 18–35mm lens can be adjusted to any focal length from 18 to 35mm. Some zooms cover a much broader focal length range than others, although zooms with very broad focal length ranges are more difficult to build, which often results in a lower optical quality. Notice that some zoom lenses, such as the Canon 17–40mm f/4.0 lens, have a constant maximum aperture, whereas other lenses, like the Tokina 19–35mm f/3.5–4.5, have an aperture that smoothly changes from f/3.5 at the 19mm focal length to f/4.5 when the lens is zoomed out to 35mm.

Lens makers have offered two kinds of zoom lenses. The so-called *push–pull* zoom is operated by pushing or pulling back and forth a collar that's around the lens barrel to change the focal length. The other kind of zoom lens has a shorter collar around the lens barrel, generally called a *ring*, and one turns this ring clockwise or counterclockwise to change the focal length. Both types work fairly well, but we prefer changing the focal length by turning a ring, rather than by pushing or pulling a collar. We like the greater precision of turning a ring, and we like that dust ingress seems less problematic with the ring zooms. We heartily dislike the irritating gravity-induced tendency of some push–pull zooms to zoom this way and that whenever the camera is pointed up or down.

DO ZOOM LENSES DELIVER QUALITY IMAGES?

Serious photographers shunned zooms when they were first introduced many years ago. Those early zooms were physically fragile and, perhaps worse, optically poor and gave soft images. Today, though, they're much sharper and far more durable, especially the better lenses made for serious photographers. Get lenses with low-dispersion glass, if they're available from your lens manufacturer. It's still true that an excellent fixed focal length lens is slightly sharper than the best zoom lenses, but the difference is so minuscule that it's no reason to avoid zooms. Skilled photographers use their quality

A zoom lens with VR technology is an awesome landscape photography tool. Not only does it permit you to easily adjust the composition of your image, but it makes it so much easier to shoot sharp images when you must shoot hand-held from a boat, such as the scene of Spray Falls along the coast of Lake Superior.

zoom lenses to produce consistently excellent results, so don't shy away from them.

ZOOM LENS ADVANTAGES

In many cases, you must have a zoom lens or you won't get the image. Years ago we shunned the early zoom lenses and used only fixed focal-length lenses, so we often missed nice images altogether. Many good landscape locations in parks are viewing platforms, from which it's against the rules to get off, and perhaps dangerous. Murphy's well-known law states that, if you've packed your 24, 35, 50, and 100 mm lenses and have hiked a long way uphill to your remote viewing location, you'll find that you really need exactly 75 mm for the shot, so you don't get that composition. Two zoom lenses covering focal lengths from 17 to 120 mm make every composition within this range both possible and convenient.

Zoom lenses are enormously useful to landscape photographers because they offer so many focal-length choices in a single small package. Not only does that focal-length cornucopia ease your compositional burdens, but you won't have to remove and replace lenses so often. That's more efficient for you, and it reduces the chance of dust entering the interior of the camera where it'll surely end up on the sensor. A couple of zoom lenses usually weigh much less than several fixed focal-length lenses covering the same range, take up less room in your camera bag, and are less expensive too!

When photographing the Grand Canyon of the Yellowstone with your Canon 100–400 mm f/4.5–5.6L zoom, you'll be pleased that only a single 77 mm polarizer covers your entire range of focal lengths. Your shooting pal with several prime lenses may have to lug around (and pay for) several different polarizers.

ZOOM LENS DRAWBACKS

It's not surprising to find that zoom lenses are somewhat more fragile than prime lenses because they have many more parts and many more moving parts. Our own experience bears this out. Be especially careful with them in cold weather, too. We've had students in our winter tours of Yellowstone National Park bring a zoom lens into a warm room without first putting it in a tightly closed plastic bag. Condensation immediately covered the lens and formed inside the lens, even on the glass elements. The students spent all night trying to dry the lens out by *baking* it in an oven at 90°F. Caution! Notice carefully the F in the preceding statement! When the students tried to use the lens the following morning in below-freezing temperatures, residual moisture inside the lens froze, making it impossible to zoom the lens.

We've already noted that some push–pull zoom lenses zoom all by themselves when they're pointed up or down and that fixed focal-length lenses don't have this problem. We should mention, though, that some push–pull zoom lenses, such as the Canon 100–400 mm, have a locking collar to eliminate the zoom slippage.

Zoom lenses tend to be slower than comparable fixed focal-length lenses. For example, the Canon 75–300 mm zooms are f/5.6 when zoomed out to 300 mm. The two Canon 300 mm prime lenses have speeds of f/4 and f/2.8, both faster than any of the Canon lenses that zoom to 300 mm.

VARIABLE APERTURE ZOOMS VS. CONSTANT MAXIMUM APERTURE ZOOMS

The aperture varies during zooming on most zoom lenses, but not all. The Canon 28–300 mm f/3.5–5.6L lens has a variable aperture that loses 1 1/3 stops of light as the focal length is changed from 28 to 300 mm. The Canon 70–200 mm f/4L doesn't lose lens speed (i.e., vary the aperture) as it is zoomed from 70 to 200 mm. Let's explore the pros and cons of these two types of zoom lenses.

Variable aperture zoom lenses don't need such a large front glass element because the maximum aperture is allowed to get smaller. This means these lenses tend to be lighter, smaller, and less expensive than zoom lenses that have a constant maximum aperture. On the other hand, as the aperture of a variable aperture zoom gets smaller as the lens is zoomed out, the viewfinder becomes darker and it becomes more difficult to see composition, to maintain high shutter speeds, and to discern critical focus. Even autofocus performance may become problematic at reduced apertures.

Constant aperture zoom lenses, on the other hand, tend to be bigger, heavier, and significantly more expensive because of the larger pieces of optical glass in the lenses. However, their faster lens speeds provide a brighter viewfinder, permit easier manual focusing, better autofocusing in dim

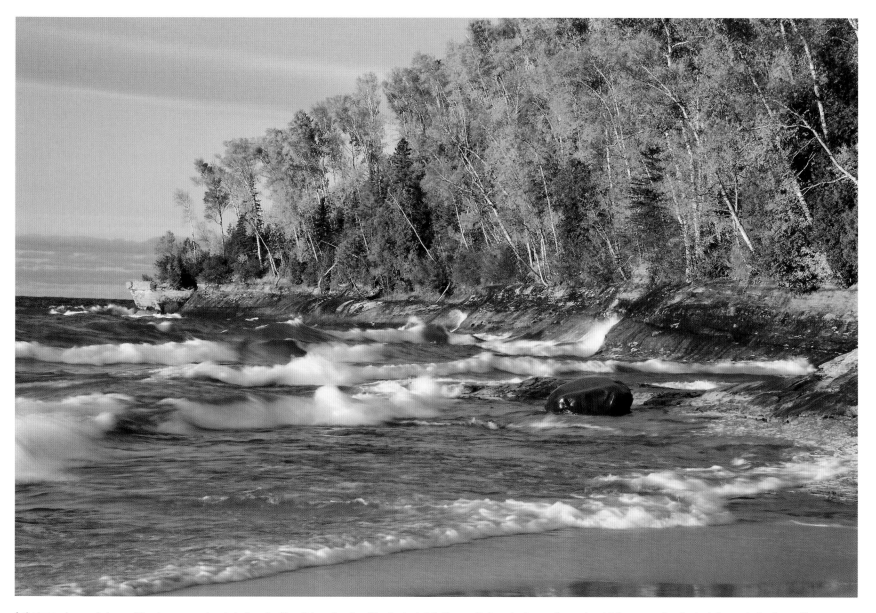

A short zoom lens easily frames this autumn scene along Lake Superior. Since it doesn't cost anything to shoot digital images, Barbara shoots many images to catch the waves when they're in the most attractive position.

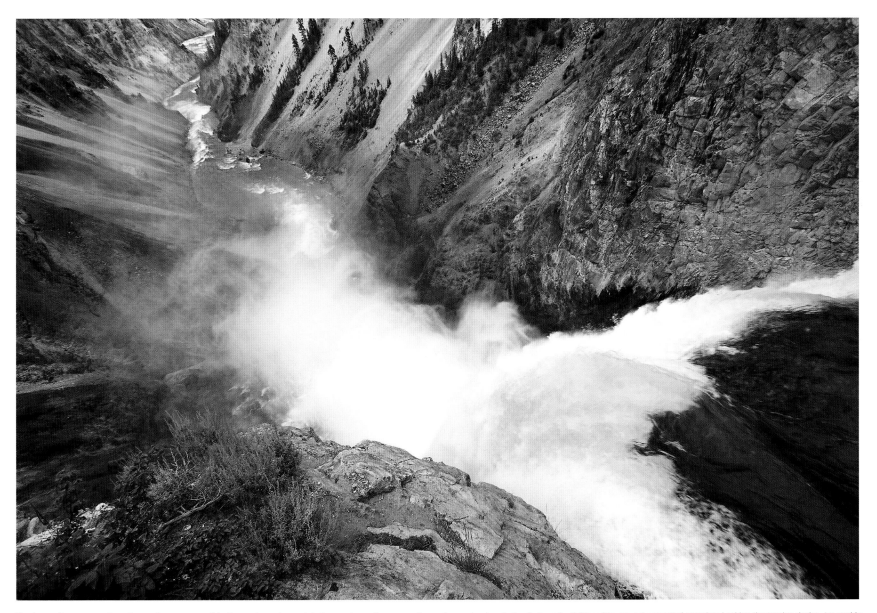

Due to gravity, many push–pull zoom lenses zoom all by themselves when pointed up or down. Some zoom lenses have a tension device that can be tightened to prevent unwanted zooming. Lacking the tension device, try a wide rubber band around the lens barrel to lock in the preferred focal length. Here's Yellowstone's Lower Falls from the brink, which has a convenient viewing platform.

light, and allow faster shutter speeds at the longer focal lengths. Both types of zoom lenses will permit you to shoot fine images. The choice between variable and constant maximum aperture zoom lenses depends on your budget, how much space and weight you're willing to devote to them, and the particular features you need. There's no wrong answer, so choose what you like. Barbara and I tend to buy constant maximum aperture zooms when they're available.

FIXED FOCAL-LENGTH LENSES

The Canon 300 mm f/4.0L IS USM, Nikon 50 mm f/1.8D AF, and Sigma 20 mm f/1.8 fisheye are all examples of lenses where the focal length is fixed. These prime lenses have but one focal length, which can't be varied. It's a fixed attribute of the lens. When using a camera with a crop factor, remember that the focal length of the lens doesn't change, but the angle of view and its resulting field of view does. Fixed focal-length lenses are usually faster than zoom lenses set to the same focal length, and they're a bit sharper as well. This sharpness difference is definitely present, albeit not great. It's easier to maximize the sharpness at a single focal length than over the full range of focal lengths covered by a zoom. Moreover, fixed focal length lenses generally have fewer elements than a zoom lens, and fewer elements translate into greater flare resistance. You'll notice this flare reduction when you're pointing your prime lens toward the sun.

We do prefer prime lenses over zooms at focal lengths of 300 mm and greater. An important excep-

These bison are searching for grass along the Madison River in Yellowstone. Even though it's cloudy, it's wise to use a lens hood to prevent light from striking the glass at an odd angle, which can cause flare and a loss of contrast. The lens hood keeps snowflakes off the glass too.

tion is the superb Nikon 200–400 mm f/4 VR zoom, which we like a great deal. The accurate focusing and faster shutter speeds of prime lenses are critical when using long telephoto lenses, such as our 500 mm f/4 lenses. Admittedly, we don't use these lenses much for landscape photography. Prime lenses are more widely used by wildlife photographers and by macro specialists, whereas zoom lenses are generally preferred by most landscape photographers, including us.

These incredible underground formations in Carlsbad Caverns, New Mexico, are illuminated by weak artificial lights. Lenses that have a maximum aperture of f/2.8 or even f/2.0 make it easier to focus and compose the image.

PROTECTING YOUR LENS

LENS CAPS AND CAMERA BAGS

New lenses generally come in a protective covering, and we use them when traveling. The lens is the second most critical component of shooting sharp, clear images, so always keep it clean and

well protected from impact shock. Second? Yes, the lens is number two. John and I are convinced the number one most critical component of sharp clear images is your own shooting technique, and later we'll cover it in Chapter 5.

However, these protective pouches make it harder to access the lenses when changing them, and they slow your operations. The assumption of landscape photography as a slow and deliberate pursuit is often valid, but occasionally shattered by a fantastic but fast-fleeting light illuminating your subject. Then you need to move rapidly, and your pre-shooting planning might need to take that into account. We find it faster to always keep both the front and the rear lens caps on, but carry each lens in plain view in a well-padded camera bag having adjustable compartments so that each lens can fit snugly in the bag. It's wise to always keep the lens caps on unless the lens is used. Yes, it may slow you down a bit, but you don't want dirt to settle on the optical glass, and a hard foreign object scratching your glass can surely spoil your day. Additionally, dirt and scratches seriously degrade image quality and diminish the resale value of the lens. By the way, your authors are happy with the Lowepro Photo Trekker AW II photo backpacks we have used for many years (www.lowepro.com).

LENS HOOD

The lens hood, sometimes called a sun shade, offers two important benefits to your photography. The first is that it helps protect your lens against impact damage and against damage to the front glass element, such as scratching. Secondly the

substantial reduction in detrimental lens flare under certain shooting circumstances. Nothing adds more protection for your lens than religiously using a proper lens hood. Most lenses come with a well-designed hood, properly engineered to provide the maximum possible protection from flare and, at the same time, eliminate vignetting of the image corners. Consequently, it's wise to buy only the lens hood offered by the manufacturer for your lens. A proper lens hood greatly reduces the chance that some hard object might scratch the front glass, and it may cushion the lens against damage from a fall onto a hard surface. Secondly, protection against physical damage isn't the only benefit of the lens hood. In fact it's main purpose is to block extraneous light from entering the lens at an unusual angle and possibly causing severe lens flare. Flare is often a problem when one's shooting direction encompasses the sun or is close to the sun, and elimination of flare noticeably improves image contrast and color rendition.

PROTECTION FILTERS

UV and skylight filters are sold to photographers to protect the lens. In theory, if something *really bad* strikes the front of the lens, the protection filter absorbs the impact, reducing or preventing damage. It sounds like a smart idea but in 35 years of professional photography, it has never saved a single one of our lenses. We're careful with our equipment, but have destroyed a couple of lenses over the years. Protection filters don't offer much protection when lenses are dropped on cement, rocks, or over a cliff. From first-hand experience, we know

the rocks at the base of a 100-foot cliff vaporize falling lenses on impact!

Quality images are important to us and the success of our business. Lenses are optimized for the glass elements they contain. Any time you introduce another glass element into the optical path, you can expect to lose some quality. All glass filters degrade the image quality a tiny bit. Therefore, we feel it's pointless to needlessly use protection filters if you're only looking for added protection. Be careful, use the lens hood, don't drop the lens, and your lenses should outlast your obligation to pay taxes.

However, there are times to use glass filters. The UV filter does reduce the effects of UV light, especially at high elevations where there's more UV light, so perhaps it does make sense to use it when shooting in the mountains. But we feel a polarizing filter is far more useful for most situations, so we haven't owned a UV or skylight protection filter for at least three decades. Unless you can articulate a specific image-improvement reason to use a filter, don't!

POLARIZING FILTER

By far the most useful filter for landscape photography is the polarizing filter. This filter, like certain sunglasses, reduces glare, thereby increasing the detail and the color in an image. We believe that landscape photographers should be using polarizing filters much of the time. Since this filter should be on your lens a lot, it also serves the purpose of a protection filter. After all, it does protect the front element and provides better image quality, too. We will return to the uses of the polarizer later in this chapter.

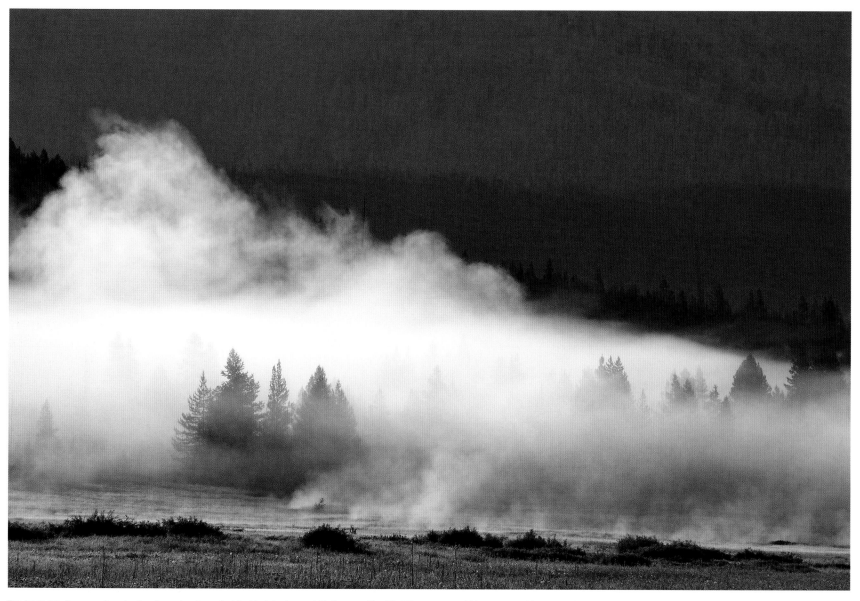

The fog in this dawn meadow stands out prominently against the black background. Barbara used her 70–200 mm zoom quickly to capture this image before the fog dissipated a few minutes later. Never assume you always have plenty of time in landscape photography!

DON'T STACK FILTERS

Light is slightly distorted when passing through the glass or plastic medium of a filter — any kind of filter. Moreover, the *glass-to-air-interface* at each filter surface causes an increased susceptibility to flare and loss of contrast. Those irritants, though, are often outweighed by the beneficial attributes of the filter. As an example, a polarizer can do so much good that we accept its shortcomings.

However, one set of shortcomings is enough! If we were to add a second filter, perhaps a UV filter, to the mix, then the combined distortion and contrast-robbing flare can become more noticeable. Some folks say they can't see this degradation, but we can spot it easily when testing for it. Unless you're absolutely petrified to use a lens without protection, we think it's best to forego the protection filter and use one high-quality polarizing filter instead.

LENS CHOICES

You have more choices of lenses than you may realize. Lens makers offer prime lenses in many fixed focal lengths and different speeds, and they offer zoom lenses in a wide range of variable focal lengths and different speeds. This cornucopia of lenses is further expanded by selections of glass type, optical coatings, mechanical construction, and the need to decide whether you want anti-shake technology.

We shoot both Canon and Nikon, so we look closely at all of the lenses made by them. If we shot Sony, we would look first at Sony's lenses.

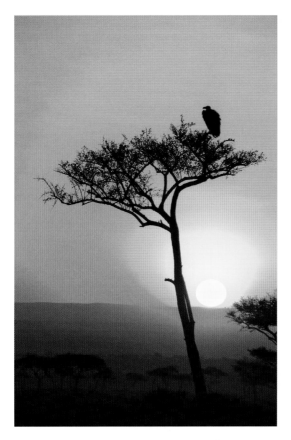

This is a Nubian vulture perched atop an acacia tree in Kenya. All extra glass surfaces greatly increase the chance of getting unwanted flare when shooting directly at the sun. Don't use any filters and favor prime lenses (zooms have more glass elements) to reduce or avoid flare.

It seems reasonable to us that the camera manufacturer is most favorably positioned to engineer and manufacture dedicated lenses that are optically and mechanically optimized for that maker's cameras. However, the dedicated lenses are more expensive because of market-share limitations when compared to the *universal* lenses made by independent lens manufacturers.

Sigma, Tokina, and Tamron are independent lens builders that specialize in making lenses that work on many camera systems. Sigma, for example, builds lenses for Canon EOS, Nikon, Sony/Minolta, Olympus, Pentax and, of course, Sigma, cameras. The independent manufacturers, servicing multiple camera brands, enjoy a larger market and can generally sell their lenses at a lower price. We haven't used independent lenses for our own photography, but many of our workshop students have, and the lenses seem to deliver satisfactory images.

SUPER-WIDE-ANGLE LENSES

Any lens having a focal length of 20 mm or less is called a *super-wide-angle* lens. These lenses permit skillful landscape photographers to create dramatic foregrounds, to make huge skyscapes because the large field of view covers so much sky, and to shoot effectively in tight places like caves or behind a waterfall. All landscape photographers can greatly benefit from the proper use of super-wide-angle lenses.

Of all the lenses available today, it seems that super-wide-angles are the most difficult for photographers to really master. These lenses cover large areas, so be sure to check all of the frame's edges to make certain that distractions don't intrude into your image. Watch for sticks, patches of white sky, wires, fences, and other man-made objects that aren't wanted. Also, be careful to make sure the horizon stays straight, rather than bowing in

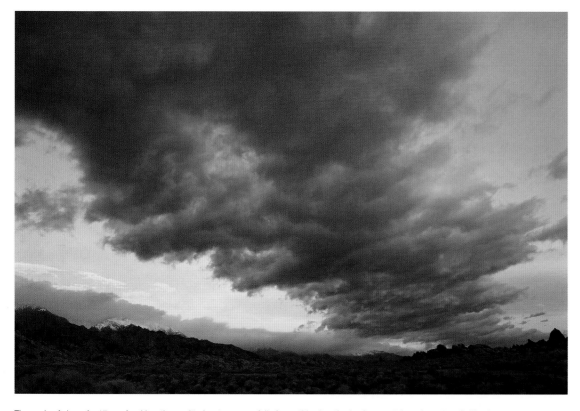

The angle of view of a 17 mm focal length permitted us to successfully frame this gigantic cloudscape at dawn in eastern California.

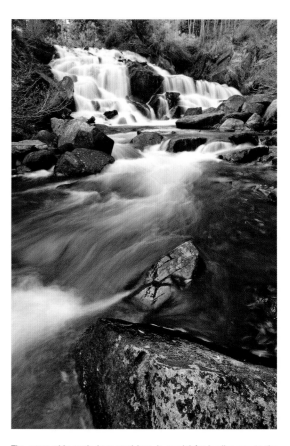

The super-wide-angle lens used here is crucial for leading you to the waterfall. By placing the camera only a couple of feet from the foreground rock, the perspective of this shooting position creates an enormous foreground that grabs your attention. Then your eye follows the stream up to the fall.

the middle. You must keep the lens parallel to the ground to prevent bowing of the horizon. On the other hand, there are times when, for artistic reasons, you might deliberately distort elements of the scene. Super-wide-angle lenses are especially effective for shooting straight up when surrounded by trees so the trees all lean inward.

These lenses are well suited for shooting images with unusual perspective. *Perspective* refers to the size relationship between near and far objects in the image. Positioning a 17 mm lens only one foot

above the surface of a creek will cause the creek to loom large in the foreground and gradually diminish in size as the creek approaches the base of a distant waterfall. We photograph waterfalls with that technique whenever possible, because the perspective offered by the creek and the waterfall and the nice composition of the *leading line* of the creek can be eye-catching and appealing.

If you have a digital camera with a crop factor, you must calculate the effect of the crop factor on the performance of your wide-angle lens. For

example, a 20 mm lens on a camera with a 1.5× crop factor ends up with a field of view equal to that of a 30 mm lens on a full-frame camera, because 20 mm × 1.5 = 30 mm. The loss of the great field of view of a wide-angle lens because of crop factor was once a serious objection to cameras with small sensors. The camera manufacturers soon responded

to the uproar by building special lenses made for small-sensor cameras — lenses that were wider than those made for full-frame sensors. Examples of these very wide lenses include the Canon 10–22 mm f/3.5–4.5, Nikon 12–24 mm f/4.0, Sony 11–18 mm f/4.5–5.6, and Sigma 10–20 mm f/4.0–5.6. The equivalent focal length of these lenses on a camera with a small sensor is merely the specified focal length multiplied by the camera's crop factor.

Let's consider the Nikon 12–24 mm f/4.0 lens when used on the Nikon D300 that has a 1.5× crop factor. Here, the lens has the same field of view as an 18–36 mm f/4.0 lens on a full-frame sensor. Remember, the crop factor doesn't actually change the focal length of the lens, but it does make it seem as if the lens gives more magnification. There are many available wide-angle prime lenses, too. You can choose from Canon's 15 mm f/2.8, 20 mm f/2.8, and 14 mm f/2.8L lenses; Nikon's 10.5 mm f/2.8, 16 mm f/2.8, 14 mm f/2.8, and 20 mm f/2.8 lenses; and Sigma's 8 mm f/3.5, 15 mm f/2.8, and 20 mm f/1.8, and many others.

WIDE-ANGLE TO SHORT TELEPHOTO LENSES

Wide-angle lenses are generally considered to cover the 20 to 35 mm range, medium lenses cover the 40 to 60 mm focal lengths, and short telephoto lenses fall into the 70 to 105 mm range. Remember, when using a camera with a small sensor the equivalent field of view of these lenses, or any lens for that matter, must take the crop factor into account.

The 20 to 105 mm range is most important to landscape photographers because many good image opportunities demand focal lengths in this range. Your kit of lenses should really cover everything in this focal-length range, a need that points to zoom lenses, because it would be impracticable to fully cover the range with prime lenses. There's nothing worse than trying to compose the Great American Nature Photograph of a wonderful waterfall, and you desperately need a 65 mm focal length but only have 35 mm and 85 mm prime lenses. Here you might be tempted to trade your firstborn for the versatility of a zoom lens!

Many excellent zoom lenses are made to cover this range. John uses a Canon 17–40 mm f/4.0L and a Canon 24–105 mm f/4.0L. Both of these lenses are superb. The L in the name designates that the optical quality and durability are of professional grade. Barbara uses the Nikon 17–35 mm f/2.8 and the Nikon 24–120 mm f/3.5–5.6 zoom lenses. Another fine Nikon zoom that covers this range nicely, and then some, is the Nikon 18–200 mm f/3.5–5.6. No matter what camera system you shoot, you should find many lenses to choose from. Again, don't forget about Sigma, Tokina, and Tamron. Look for a couple of good quality lenses that cover this range. It's tempting to buy a single lens to cover all or most of the 20 to 105 mm range, but there are two issues. One, the quality of some zoom lenses tends to deteriorate as the zoom ratio gets larger. Two, a single extremely wide-range zoom mysteriously failing or dropped over a cliff or into the river will put you out of business, although probably enlarging your vocabulary along the way. If you have two lenses that overlap a bit, you might still get by if the worst happens — and it will happen if you photograph long enough!

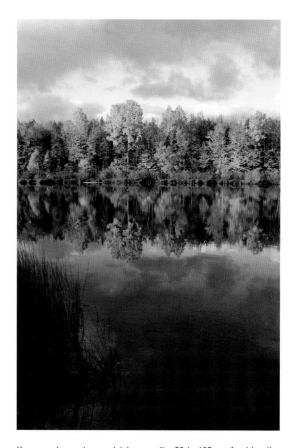

Use zoom lenses to completely cover the 20 to 105 mm focal lengths. This range is incredibly important to landscape photographers. A 24–70 mm f/2.8 lens, one of John's favorites, easily frames this autumn season at Thornton Lake in northern Michigan.

MODERATE TELEPHOTO LENSES

This category includes lenses in the 100 to 300 mm range. Landscape photography invites the use of wide-angle lenses to include the very large scenic vistas often encountered. But caution is indicated! Beginning landscape photographers start out with an inclination to include everything within eyesight in the image they're composing. As they gain

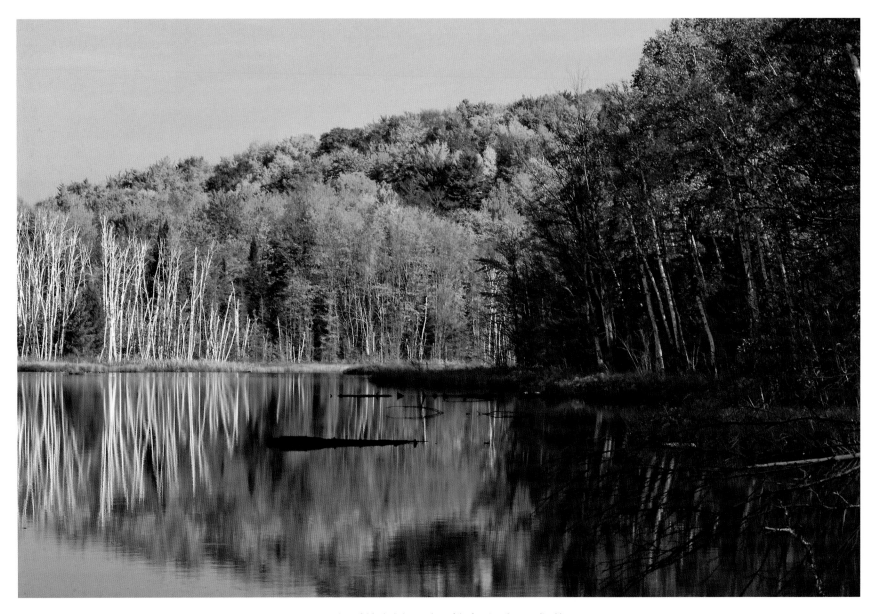

Council Lake is larger than other lakes so a zoom that covers the 100 to 300 mm ranges is useful for isolating sections of the forest on the opposite side.

experience, they learn to concentrate on smaller areas of the visible scene. Moderate telephotos are very useful for filling the image with those smaller areas that emphasize the most pleasing parts of the landscape, or for illustrating nature's captivating patterns.

Anyone who has stood on an overlook at the Grand Canyon in Arizona or Bryce Canyon in Utah sees many a possibility as they view the canyon. The overall view is magnificent, but many of the best prospective images require telephoto lenses to isolate impressive rock formations and make strong compositions. Even when photographing autumn color reflections in northern Michigan waters, we frequently use focal lengths from 200 to 500 mm to isolate the most colorful sections of the overall reflections.

The longer 100 to 300 mm range of focal lengths is also critically important to the making of many fine landscape images, so be sure to cover that range with good zoom lenses. The Canon 75–300 mm f/4.0–5.6 and 100–400 mm f/4.5–5.6L zoom lenses cover this range quite effectively. Nikon offers a couple of 70–300 mm lenses that would work equally well. Barbara presently uses Nikon 80–200 mm f/2.8 and 200–400 mm f/4 lenses for images that need the extra focal length. However, the Nikon 200–400 mm is quite large, quite expensive ($5000 range), and most landscape photographers probably won't like either the price or the weight of this fine lens. Barbara likes it, though, because it's a superb lens for her wildlife photography and does double duty for landscapes. Consider the lenses made by your camera manufacturer first.

If you find nothing that you consider suitable, or nothing that fits your budget, look to the independent lens makers. There are many good lenses that cover this range, so you should have no trouble finding the perfect match for you.

LONG TO SUPER-TELEPHOTO LENSES

These lenses begin at 400 mm and go up from there. Lenses of 500 mm and 600 mm are most common. They're used primarily by wildlife photographers when the subject is difficult to closely approach. They're seldom used by landscape photographers. We use our 500 mm lenses from time to time to isolate small portions of the grand landscape, and we find them incredibly useful for filling the frame with autumn color reflections. Most landscape photographers can probably get by without such long lenses but, if you have one, use it for landscapes. Landscape specialists using something like a 75–300 mm zoom generally prefer to achieve the longer focal lengths by using a smaller, lighter, and far less costly teleconverter. This optical accessory fits between your camera and the lens. It multiplies the focal length by the power (usually $1.4\times$, $1.7\times$, or $2\times$) of the teleconverter.

Photographers must employ good technique to get sharp images at longer focal lengths. Often you'll stop down to, say, f/16 to achieve good depth of field, but that demands a slower shutter speed, which invites soft images. Even though one uses superb optics and impeccable technique, many landscape images are marred by atmospheric dirt or heat waves that reduce sharpness and

contrast. In clean cool air, though, it's possible to use a long lens in capturing images not otherwise achievable.

TILT-SHIFT AND PERSPECTIVE CONTROL LENSES

These are among the least known, most poorly understood, and underutilized lenses. Yet, they can be of great value when photographing certain subjects. Both Canon and Nikon make lenses that tilt and shift. Canon calls them *TS* lenses and Nikon calls them Perspective Control (PC) lenses.

The Tilt-Shift Lens

Canon makes three tilt-shift lenses: the 24 mm f/3.5L TS–E, the 45 mm f/2.8 TS–E, and the 90 mm f/2.8 TS–E. Nikon also offers three tilt-shift lenses: the 24 mm f/3.5 D ED PC-E, the 45 mm f/2.8 D ED PC-E, and the 85 mm f/2.8 PC-E. The tilt-shift lenses can be very useful to landscape photographers in certain situations because the great versatility of a view camera's lens controls can be enjoyed by DSLR users. (Incidentally, Nikon users can ply the used-equipment markets for the discontinued Nikon 28 mm and 35 mm PC lenses that shift but don't tilt.)

The camera gains tilt and shift capabilities by two separate controls used to solve two separate problems. First, let's consider shift. Have you ever noticed when photographing lofty subjects, like tall trees or waterfalls or a lighthouse, that when pointing your camera upward to bring the tops of those tall subjects into the frame the vertical lines seem to converge and the subject seems to be

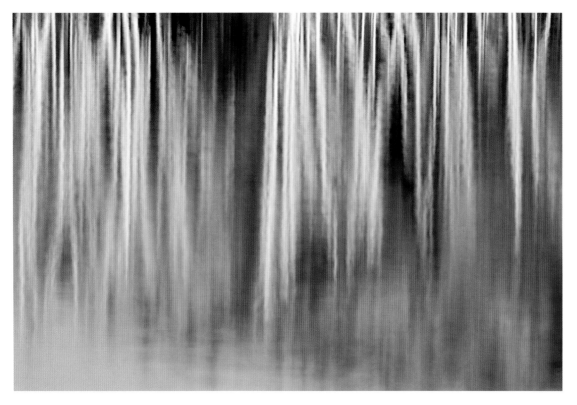

Both of us are avid wildlife photographers, so we have extensively used prime 500 mm super-telephoto lenses for years. While it might be unconventional, we often use these long lenses to photograph the landscape. The 500 mm lens enabled us to easily fill the entire viewfinder with just an autumn reflection of red maple leaves and white birch trunks.

We use tilt more than shift. The front element of a conventional lens is parallel to the camera sensor. (Remember when we referred to something called a film plane?) A tilt lens, though, can be adjusted so that it isn't parallel to the sensor plane. The lenses can be tilted this way and that, but a common usage finds the camera sensor perpendicular to the ground and the front glass of the lens pointing slightly down toward the ground. Tilting the lens that way can provide extreme depths of field, a boon to landscape photographers. Further, the extreme depth of field is easily achieved at any aperture. Using a tilt lens allows us to adjust the camera's *plane of focus* such that our foreground flower, only inches away, is in crisp, sharp focus as well as the mountain on the horizon and the clouds in the sky. And we can do that even when using f/2.8 or f/4! We get the higher shutter speeds necessary to freeze the motion of the blowing flower without any of the diffraction experienced at f/16 or f/22 when using a conventional lens. To learn more about the theory and application of the tilt lens, read a simple explanation of the *Scheimpflug Principle*, a name far more intimidating than the principle. (See, for instance, http://en.wikipedia.org/wiki/Scheimpflug_principle.)

falling backwards? The shift control will help correct this effect. To avoid the leaning vertical lines, you must keep the optical axis of the lens parallel to the ground. Point the camera straight ahead, not up. If the top of the subject is cut off, use the shift control to shift the lens upward until the top of the subject is within the frame. The optical axis has remained parallel to the ground, so vertical lines remain vertical. Software is available now that can straighten leaning vertical lines too, so a shift lens isn't as important as it once was. Although beyond the scope of this book, you should also know that the side-to-side shift capability of these lenses has certain additional applications.

Tilt-shift lenses aren't for everyone and they're expensive ($1000–$1800). Their mechanical construction precludes autofocus, so they require manual focusing. That's not a big deal unless you forgot how to manually focus (!), but they're consequently slower to use. The effects of the tilt and shift controls can helpfully be seen in the

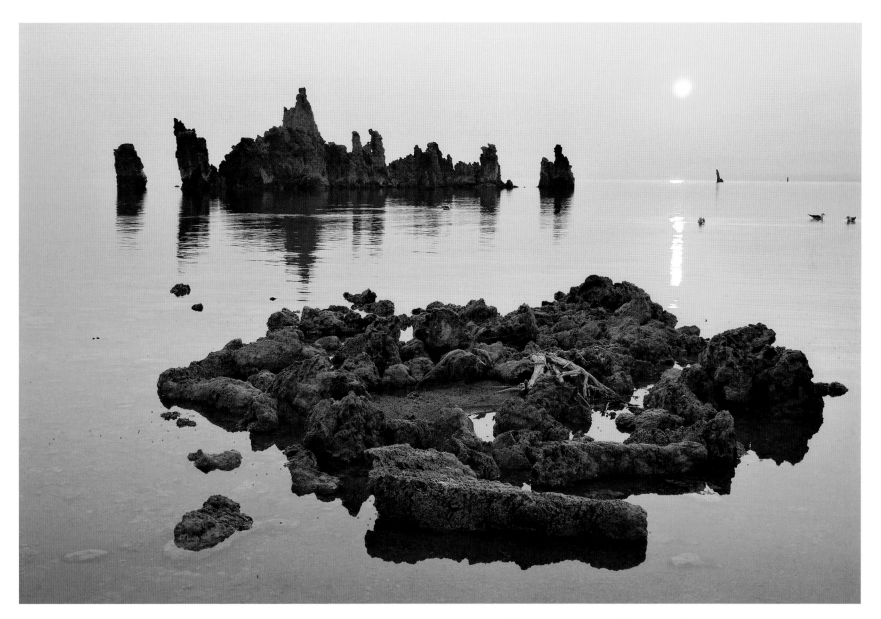

Using a Canon 45 mm TS lens easily handles the extreme depth of field these Mono Lake tufa formations present at dawn. By using a little downward tilt, the plane of focus is rotated so it passes through all of them.

viewfinder, so simple observations confirm your lens settings. Not so helpfully, a detailed explanation of using a tilt-shift lens is far easier to demonstrate than to write. The lenses do require some understanding and experience, and perhaps your local camera store can demonstrate one, but a fundamental approach is this:

1. Set the camera to manual focus and the lens to its widest aperture.
2. Adjust the focus control to make the *foreground* sharp.
3. *Slowly* tilt the lens downward (usually) or upward (rarely) to make the *background* sharp.
4. Repeat 2 and 3 a few times, making slight tilt adjustments until both foreground and background are perfectly in focus.
5. Set any aperture you want and determine the exposure by using the histogram.
6. Shoot.

We've both used large-format view cameras in the past. When Canon introduced its TS lenses in the 1980s, we understood their benefits and we've been using those lenses ever since. For the new user, a tilt-shift lens offers problem-solving powers not appreciated until experienced. Then you won't ever leave home without it.

FILTERS

Filters are optical accessories that are generally screwed onto the front of a lens, but are occasionally hand-held in front of the lens. The purpose of a filter is to modify the light entering the camera, in color, in intensity, or in many other ways. Use filters of only the highest quality, because a poor filter can have significant detrimental effects on the quality of your images. We once used various color-correction filters for our landscape images, but today, it's so easy to adjust the color balance of a digital image in post-capture editing, especially that of a RAW image, that color-correction filters have fallen into disuse. Other filters remain valuable, especially the widely used polarizer.

THE POLARIZER

Most landscape photographers agree that the most useful filter of all is the polarizer. There are two basic types. Older polarizers were called *linear* polarizers, but newer ones, the ones needed for modern cameras with autofocus, are called *circular* polarizers. Note that the terms linear and circular refer only to certain optical characteristics, and *not* to the physical shapes of the filters! The polarizer eliminates randomly scattered light making the sky darker leaving only the polarized light rays traveling on a single plane (similar to a mirrored reflection), which can be admitted to the sensor and limited to a greater or lesser amount by shooting at an oblique-to-parallel angle to those rays. A common use is for darkening a blue sky and making the white clouds more prominent. Note that the effectiveness of a polarizer used this way is governed by the angle between the shooting direction and the sun with the maximum effect achieved when shooting at right angles to the sun. For the trigonometricians among you, the effect is proportional to the sine of the angle between the shooting direction and the sun direction.

Polarizers are widely used for making dramatic skies, but the experienced landscape photographer knows that their photographic gifts go far beyond the sky. Polarizers remove glare from wet objects, such as the rocks in a waterfall and the nearby wet vegetation. Removing the glare causes the rocks to be nicely darkened, providing more contrast to the white water. The polarized wet vegetation shows improved color saturation and increased detail. Moreover, even dry subjects can be beneficially polarized — a common example is dry foliage. Here, a polarizer's reduction of glare and spurious reflections brings out a lot of otherwise obscured color and detail.

There are *warming* polarizers with a slight yellowish tint used to both polarize the light and to remove some blue light, resulting in a warmer image. This color-correcting polarizer was important for color film, but unnecessary for digital because software can easily adjust the color of an image.

A polarizing filter must be used properly to get the desired effect. We've learned over the years that an astonishing percentage of our thousands of field workshop students misunderstood the polarizer. They believed that the act of screwing the polarizer onto the lens completes the preparation, and that they were then ready to shoot. They hadn't yet realized that the polarizer has two discs of glass and must be adjusted by rotating one with respect to the other to achieve good results. Adjustment is best accomplished by rotating the outer ring of the polarizer counterclockwise when viewed from *behind* the camera. Lots of photographers have discovered that wrongly turning the polarizer

clockwise risks it becoming unscrewed from the lens and falling off the camera. Polarizers make a very expensive noise when hitting the rocks below.

Turn the polarizer while looking through the viewfinder. Turn until the glare on the subject has been minimized, or until the blue sky is satisfactorily darkened. Use caution here. There's no law demanding that you always use maximum polarization, and some shooters make the sky so dark that it looks unnaturally gaudy. A common mistake made by many a photographer, inexperienced and otherwise, is forgetting to readjust the polarizer when switching between vertical and horizontal compositions.

A polarizer attached to the front of a lens increases the lens's susceptibility to flare because of the additional glass surfaces that can reflect stray light. A lens hood easily solves the problem. Many of today's lenses allow the supplied *official* lens hood to be used even while a polarizer is attached; if not, then be certain to acquire a hood that will attach to your polarizer. Flare protection is often critical to an image and, to keep the sun off your lens, even a proper lens hood occasionally needs augmentation by a well-placed hand or a dark hat.

Often, a specific combination of hood and polarizer makes it difficult to adjust the polarizer, and the photographer is dissuaded from using the lens hood. Bad move! We seldom shoot without a lens hood, and neither should you. Instead, when using a polarizer on a short lens like the Canon 24–70 mm, we slip one finger inside the hood to carefully turn the polarizer without touching the glass. The deeper hoods of longer lenses make this impracticable, in which case we remove the lens hood, turn the polarizer for the desired effect, and then reattach the hood. It takes only a few seconds and ensures that we get the best possible image quality.

Let's talk a bit more about getting the effect you want. In some cases, the positive effects of the properly adjusted polarizer are readily apparent. Sometimes not. There are situations in which no polarization effect might be seen, depending on the subject and the light. Remember that in sunlight the angle between sun direction and shooting direction is important. At other times, a subject is in polarized light, but an inexperienced user has a hard time seeing the polarizer's effect. Be sure to look at the scene where glare is most egregious, because it's the easiest place to see the effect. Polarizers work well on waterfalls, and we highly recommend them for this subject. Yet, most of our students have trouble adjusting the filter because it's tough to see the effect on the cascading water. It's tough for us too, so we don't look at the tumbling water. Normally, the change in glare is easiest to see when looking at the water above the very top of the waterfall just before it plunges over the edge. When you turn the filter and see the river at the top of the waterfall darken, that's the polarizer position you want. The darkening was caused by the polarizer having removed the glare from the water. Another technique is to turn the polarizer to maximally darken the wet rocks around the waterfall.

Polarizers reduce the amount of light passing through them by about 1.5 to 2 stops of light. However, when using the camera's through-the-lens metering system, the camera's meter takes the light loss into consideration, so the photographer doesn't need to worry about it. There are times when you might want to use a longer shutter speed

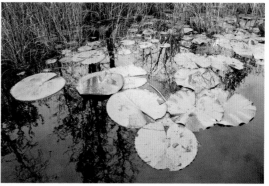

(a)

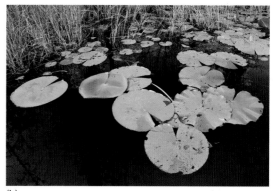

(b)

(a) The glare on the water and these Okefenokee Swamp lily pads "hide" much of the color and detail. (b) Rotate the polarizing filter slowly until it eliminates most of the glare, providing much better color saturation and detail in the plants.

anyway, such as when photographing a waterfall. Even if you don't think you need to remove glare, an admittedly rare occurrence on a waterfall, you can benefit from the polarizer's attenuation of light. At any given ISO and aperture, the polarizer's light loss allows a longer shutter speed, helping to produce that smooth and silky water that's so pretty in many waterfall images. If the polarizer loss is 2 stops of light, then one can use a shutter speed 4 times longer than that without the polarizer. If the unpolarized scene is metered at a 4-second exposure before using this filter, you then can have a 16-second exposure by adding your polarizer.

Polarizers are also effective for making rainbows brighter and more dramatic. Turn the filter until the rainbow is as brilliant as possible. Be careful though, because it's possible for the polarizer to obliterate the rainbow. Just look through the viewfinder and rotate the polarizer until the rainbow looks best. Be careful that a broad expanse of bright sky doesn't cause excessive underexposure in some parts! Use the histogram to guide you to an excellent exposure throughout.

CLEANING LENSES AND FILTERS SAFELY

Lenses and filters must be spotlessly clean to ensure that they don't do more harm than good. Dirt or smudges on filters or on the front or rear glass elements will surely degrade image quality. Sadly, we often find that our students are using filthy lenses, so we know that dirt and smudges are common

problems. Lenses must be scrupulously clean to maximize the image's contrast and sharpness.

Lenses are easy and relatively safe to clean, so there's little excuse for dirty lenses. Keep the front and rear lens caps on the lens when it's not in use. This will help to keep the glass clean in the first place. When the protective caps are off, always put a lens hood on the lens, and never rest the lens with either the front or rear glass pointing up, because airborne dust will certainly settle on the exposed glass. Either put a cap on the side of the lens facing up, or lay the lens on its side so neither side is facing up. Of course, make sure the lens can't roll around, as that presents its own hazards. It doesn't hurt to wash your lens caps occasionally, because they collect dirt that eventually migrates to the glass of your lens.

STEP #1: BLOW THE DUST OFF

No matter how careful you are, dust and dirt will find its way to the glass surfaces. Every time you use a lens, make sure that no dust has taken up residence on either the front or rear lens surfaces. Most of the time you'll need to remove some minor specks of dust. The safest and most efficient way to remove dust is to use a rubber squeeze bulb that throws quite a bit of air when squeezed. This air easily blows away most of the dust, lint, and grit. The Giotto Rocket Blower in the large size works very well for this purpose as well as for blowing dust off computer monitors and keyboards. Some photographers use canned air, but it costs money and might shoot propellant out, which can be difficult to

remove from the lens. *Never* use canned air to clean your camera's imaging sensor! Use the Giotto Rocket Blower and the chances of damaging either your lens or the sensor are low indeed. Caution #1 — Use only a high-quality blower, such as the Giotto, especially when cleaning a sensor. Some lesser quality blowers are reputed to be contaminated by residual rubber particles that promptly attach themselves to your sensors and lenses like leeches! Caution #2 — Don't use blowers that have an articulating nozzle! Reports state that one well-known brand, upon a vigorous squeeze of the bulb, caused its nozzles to be violently ejected from the bulbs with catastrophic potential when cleaning sensors! If you can't see any dirt or smudges on the lens surface, you're done. Needless further cleaning of the lens only increases the chances of scratching it.

STEP #2: USE A MICRO-FIBER CLOTH

If blowing strong puffs of air on the front and rear glass elements doesn't remove the contamination, there may be dust or grit stuck to the surface of the glass. Also, carefully examine the front glass element for smudges. Perhaps there's a fingerprint from careless handling. Or, if you photograph on dewy mornings or in wet weather, you're likely to find dried water drops that degrade lens performance. The best way to remove stubborn contamination, smudges, and dried water drops is by using a micro-fiber cloth, which is obtainable at any camera store or eyeglass shop. Use it to gently rub the lens, beginning in the center, rubbing in a spiral outward toward the edges of the lens. Be very certain there's no grit on the lens and be sure to use

a clean micro-fiber cloth! The last thing you want to do is rub that lens with grit trapped between the lens and the micro-fiber cloth, because it could easily scratch the delicate coatings of the lens. You paid good money for the manufacturer to grind and polish that lens, so don't try to *improve* on their work. Those who can just never remember to clean or replace their micro-fiber cloths might be better off using a good quality paper lens tissue designed for camera lenses, such as that sold by Tiffen. Certainly don't use the ones sold for cleaning eyeglasses! Many tissues sold for eyeglasses have liquids or chemicals in the paper to help clean them. These additives could be harmful to the coatings on a camera lens. Usually the above process does a fine job of cleaning a lens.

STEP #3: USE LENS CLEANING SOLUTION

Very seldom is it necessary to go to this step. However, it's possible to get a smudge on the lens that can't be removed with the dry micro-fiber cloth. Perhaps a bit of pine sap or other sticky stuff settled on the lens. After going through the first two steps, put some lens cleaning solution directly on a small portion of the micro-fiber cloth and rub the stubborn smudge again. This should remove the smudge. Don't squirt the lens cleaning solution directly onto the lens itself, because excess fluid might leak into the inner workings of the lens. Always put it on the cloth. Unless you're incredibly careless, unlucky, or photograph in horrific conditions, you should seldom need this step.

STEP #4: LET A PROFESSIONAL CLEAN THE LENS

If the previous three steps fail to clean the lens to your satisfaction, it should be cleaned by the manufacturer's repair facility or by an independent professional repair shop. We have done this only when dust was *inside* the lens and we couldn't access the dust without disassembling the lens.

Mastering Exposure

EXPOSURE HISTORY

Shooting excellent exposures is easily the most widespread problem our students have had over more than three decades of teaching nature photography. Many students attended our classes primarily to master exposure techniques. In the mid-seventies we used the camera's through-the-lens meter, metered the subject using manual exposure, compensated for tonal (reflectance) values, and shot superb exposures on finicky color slide film, shot after shot, and we did it fast. We taught this method to tens of thousands of students over the years. The method we developed to suit our own shooting style was a simple version of the zone system modified for exposing color slides. Once understood, it was enormously effective, but it did require learning to precisely judge the reflectance values of the object being metered, which wasn't intuitive for everyone and did require a good bit of practice.

Many of you reading this book have probably attended our classes. You might expect us to explore the intricate details of this modified color zone system, but don't be shocked when we don't. Exposing the digital image is significantly different from properly exposing slide film, so different strategies and techniques are required.

EXPOSURE DIFFERENCES BETWEEN FILM AND DIGITAL CAMERAS

Color film must be properly exposed to retain detail in important highlights. Sometimes shadows must be allowed to go black to retain the highlight detail. The range of image brightness that slide film can handle while maintaining detail in both highlights and shadows is called the film's dynamic range and is only about five stops of light. Print film must be given more exposure than slide film to get detail in the shadows. Print film can deal with a wider dynamic range, typically eight or nine stops of light. Digital capture handles a dynamic range greater than slide film but perhaps less than print film. However, digital cameras are getting better all of the time for handling extremes

Sunlight passing through fog enshrouded trees sometimes explodes into shafts of light such as in this Idaho forest. This opportunity lasted only seconds, so Barbara caught it with her hand-held point-and-shoot camera!

in contrast, and image-processing techniques improve the situation even more. The best digital exposure requires controlling the quantity of photons striking the sensor to ensure that detail is kept in the important highlights, and satisfactory color and low noise levels in the shadows are still achieved. By adequately exposing the dark areas, the ratio of picture information to the electrical noise inherent in digital cameras, called the signal-to-noise ratio, is increased. This is an improvement that reduces picture degradation caused by noise. Good digital exposure might seem difficult because it requires concern with both the highlights and the shadows.

THE GOOD NEWS!

The histogram and highlight alert exposure aids found on all digital cameras (or should be) have made the art and science of shooting proper digital exposures straightforward and guaranteed. No longer must you wonder if the exposure of your images is correct. You know it is when the histogram is properly used. We are thrilled that exposure is so much easier now that it's easily mastered by anyone. After all, there are far more important aspects of photography to concentrate on, such as light, composition, depth of field, sharpness, and finding photogenic subjects. Finally, we're all freed from struggling with exposure!

HOW TO DETERMINE THE BEST DIGITAL EXPOSURE

Here's a brief description of how we determine exposure with our Canon and Nikon digital cameras. We both use manual exposure most of the time, which

means we set the ISO, shutter speed, and f/stop. We don't let the camera select any of these. We use either spot metering or the more sophisticated but functionally similar systems called *color matrix metering* by Nikon and *evaluative metering* by Canon. (John uses spot metering while Barbara likes the color matrix pattern.) We use the analog scale in the camera's viewfinder or on a body-mounted display panel to align the indicator to the zero point, or to a different point if we feel the exposure needs to be compensated for reflectance values. We always use the far more informative RGB histogram instead of the averaging luminance histogram. Once we manually set the camera's meter, we shoot an image and immediately check the histogram on the LCD monitor screen.

We look at the histogram for each of the three color channels to find the one that shows data farthest to the right. We want the extreme right side of

the histogram curve to be as close as possible to the right edge of the graph without actually touching. Let's say the red-channel histogram has some data farther to the right than either the green or blue channel. If, though, no part of the red-channel histogram is close to the right edge, we add light by slowing the shutter speed, increasing the ISO, or by opening the aperture. We recheck the red-channel histogram and, if necessary, continue to change, shoot, and check until the red-channel histogram is as close as possible to the right edge, but not touching.

Suppose that the first image showed the red-channel histogram to be farthest right, but that it was touching the right edge. The touching condition shows that the red channel may be overexposed, a condition sometimes called *clipped*. Now we must reduce the exposure. We subtract light with the shutter speed, ISO, or aperture and shoot and recheck,

Here's the Canon 1D Mark III brightness (also called luminance) histogram in use. It averages the three color channels and graphs these data. Unfortunately, it's easy to overexpose a color channel, but when these data are averaged, no clipping is shown. To avoid overexposing a color channel, use the RGB histogram instead.

Here's how the RGB histogram looks on the same camera. Notice that the red, green, and blue color channels each have their own histogram. Look at each color channel, find the one that has data farthest to the right, ignore the others, and adjust the exposure until the rightmost data are almost touching the right edge of the graph. That should produce a terrific exposure.

until we get the histogram we want; that is, close but don't touch! This prevents overexposure of the red channel. Normally it only takes a couple of shots to get the desired exposure. Then we process the RAW image with software to get the finest digital image possible. Every photo in this book and our previous book, *Digital Nature Photography — The Art and the Science*, was exposed exactly this way so we know it works well.

If you follow our example, you'll find shooting well-exposed digital images is simple! Of course, the devil is in the details, so we won't end this exposure chapter yet. There are a lot of fundamental exposure details you need to master and it will help to understand the strategies we use in various situations. You'll notice we both use manual exposure techniques, even though digital camera companies constantly promote how terrific their autoexposure is. We admit the vast majority of nature photographers primarily use autoexposure, and they do fine because modern meters do a fairly good job. However, we want exposing digital images to be fast, efficient, and precise, something we can't really get with any autoexposure mode. We'll discuss why this is so later in this chapter.

Let's cover the important exposure fundamentals you really must know and go over your autoexposure choices in detail. It helps to have some background so you can understand exposure more fully. You may know your camera has an exposure compensation dial, but do you know why and when and how to use it? Do you thoroughly understand the histogram? Why must you add light to a sunny snow scene? Is program, shutter priority, or aperture priority the best autoexposure mode for landscape photography? Why do we use manual exposure? You'll learn the answers to all of these questions shortly.

EXPOSURE BASICS

LENS APERTURES

Within the interior of a lens is a set of thin overlapping metal blades that can be user adjusted to control the size of an approximately circular central hole. That variable-size hole is called the *aperture* of the lens. The aperture's fundamental function is controlling the amount of light striking the camera sensor and thus the exposure of the image. A secondary function, but of importance to most photographers and especially important to landscape shooters, is the aperture's control over depth of field; that is, the image's zone of acceptable sharpness.

Landscape images are usually most pleasing with enough depth of field that everything from the near foreground to the distant background is in sharp focus. A small lens aperture endows an image with large depth of field. A large lens aperture produces a small depth of field. The aperture, as stated, controls the amount of light getting to the sensor. A larger aperture passes more light. Of more interest to the lens designer than to photographers, the location of the aperture within the lens structure, specifically the distance between aperture and sensor, also has an effect on the intensity of the light striking the sensor.

The amount of light passing through an aperture is defined by the f-number of the lens, where the f-number is the lens focal length divided by the diameter of the aperture. Consider a 200 mm lens with an aperture diameter of 50 mm. The f-number is

$$f = FL/D = 200/50 = 4$$

It's an f/4 lens! But wait! There's more!

What if the aperture were smaller, say only a 25 mm diameter? Using the same formula, we get:

$$f = FL/D = 200/25 = 8$$

Now, this is truly important: The larger aperture has the smaller f-number, and the smaller aperture has the larger f-number. An aperture of f/4 is larger than an aperture of f/8, so an f/4 aperture will pass more light than an f/8 aperture.

All very interesting, you say, but do I really need to know all that? Nope! You can be an excellent photographer without knowing most of that, but there are a few things that you do need to know.

1. You need to know the standard f-number series.
2. You need to know the language of stops.
3. You need to know how f-numbers control depth of field.
4. You need to know how varying f-numbers and shutter speeds add and subtract light.
5. You need to know when to change ISO settings.

Memorize the F-number Series

The standard f-numbers must, absolutely must, be thoroughly memorized. You must be able to rattle them off at low speed or high, forwards to backwards, backwards to forwards, from the center to

one end, and from the center to the other end, even after several strong drinks. They are

1 1.4 2.0 2.8 4.0 5.6 8 11 16 22 32 45

We often use f-numbers in talking photography: *How much is that f/2 lens in the window?* No lens that we know of has all of the f-numbers. Most lenses begin at f/2.8 or f/4.0 and they go to f/22 or perhaps f/32. Be aware the smallest f-number (largest aperture size) on many lenses is an intermediate one that falls in between the main ones. As examples, Canon offers a variable aperture zoom with a maximum aperture of f/3.5, and another with a maximum aperture of f/4.5 and a 50 mm prime lens with a maximum aperture of f/1.2.

F-numbers Control Depth of Field

As the f-number gets larger, the aperture in the lens gets smaller. Small apertures offer more depth of field. Many photographers have trouble remembering that large f-numbers such as f/22 have the small apertures that give increased depth of field. It seems counterintuitive, but learn to accept it (they're actually fractions) and memorize how it works. Landscape photographers tend to use the greater depths of field offered by smaller apertures like f/16 and f/22, so you'll be using those f-numbers a lot. It's helpful to remember to use f/16 and f/22 anytime you want plenty of depth of field, which is most of the time in landscape photography!

Adding and Subtracting Light Using F-numbers

Look at the standard f-number series again. Each f-number listed varies from its nearest neighbor in

B	30	15	8	4	2	1	1/2	1/4	1/8
1/15	1/30	1/60	1/125	1/250	1/500	1/1000	1/2000	1/4000	1/8000

Numbers in seconds.

terms of how much light it passes to the sensor. F/4 only passes one-half of the light as f/2.8, but passes twice as much light as f/5.6. Each f-number passes twice as much light as the next larger f-number, but passes only one-half as much light as the next smaller f-number. If you begin at f/8 and then move the aperture to f/4, you have quadrupled the light passing through the lens.

THE LANGUAGE OF STOPS

All of this doubling, halving, quartering, and quadrupling can get messy, so the language of *stops* was developed to make talking about exposure easy once you got used to it. Stops are found throughout photography. F-numbers, shutter speeds, ISO values, and even guide numbers for flash can all be divided into stop increments. A stop refers to a quantity of light. Each f-number in the standard f-number series is said to vary from its nearest neighbor by one stop. F/4 passes one stop more light than f/5.6 and two stops more light than f/8. If we tell you to begin at f/8.0 and add two stops of light, what f-number must you go to? If you said f/16, you have certainly changed the f-number by two stops, but you went the wrong way! Changing to a higher f-number subtracts light, because the aperture is smaller. The correct answer is f/4.0! How many stops are found between f/1.0 and f/45? It's okay to peek. You should count a total of 12 stops included in the f/1.0 and f/45 series.

SHUTTER SPEEDS

Shutter speeds control the camera's ability to freeze action or to show motion. The faster the shutter speed, the greater your ability to arrest the motion of the subject or the camera. The slower the shutter speed, the more motion-induced blur appears in the image. Above is a list of common shutter speeds, in seconds, that many cameras have.

Let's ignore B for a few moments and study the other shutter speeds. Notice that each one is half of its neighbor on one side, and twice its neighbor on the other side. For example, a shutter speed of 1/250 second is twice as long as 1/500 second and half as long as 1/125 second.

Do I care? Yes, you do. This is important stuff. Of the three example numbers, the 1/500 number means that a push of the shutter button will cause the shutter to open for 1/500 second and then close, a speedy event indeed when one considers that it could theoretically be done 500 times in only one second! If we set the shutter control to the middle choice, 1/250 second, then the shutter would be open for twice as long as before. Thus, a shutter speed of 1/250 second will let in twice as much light as a shutter speed of 1/500 second. In photographer jargon, 1/250 second is one stop brighter than 1/500 second. Using similar thinking, we see that 1/250 second is a shorter period

of time than 1/125 second. Twice as short. So, the photographer would note that 1/250 second is a stop darker than 1/125 second, or that 1/250 second is *a stop down* from 1/125 second, and so on.

The letter B stands for bulb exposure. When you use the B setting, pressing the shutter button and holding it down keeps the shutter open for as long as the button is held down. Landscape photographers often use a cable release to hold the shutter open when shooting long exposures, such as the stars twirling about the heavens, the northern lights, lightning bolts, and sometimes waterfalls.

THE LAW OF RECIPROCITY

This law describes how the shutter speed and f-number work together to control the exposure. It can be written as a simple formula:

$$E = A \times T$$

The exposure is a product of the aperture value times the shutter speed value. For example, if you reduce the exposure by using a faster shutter speed, then you must open up the aperture to allow more light to enter and strike the sensor so the exposure can remain the same.

Enough formulas! Let's consider a specific example. Suppose the proper exposure for a waterfall is 1/15 second at f/8. Using the reciprocity principle, if you change the aperture to f/22 to obtain more depth of field, you must then also change the shutter speed to 1/2 second to maintain the original exposure. Changing the aperture from f/8 to f/22 subtracts three stops of light (f/8 to f/11 to f/16 to f/22 = −3 stops). The 3-stop reduction in light is

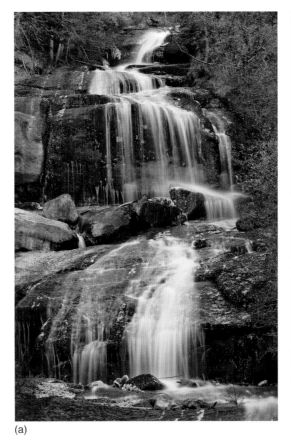
(a)

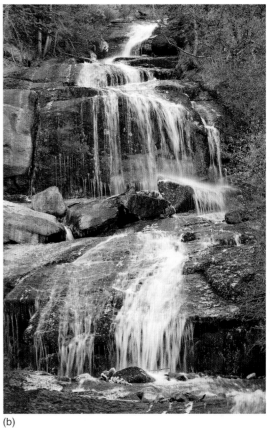
(b)

(a) A 1-second shutter speed nicely blurs the cascading water of Portal Falls near the trail head to Mt. Whitney. (b) The faster shutter speed of 1/15 second "freezes" the water considerably. Neither image is wrong because it's an artistic choice. We tend to like blur in our waterfall images, but if you prefer to arrest the motion of the water more than we do, that's what you should do.

offset by changing the shutter speed to 1/2 second (1/15 to 1/8 to 1/4 to 1/2 +3 stops). After we're done changing this and that, we have an exposure of f/22 at 1/2 second that puts exactly the same amount of light on the sensor as the original exposure of f/8 at 1/15 second. Yes, the *amount* of light

is the same, but much has changed. The smaller f/22 aperture has increased the depth of field, so more of our waterfall may be in focus than it was at the larger f/8 aperture. The slower 1/2-second exposure has allowed the water to blur a little more, giving us smoother and silkier water than the faster

shutter speed of 1/15 second. Which exposure is better? The one you like better.

ISO VALUES

Both film cameras and digital cameras use an *ISO* rating as a measure of the light sensitivity of the film or digital sensor. All films and sensors rated at the same ISO should produce identical exposures when irradiated by identical light. For example, in a circumstance where a film or sensor sensitivity of ISO 100 produces underexposure, one could correct his film camera's plight by changing to a higher ISO film. But the digital photographer would just smile, turn a knob, and reset his camera to a higher ISO setting. That lucky digital photographer has a wide choice of ISO settings available at his every whim!

ISO Values (in Stop Increments)

Digital cameras generally offer a selection of several ISO settings. A typical set is

50 100 200 400 800 1600 3200 6400

Interesting, eh? Like shutter speeds, each ISO setting has half the light sensitivity of one neighbor and twice the light sensitivity of its other neighbor. Or, slipping again into photo jargon, ISO 400 is two stops more sensitive than ISO 100.

A sensor's inherent design speed, called its *native speed*, is ISO 100 in most cameras, although some cameras have a native ISO of 200 and some may have other native speeds. Users generally can't change a camera's sensor, so the native ISO can't be changed. However, cameras do provide the user with several ISO speeds by electrically amplifying

the sensor's output data. The ability to change the ISO value from shot to shot on a digital camera is a major advantage.

WHY CHANGE ISO VALUES?

If ISO 100 (ISO 200 on some cameras) is the native speed of your digital sensor, why would you want to change it in landscape photography? Increasing the ISO value to ISO 400 or even ISO 800 makes it easier to get more depth of field at f/16 or f/22 while keeping the shutter speed fast. Serious landscape photographers use a tripod most of the time, which minimizes the importance of faster shutter speeds. However, even on a tripod, there are times where fast shutter speeds are helpful. For example, a fast shutter speed is valuable to sharply record a wave crashing into a rocky outcrop. Fast shutter speeds reduce the problem of high wind vibrating your tripod or blowing foreground wildflowers in your mountain landscape image. One occasionally shoots landscape images hand-held. It can be difficult or impossible to use a tripod in situations such as on crowded viewing platforms, in deep snow, when photographing from boats, and where tripod use is prohibited.

THE SENSOR NOISE PROBLEM

Changing the ISO value from the native sensor speed does reduce image quality. A change in the ISO speed is accomplished by electrically reducing the signal from the sensor, or more common, by electrically amplifying it. Either way, but especially when a higher ISO is selected and the signal is amplified, digital noise will be increased. The higher the ISO invoked, the higher the noise. Do

you remember what prints looked like when shot with high-speed film?

Film had large light-sensitive crystals that showed up in prints as tiny specs that looked like sand and were called *grain*. Digital images don't have grain, but sensor noise resembles the appearance of grain. Sensor noise is easiest to spot in the dark portions of the image. It shows up as specks of an unexpected color or brightness. If there are specks of red or blue in a part of the image that should be black, you're probably looking at sensor noise. The native ISO of your sensor generates the least amount of noise. The highest ISO setting on your camera gives the worst noise. Digital cameras are rapidly improving in many ways, and lower sensor noise is one of them. Indeed, the new Nikon D3 controls noise so well that it appears to shoot acceptable images even when used at ISO 6400 and higher.

OUR ISO RECOMMENDATIONS

Although new camera technology is minimizing the problem of sensor noise, and software is also available to reduce the problem, we use the camera's native ISO speed whenever possible. The native ISO speed delivers the cleanest possible digital image, so there's no point most of the time to use anything else in landscape photography. We use a tripod 95% of the time, so shutter speed isn't that critical for the vast majority of our landscape images. However, we do love photographing landscapes from boats, and then we typically use ISO 400 (more if necessary) to obtain the higher shutter speeds needed for sharp images. We will discuss shooting strategies from boats in more detail in Chapter 8.

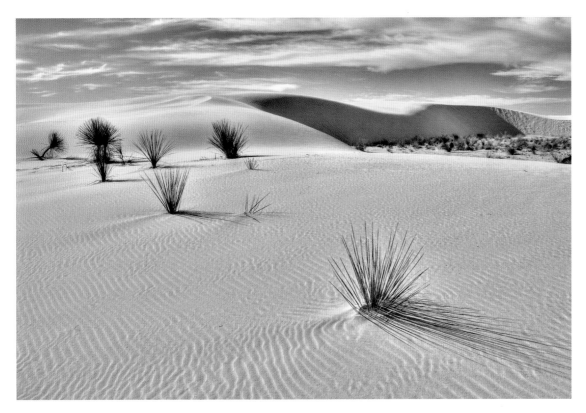

Always use the camera's native sensor speed if there's no compelling reason to use another speed. For most cameras, it's ISO 100, but some use ISO 200 as the native speed. Since there's no wind to vibrate the tripod or wiggle the vegetation, using the native sensor speed is best to record the highest quality digital image of these dunes in White Sands National Monument.

EXPOSURE INCREMENTS

Most digital cameras offer exposure increments that are finer than the full-stop increments listed above for f-numbers, shutter speeds, and ISO values. A choice of these increments is normally found in the shooting menu or in the custom functions.

Your camera probably offers intermediate exposure increments that are smaller than the full-stop increments we've been discussing. Some cameras can be configured to change shutter speeds, apertures, and ISO numbers, not in full-stop increments, but in 1/2 or 1/3 stop increments. For example, the Canon 1Ds Mark II and many others can be set to exposure increments of 1/3 stop. If so set, then between every f-stop of the basic series one could set two intermediate f-stops. For example, you'd have the f-stop series of f/16, f/18, f/20, and f/22.

Likewise, if set to 1/3-stop exposure increments, one would find two shutter speeds between the basic speeds of 1/60 and 1/125 second, producing a series of 1/60, 1/80, 1/100, and 1/125 seconds.

SELECTING THE EXPOSURE INCREMENT

One-Stop Increments

Don't use one-stop increments. It's easy to expose more precisely than one-stop increments allow, so there's no point in using them. You get more flexibility when using shutter speeds and f-numbers if you use a smaller exposure increment. Some cameras offer intermediate increments for the shutter speed and aperture, but not for ISO values, which is a minor deficiency. We like having 1/3-stop increments for setting our ISO, but could easily live with full-stop ISO increments if we had no choice.

One-Half Stop Increments

The ability to use half-stop increments between the shutter speeds and f-numbers is very useful. It gives finer control over the depth of field and shutter speed. This setting should work fine for most landscape photographers. One advantage of using 1/2 stop increments over 1/3 stop is that changing the shutter speed or aperture is a bit quicker when using manual exposure because you don't have to rotate the control dials through so many values. Yes, it's only a small advantage, but every little bit helps.

If you use autoexposure modes such as aperture priority, shutter priority, or program; using one-half stop increments makes perfect sense. It's quite

effective to use autobracketing and autoexposure to shoot static landscapes. The autobracket feature can be set in several ways, depending on the camera. We suggest bracketing the meter's recommended exposure by plus and minus a half stop. A three-image autobracket series provides an image the camera thinks is properly exposed, plus a second image that is one-half stop darker, and a third image that is one-half stop lighter. When editing the three images, select the one that has the best exposure as indicated by the histogram. A three-shot bracket using half-stop increments will likely ensure that most landscapes will produce at least one well-exposed image, provided the scene isn't much more or much less reflective than middle tone. If you used a 3-shot bracket with 1/3-stop increments, you would only cover a range of 2/3 stops, so your chances of getting the optimum exposure are slightly less (1/3 stop).

One-Third Stop Increments

This choice offers fine control over depth of field and shutter speeds, more than most of us really need. However, if your camera offers and you use the RGB histogram (as we do) that shows individual histograms for the red, green, and blue color channels, then 1/3-stop increments is the preferred way to get the best exposure. It works best for us because we expose our landscapes to avoid losing highlight detail. We ensure that the color channel with histogram data farthest to the right has that data as close as possible to the right edge of the graph without actually touching. The precision of the 1/3-stop exposure increments helps us achieve the desired exposures.

METERING MODES

Before using the exposure meter to shoot well-exposed images, you have another choice to make. All DSLRs offer a few metering patterns. The common metering modes are Canon's evaluative metering, Nikon's color matrix metering, and partial, center-weighted, and spot metering. These choices refer to the portion of the scene the meter is reading, whether the meter emphasizes certain areas in the scene, and whether software and stored data are consulted by the meter.

CANON'S EVALUATIVE METERING AND NIKON'S COLOR MATRIX METERING

These are the most complex and sophisticated metering patterns that today's cameras offer. Conceptually, they measure the scene brightness in multiple areas of the frame (some Nikons also measure the scene color in different areas). The meter systems then compare their measured data with a large bank of stored data already in the camera's computer (a *look-up table*) and after some unfathomable calculations, they reach an exposure recommendation. I say *recommendation*, because the meter output will be sent to the camera when in autoexposure mode, although the shooter can intervene by using the compensation dial. In manual exposure mode, the meter output is presented not to the camera, but to the photographer. These fancy systems work quite well in most situations and they take into account bright skies, back-light, background, and other factors. When using any autoexposure mode such as program, aperture

priority, or shutter priority, this may be the best metering pattern. All metering patterns can produce a fine exposure by using exposure compensation, but the evaluative and color matrix systems are more likely to get you close to the ideal exposure in more situations than other metering modes. We use them for manual metering too, and they really shine when shooting landscapes. If a scene is very dark or very bright, these metering modes normally get the exposure close to perfect. We achieve a precise exposure by manually adjusting the exposure so the histogram's right-most data are as close to the right edge of the graph as possible without climbing it.

PARTIAL METERING

Partial metering considers only about 8–10% of the middle of the frame. It can be useful for metering back-lit subjects, but evaluative metering used in conjunction with the histogram works perfectly for our needs, so we never use or recommend partial metering. And, if precise metering of a small portion of the scene is necessary, it makes sense to use spot metering.

CENTER-WEIGHTED METERING

This metering pattern is typical of old film cameras from the 1970s and earlier but still lives on, though we don't know why. The meter averages the entire scene, and as its name suggests, applies a greater importance to the center area. Center-weighted metering has survived because so many photographers are accustomed to it, although we find no compelling reason to use it. If you're one who still loves it, then it's the perfect choice for you. However, we

feel evaluative or color matrix metering is far more effective and will get you closer to the ideal exposure in more situations.

SPOT METERING

Spot metering measures a very small part of the frame, perhaps only 2–3%, so it's very precise and simplifies metering small areas and small objects. Spot metering is a terrific way to meter if you carefully meter something and compensate for its reflectance. For example, John uses the camera's spot meter to carefully meter the light-toned sand dunes in Death Valley National Park. He compensates for the sand's high tonality by adjusting his viewfinder's analog display to +1 1/3-stops above zero and shoots the image. Then he confirms that the RGB histogram channel with the farthest right data has that data as close as possible to the right edge of the graph without actually touching. If not, he changes the exposure accordingly and shoots again.

Spot metering is quite useful in landscape photography for measuring the contrast range in a scene. If a scene has a shadowed foreground and a sunlit distant mountain, it's easy to spot-meter both foreground and background to see how many stops separate the two. The spot meter is a fine way to measure a scene's brightness range to see if the digital sensor can handle it. By knowing the contrast range of the scene in stops, it's easier to figure out how widely you must bracket exposures so they can later be assembled into one image using high dynamic range (HDR) software to provide excellent detail throughout the image.

USING THE HISTOGRAM

The histogram is a simple bar chart of exposure that's enormously useful once you learn how to read it. It tells whether you have under- or overexposed areas in the image. The histogram helps to shoot perfectly exposed images while the subject remains available, which is nearly always true in landscape photography.

Histograms can look a bit intimidating if you're not familiar with charts and graphs. Don't be alarmed, though. You can use the histogram as a reliable guide to excellent exposures shot after shot, and it's truly easy! A histogram is a simple graph representing 256 brightness values along the horizontal axis. Those brightness values range from 0, (pure black), which is on the extreme left, and 255 (pure white), which is on the extreme right edge of the graph. For any brightness point along that horizontal axis, the height of the histogram at that point, that is its height on the vertical axis, represents how many pixels of the sensor have that particular brightness. An important note, though. The graphical picture of the histogram doesn't contain numerical data for the brightness values nor for the number of pixels having any given brightness. That's unimportant, though, because photographers don't normally need to know the numerical data — they just need to understand the meaning of the histogram's shape and the meaning of its left-to-right location within the graph's frame. Suppose, for example, your histogram shows a large hill of data between the (unnumbered!) brightness values 189 and 242. The substantial vertical development shows that there's a large quantity of the sensor's

pixels having brightness values within that range. If, though, there's little or no vertical data between brightness values 189 and 242, then your scene, as exposed, has few or no areas of brightness within that range, so your sensor has few or no pixels having those brightness values.

Beginners tend to hope for a perfectly shaped histogram. They often envision a shape that begins fairly low on the right and left edges of the graph, but gradually rises toward the middle similar to the shape of a mountain or the familiar shape of the common *bell curve*. But there's no such thing as a histogram perfectly shaped for all images. The perfect histogram is totally dependent on the image.

If you fill the frame with snow mounds and soft shadows, you should expect to see a lot of pixel values near the right edge of the histogram, because nearly everything in the image is white. You may have some pixels near the middle of the histogram that represent the shadows, but don't expect any pixels showing up on the far left edge because nothing in the scene, as exposed, is black or even close to black.

As you can see in the snow mound example, don't be worried if some brightness values don't show up in the histogram. If the histogram doesn't contain any pixels of certain brightness values, you just don't need those tones. It merely means that your scene, as exposed, didn't contain those particular brightness values. Also don't be worried if gaps appear in your histogram. If the scene is comprised mainly of blacks and whites, you should expect to see very few pixels of midrange brightness values, because they simply aren't in the scene as you've

These back-lit overlapping ridges of snow make appealing patterns. We call them "intimate landscapes." Since nearly all of the brightness values in this scene are light to entirely white with few dark areas, don't expect to see much data appear near the left side of the histogram if the image is properly exposed.

exposed it. Although gaps in a camera's histogram are no problem, problematic gaps can occasionally arise during post-capture editing, such as aggressive Levels adjustments in Photoshop although, in this regard, the processing of RAW images is more forgiving than the processing of JPEGs.

HISTOGRAM SHAPES

The shape of the histogram does tell you a few things about the image right away. A high-contrast image will generate a lot of pixels with brightness values toward the left (black) edge of the graph and a lot toward the right (white) edge of the graph. If, on the other hand, nearly all the pixels reside on the right edge (greater brightness values) of the histogram, then the histogram is depicting a low-contrast, high-key image, i.e., an image comprising mostly brighter tones. Conversely, should a histogram show most of the pixels having brightness values toward the left edge (lower brightness values) of the histogram, then the histogram is depicting a low-contrast, low-key image, i.e., an image of mostly darker tones. Remember, each and every scene gives a histogram having a unique shape determined by the tonalities of that scene. Also, remember that while the shape itself is set by subject tonalities, it's the photographer's selected exposure that sets the left-to-right location of that shape within the graph. This is a critical issue discussed in detail later in this chapter.

AVOID CLIPPING

Clipping is a condition where subject matter and exposure result in the histogram actually touching the extreme left or right edges of the graph. A histogram touching the left edge depicts some pixels recorded at such low brightness levels that they contain very little or negligible picture information. This condition is known as *blocked shadows*. Likewise, a histogram touching the right edge of the graph shows some pixels recorded at such high brightness levels that the sensor's photo sites are saturated and can't contain the correct picture information. This condition is known as *blown-out highlights*. It's desirable to retain detail in the important highlights and black shadows if possible. If the dynamic range of the scene is greater than the sensor can record, it's best to ignore the blacks and retain detail in the generally more important highlights. Photographers refer to areas of the histogram touching either edge of the graph as *clipped areas*, and shun them because they may lack picture detail.

Some scenes generate histograms where some brightness levels have pixel quantities hitting the

top of the graph. This might happen when photographing a scene like a tree against a uniform blue sky or against sand dunes of largely similar brightness levels. For example, a spike of data between brightness levels 189 and 231 not touching either the right or left of the graph, but hitting the top edge, isn't clipped. It's hitting the top edge only because the graph isn't tall enough to show the thousands of pixels in that range of brightness values. You haven't clipped any data nor lost any picture detail, because clipping can occur only when histogram data touch or actually climb the left or right graph edges.

Problems with Clipping on the Right

Clipping on the right edge of the histogram is the more serious clipping, because it indicates that some pixels accumulated so many photons of light that they filled to capacity. When a pixel is filled to capacity, it becomes saturated and loses its ability to faithfully represent image detail. Retaining detail in important highlights is critical because bright areas in the image quickly draw the viewer's eye and they expect to see detail. However, clipping can be acceptable where there's no need to preserve detail in the highlights; for example, where the highlights are *specular highlights*, such as a brilliant reflection from a metal surface or a glare from water drops. If the sun appears in an image, the portion of the histogram representing the sun will undoubtedly be clipped because the sun is brighter compared to everything else. However, overexposing the sun is quite acceptable because we're accustomed to not seeing any detail in it.

Problems with Clipping on the Left

One can usually avoid clipping on the left edge of a histogram graph unless a properly exposed scene has a very large brightness range; that is very high contrast. However, one can get clipped black areas in an image where there's simply not enough light for the pixels to measure adequate picture information. When a pixel doesn't accumulate enough photons, the pixel can't accurately determine the true brightness and color of the spot in the scene that corresponds to the pixel. This often results in objectionable digital noise, which appears as unexpected brightness or colors in the image and looks a little like film grain. Digital noise should be strictly avoided unless it serves an artistic purpose. Noise isn't the only problem with clipping on the left, though. Left clipping also causes inaccurate colors because the pixels are unable to record enough photons for an accurate reading of the light. If left clipping is unavoidable, software dealing with digital noise can help considerably. However, if you always expose digital images the way we do, you'll have very few problems with clipping on either the left or right edge of the histogram.

Light has a lot to do with the brightness range of a scene. If the scene has both black and white objects at the same time and the day is cloudy, you have a fairly wide brightness range, i.e., a large contrast, but because of the soft light, your camera's sensor might handle it without any clipping if you do your part and expose well. However, if this same scene is illuminated by bright sun so some white objects are in the sun and some dark objects are in the shadows, the scene's contrast may be far too great for your sensor to record it without clipping.

THE PERFECT DIGITAL EXPOSURE FOR THE RAW IMAGE

The ideal RAW exposure is one that's as bright as possible without losing highlight detail. This means the histogram should be nearly touching the right edge without actually touching. Exposing this way retains the fine detail of the highlights, while making all of the other tones, including the dark ones, as bright as practicable. This technique permits all pixels to accumulate more photons, and that's especially important in allowing the darker tone pixels to accumulate more photons, which results in more accurate colors and lower apparent noise.

And, it's easy to achieve this exposure by using the histogram. As we've said over and over, the histogram data should be as close as possible to the right edge of the graph without actually touching. If it isn't, move it there! When in manual exposure mode, adjust aperture, shutter speed, or ISO speed to move the histogram; when in any autoexposure mode, adjust the exposure compensation control.

JPEG EXPOSURES

We realize that many of you prefer to shoot JPEG images and there's nothing wrong with that. If you don't plan to do a lot of post-processing with the file, the white balance choice is suitable and the exposure is good, JPEGs are perfectly suited for most applications. However, JPEG shooting demands a higher level of exposure accuracy in the

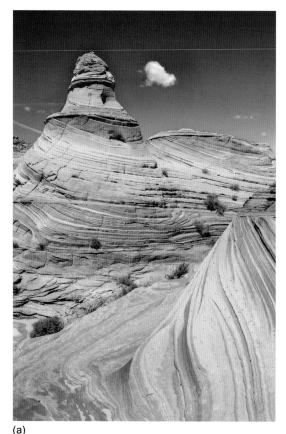

(a)

Histogram ▲

(b)

(a) The gorgeous wavy rocks at Coyote Buttes are easy to expose. Monitor the RGB histogram to make sure the color channel with data farthest to the right, in this case the red channel due to all of the red in the rocks, is nearly touching the right edge of the graph. (b) This histogram shows the red channel is nearly touching the right edge of the graph. Exposing this way preserves highlight details, captures more image data throughout the scene due to the linear nature of how sensors measure photons, and reduces noise in the shadows.

camera, because JPEGs have a limited ability to be manipulated during post-capture editing in your digital darkroom. JPEG images should be shot with a slight bias toward more exposure but, unlike when shooting RAW images, you don't want the histogram nearly touching the right edge most of the time. With JPEGs, it's better to place the bulk of the histogram data slightly to the right of the graph's center. However, recent advances in image-processing software that address the special needs of JPEG images may be available by the time you read this.

MOVING THE HISTOGRAM LEFT OR RIGHT

AUTOMATIC EXPOSURE MODES

If a histogram is clipped on its right edge, move it to the left in the next shot by adjusting the exposure compensation to subtract light. If the histogram is clipped on its left edge, or otherwise needs to be moved to the right, adjust the exposure compensation to add light. Depending on your camera, the compensation control might allow plus or minus two or three stops of light, in increments of 1/3- or 1/2-stops. Use the histogram to guide you to the very best exposure compensation. If the histogram doesn't move when you take another image, you may be trying to make the adjustment with the flash compensation control instead of the control for the camera's compensation. Watch out for light passing through the viewfinder when using automatic exposure, too. In certain situations, light streaming through the viewfinder influences autoexposure causing underexposure, so you should always shield the viewfinder eyepiece with its built-in shutter, its separate cover, or your careful-to-not-touch hand or hat.

MANUAL EXPOSURE

Techniques

In many ways, manual exposure is easier to compensate. Digital cameras in manual exposure mode don't automatically set the aperture or shutter speed — you must do it manually. It's simple enough. The cameras show an exposure-level indicator inside the viewfinder. It generally appears on the bottom or on the right side of the viewfinder display. Oftentimes the exposure indicator is duplicated on an LCD panel elsewhere on the camera.

Setting the camera controls so that the indicated exposure aligns with the *zero* position of the exposure indicator scale results in an exposure following the meter's recommendation without any

compensation. To introduce compensation, merely align the indicated exposure to something other than zero. Set the indicated exposure to +1 on the exposure scale to add one stop of light, to −2 to subtract two stops, and so on. The exposure indicator scales of most cameras allow adjustment in increments of 1/3 or 1/2 stops.

Should your camera not have + and − signs on the exposure scale, showing which direction of change adds light and which direction subtracts light, take this simple test: Meter a scene and set the exposure indicator to zero. Adjust the camera to add light by changing it to a slower shutter speed. The direction in which the exposure indicator moves is the direction of plus compensation. The other direction is negative compensation.

We've already said that we use manual exposure for nearly all of our digital photography because manual exposure makes it easier to obtain the precise exposures we demand. The disadvantage of manual exposure is that one must manually adjust the shutter speed and aperture controls when metering because the camera doesn't do it for you. That's also an enormous advantage! We'll tell you why a bit later. We do admit manual exposure is also slightly less efficient when ambient light levels are frequently changing.

Let's describe how we use manual exposure to photograph the gorgeous Orange Spring Mound near Mammoth in Yellowstone National Park. Orange Spring Mound is quite large and you must be close to it to prevent roads and signs from appearing in the image, so a wide-angle lens, such

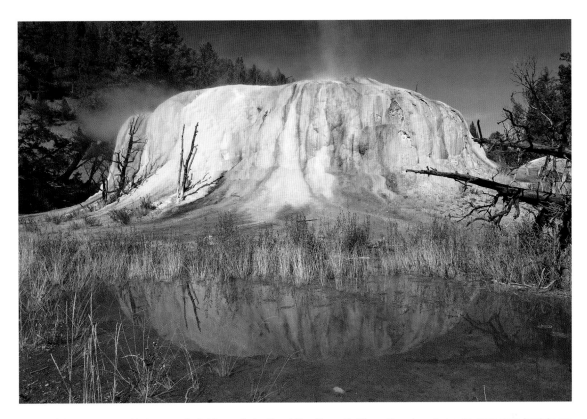

A torrential downpour occurred just as we arrived at Orange Spring Mound Near Mammoth. After waiting a few minutes, the storm cleared and the sun returned, making a splendid reflection in a temporary pool of water at the base of the mound. Using her Nikon's color matrix meter, Barbara manually adjusted the exposure to the zero position using the scale in the viewfinder and took a shot to view the histogram. She found the color channel with data farthest to the right was a little shy of the right edge of the graph, so she manually added 2/3 stop of light with the shutter speed and shot another image. This new histogram showed the data were now nearly touching the right edge of the chart, exactly what she wanted.

as a 24–70 mm zoom lens, is needed. The mound doesn't move, so shutter speed isn't important, but depth of field is very important to sharply focus the foreground and the mound itself. We'll use f/16 to get adequate depth of field. We didn't use f/22 because of diffraction considerations. With the aperture at f/16, we move the shutter speed control until the exposure indicator aligns with the zero position, which means no compensation. Shoot the image and check the histogram. The unique hot spring is mostly light red and yellow (the color of the bacteria living in the hot water), so the metering

causes the histogram to fall short of the right-hand edge. We add 2/3 stop of light by moving the shutter speed two clicks to a slower speed (our cameras are set to use 1/3-stop increments) and we shoot another image. The new histogram is nearly touching the right edge without clipping, which is exactly how we want to expose our RAW image. Although we went through several steps, arriving at the optimum exposure took less than 10 seconds. It's quick, simple, and precise, and we know of no better way to obtain the optimum exposure.

RGB Histogram

The manual metering technique works very well indeed, but there are two more variables you should know about. First, most cameras offer a luminance histogram, also called a brightness histogram. This histogram averages the exposure for each of the three color channels (usually red, green, and blue), although some cameras use different colors. Caution! A luminance histogram's averaging scheme makes it entirely possible to clip one or two colors, even though the averaged result shows no clipping! If you shoot a section of forest full of various shades of green, a majority of the light striking the sensor is green. This makes it easy to clip the green channel while the blue and red channels might be fine.

We prefer to use the RGB histogram. Some have suggested that we not talk about the RGB histogram because it's too difficult for mere mortals to use and understand. We don't agree. The RGB histogram is as simple to use as the averaging luminance histogram: You look at the graph for each

color channel and note which channel has its data farthest to the right. In our green forest example green would be farthest right, and you'd get an excellent exposure by exposing so that the green channel data are snuggled up to the right edge short of actually touching. You needn't worry about the other color channels.

How the Histogram is Created

The histogram, as stated before, is a graph in which the horizontal axis depicts the range of darkest to lightest brightness values that the camera can record. The brightness values range from pure black, shown at the extreme left end of the axis, to pure white, shown at the extreme right end of the axis. Although of limited interest to the photographer, every brightness along the horizontal axis is assigned a number ranging from 0 for pure black at the left end, up to 255 for pure white at the right end.

The vertical axis represents the quantity of pixels that have the specific brightness defined by their horizontal position. The horizontal axis of the graph, while not numbered, does represent a range of brightness values from 0 to 255, although the photographer ordinarily has no need for this numerical information. The vertical axis doesn't have any numbers either, but the height of the graph at any specific brightness is only a graphical proportional representation of how many pixels in the image are of this specific brightness.

A histogram graph is derived from the color and brightness data extracted from the camera's sensor.

Yes, you say, that's okay for JPEGs, but how does a camera obtain histogram data when shooting RAW images wherein the sensor data are largely unprocessed by the camera? The secret is that considerable in-camera processing is done on the RAW data, and a small JPEG is created from which the camera's histogram data are derived.

The in-camera processing for histogram generation involves color, contrast, and white balance. Contrast is generally increased. This processing may be desirable for many purposes, but can result in a JPEG — and its resulting histogram — that don't accurately represent the actual data of the RAW images. For example, a histogram may erroneously show highlight clipping. The error arises from the underlying JPEG having been made into an image higher in contrast whereas, in fact, the RAW image is properly exposed. Later, in RAW conversion, that image may show a perfectly satisfactory exposure even though the camera histogram implied it was overexposed by a whole stop.

So don't be too quick to delete a RAW image if its histogram shows a small amount of highlight clipping. To be safe, though, we still advocate that RAW images should be exposed to closely approach the right edge of the graph without actually touching it, but you probably have a little more leeway than that.

We still insist, despite this additional consideration, that we use the histogram and are happy with the consistent correct exposure that our method provides. However, we suggest that, if you shoot RAW rather than JPEG, one way to obtain even

greater accuracy of the histogram with reference to the RAW data is to turn off as many in-camera photo enhancement settings as possible, especially saturation, contrast, and sharpness. The image on the back of your LCD (also based on the JPEG thumbnail) might not be as immediately gratifying, but your histogram will more closely reflect your actual exposure.

Moreover, if a scene is high in contrast, we cover our bases by shooting a couple of extra frames. We do one at +1/3 and one at +2/3. We keep all of the exposures. We begin processing by studying the most clipped file to learn whether we can retrieve all of its important highlight detail. If those details are present, we know that the sensor has accumulated all possible detail in the image and has presented it with minimum apparent noise.

THE HIGHLIGHT ALERT

This is another exposure aid that helps you arrive at the optimum exposure. It may require activation as a menu item or through a custom function. When the highlight alert is activated, any overexposed areas conspicuously flash off and on; that is flash black and white during image inspection on the LCD monitor. Photographers often say they are checking for *blinkies* which, if present, indicate the presence of overexposed areas in the image. If you do have blinking areas, subtract light and shoot another image. When you no longer have the blinkies, your highlights should be fine.

Don't forget that clipping and blinkies are warnings of detail loss, but there are indeed highlights in which no detail is needed, especially specular highlights. If such highlights clip or blink, it's okay to ignore them. A good example is the widespread sparkling of the wind-swept sea in the bright light of the sun.

EXPOSURE-MODE CHOICES

Beyond manual exposure mode, your camera may offer several autoexposure modes. Different models offer aperture priority, shutter priority, full auto, and various program modes. The program modes may address specific subjects, such as wildflowers, landscapes, sports, portraits, and close-ups. While all of these choices can work fairly well, we think having so many choices makes things unnecessarily complicated. You might think the landscape shooting mode would be perfect, but don't use it unless you want to give up control and let the camera determine the nature of your picture. Avoid full auto, too, because it assumes you know nothing and we know that's not the case because you're reading this book! Besides, full auto does take away many of your choices and, in some cameras, even removes some menu options. We believe that only four of the autoexposure modes listed above are suitable for the serious landscape photographer, so let's examine each of them.

PROGRAM AUTOEXPOSURE

This exposure mode lets the camera select the aperture and shutter speed that will be best (it hopes) for the scene. It does consider the lens in use, so it knows to increase shutter speed when longer lenses are in use to minimize the effects of camera shake, which is very important with those longer lenses! Yet, when increasing shutter speed, the mode must enlarge the aperture to maintain the proper exposure, and this results in a reduced depth of field. Of course, if shooting on a calm day and using a sturdy tripod, you won't have a problem with camera shake, so it makes no sense to give up depth of field, especially in landscape photography. You can override the program mode to maintain the optimum depth of field by turning the aperture control. This mode makes sense for those who insist on shooting landscapes hand-held, so it's a viable choice for some. It's also a good choice if you're lending your camera to someone who knows nothing about photography (very risky!). In the interest of full disclosure, you should know we never use the program mode!

APERTURE PRIORITY AUTOEXPOSURE

This mode does just what is says: You select the aperture and the camera adjusts the shutter speed to get a recommended exposure. Depth of field is important in most landscape images, so aperture priority is often used by landscape photographers. It's quite simple to use. Set the aperture to f/16 or f/22 (remember diffraction!) for lots of depth of field, and the camera will shoot at whatever shutter speed the camera considers appropriate. The astute photographer will always intervene by using the exposure compensation control if she thinks it's necessary to adjust the exposure.

SHUTTER PRIORITY AUTOEXPOSURE

Here, the photographer selects the shutter speed and the camera picks the aperture to give a good exposure. A specific shutter speed is normally

unimportant to landscape photographers, so they seldom use shutter priority. It's more often used by sports and wildlife photographers when shutter speeds are critical for arresting motion of moving subjects, or occasionally for the artistic purpose of depicting motion by deliberately showing blur.

However, if using autoexposure, there are times when shutter priority is very useful in landscape

photography. Shutter speed can have a substantial effect on images of waves crashing on a rocky shoreline or of waterfalls. Faster shutter speeds, such as 1/250 second, tend to freeze the motion in the water while longer shutter speeds, such as 2 seconds or more, permit the water to nicely blur. As in sports photography, shutter speeds provide creative options for depicting motion in your landscape images, so it's occasionally useful.

Suppose you're in a boat or in powdery snow or otherwise prohibited from tripod use and you must shoot hand-held. Also suppose you want to use autoexposure. You can use shutter priority to lock in a shutter speed fast enough to ensure sharp images, providing you're a steady enough camera holder.

If you were to use aperture priority in those situations, it would be all too easy to unthinkingly set the camera to f/22 and fail to notice the resulting shutter speed was far too low for sharp images. The hand-holder's rule is that the shutter speed should be at least equal to 1/(focal length in mm) to get sharp images hand-held. With a 100 mm lens, you need a shutter speed of at least 1/100 second. And a bit faster is better yet.

MANUAL EXPOSURE

This mode does nothing automatically. You must manually set both the aperture and the shutter speed to reach the desired exposure. Manual exposure requires that you first select a metering pattern and then determine the meter's recommended exposure by consulting the exposure indicator that appears in the viewfinder or on an LCD panel, or both. Then, either accepting that recommendation or compensating it as appropriate to the scene, you use it to set the aperture and the shutter speed.

With all the sophistication and bells and whistles of new cameras, is there any reason to use manual exposure? Well, all of the autoexposure modes have problems we consider so egregious, that we invariably use manual exposure for landscape images. A problem with manual exposure, albeit minor in landscape photography, is that you must manually

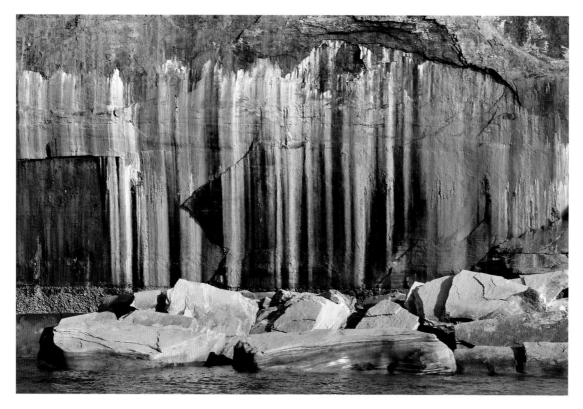

The colorful cliffs along Pictured Rocks National Lakeshore have very little depth, so f/11 easily covers the depth of field needed. Shutter speed is critical for shooting sharp images from a rocking boat. At times like this, it makes perfect sense to use shutter priority if you prefer to use autoexposure.

set the aperture and shutter speed, which slows you down a bit. However, sometimes slow is good, as it gives more time to contemplate your composition. The manual mode's separation of meter and camera controls can also be an advantage because the camera can't automatically change the exposure on its own. Once you've learned how to meter and how to set the camera controls, the histogram makes good landscape exposures a piece of cake!

The shooter facile with manual exposure is a shooter fluent in the language of stops. He must be fully comfortable with the exposure indicator in the viewfinder and intimately acquainted with its metering scale. Does it show you plus or minus, one, two, or three stops of exposure variation? Are the increments in full stops, one-half stops, or one-third stops? For a greater exposure, should the indicator be moved to the right side of the scale, or to the left? Some cameras, such as the Nikon D3, have a vertical exposure scale. The D3 exposure scale shows ±3 stops with the plus, or overexposure, side at the top. An arrow at the end of the scale illuminates if the 3-stop limit is exceeded.

What if the exposure meter is way off scale because the camera is set to six stops of underexposure? If the metering scale shows only plus and minus three stops, it can't show that you're off by six stops. It will, though, show the direction of the error. By seeing the *direction* of the meter indication, even if not the *amount*, the facile shooter knows whether he's under- or overexposed and he knows which way to change his camera controls to bring the exposure meter back into the real world. It truly is simple after you've done it a couple of times.

THE NEED FOR COMPENSATION

Unfortunately, excellent metering isn't without problems. Your camera's light meter measures reflective light, and all reflective-light meters have a huge problem. Camera manufacturers hope you capture outstanding images with excellent exposures so you'll be a loyal and happy customer. They try their best to make a meter that will accurately determine the amount of light that's illuminating the scene and, based on that, recommend a proper exposure.

Therein lies the rub! The meter measures how much light is reflected from a so-and-so, but the meter has no way of telling whether that amount of light is from a dark so-and-so in bright light, or from a bright so-and-so in dim light. Or, as a math major might say, we have a problem of two variables — light intensity and subject reflectance. To make a viable exposure meter, we need to find a way to get rid of one variable or the other!

Never let it be said, though, that a clever exposure meter engineer can't solve that one! The engineer assumes the world reflects 18% of the incident light falling on it. And if the world does, so does everything in it. So, our clever engineer merely kills off one variable — how bright the subject — by simply assuming that *all* subjects reflect 18% of their incident light. He designs his exposure meters accordingly. Incidentally, the 18% figure is somewhat controversial, and some exposure mavens dispute its accuracy. But meter manufacturers have standardized their designs to accept it.

Subject matter having 18% reflectance is called mid-toned, or middle-toned. Some writers carelessly refer to a condition of mid-tonality as *mid-toned gray*, *middle gray*, or something similar. Danger! Middle-toned subject matter, that is something of 18% reflectance, may be of any hue in the color spectrum! There's mid-toned green and mid-toned purple and mid-toned blue. In fact, any color can exist in a mid-tone reflectance or in any other reflectance; for example, there's dark red, light red, and mid-toned red.

Getting back to my exposure meter. If my meter measures the light reflected from my so-and-so, and then performs an appropriate arithmetic operation on it, my meter then knows what the incident light is and presents an appropriate exposure recommendation.

Well, that's all well and good, except for one little thing. The world as a whole may indeed average 18% reflectance, but we can't photograph the world. We only photograph specific parts of the world, and those parts may have quite different reflectance values. As I write this, we just had 8 inches of snow fall at our home, and the reflectance of new fallen snow is probably over 90%. The black robes of a judge have a reflectance far lower than mid-toned 18%. (For that I won't hazard a guess for fear of legal repercussions!)

At this point, we come to an all-important revelation. Study this until you know it backwards and forwards. Not only know it, but understand it. Because the meter designer made an assumption of an 18% reflectance world:

Any metered subject gives a meter recommendation that will cause that subject to be mid-toned in the image.

So, if I meter:

- My white cat, it will appear as a mid-toned cat (here, gray) in the image.
- My black rat, it will appear as a mid-toned rat (here, gray) in the image.
- My very dark fuchsia hat, it will appear as a mid-toned fuchsia hat in the image.
- My very light chartreuse mat, it will appear as a mid-toned chartreuse mat in the image.

Many landscape scenes — such as snowy mountains, tan-colored sand dunes, a forest ablaze with yellow leaves in autumn, or black lava fields — are all far from middle-toned. The meter doesn't know that it's looking at a scene varying considerably from middle tone, so the meter *does its thing* and recommends a shutter speed and aperture combination that causes the scene to be rendered as middle tone, which is not, of course, the correct exposure.

As pointed out previously, if you aim a meter (either a hand-held spot meter or the one in your camera) at white snow, the meter will suggest an exposure that causes the image to have mid-toned snow. Gray snow is not pretty. Point the same meter at a black lava field and the meter will suggest an exposure that results in a mid-toned lava field, which is far too light.

USING EXPOSURE COMPENSATION

The camera manufacturers, who are well aware of the meter characteristics, have added exposure compensation controls to your camera. If you use automatic exposure modes, you should learn to use the compensation control. Learn where it is on the camera. It's often a button or dial with plus and minus signs imprinted on it. Now here's a very important thought, which is unfortunately counterintuitive for many, but extremely important:

*When metering a subject **lighter** than middle tone, you must **add** light to the meter reading, and when metering a subject **darker** than middle tone, you must **subtract** light from the meter reading.*

Perhaps a mnemonic will help you remember this. Just remember that many smart lads are good photographers, and LADS is an acronym for Light, Add — Dark, Subtract. Hokey? Maybe, but if it saves a picture someday…

When in manual mode you add or subtract light generally by changing shutter speed or aperture. We say generally, because a photographer sometimes elects to change the ISO setting or use a filter. Light

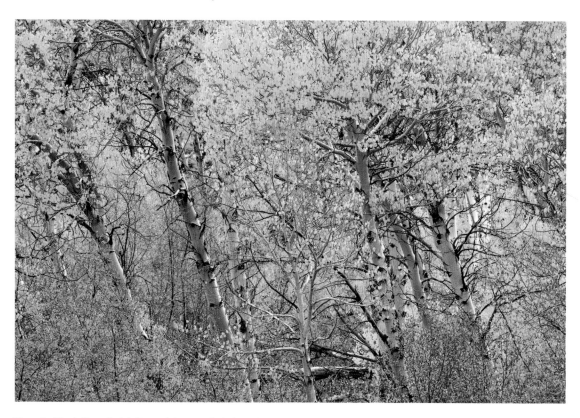

The meter tries to figure the brightness of the scene that's determined by the amount of ambient light illuminating the scene and the reflectance of the objects that make up the scene. Is this dense aspen forest middle tone, darker, or lighter? Due to the overwhelming abundance of golden leaves, it probably is lighter, but your meter doesn't know that, so it may suggest an exposure that's too dark. This situation is precisely why you have and must use exposure compensation to capture the best exposure possible.

is added or subtracted when in an autoexposure mode by changing the setting of the autoexposure compensation dial.

Caveat: Be careful to identify and use the compensation control that operates on camera natural light exposure, and not the compensation control that operates on flash exposure. Of course, if you're shooting flash images and need to introduce compensation, then you must use the flash compensation control.

AUTOEXPOSURE PROBLEMS

We know the vast majority of nature photographers rely on autoexposure modes and exposure compensation when necessary to get fine exposures. Most are happy with autoexposure and it does work, but we really don't think it's the best way to expose most nature images. Should we leave autoexposure's problems alone and not rock the boat? No, it would be a disservice to you to omit a discussion about the serious shortcomings of autoexposure, especially for landscape photography. Besides, if you attend one of our field workshops we will insist (in a friendly way, of course) that you use manual exposure, because it's so much faster, easier, and precise.

We could go on and on about autoexposure pitfalls, but in an effort to keep this book to a size you can lift, we'll briefly cover the key problems.

LIGHT THROUGH THE VIEWFINDER

You may get underexposed images when your camera is set on autoexposure and your eye isn't up to the viewfinder during the actual exposure time. This is a common occurrence for landscape photographers because they tend to mount the camera on a tripod, compose through the viewfinder, and then step back as they release the shutter. They do so to avoid touching and wiggling the camera during the actual exposure. An honorable goal indeed. However, when the viewfinder isn't shaded by the photographer's eye shielding the eyepiece, stray light enters the eyepiece. That stray light adds to the light coming through the lens and wrongly makes the meter think that the measured light is much brighter than is correct. The meter reduces its recommended exposure accordingly, and the scene is substantially underexposed. This problem doesn't happen all of the time. If the camera is in a shaded spot, but the scene is illuminated by

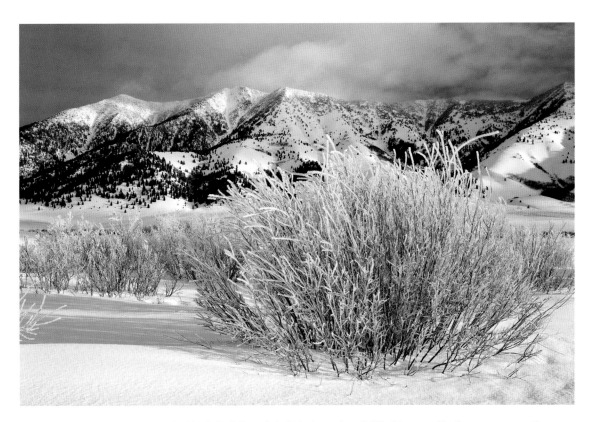

Snow scenes like these frosted willows with Idaho's Black Mountain in the background aren't difficult to expose. Yes, the snow may cause the camera to underexpose the image. So, use the exposure compensation control to add light or meter manually until you get the histogram appearing its best.

sun, you probably won't have difficulty. However, if the scene you're photographing is dark or you've darkened it with filters and if there's a fairly bright ambient light shining on the viewfinder, you will probably get underexposed images. Note that using the compensation control to add light won't help.

This problem is well known to camera manufacturers. Some have incorporated an eyepiece shutter and some offer an accessory eyepiece cover to close off the viewfinder when using automatic exposure and your eye isn't up to the viewfinder. If your camera doesn't have a shutter or a cover for its viewfinder, hold your hand closely in front of the viewfinder without touching the camera. Also effective is the hat trick: Solve the problem by holding your dark hat to shade the viewfinder from stray light. Incidentally, that same dark hat can be helpful in shading the front of the lens to reduce sun-caused lens flare. Any of the shading methods are monotonous when needed frequently,

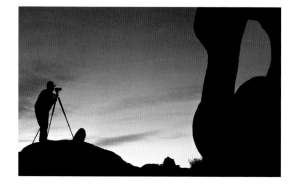

Barbara and our dog Yogi Bear are photographing a natural arch in the Alabama Hills at dawn. She's using manual exposure, so there's no need to cover up the viewfinder. If you use any autoexposure mode, be sure to prevent any light from passing into the viewfinder to avoid underexposure.

especially with the always lost accessory eyepiece cover; a little monotony is far better than a lot of underexposed images!

Your eye is shading the viewfinder when metering in the manual exposure mode. Once the exposure is set, you can ignore the ambient light entering the viewfinder, because without the photographer's deliberate intervention, the exposure can't change. With stray light no longer a problem for the photographer, she's free to concentrate on other matters. That benefit alone is enough to make us choose manual exposure!

COMPOSITION CHANGES

Changing the composition is another source of difficulty when using autoexposure. Assume you're photographing a lovely waterfall. You start by framing the waterfall fairly tight so the image is about 80% white water surrounded by 20% dark rocks and pine trees. Using the histogram and exposure compensation control, you determine the optimum exposure. Everything is fine until you recompose to make the waterfall smaller and include more of the dark surroundings. If the metering method in use is influenced by the *area* of the dark rocks, the meter will see things get darker and will add light to its recommended exposure. The additional light might easily overexpose the white water. Of course, one should always check the histogram and highlight alerts, although it takes time, to ensure a good exposure!

Composition changes are less dangerous when using manual exposure. You can zoom in and out all day long while maintaining the same exposure as long as the ambient light doesn't change. The

re-arrangement of one's dark rocks and light trees during zooming may indeed induce changes in the meter recommendation, but the camera can't change its shutter speed or aperture without the photographer's concurrence.

The foregoing discussion is true even with most variable aperture zoom lenses, provided you're stopped down a ways from the maximum aperture. You're probably shooting at about f/16 to maximize the depth of field, and a typical modern zoom lens at smaller apertures is no problem. Those lenses can maintain f/16 at any focal length. However, if you're at the maximum aperture of, say, f/3.5, and at the shortest focal length, upon increasing focal length to zoom in on the waterfall the aperture will automatically change toward f/5.6 or thereabouts. This necessitates a corresponding change in shutter speed to maintain the same exposure. A nuisance at best; a photographic disaster at worst.

SUBJECT INFLUENCES

If your subject changes from one shot to the next, you might have autoexposure problems. We think of landscapes as fairly immobile, but some landscapes certainly change, even though you don't change composition. Have you ever photographed on a foggy morning when the fog thickens and then thins? If the exposure is correct for the scene when it's shrouded in thick white fog, images will certainly be overexposed when the fog thins and reveals more dark tree trunks in the scene. Try photographing waves crashing on the rocky shoreline. You want to keep detail in the white wave, so you use autoexposure, exposure compensation, and the histogram

and a blinkies indicator to get the optimum exposure. Let's say the wave has been filling one-third of the image. What happens when an especially powerful and dramatic wave fills two-thirds of the image?

The meter now sees a lot more white water causing the meter to reduce the exposure and underexpose the image. None of these situations are problems for manual exposure.

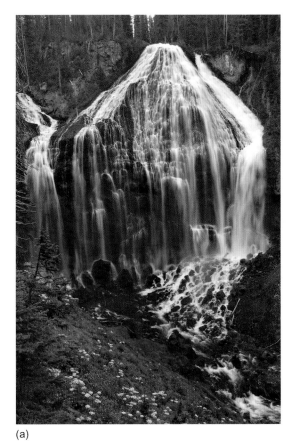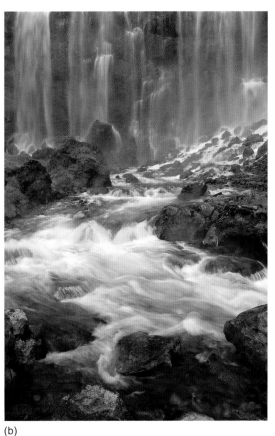

(a) (b)

(a) Union Falls may be the most beautiful waterfall in Yellowstone National Park. It's well named because two rivers join together at the top of the cliff just as they plunge over the edge. You'll notice the smaller creek on the left-hand side. We believe that manual exposure is the most efficient way to photograph this magnificent waterfall. Once the exposure is set for one composition, we can recompose at will and the exposure remains good as long as the ambient light doesn't change. (b) We can zoom in tightly and still avoid exposure problems using manual exposure. Autoexposure systems do poorly because now there's a far higher percentage of light tones in the image, so the meter may automatically reduce the exposure — exactly what you don't want. You may choose to use autoexposure, but be aware that every time the meter "sees" a different percentage of tonalities in the scene, it may change the exposure automatically and inaccurately.

WHEN THE BACKGROUND CHANGES

Changing backgrounds is a common problem for action shots of wildlife. Think about white snow geese taking flight at the Bosque del Apache Wildlife Refuge in New Mexico. As they leave the water, they might be against dark blue water. Then they're against yellow brush-covered hillsides, and as they fly higher they appear against the light blue sky and may even pass a white cloud. The changing backgrounds keep changing the automatic exposure. However, the ambient light on the geese is constant, so the exposure changes are incorrect. This can happen with landscapes too, if you change your position. It's possible to nicely isolate a vibrant red maple tree at the peak of autumn color against a dark forest background. Use the normal technique of getting the histogram exactly where you want it. Then change the shooting angle by walking down the hill so the tree is equally and nicely isolated, but against the light blue sky. Most metering modes will automatically consider not only the tree, but also the light background, and cause underexposure of both sky and foliage.

Neither of those examples are problems for manual exposure, but autoexposure modes can snatch control from the photographer's hands and ruin an image without his awareness. This is precisely why we dislike autoexposure!

UNEVEN PANORAMA EXPOSURES

The ability to stitch digital images together has opened the world of panoramic photography to everyone. By shooting several images of a sweeping

landscape and overlapping each image by about 30%, it's quite easy to stitch them all together. This works well only if the images have identical exposures, which is only likely when using manual exposure. Suppose you use autoexposure on a panorama where one end of the scene is full of dark pine trees and the other end is light gray rocks. As you pan from one end to the other, the change in subject tonality will cause the camera to change exposure. The different exposures on the rocks and the trees may not be noticeable, but each section of the panorama will have a different sky. But you want the sky to be uniformly blue, not light on one side of the image and dark on the other. That's another reason we recommend manual exposure when shooting panoramic images!

BACK TO BEING DIPLOMATIC

We have highlighted some of our more serious objections to using autoexposure. However, we do realize that plenty (perhaps the majority) of photographers rely on autoexposure. They get fine images too, if they use their exposure compensation wisely and check the histogram after each shot. There's no right or wrong choice here. The decision to use manual or automatic exposure is entirely up to you. Only you know which way works best for you. Our choice is manual exposure and yours could be aperture priority, and we would both be right. We felt it was important to fully disclose how we meter and why. Even if you decide to use autoexposure, at least we have disclosed some of the problem situations you'll certainly and frequently encounter so you can look out for them.

COMMON EXPOSURE MISTAKES

DON'T TRUST THE CAMERA'S LCD MONITOR

Don't judge exposure by how the image looks on the LCD monitor! Trying to judge exposure by viewing the monitor is the most widespread common mistake our students make. Wouldn't you agree that the angle you use to view the monitor affects the apparent exposure of the image that's displayed? Doesn't bright ambient light make the image look darker and dim ambient light make the image look brighter? Does your camera let you adjust the monitor brightness? All of these variables make judging the exposure quality by viewing the LCD monitor virtually impossible! You must judge exposure by the histogram only! You must judge exposure by the histogram only! You must judge … Okay, okay, we've made our point.

The exposure technique we use is widely accepted by serious photographers. It's called *exposing to the right* (ETTR). If you do use ETTR, you're exposing to preserve highlight details while still giving the shadows the best possible exposure. But your images will likely appear on the camera's LCD monitor to be overexposed and washed out. They aren't overexposed if there's a good histogram, so don't let the image's appearance on the monitor scare you.

DON'T TRUST HOW THE IMAGE LOOKS ON THE COMPUTER MONITOR

Also, be careful about judging the exposure by how it looks on the computer monitor. Ambient light in the room, the brightness setting of the monitor, the overall calibration of the monitor, and its viewing angle all change the apparent exposure. In the computer, just like in the camera, you must evaluate the exposure only by histogram. In post-capture editing use the histogram that's shown in your image-editing software.

USE THE HISTOGRAM AND HIGHLIGHT ALERT

We're constantly amazed at how many photographers don't know they have these important exposure aids. Often they aren't even activated! Be sure to activate them and be certain that you know how to use them as a guide to the optimum exposure. We agree that most camera manuals (perhaps all) do a poor job of explaining the histogram and how to use it. Nevertheless, the histogram and the highlight alert are the most powerful tools available for shooting good exposures, shot after shot.

HAND-HELD METERS

For years we shot large-format cameras to make gorgeous 4×5 inch transparencies. These cameras didn't have a built-in meter, so we used hand-held spot and incident meters to make thousands of images. We often hear that a camera meter is okay, but that hand-held meters are far more reliable and accurate, especially for landscape photography. In our opinion, though, the histogram is the most accurate and reliable. Hand-held meters are expensive. You have to carry them with you and they need batteries. An incident-light meter only works when you can place the meter in the same light that illuminates the scene. If you're standing in the shade and your autumn foliage is in the

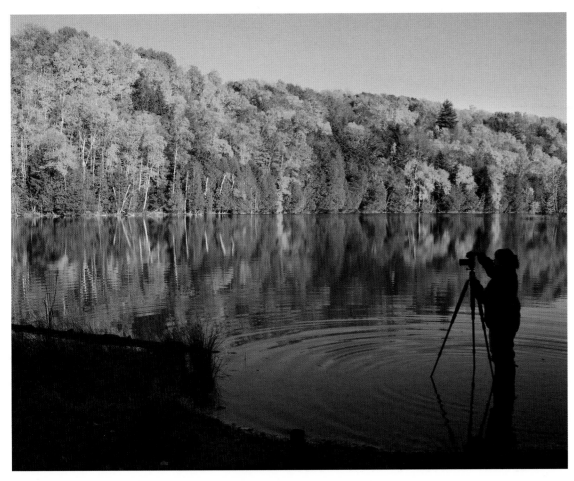

The camera's exposure meter, along with the histogram, is clearly the better way to determine a fine exposure for most landscapes. We have used many hand-held exposure meters, but there's no advantage in using them with digital landscape photography. For example, a hand-held incident light meter must be in the same light as the subject. It certainly doesn't work here as Barbara stands on the shaded side of a pond to photograph the gorgeous reflections on the other side that are nicely bathed in late afternoon golden light.

early morning light, you're out of luck. Just try to correctly expose a sunset using an incident-light meter! You can't do it. A hand-held spot meter works a little better, but if you're using devices that cost light, such as a polarizing filter or a tele-converter, you have to modify the meter reading to compensate for the light lost to these tools.

The histograms and highlight alerts of today's digital cameras make it impossible to make a serious case for hand-held meters. A hand-held spot meter does make it easy to measure the dynamic range of a scene high in contrast, but you can do the same thing with a spot meter built into the camera. If you do a lot of flash photography — and most landscape photographers don't — then a flash meter could come in handy at times. We don't understand why some feel hand-held meters are better than the camera's meter. Everyone has a choice, but we feel your money is better spent elsewhere. The meter that came with your camera is quick and precise, so use it!

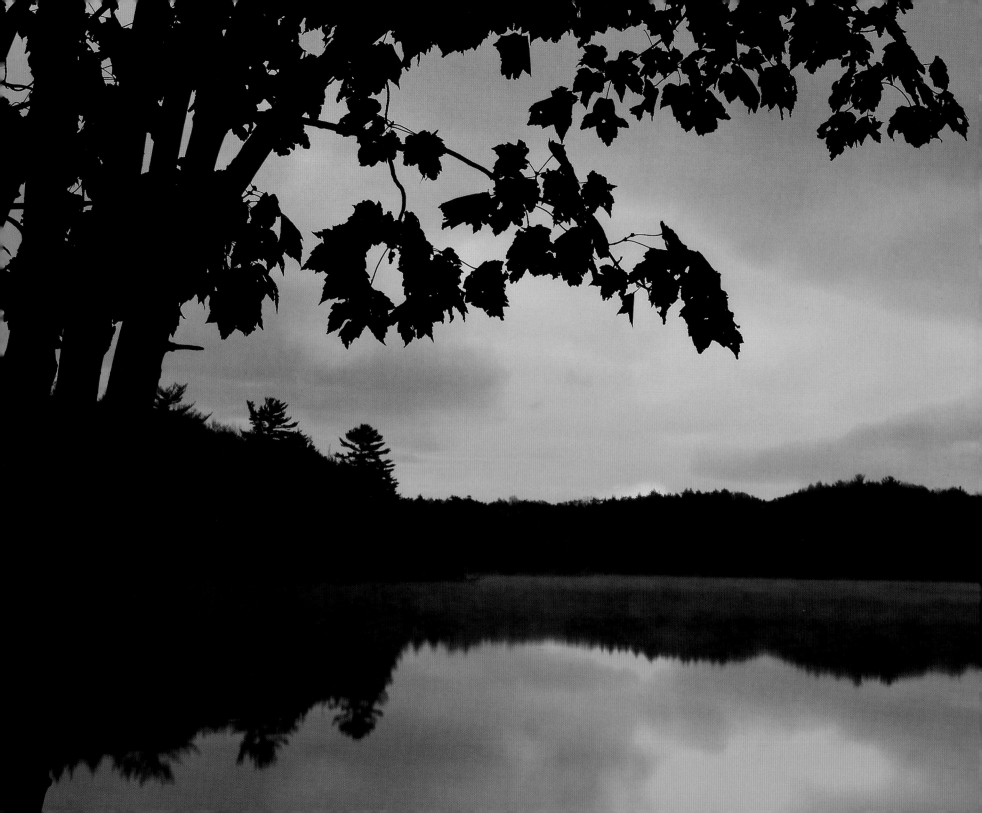

Techniques for Sharp Images

WHAT IS QUALITY?

Just what is a quality landscape image? It must be well exposed so that color, detail, and contrast make the image appealing and noise problems are reduced. It should be illuminated by an attractive and complimentary light. Good composition, pleasing perspective, and interesting viewpoint are all keys to quality landscape images. Even if all of these goals are met, most landscape images fail miserably if they aren't sharp. Fortunately, making sharp images is easy with suitable equipment and by employing excellent photographic techniques.

Let's discuss the factors and techniques that deliver superbly sharp images shot after shot. It may seem like there are many details to remember, but just make good shooting techniques an ingrained habit and it all becomes automatic! Then, you can concentrate on finding photogenic subjects and working with light and composition.

Never underestimate the extreme importance of good shooting techniques. Landscape images that aren't as sharp as they could be are a common problem for many, but it doesn't have to be that way. We realize the specialized equipment that helps everyone shoot sharp images does cost money, but for most the cost isn't so high that it's a barrier.

BUY QUALITY LENSES AND FILTERS

LENS MANUFACTURER CHOICES

All of the images in this book were taken with Nikon and Canon lenses because we shoot both systems. It's reasonable to think your camera manufacturer can produce the lenses that work best with your camera, so if the cost isn't prohibitive, consider those lenses first.

Some independent makers build lenses for several camera systems. The better known brands are Sigma, Tokina, and Tamron. We haven't used these lenses, but frequently see our workshop

The best color at sunrise may occur well before the sun actually rises above the horizon, so always be early, select your shooting location, and wait patiently for the magic to happen. These exquisite magenta colors developed 20 minutes before sunrise at Pete's Lake in northern Michigan.

students using them, and we haven't noticed any sharpness problems. They all seem to do well. We had noticed, though, that some of them aren't made as well as others, aren't as rugged, and may be less reliable in the field. However, if there's a difference in reliability, it's only a small difference when the lenses are compared to Nikon and Canon lenses, so don't be afraid to buy the independents if price limits your options. The independent makers produce lenses for several camera systems and enjoy such a large market that they can mass produce lenses to sell at significantly lower prices than Nikon and Canon.

Today's computer-aided design and manufacturing techniques make it much easier to build optically sharp lenses in the intermediate focal lengths. The widest focal lengths and longest telephoto lenses are the most difficult to produce and that's where the camera manufacturer's lenses are more likely to have the edge in overall sharpness and quality.

USE THE BEST GLASS

Most lens manufacturers make two classes of lenses. The less expensive lenses are made with good optical glass while the most expensive lenses have special low-dispersion glass elements that deliver a bit more sharpness and reduce other optical limitations. Moreover, lens makers often advertise that their better lenses benefit from magical concoctions of performance-enhancing coating technologies (e.g., Nikon's *nano technology*) to the better good of the resulting images. The manufacturers differently designate the lenses made with their best glass. As examples, Canon is calling them L lenses and Nikon uses the letters *ED* (extra low dispersion) in their lens descriptions.

BE CAREFUL ABOUT *PROTECTION* FILTERS

All too often, the camera store clerk that sells you the lens implores you to buy a skylight or UV protection filter to fit your lens. The salespeople have sad tales of woe and issue dire warnings about how the astute photographer must buy these filters to protect his new lens against abrasive sand, filthy dust, smudgy fingers, and other horrific hazards. It sounds like a fine idea, so many folks buy them. They do offer some protection, but quality suffers. Any extra glass that you add to the optical path, such as a filter or teleconverter, will cost you a bit of image quality. Furthermore, many protection filters are cheaply made and very poor in quality. The additional glass and the additional glass-to-air interfaces that you're placing in the optical path will cause a loss of sharpness, increased flare, and reduced contrast because of flare. We don't use filters solely for protection, but in rare circumstances of severe environmental conditions, such as saltwater spray or steam from a geyser, it might be an acceptable compromise.

Sometimes a single high-quality filter offers substantial benefits to an image that outweigh any negative effects. We use polarizing filters in our landscape work and we recommend that landscape shooters use polarizers or other filters. Use only the best quality, such as those made by B + W and Hoya. A polarizer will protect your lens and negate any need for additional protection. In fact, the *stacking* of multiple filters will most assuredly degrade your image.

KEEP LENS AND FILTER GLASS CLEAN

Be sure to frequently and aggressively inspect the glass surfaces of your lenses and filters. Surface grime of any kind interferes with a lens' ability to focus the light and a filter's ability to pass light, so lenses and filters must always be kept scrupulously clean. There's no point to buying an expensive piece of glass to ensure high-quality images and promptly lose that quality because dirt and smudges have taken up residence on the glass.

Lenses and filters do seem to have an affinity for dust and smudges, so prevention is the first order of business. Always store lenses and filters in a protective case when they're not in use, and always keep front and rear caps on lenses to prevent the lenses from becoming dirty or suffering catastrophic scratching.

Inspect lenses by removing protective caps and checking the front and rear glass surfaces for dust and smudges. The front glass is more likely to get dirty, but the rear glass can too, so be sure to examine both ends. We nearly always see some dust on the front of the lens, no matter how careful we've been, so we always clean the lens surfaces at least a little every time we use the lens. We've already detailed how to clean lenses in Chapter 3, so we won't discuss this important and critical process here. Remember that all glass surfaces of your lens must be perfectly clean to capture the highest quality images!

ISO CHOICES

As you know, cameras offer a choice of ISO values. For example, the Canon EOS 1D Mark III offers ISO 100 to ISO 3200 in 1/3- and 1-stop increments. If custom function 1–3 is activated, the ISO choices are expanded to ISO 50 and ISO 6400. It makes good sense to use the native ISO speed whenever possible for landscape images, but there are times when one should use other ISO choices. For example, a lower ISO, like ISO 50 on the Canon 1D Mark III, might be useful for reaching a longer shutter speed to artistically blur cascading water or wildflowers swaying in the breeze. On the other hand, you may be photographing the waves crashing on a beach at sunset and want the waves to be sharp and the entire beach to be in focus. A small aperture, like f/16, may provide the needed depth of field, and you'll need a fast shutter speed to freeze the action of the crashing waves. Pushing the ISO speed up to 400 or 800 lets you use that sort of aperture and shutter-speed combination.

While freezing or blurring the motion in a landscape image is desirable at times, the typical landscape subject isn't moving, so using the native ISO speed is a wise choice. The native ISO is usually 100 or 200, depending on the camera. Fortunately, each new generation of cameras offers reduced sensor noise and amplifier noise when used at higher ISOs. The image quality of recently introduced cameras at ISO 400 and ISO 800 and even above is absolutely amazing. This technological improvement benefits all photographers, and makes hand-held landscape photography more feasible, especially with shorter focal-length lenses. We don't advocate hand-held

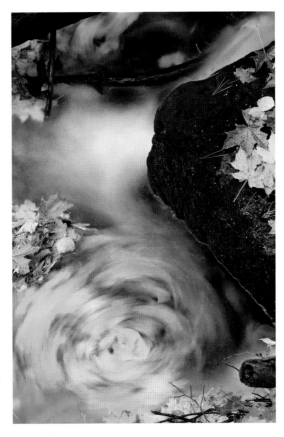

Use the native ISO speed of your sensor, or a lower ISO if your camera offers an extended range in that direction to achieve longer shutter speeds to reveal the motion of the maple leaves swirling about in a miniature whirlpool.

landscapes unless they're necessary, but we realize some folks just don't want to use a tripod.

FILE CHOICES

Your camera lets you choose the type of image files that best suits your needs. The typical choice is between RAW and JPEGs of various quality levels. We see no purpose in choosing a low resolution JPEG because that locks in low quality. While a small JPEG might be fine for Web use, so much data have been discarded when the file is compressed by the camera that making quality large prints isn't feasible. If you really don't want to use post-capture processing to make a fine print from a RAW image that contains the most data, then select the highest quality JPEG choice. You can always reduce its size later for Web or other uses.

Many cameras offer a setting so the camera records a RAW image and a high-quality JPEG at the same time. Both images have the same file number, but use a different file extension such as JPG and CR2. JPG is the JPEG and CR2 is the Canon RAW extension. We set all of our cameras to record the highest quality JPEG and RAW file for each shot. Now we have a choice of either type of file for every image we shoot. Storing two files of every image does use up more memory, be we edit ruthlessly using PhotoMechanic (www.camerabits.com), so it isn't a huge problem, especially for landscape photography where shooting speed and buffer capacity isn't crucial.

COLOR SPACE CHOICES

Your camera lets you select the color space, too. The two most likely choices are sRGB and Adobe RGB 1998. We once exclusively used Adobe RGB 1998 because it has a wider color gamut than sRGB. However, many output devices like your computer monitor, digital image projector, and the Web make images shot using sRGB look better.

On the other hand, printers such as Barbara want the wider color gamut so the Adobe RGB 1998 and ProPhoto RGB color spaces are preferred by this group to achieve the finest quality images. What color space do you select if you wish to use your images to make prints and for Web use? Here's our simple answer. We use sRGB so the image looks terrific on our camera's LCD monitor, computer monitor, and for use on our Web site. When making prints, we (actually Barbara) use the RAW file and convert it with Barbara's RAW converter of choice (Adobe Camera RAW) to Adobe RGB 1998 or sometimes the even wider color gamut of ProPhoto RGB. Now she can use sRGB when it works best and the wider color gamuts for printing. We find many photographers don't realize the color space isn't *baked* into a RAW image, but can be chosen later during the RAW conversion! Make sure you fully understand that last sentence. There's no single correct color space choice for all users, so consider your needs and make the choice. We use sRGB because we shoot both JPEG and RAW at the same time, so we have a choice of any color space we want with the RAW image.

OPTIMUM APERTURES

Let's review apertures briefly. A lens' optical path contains a device that controls the amount of light passing through a variable-size hole called the aperture. Photographers measure the amount of light that can pass through an aperture using a unit called an f-stop and frequently written as f/stop. The f/stop of a lens is its focal length divided by its aperture's diameter or, as the mathematician would say, f/stop = FL/D. Photographers usually use millimeters as the units for FL and D, but you could use inches or yards, or any other unit, as long as you use the same for both quantities. The aperture is in the denominator of the equation, so for any focal length, a smaller aperture diameter produces a larger f/stop number. And it follows that a larger aperture means a smaller f/stop number. Consider a lens with a focal length of 100 mm. If we adjust its variable aperture diameter to 25 mm, then the f/stop would be 100 mm/25 mm = 4. But, if we adjust the aperture diaphragm to a diameter of 50 mm, then the f/stop is 100 mm/50 mm = 2. In summary, the smaller numbered f/stop, f/2, is arrived at from the larger diameter 50mm aperture, which passes more light, and the larger numbered f/stop, f/4, is derived from the smaller diameter 25 mm aperture, which passes less light.

In summary, the f/stop and the aperture are closely related but aren't exactly the same thing. Try this test: Set the aperture to f/22 on a wide-angle lens, say a 24 mm lens. Now do the same on a long lens, perhaps a 300 mm lens. On each, press the camera's depth of field preview button and look through the lens at the size of the aperture. Do the apertures have the same diameter? Both are set at f/22, but as seen from this test, they have much different diameters. Apparently, the equation was right!

Another reason that the physical size of the aperture is important is that, as the hole gets smaller, a larger percentage of the light rays passing though the aperture touches its edges. This touching causes the light rays to bend, an optical phenomenon called *diffraction*, which reduces image sharpness. The smaller the aperture, the more the diffraction and the less the sharpness. That's why lens makers don't include f/45 on a 24 mm lens. Although the depth of field is huge at f/45, nothing is truly sharp because of the negative effects of diffraction.

You don't need to know the math and physics behind diffraction. It's sufficient to know it exists and how to deal with it. Lenses tend to be sharpest about two to three stops down from their wide open setting. For example, you can expect f/5.6 or f/8 to be the sharper f/stops on a 24 mm f/2.8 lens. F/5.6 is two stops down from f/2.8 and f/8 is three stops down. The f/2.8 setting isn't quite as sharp as f/8 due to some other optical limitations, such as spherical and chromatic aberration. Larger f-numbers, such as f/16 and especially f/22, are less sharp because of diffraction. The photographer can achieve improved sharpness by using the *sweet apertures*, which are those two or three stops down from the maximum aperture whenever there's no compelling reason to use other apertures. For example, there may be times when you wish to use selective focus techniques, so go ahead and shoot wide open at, say, f/2.8. There may be some loss of quality, especially around the edges of the image, but you still have a nice image. If you need great depth of field, use f/16. The results are probably more than satisfactory for your (and our) needs. Use f/22 only if you really need more depth of field to adequately cover the scene. The negative effects of diffraction can be serious when the lens is stopped all the way down, especially with wide-angle lenses.

Remember that the physical size of the aperture is larger at f/22 with a 300 mm lens than with a 24 mm lens. At f/22 a 300 mm lens has an

aperture of about 14 mm diameter and the 24 mm lens has an aperture of only about 1 mm diameter. Therefore, as a guideline, you're safe to use f/22 for landscapes where the focal length is 100 mm or greater because the diffraction isn't so serious. With shorter lenses, consider f/16 as your smallest aperture unless there's an overriding reason to stop down more. Great depth of field is often desirable, especially in landscape photography. However, if your subject doesn't demand the depth of field offered by f/16 or f/22, then use the more intermediate and sharper apertures of f/8 and f/11.

TRIPODS

WHY YOU NEED TO USE A TRIPOD

Serious landscape photographers must use a tripod whenever possible. The tripod is indispensable for shooting sharp images and opens up a world of image possibilities. A good tripod supports the camera and lens and holds them perfectly still, thus allowing utilization of all shutter speeds and f/stops in your pursuit of excellent images. Some photographers pride themselves on never using a tripod, thinking they can hand-hold while still getting sharp images. It's true. You can hand-hold wide-angle lenses and shoot them using high shutter speeds and high ISOs in bright light, but as an exclusive procedure this needlessly limits your possibilities.

Many attractive landscapes are illuminated by soft light just before sunrise or after sunset, and longer shutter speeds are needed to capture such an image. It's impossible to shoot a truly sharp image hand-held with a one-second exposure using almost any lens, much less a more likely 100 mm or 300 mm lens. We frequently shoot artistic images of waterfalls, using wide-angle lenses and exposure times measured in several seconds. We like the cascading silky smooth and blurred water surrounded by sharply focused rocks and trees. You could make everything in this situation blurred by hand-holding the camera, but a tripod offers the choice of having some sharp image elements.

Admittedly, tripods slow you down while adding weight to carry. The slowing may be problematic in some situations, but as well as offering sharpness, it's a tremendous boon to good composition! The tripod holds the camera still and lets one carefully study the image in the viewfinder, making it easy to fine-tune the composition. Hand-held shooting is hampered by an always changing composition and the photographer's often unconscious tendency to shoot right now and get it over with. But the hand-held camera is nearly impossible to hold perfectly still, and the composition continuously wiggles. Any rifle shooter who has used telescopic sights knows how much those crosshairs wobble about the target, no matter how careful he may be. The same is true of your camera.

Landscape photographers must often wait for the good light to develop or reappear, and it's far easier for a tripod, not a photographer, to support the camera gear while waiting. Sometimes it's necessary to wait for the optimal moment to fire the camera — even in landscape photography. Suppose you're waiting for a huge wave to crash onto a beautiful rock along the shoreline. The easiest method is to compose the image on the tripod, watch for the approaching wave, and then use a remote release to trip the camera at the peak of the action — all without having to peer through the viewfinder. Further, the tripod frees your hands so it's much easier to use a reflector or an electronic flash to light up the foreground.

FEATURES OF AN EXCELLENT TRIPOD

1. An excellent tripod will be high enough that the viewfinder of your mounted camera reaches your eye level when the tripod legs are extended, but without raising the centerpost. Raising the camera to eye level by elevating the centerpost makes the whole system less stable and reduces image sharpness, or as one famous photographer noted, merely places a monopod on top of your tripod.

2. An excellent tripod has legs than can be independently locked at different angles, so the tripod can easily be used on uneven ground, such as a rocky hillside.

3. An excellent tripod has legs that can spread out flat, getting the camera as close to the ground as possible. The tripod has no center bracing system and no centerpost. This flat-to-the-ground requirement is important for making those wonderful wide-angle landscapes where the camera is close to the foreground, often giving an appealing viewpoint. It's also a boon to the macro photographer shooting mushrooms, flowers, insects, and other subjects close to the ground.

4. An excellent tripod that's both sturdy and lightweight is a contradiction and just doesn't exist. Many small tripods are so unstable that shooting quality images is almost impossible.

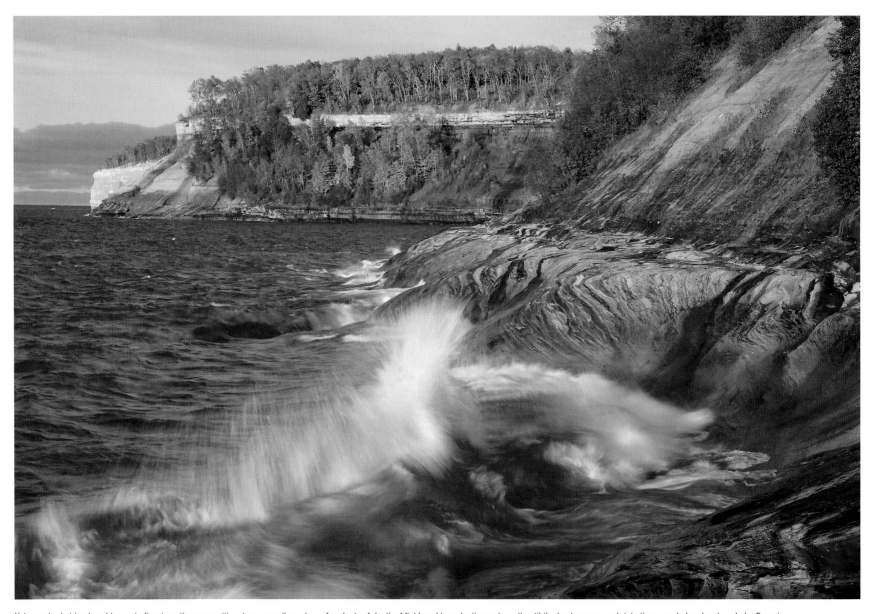

Using a sturdy tripod enables us to fine-tune the composition, to use small apertures for plenty of depth of field, and to make it easy to wait until the best waves crash into these eroded rocks along Lake Superior.

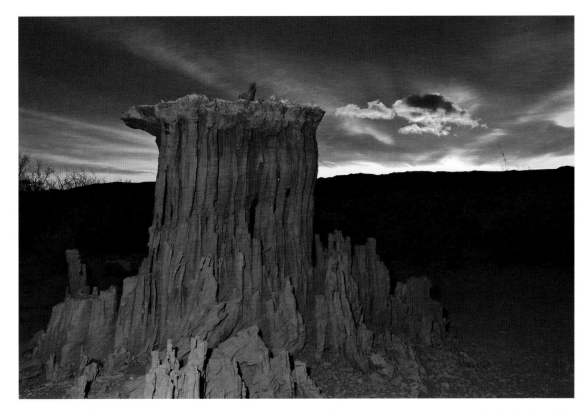

The tripod holds our camera perfectly still while we use one hand to gently press the cable release and the other hand holds the flash in the best position. This fragile sand tufa is found along the shores of Mono Lake.

Those tripods are worthless. However, a tripod that's so heavy that you don't bother to take it with you is equally worthless. The best tripod is the sturdiest one you can afford that you're willing and able to carry. Modern materials, such as carbon fiber and boron, although relatively expensive, allow very sturdy tripods that are actually lighter than less sturdy tripods of traditional steel or aluminum construction. Plan your camera system recognizing many writers' opinions that the most important single accessory a photographer can own is a fine tripod.

TRIPOD RECOMMENDATIONS

We see mainly Manfrotto (Bogen) and Gitzo tripods in our workshops, and both brands offer models that are excellent for landscape photography. Most professional and advanced amateur nature photographers use Gitzo tripods, and throughout our entire careers so have we. The less expensive Bogen-Manfrotto Model 3221 and its several variants have been very popular with nature photographers for decades. The Gitzo 1340 model is perfect for landscape photographers and we used it for years. In 2005, we upgraded to the similar, but more expensive, G1325 CF Studex 3 carbon fiber tripod. This carbon fiber tripod is sturdier and lighter than the Gitzo 1340, and the leg locks are a tiny bit easier to work, but it's about twice as expensive. Tripods are constantly upgraded and their model numbers frequently change, so watch for discontinued and new models.

TRIPOD HEAD RECOMMENDATIONS

Pan-Tilt Heads

The pan-tilt head has three controls allowing easy and independent adjustment of each of three axes of camera movement. Those axes are a side-to-side rolling motion, an up-and-down vertical tilt, and a side-to-side panning motion of changing azimuth. The airplane pilot would call those axes *roll*, *pitch*, and *yaw*. The pan-tilt head's ability to independently adjust each axis allows a more precise positioning of the camera than some other heads, specifically the single-control ball head. Another advantage of the pan-tilt head over the popular ball head is that the pan-tilt makes it easier to shoot vertical panoramas. To put some frosting on the pan-tilt cake, a good pan-tilt head is far less expensive than a good ball head. With all that said, we don't like pan-tilt heads, even though some photographers do. We think that pan-tilt heads have too many awkward-to-use handles, and occasionally

one pokes you in the eye when you're trying to look through the viewfinder.

Ball Heads

We love sturdy ball heads and have used them exclusively for the past 20 years. A good ball head lets you use only one control to tilt the camera in all directions and to pan. No handles are poking you anywhere! They're very efficient, making it easy to rapidly compose the landscape image. Nearly every professional nature photographer we know, and most advanced amateurs, use ball heads. Excellent ball heads are made by Kirk Enterprises of Angola, Indiana, and Really Right Stuff of San Luis Obispo, California. We use Kirk ball heads. Kirk offers the robust BH-1 and the smaller BH-3. If you plan to do any landscape photography with a super telephoto lens such as the Canon 500 mm f/4, then you need the larger BH-1. Most landscape photographers don't use big and heavy lenses for landscape work, so the smaller, more affordable, and easier to carry BH-3 is all that's needed. The Really Right Stuff ball head is terrific too, but size for size, the most expensive of the bunch. No matter what ball head you buy, be sure it has a second control for precisely panning the camera. A separate pan control is virtually essential when shooting multiple images for later assembly into a wide-view panorama.

QUICK-RELEASE PLATES AND L-PLATES

ADVANTAGES

These devices speed up mounting the camera, or a lens with a tripod collar, to the tripod head. The ability to move rapidly with a minimum of fuss makes photographing more enjoyable and helps you capture superb landscape images when spectacular but fleeting light suddenly appears. Quick-release plates come in different sizes and styles for a variety of tripod heads. Make sure any plate or L-plate you buy is compatible with your tripod head.

Speaking of mountings, here's a common mistake: The camera with a mounting plate is attached to the tripod. Hanging from the camera is a big heavy lens with an unused tripod collar and its own mounting plate floating unused in space. This configuration begs for camera wiggle and fuzzy images! If you don't believe us, ask your pal the architect about *cantilever beams*. Bottom line? If a lens has a tripod collar, it's nearly always better to mount the lens to the tripod and let the camera hang from the lens.

UNIVERSAL QUICK-RELEASE PLATES

These plates are made to fit all cameras and tripod collars. They come in specific styles to work with a variety of quick-release designs. While it sounds appealing to buy plates that work on all of your cameras and lenses and any you might own in the future, it's best to avoid them. Unfortunately, universal plates don't seem to work perfectly with anything. Universal plates often become loose, so they require frequent tightening. Constant tightening implies constant looseness, which is no help to your never-ending quest for sharp images. The incessant tightening is inefficient too, and will annoy you time and time again. Also, you might attach a universal plate to the bottom of the camera and everything seems to work fine right up until the time your battery fails. Then you discover the plate has to be removed before you can replace the battery. Sometimes the plate covers up an important button you need to use. When some universal plates are attached to the tripod collar on the lens, it becomes impossible to rotate the camera to the vertical position. These plates might work well for some equipment and for some photographers, but the vast majority of serious photographers use custom plates.

CUSTOM QUICK-RELEASE PLATES

Custom plates are those designed for specific cameras and specific lenses. They'll stay tight unless you use the correct tool, generally an Allen wrench, to loosen them. These custom plates allow access to all of the camera's buttons, dials, and batteries without having to be removed first. They're not much more expensive than universal plates, so don't scrimp on price. Contact Kirk Enterprises or Really Right Stuff and tell them what camera or lens you're equipping. They'll tell you the model number and cost of the custom plate for your application. We use custom quick-release plates on all of our cameras and on all of our lenses having a tripod collar.

L-PLATES

These specialized quick-release plates are enormously helpful to landscape photographers. As its name suggests, the plate looks like the letter L, and each leg of the L is a quick-release plate. These plates are used on camera bodies. Attach the

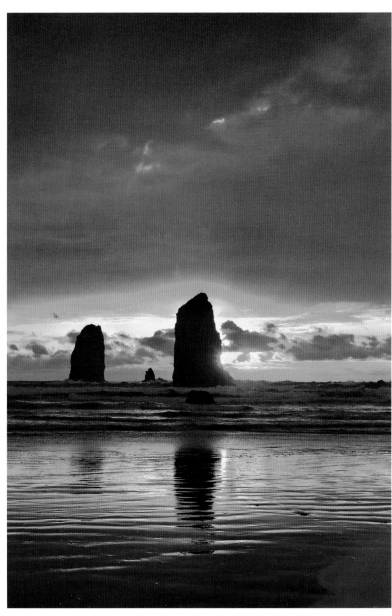

(a)

(b)

(a, b) Most landscapes suggest right away if they work best as a horizontal or vertical image. The camera captures more color as a horizontal image, but the more vertical sea stacks along the Oregon coast do suggest a vertical composition, too. Expand your compositional skills by always trying to compose every landscape image both ways.

L-plate to your camera and leave it there. A custom L-plate should allow access to everything on the camera without having to first remove it. Shoot horizontal compositions by sliding the L-plate leg on the bottom of the camera into the tripod's quick-release clamp, and securely tighten the clamp. Now you're ready for a horizontal composition.

Shooting verticals is easy with an L-plate. Don't flop the camera over to the side on the tripod head,

because even though everything is tight, gravity tends to pull the camera down, especially when a heavy lens is attached. Also, the center of gravity of your camera and lens is off to one side instead of over the center of the tripod, resulting in a greater susceptibility to vibration and loss of image sharpness.

Instead, loosen the quick-release clamp, slide the camera out, and use the other leg of the L-plate

to remount the camera on the tripod head. Now the camera and lens remain over the center of the tripod, eliminating the gravity problem, providing a more stable support, and making it easier to look through the viewfinder. Once again, call Kirk Enterprises or Really Right Stuff to find out if an L-plate is made for your camera. These fine companies build lots of L-plates, other quick release-plates, and clamps, so the odds are good they'll have a model for any popular camera or lens.

ENVIRONMENTAL PROBLEMS FOR TRIPODS

WIND

Just because the camera or lens is mounted securely to a tripod doesn't mean the images will be sharp. Wind can make it very difficult to shoot sharp images so, if possible, avoid shooting in the wind. Many photographers underestimate the negative effects of wind. Here's a test: In a wind gusting to 10 mph or more, mount your camera and a medium or long focal-length lens on a tripod and carefully focus on a subject having visible detail. Without touching tripod or camera, watch through the viewfinder while the wind is blowing. You'll be able to see the image vibrating and, if you were to shoot in such conditions, you'd likely have soft images.

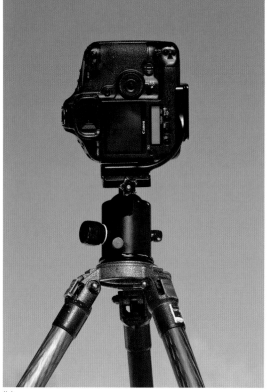

(a) (b)

(a, b) Tremendous light on the landscape is often fleeting. At times you must be fast! Using equipment that helps you be efficient is crucial. All landscape photographers benefit greatly by using L-plates on their camera bodies to switch from horizontal to vertical compositions and vice versa. It's so much easier to shoot a vertical by using the L-plate, rather than flopping the camera off to the side of the tripod head. Do yourself a huge favor and get L-plates for your camera from Kirk Enterprises or Really Right Stuff.

WIND TECHNIQUE

If circumstances require that you photograph in the wind, there are techniques that reduce the problems. Can you find another shooting angle behind some trees, a cliff, or perhaps a building to block the wind? We find it's frequently effective to *hide* from the wind by shooting from the calm side of a large object. But be careful in selecting your hiding place! We once moved to the calm side of a high sand dune, but the wind-blown sand raining down from the sky soon drove us out.

Here's an effective technique if you must shoot in the wind. Use a tripod to hold the camera as still as possible. Hang on to the camera with both hands and press down, adding some of your body mass to the tripod. This eliminates a lot of wind vibration, but not all. Don't use a self-timer or cable release to trip the shutter. Instead, use your finger. Apply the reciprocity principle to favor a higher shutter speed over depth of field, and consider raising the ISO to the highest speed acceptable for your image. Focus carefully and wait for a lull in the wind. If no lull is forthcoming, shoot multiple images of the same thing, hoping that one or more are acceptably sharp. Try placing the tripod as low to the ground as possible to reduce the surface area of the tripod so the wind is less troublesome. We usually don't use Canon's image-stabilization or Nikon's vibration reduction when shooting on a tripod during calm days, but they can be very helpful in a gusty wind.

SNOW

Tripods can be very unstable in soft, deep snow. The legs tend to bow out when pushed into the snow which, by the way, might damage them, and the tripod is very susceptible to vibration if its legs aren't on a solid base. In deep, powdery snow try hand-holding with short focal-length lenses favoring higher shutter speeds such as 1/125 second or more. To use the tripod, try stomping down the snow to make a solid base. We often use snowmobiles to reach photogenic spots. Driving the snowmobile in a small circle about three times on the same track makes it less likely the snowmobile will get stuck and more likely that our tripods will be well supported.

SOFT GROUND

Sometimes landscape photography must be done in boggy places where the ground is soft. Find the firmest ground and spread the tripod legs out a bit farther than normal. Gently push the fully extended lower legs into the soil until they're more stable. Don't walk around too much either, because you want the ground to remain as firm as possible to keep the tripod from shifting about and causing instability of your composition and focus.

MOVING WATER

Running water and lapping waves easily vibrate your tripod making sharp images very difficult to shoot. So, you should keep tripod legs out of moving water whenever possible. If you like to set up in the middle of a stream (we do), find a quiet place in the stream where the water is barely moving. Perhaps there's an area of calm water just behind a log or large rock. Often, if you're careful, it's possible to set the tripod up so that each foot is actually on a rock, log, or some other solid object, and the legs aren't immersed in moving water. If you must shoot in fast-moving water, use the above-mentioned high wind technique for best results.

TRIPPING THE SHUTTER

HAND-HOLDING

Try to ensure high image quality by always striving to avoid hand-held shooting. This is especially true of landscape photography where, in most scenes, everything from the near foreground to the far background should be in sharp focus. It's common practice to shoot at f/16 or smaller to achieve these great depths of field, but that in turn demands lower shutter speeds, which makes hand-held shooting more troublesome. Consequently, we try to avoid hand-held shooting, but it's sometimes necessary. Hand-held shooting techniques are always used to photograph, for example, Antarctic icebergs from bobbing ice-encrusted Zodiacs and northern Michigan fall color scenes from a drifting kayak.

It may be necessary to shoot hand-held when using extreme wide-angle lenses from some viewing platforms, such as the one at the top of the famous Miner's Castle in northern Michigan. On that platform it's impossible to position a tripod-mounted camera a foot or so over the railing to keep the platform from intruding into your image, so a tripod is out!

Hand-held photography requires being as still as possible at the instant the image is shot. Camera movement reduces sharpness and degrades the image. We can't stress this enough!

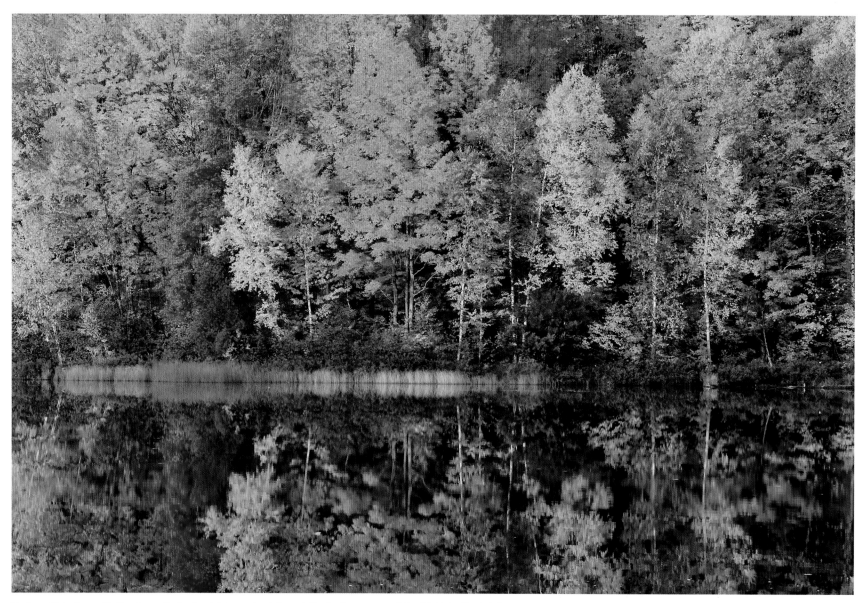

Photographing autumn reflections from a floating kayak is tremendously fun and effective if you use superb hand-held shooting techniques.

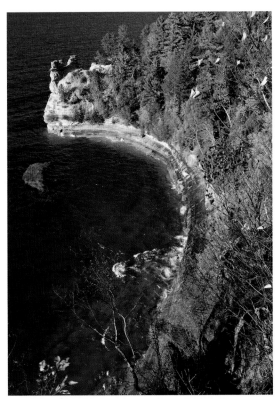

It's necessary to shoot hand-held to capture this view of Miner's Castle, Michigan's most famous rock. A super-wide-angle lens is needed to make this composition, so to keep the viewing platform's railing out of the image is virtually impossible if the camera is mounted atop a tripod. Instead, choose a bit higher shutter speed such as 1/60 second with 20 mm lens and rest your elbows on the railing to steady the camera.

I (John) did some state competition target shooting as a Michigan teenager. I used a .22 rifle with peep sights and, even when in the very stable prone position and using a tight sling, properly holding my breath, and carefully squeezing the trigger, it was amazing how much the gun sights wandered around the bull's-eye. Your camera wanders, too, a lot more than you realize, causing unsharp images. The hand-holding shooter must religiously concentrate on holding very still.

USING GOOD TECHNIQUES FOR HAND-HOLDING

- Use any nearby steady object to brace your camera, such as a tree, fence post, railing, car hood, or even a non-drinking friend. Any makeshift alternative to your tripod helps a lot.
- Use your camera's image stabilization, if available. Now's the time to use it!
- Use higher ISOs to allow higher shutter speeds.
- Use larger apertures to allow higher shutter speeds, trading off some depth of field.
- Use a stable stance, feet apart, firmly planted, and your elbows held tightly against your body.
- Use good breathing techniques. Take in a deep breath, let half of it out, and hold the remainder.
- Use the shutter button in a smooth and gentle motion. Better, some shutter buttons can be activated by a rolling motion of the finger rather than a pushing motion.

SHUTTER SPEED GUIDELINE

The rule of thumb for hand-holding is that one can achieve an acceptably sharp image at shutter speeds equal to or faster than 1/lens focal length. The reasonably steady shooter using a 200mm lens, for example, is probably safe at shutter speeds of 1/200 second or faster. Likewise, using a 24mm lens would require a shutter speed of 1/25 second or faster. Image-stabilization advertisements claim an advantage of at least two stops of shutter speed. Accordingly, one using an image-stabilized 200 mm lens could find equivalent sharpness at 1/50 second.

We're conservative folks, though, and suggest that, if you need critical sharpness, the original guideline of 1/(focal length) should be observed even with image-stabilization.

CABLE OR REMOTE RELEASE

The cable release is a mechanical device comprising a metal sheath and a stiff inner wire. The device has a push button on one end and a plunger on the other. It's screwed to the camera, and to trip the shutter, the photographer pushes on the button and the plunger operates the camera. Modern cameras use an electrical release. The electrical release comprises a hand-held push button connected to an insulated flexible wire, the other end of which has a connector that mates to the camera body. Regardless of the differences, electrical releases are generally called *cable releases*.

A remote release does the same thing as a cable release, but isn't attached to the camera. It uses radio or infrared signals to fire the camera. These releases work well because your quivering and fluttering hand is separated from the camera, thereby greatly increasing your chances of capturing a truly sharp image.

Cable releases are especially good when you're trying to capture the peak of the action. It's true that most landscapes are static with little to no action. However, certain images, such as a huge wave exploding into a rocky shoreline, do require timing to capture the peak of the action. Anytime you must catch the decisive moment always use a cable release, because it's easier to trip the shutter at precisely the peak moment.

Watch out for this problem though: Many cable releases have a lock position for shooting long time exposures. Set the camera to bulb and press the cable release to trip the shutter and lock it, and the shutter will stay open for as long as you keep the cable released locked. Unfortunately, this lock option is easy to set accidently. If you find you have lost control of your camera when you're using the cable release, always check to see if you unknowingly locked it. This happens frequently to our students, so be alert to it.

SELF-TIMER

Most cameras have a self-timer. This is extremely useful in landscape photography. The default setting for most self-timers is about 10 seconds, which is enough time to get yourself into the image, too, but way too much time if you want to use it to trip the shutter instead of using your finger or a cable release. Fortunately, many cameras let you adjust the duration of the timer. Two seconds is a much better choice for static landscapes where you aren't trying to catch the peak of the action. Gently push the shutter and remove your finger. The camera counts down 2-seconds, during which the vibration caused by your touching the camera dissipates, and then the camera makes a sharp image. Using the self-timer is efficient and effective. We use this strategy whenever possible, which is most of the time! Using the self-timer eliminates the need to attach or use a remote triggering device. Dangling cable releases often get in the way, so this nuisance is eliminated with the self-timer shooting technique.

MIRROR LOCKUP

Many cameras offer a mirror lockup feature that raises and locks the mirror before the shutter opens. The purpose is to prevent vibration caused by the moving mirror from interfering with image sharpness by eliminating vibration caused by mirror movement during the exposure. The effects of an unlocked mirror's vibration are most noticeable at shutter speeds between 1/4 and 1/60 second. Mirror-induced vibration isn't a problem at faster or slower shutter speeds. Why? Mirror vibration and the resulting camera shake occur for a certain length of time. If the shutter speed is fast enough, the shutter opens and closes before the camera can move sufficiently to cause image softness. If the shutter speed is slow enough, then the time the camera is shaking is just a small part of the exposure, and no image softness is detectable. So, fast is okay and slow is okay, but in-between is a problem, hence the recommendation above.

Many cameras don't have mirror lockup. If your camera doesn't, then avoid shooting images in the 1/4 to 1/60 second range for optimum sharpness. If it is capable of mirror lockup, you usually activate it by turning a switch on the camera body or setting it with a custom function.

FOCUSING TECHNIQUES

DIOPTER ADJUSTMENT

Most cameras have an adjustment to ensure that the viewfinder is properly set for the user's eyesight. It's called a *diopter control*. It doesn't affect how the eventual image is focused on the sensor, only how the scene appears to the photographer's eye. Adjust the diopter control by first removing the lens to eliminate the distraction of an image in the viewfinder. Then, with the body cap off, point the camera at a bright surface and look through the viewfinder at the lines on the viewing screen. Lastly, adjust the diopter control so that the lines are as sharp as possible. If no position of the diopter control produces sharp lines, find out whether your camera maker offers diopter-correction eyepieces for your viewfinder. Your optometrist can help you determine which such eyepiece might correct the problem. Always make sure your viewfinder is perfectly adjusted for your vision! It makes a world of difference when using manual focusing.

MANUAL FOCUSING

Most of us over forty remember when cameras were only focused manually. Many viewfinders incorporated aids to help us focus the camera. Manual-focus cameras still exist, but autofocus is by far the norm with modern equipment. Still, if you have good eyesight and work carefully, manual focusing works well. Indeed, if you're shooting a landscape in heavy snowfall or fog, you're forced to use manual focus because autofocus can be rendered useless where there is little contrast. Some modern lenses, such as the Nikon and Canon tilt-shift lenses, don't offer autofocus, so they must be manually focused, too.

For us mere mortals over forty, autofocus is far faster and more accurate than manual focusing. Both of your authors still have good vision, but we prefer autofocus anytime it works, which in

landscape photography is most of the time. That said, a few of today's cameras offer what's called *live view*, a feature allowing pre-shooting display of the intended image on the camera's LCD monitor. This display can be highly magnified in some cameras, allowing selected portions of the image to be closely scrutinized while manually adjusting the focus. This procedure eliminates many operational variables and tolerances of the autofocus system, and can achieve an extremely critical manual focus.

HYPERFOCAL FOCUSING

Landscape photographers sometimes use the *hyperfocal distance* characteristic of a lens to maximize the zone of sharpness in an image. *A lens set to its hyperfocal distance is acceptably sharp from one-half that distance all the way to infinity.* The hyperfocal distance of a lens is determined primarily by its focal length and its aperture, so it varies with aperture changes. Lenses of yesteryear had hyperfocal distance scales engraved or silk-screened on the lens barrels, and could be easily set to their hyperfocal distance. Regrettably, most modern lenses don't have those scales. However, hyperfocal distances can easily be determined from a proper chart readily downloaded from the Internet (e.g., www.cambridgeincolour.com/tutorials/hyperfocal-distance.htm). Here's how to use this useful principle: Assume a nice landscape with a splendid wildflower only 6 feet in front of us, a tree with an eagle at 100 feet, and a nice mountain on the horizon. Also assume you'll be using a 28 mm lens. Your chart says that a 28 mm lens, at an aperture of f/11, has a hyperfocal distance of about 8 feet. So, using f/11, you set the lens' distance scale to eight feet, and you know that *everything from four feet all the way to infinity will be in focus*! What should you focus on? Nothing! Don't even bother! Just point, compose, and shoot!

We use a different strategy now for adjusting the zone of focus, a strategy that takes advantage of the live view capabilities of several modern cameras. Remember our scene that has a flower in the foreground and a mountain on the horizon. We don't want to focus on the mountain because the depth of field will likely not include the flower. Conversely, we don't focus on the flower or we'd end up with a fuzzy mountain. We solve the problem this way: We initially focus on something, anything, that's about 10 or 20 feet into the scene. We activate our live view display to see the scene on

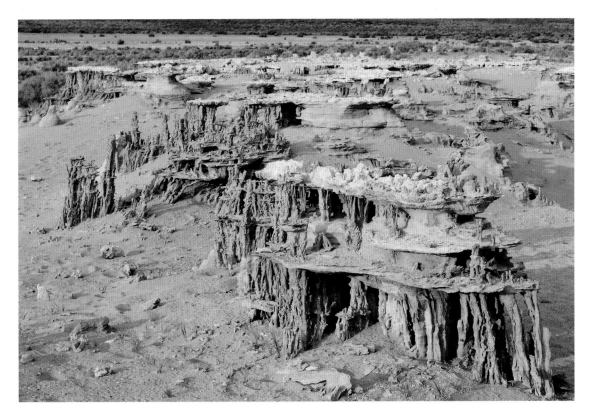

This group of delicate sand tufas at Mono Lake is sharply rendered by using f/16 for good depth of field, a 2-second self-timer to trip the shutter, mirror lockup, and a 45mm Canon T/S lens to rotate the plane of the sharpest focus through the tufas. By the way, the Canon and Nikon tilt-shift lenses don't have autofocus, so they must be focused manually with extreme care.

our bright LCD monitor screen. Then, we press our depth-of-field preview button to inspect the zone of focus while at the shooting aperture. Finally, we manually adjust the focusing to ensure that the zone of focus encompasses both flower and mountain. Although the lens is stopped down to the shooting aperture, say f/16, the live view display remains bright (unlike the viewfinder image), so it's easy to see how the depth of field covers the scene.

SINGLE AND CONTINUOUS AUTOFOCUSING

Cameras offer two, and sometimes more, focusing modes. They're called by various names, but the main two are generally called something like *single autofocus* and *continuous autofocus*. Single auto-focusing is used for subjects that aren't moving which, of course, includes most landscape subjects. With single autofocusing, one presses the shutter button half-way down and the camera establishes focus on whatever subject matter is within the selected focus brackets. The focus remains locked there, even if the subject moves, until the shutter button is released and pressed again.

Continuous autofocus is especially valuable for moving subjects. Suppose you point the selected focus brackets at a sprinting cheetah. You press the shutter button half-way down, the camera promptly focuses on the cheetah, and the camera remains in focus even as the cheetah's distance is changing. Most landscapes don't gallop around very much, but a wandering fast-moving tornado can easily be considered a landscape.

This Alabama Hills sunrise can confuse a camera set on autofocus. Many cameras that have the autofocus controlled by the shutter button won't fire if the activated autofocus point isn't on an object that's in focus because it's designed for focus priority. Therefore, we set our camera to back-button focusing and continuous autofocus, which is release priority. Then we point the single autofocus point that we have activated at the top of the lower right-hand rock so the point overlaps the bright sky and the black rock. The camera detects contrast between the sky and the rock and focuses precisely on the rock. Then we compose the scene as you see here and use a cable release or self-timer to trip the shutter.

Single autofocus, then, seems like it would be the most useful mode for landscape photography, but it depends on the camera. Some cameras, set to their single autofocus option, operate in a *focus priority* mode and refuse to shoot the image if the subject matter within the selected autofocus brackets isn't in focus. Fortunately, though, some of those cameras also have a custom function that can change the camera to a *release priority* mode in which the image will be shot upon pressing the shutter button irrespective of whether the active autofocus bracket or brackets are in focus.

If our camera can't be changed to release priority, we set the camera to continuous autofocus — even when shooting static landscapes. Most cameras, when in continuous mode, use release priority so you can shoot even if the subject matter within the selected autofocus brackets isn't in focus.

MULTIPLE AUTOFOCUS POINTS

Modern DSLRs have several *points* in the viewfinder that control focusing. (A point is the term Nikon and Canon use for a small rectangle that contains the subject matter being focused on.) As an example, John's Canon 1Ds Mark II has 45 selectable autofocus (AF) points distributed across the image in the viewfinder. All 45 points are activated in the camera's default state, but one or more can selectively be activated by the camera's various buttons and custom functions. Less expensive cameras often have fewer AF points. The Canon 40D, for example, has only nine, yet nine or some other small number of AF points is more than sufficient for landscape photography.

Multiple AF points are an enormous help when photographing fast-moving subjects, such as leaping deer or soaring birds, and dramatically increase

your chances of a sharply focused image. However, in landscape photography, we have never found any benefit from multiple focus points, so we deactivate all but the middle one. A single focus point fixed in the center of the viewfinder is easier to find quickly, and is often intrinsically more accurate than some of the *outlying* focus points.

Most landscapes have depth, and you can select a specific area or item that you want in sharpest focus. For example, it makes sense to focus on the cone of a geyser or on the trunks of white birch trees that are reflecting in foreground water. Wildlife photographers almost religiously focus on an animal's eye. As a landscape photographer, you might want to focus on that part of a sand dune that's 10 or 20 feet in front of you to optimize placement of your zone of focus. In those examples, multiple activated AF points might allow the camera to focus on some different but unwanted

part of the scene so you can well benefit from the fast, easy, and precise focusing that's offered by using a single AF point.

PROBLEMS WITH AUTOFOCUS

Automation offers many benefits but can also create problems. Autofocusing, for example, is fast and can be precise but must be carefully controlled by the photographer. As an example, let's use a wonderful scene in the famous *wave* that lies in Paria Canyon west of Page, Arizona. We'll use our Canon 17–40 mm lens, zoomed out to about 20 mm, and compose a vertical image. We set the lens to f/16 and, using a single AF point in the center of the viewfinder, we focus on a rock about 10 feet into the foreground. Focusing 10 feet or so into the frame optimizes placement of the zone of focus so that it's most likely to extend from the near foreground to the clouds in the background. We didn't use f/22 because of the greater diffraction-induced loss of sharpness that occurs in wide-angle lenses used at smaller apertures.

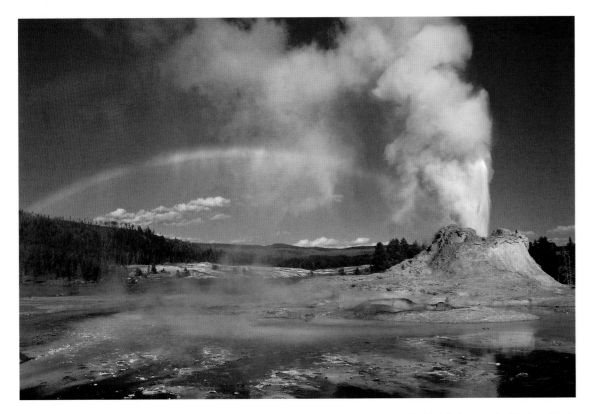

We don't have any use for activating multiple AF points in landscape photography. When there are many solid objects in the scene like this view of Castle Geyser, how does the camera know what should be the most sharply focused? Use back-button focusing to precisely focus on the cone of the geyser.

We support the camera on a sturdy tripod, aim the selected AF point at the rock 10 feet away, and press the shutter button half-way down to cause the camera to acquire focus. Aiming the camera at that rock gave good placement of the zone of focus, but gave an unacceptably poor composition, so we must recompose. Now we have an attractive composition, but the selected AF point is aimed at some insignificant rock in mid-scene, perhaps 100 feet away. We press the shutter button or cable release to record the image. But wait! The camera just refocused! This time, though, it focused on

that meaningless rock. Our careful placement of the zone of focus was just nullified, and now we have an attractive composition spoiled by a fuzzy foreground. We need a way to prevent the camera from autofocusing when we don't want it to.

One solution is to switch the camera from auto-focus to manual focus just before releasing the shutter, but that's an ongoing nuisance. Another solution favored by some photographers is activating several AF points, hoping that a selectable AF point covers a suitable focus target, in this case the foreground rock. That, too, is a pain because, far more often than not, none do, and there's no suitable focus target under any AF point. Consider a wide expanse of still water, such as the early morning surface of a calm lake. The always present rock is 10 feet in front of you, and there's a pretty loon at 100 feet. You focus on the rock, but when you recompose to include both rock and loon, no AF point is anywhere near the rock. They're all pointed at still water and, with no suitable target, a push of the shutter button just causes the camera to aimlessly *hunt* for focus.

To the rescue comes a great scheme for removing autofocus control from the camera and giving control to the photographer. This scheme is called *back-button focus* and, because you're one of our favorite readers, we're going to reveal it to you.

THE POWER OF BACK-BUTTON FOCUSING

Almost every digital camera we've seen offers a little known feature that gives full control of autofocus initiation to the user. We call it *back-button focusing*, a self-descriptive name. However, we

This aspen scene is easy to photograph. Stop down to f/16 and try some shots at f/22 because there's a lot of depth between the foreground rocks and the trees across the lake. Back-button focus on the rocks making sure the activated autofocus point is partially on the light yellow reflection and the black rock. Use a self-timer or cable release to trip the shutter. Determine the exposure using the histogram to guide you.

haven't seen any camera manual using this term, so one would have to hunt around to find it. Sadly, camera manuals describe this option so poorly that it's hard to understand what it does, let alone why or how to use it. Nearly every Canon and Nikon DSLR can activate back-button focusing by using a custom function. Unfortunately, at least with Canons, the number of that custom function varies model to model. Nikon can be troublesome, too,

because some models use a menu selection and others use a custom function. Still, learning how to set back-button focusing on your camera is well worth the effort. Back-button focusing gives efficient and precise control over autofocus, and we use this powerful technique for all of our autofocus shooting — everything from landscapes to wildlife, but not close-ups. It's inapplicable, of course, to manual focusing.

We will continue to use the term back-button focusing until such time as the marketing mavens at Canon and Nikon finally adopt a reasonable name for it. To illustrate our point, the Canon 1D Mark III back-button focusing selections are buried way down in the fourth group of custom functions with the official name of *Shutter button/AF-ON button*. Nikon also calls this *AF-ON* in the custom menu for setting the AF-L/AE-L button. Okay, if you stare at the name for a while, and if you already know what it does, then it can make a little sense, but otherwise… When properly configured, this custom function disables autofocus initiation by the shutter button and moves autofocus initiation to a button on the back of the camera. Our various Nikon and Canon bodies all have that button (AF-L/AE-L) about an inch or so to the right of the viewfinder eyepiece easily reachable by the thumb when conventionally holding the camera.

After autofocus initiation has been removed, the sole functions of the shutter button are to activate the exposure meter when pressed half-way down and to trip the shutter when pressed all the way down. Now, on the rear of the camera, you have a dedicated autofocus button! Only pressing that button initiates autofocus, and happily, the camera will no longer refocus on the wrong spot when you recompose a picture.

Suppose you're photographing a waterfall and your camera is configured for back-button focusing. Even though you're reasonably confident that the waterfall won't run away very fast, set the camera into continuous AF mode. Activate only the center AF point. Aim it at the rocks along the edge of the waterfall and press the AF button on the rear of the camera. The camera autofocuses on those rocks. Release the button, and the focus is instantly locked. Recompose the scene. Set the aperture to f/16 for a large depth of field and shoot.

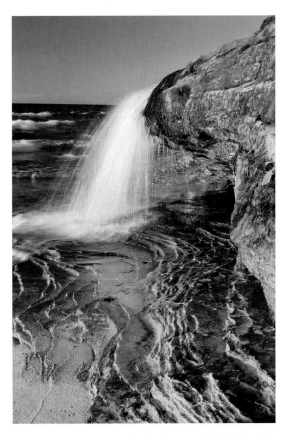

The lines of eroded sandstone nicely lead your eye to this 2-foot waterfall on the east side of Miner's Beach at Pictured Rocks National Lakeshore. Here we back-button focused on the sandstone about one-third of the way up from the bottom of the image and stopped down to f/22 to sharply record the entire scene. Normally we use f/16, but the extreme depth of this image encouraged us to try for even more depth of field, even though diffraction is slightly more serious at f/22.

Even though you've recomposed the shot, the focus didn't change when you pushed the shutter button. You've removed autofocus initiation from the shutter button and you, not the camera, now have sole control over when and upon what to focus.

KEEP THE SENSOR CLEAN
PREVENTION

Image quality suffers from a dirty sensor. Pixels that are covered up by dust and grit, can't properly measure any photons, causing loss of valid picture information. It's virtually impossible to keep your sensor spotlessly clean, but absolutely worthwhile to keep dirt to a minimum. Always keep a lens or a body cap on the camera. An uncovered camera body sitting around will most assuredly gather dust and dirt that soon settles on the sensor. Point the camera down when changing lenses or removing a body cap so that dirt falls away from the open camera instead of into it.

SPOTTING DUST ON THE SENSOR

An effective way to check your sensor for dust is to stop the lens down to f/22 and photograph the cloudless clear blue sky or a clean white sheet of paper. Overexpose by a stop or so to get a bright image. Load the image into your computer and view it with editing software. Magnify the image to 100% and scroll around. Serious dust spots should be obvious. If only a few small spots are present, you might ignore them, because you can easily remove them from your images during post-capture editing.

CLEANING THE SENSOR

Send It to a Pro

Some camera makers recommend that sensor cleaning be done only by their own repair facility or by an independent professional repair shop. Many camera stores, too, will clean sensors. Professional cleaning is likely the safest way, because the practitioners are presumably experienced, skilled in the task, have all of the right tools, and, as *bailees*, are generally responsible for loss or damage to your camera. However, professional cleaning does cost money and, if you must ship the camera elsewhere, there's a risk of loss, the cost of insured shipping, and the unavailability of the camera until it's returned. It's possible to clean your own sensor, but you must be extremely careful — a damaged sensor will substantially damage your pocketbook! We clean our sensors ourselves because we're often shooting in locations far from help, so we have no choice.

Cleaning the Sensor Yourself

Some people shouldn't try to clean the delicate sensor themselves. It requires good planning, a low-dust environment, the correct materials, bright light, good eyesight, perhaps a magnifier, a steady hand, and even steadier nerves. Sometimes a post-cleaning check of sensor cleanliness shows that it isn't really clean and must be done over again. Maybe that professional cleaning fee isn't so bad after all! If one is heavy-handed, slips, or is careless, a very expensive sensor can be ruined!

Our dire warnings notwithstanding, if you insist, here's how we do it: We clean our sensors only when our periodic test exposures, or our working images, show unacceptably high levels of dirt. We

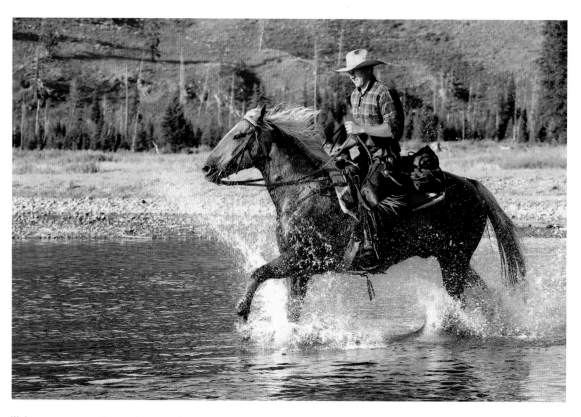

We leave our cameras set on continuous autofocus most of the time. Since we use back-button focusing 99% of the time, we have the choice of single focusing or continuous focusing at the touch of a button. Let up on the back-button focusing to lock focus. Hold the button in and the lens continuously refocuses on moving targets such as Kendal loping across the river. He's a terrific mule packer and horseman.

carefully follow the manual's instructions to enter the camera's *cleaning mode*, which will raise the mirror, open the shutter, and expose the sensor. Then, with the camera facing down, and exercising the most extreme care to not actually touch the surface of the sensor, we apply several vigorous gusts from our Giotto Rocket blower to blow the dirt from the sensor. We take another test shot and re-inspect for dirt. If everything looks good, we're done. Usually, though, some dirt is successfully blown off while other dirt stubbornly meanders around the sensor or clings to it. Try blowing the sensor off a couple more times, which usually helps, but sometimes just doesn't take it all off.

Delkin Cleaning Kit

We use a kit made by Delkin Devices (there are others, such as those made by Visible Dust) that is specifically designed for cleaning DSLR sensors. The kit includes a lighted magnifier for careful

inspection of the sensor surface and the location and type of contamination. The kit also includes a miniature vacuum, which we use with the most extreme care (!) to clean not only the sensor surface, but also the interior walls of the camera, aka, the *sensor box*. We do so, because these walls have a mysterious affinity for dirt, which will most assuredly — and soon — migrate to the sensor.

After vacuuming the sensor, we again shoot a test image as described above and inspect for dirt. If all looks well, we quit. If some dirt stubbornly remains, we use the cleaning swabs included in the kit. Carefully and precisely following the kit directions, we apply a correct amount of the special cleaning fluid to a swab. We carefully and gently draw the swab across the sensor surface. The swab typically picks up any stubborn bits of dirt, and a clean sensor should result. Sometimes, though, we must use two or even three swabs to clean the sensor to our satisfaction. We never re-use a swab. We also never get every spot off, but we can live with a few small dust bunnies as long as they don't multiply. Good luck and do be careful!

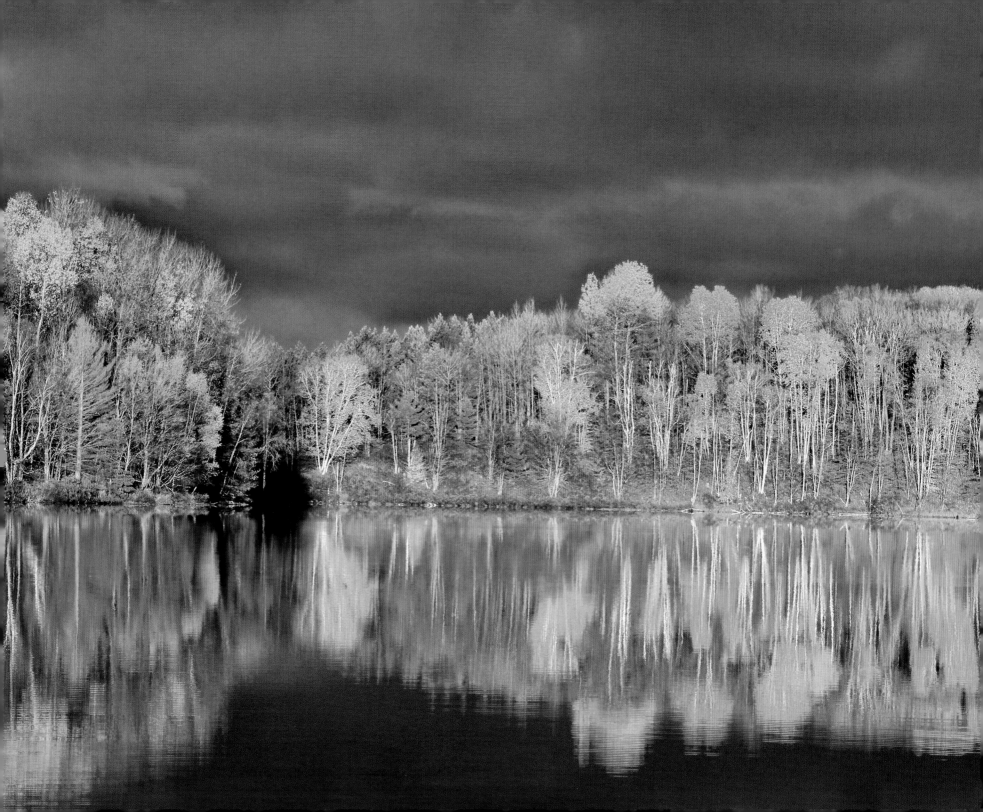

Light on the Landscape

LIGHT MAKES THE IMAGE

It's no secret that light is extremely important to making consistently wonderful images of the landscape. Everyone seems to know that, which makes us wonder why so many landscape images are marred by mediocre light. Shooting in light unsuited for the subject is a sure-fire recipe for lousy and very forgettable images. Pleasing and memorable landscape images demand light with the right combination of attributes. Color, contrast, and direction must all work together to enhance the scene! Photography captures only the light, and it's crucial to your image.

Some argue there's no such thing as bad light. In very limited ways, we agree. Any light can make good images, if used for an appropriate subject. Natural light can often be modified with reflectors, diffusers, filters, or flash to make subjects more photogenic. However, some light is just horrible for some subjects, no matter how skillful the photographer. For example, bright sunshine on a waterfall surrounded by trees and bushes is a photographic disaster! The difference in brightness between the whitest water lit by the sun and darkest shadows of the foliage and black rocks is just too much contrast for the camera's sensor. The image either loses important highlight detail or it suffers noise, poor colors, and detail loss in the shadows or, in extreme cases, both. In that light, you can favor the highlights or you can favor the shadows. Pick one. Either pick ends up with a terrible image. (**Hint**: Photographers who must pick one will always favor the highlights!) Cloudy days and full shade both offer the soft and low-contrast light that's so much more suitable for making a fine woodland waterfall image.

Wind and light combine to restrict what landscapes can be successfully photographed. We have taught field photography workshops in the gorgeous and uncrowded Upper Peninsula of Michigan each year since 1985. During the fall color workshops our students frequently ask where we'll be going the next morning, and our answer is: *It depends on the light and the wind, so we'll decide early tomorrow morning just as we're leaving.*

It doesn't happen often enough. The combination of totally still water, intense autumn color reflections, golden light at dawn, and black storm clouds in the western sky is a sure-fire recipe for dramatic images.

If morning brings clear and calm conditions, we go for autumn color reflections in the quiet waters of inland lakes. If conditions are clear and windy, waves ruin the reflections, so we look for landscape opportunities along the rocky coastline of Lake Superior. Hopefully, the wind is out of the north, as it often is during that time of the year, causing spectacular waves to crash onto the rocky shoreline and offering rich opportunities for dramatic images.

If the new day dawns cloudy and calm, then the lake reflections have muted colors. So we don't hit the lakes. Instead, we look for colorful trees that offer pleasing compositions of branches and leaves, always reminding students to avoid any white or gray bland sky that may be offensively visible through the leaves. We do stay close to the lakes, though. Sometimes the morning sun slips through a hole in the clouds and provides marvelous images of autumn reflections in a lake, dramatically emphasized by ominous black storm clouds.

Cloudy and windy is a tough combination, unless you like images of blurry leaves. Yes, at times that can be artistic (in small doses), but not generally. Instead, we seek secluded waterfalls that are tucked into canyons facing away from the wind. High winds can sway the vegetation surrounding the waterfall, but they don't affect the rocks, and rarely the water, so even high winds can permit nice images.

With a little practice, everyone can learn to select good photo locations suited to the prevailing weather conditions. Selecting the right spot is at least 50% of the battle for fine images. Always consider a wide range of possibilities and then carefully select your destination. We listen to weather forecasts, but we know from decades of bad experiences that many weather guessers have low success rates. Don't be afraid to change your destination when weather changes. We sometimes announce our photo destination, only to switch to an alternate spot en route when the weather suddenly changes.

LIGHT QUALITIES

Light has four distinct qualities: amount, color, contrast, and direction. Those four qualities are each important to the making of fine images. Of the four, we believe that contrast and light direction are the most important to the landscape photographer. Let's look at each of the four qualities.

AMOUNT

This is the easiest one to understand and manage when making wonderful landscape images.

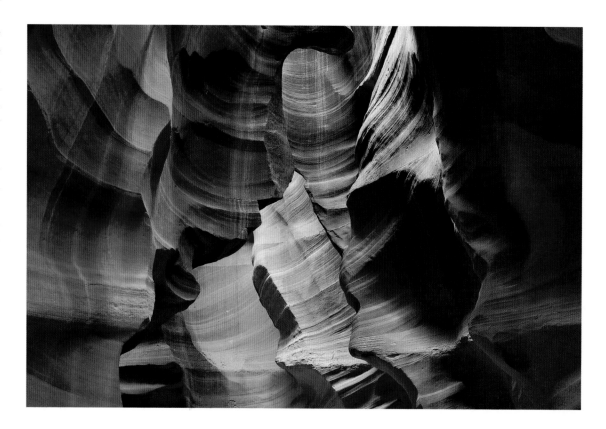

The light is dim in this slot canyon near Page, Arizona. Fortunately, new digital cameras produce much better quality when used for long exposures measured in seconds and at higher ISOs.

It simply refers to how much light is illuminating the scene. Too many of us have been programmed to shoot in bright sunlight shining over our shoulder. A bright sun high in the sky gives the worst possible light for the vast majority of landscapes, because that light is extremely contrasty, giving muted colors and ugly harsh shadows. As always, there are exceptions. For example, we've made many pleasing images of slot canyons at noon on sunny days because we needed a high-in-the-sky sun to penetrate the slot and illuminate the canyon walls.

There always seems to be one or more exceptions that contradict any photographic rule, but here's one strong guideline: A clear morning has its best light starting about an hour before sunrise and continuing until a couple of hours after sunrise. Likewise, the best evening light begins a couple of hours before sunset and continues until the final colors disappear, perhaps an hour or more after sunset.

The direction of the sun at sunrise has a substantial effect on the period of golden light. That period is much longer in high-latitude locations, such as within the Arctic Circle, Alaska, and Antarctica. In North America, the golden light lasts longer in the winter, because in summer, the sun rises farther north and more quickly. The beautiful red and gold ambient light of dawn and dusk certainly varies with the latitude and seasons, but the day's earliest light and its latest light nearly always produce excellent lighting for outstanding landscape images.

Low light is a minor issue for landscape photographers. The amount of light can be extremely low on cloudy mornings and cloudy evenings, too, when the sun is low in the sky. The absolutely invariant use of a good tripod and the other techniques for shooting sharp images, as discussed in Chapter 5, are very important for successful low-light landscape work.

If you're inclined to shoot hand-held in light so dim that you need to take heroic measures, you can help by bracing your camera against any available steady object, such as a fence railing, a tree, the car hood, or even the aforementioned sober friend. You can use shorter lenses, raise your ISO, and use a larger aperture to permit higher shutter speeds. If available, turn on your anti-shake system. All of that will help. But the real solution, in case you missed it before, is *the absolutely invariant use of a good tripod*.

POLARIZING FILTER

All landscape photographers should make routine use of this important filter. Glare, scattered light, and polarized light are present in all scenes, no matter if they're illuminated by sunshine or by the diffused light of a cloudy day. The polarizer removes subject glare, removes unwanted reflections, darkens blue skies and enhances white clouds, reveals greater subject detail, and provides more color saturation. Polarizers are so important that you should have one to fit every one of your lenses. The lenses we use for most of our landscape images have filter-thread sizes of 77mm, 72mm, 62mm, and 58mm, and we have a B + W circular polarizing filter for each of those sizes.

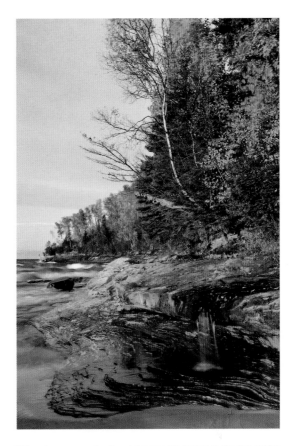

This autumn scene stands out because it's bathed in the last golden light of the day. A circular polarizing filter removed much of the glare from the water and shiny leaves.

Several of our lenses each have the popular 77mm thread, so we move our one 77mm polarizer from lens to lens as needed. Some photographers have only a single polarizer, one that fits the largest thread size in their lens arsenal, and they use adapter rings for the smaller lenses. This reduces cost, because only one polarizer is needed and the

adapter rings are relatively cheap. However, some workshop students have found this scheme to be inefficient. Adapter rings get lost. They also get twisted, distorted, deformed, bent, warped, worn, and broken, which can cause them to be difficult or impossible to install and can cause them to be equally difficult or impossible to remove. We just don't recommend them.

Polarizers come in two basic types: older ones called *linear* polarizers and newer ones called *circular* polarizers. The terms define only their optical characteristics, not their physical configuration. Indeed, they look alike. The metering and autofocus systems of modern cameras may or may not work properly with linear polarizers, so it's best to buy and use only circular polarizers.

Polarizers tend to give a slight blue cast to the image, so *warming polarizers* with a slight yellowish tint were developed to help cancel the blue cast. Film photographers routinely need warming polarizers, but digital photographers can so easily manipulate color-cast with the camera's white balance controls and with post-capture editing software that they have little need for warming polarizers.

If you're buying a polarizer, get a good quality multi-coated circular polarizer, such as those made by B + W, Tiffen, Canon, or Nikon. Polarizers comprise two circular discs of special glass housed next to each other in a two-piece metal mounting ring. The rear disc is adjacent to the lens and remains stationary. In use, the photographer manually rotates the front disc to achieve the desired polarization effect.

As you know, adding extra glass to the optical path will cause a slight loss of sharpness and can worsen flare problems. However, the polarizer's many benefits more than compensate for the slight loss of sharpness. Nonetheless, you should minimize that loss and minimize flare by spending the extra money to buy only high-quality multi-coated polarizers.

Using the Polarizer on a Sunny Day

Polarizing filters effectively remove polarized light except on one plane from the blue sky, darkening the sky, saturating the colors, and making the white clouds more prominent. It's possible, though, to make the sky too dark, unnaturally so, especially at elevations above 5000 feet. It's easily avoided — merely turn the polarizer to something less than maximum polarization.

Polarizers show the greatest effect when shooting at right angles to the sun; that is, polarization is zero at 0 degrees and is maximum at 90 degrees. At dawn and dusk, the greatest amount of polarized light lies in the northern and southern skies, so they show the greatest polarization effect.

As said, the polarizer has little effect on the sky when shooting directly toward or directly away from the sun. Also, when the sun is high overhead, the polarizer can darken the sky near the horizon in any direction. Don't forget that beyond darkening blue skies, the polarizer has many other uses — it reduces glare, it saturates colors, it eliminates unwanted reflections, and it enhances detail — a veritable potpourri of benefits that shout for the landscape photographer's frequent attention.

Using the Polarizer on Overcast Days

Polarizing filters are quite effective on cloudy days, too. Although you won't be using the polarizer to darken a blue sky when the sky is totally cloudy, the polarizer nicely removes glare from leaves and wet surfaces, revealing the detail and color that was hidden by the glare. The effects of the polarizer are more subtle in overcast light, but apparent if you look carefully as you turn the filter. Look for an increase in color saturation and a reduction of glare on wet or shiny surfaces. Our polarizing filters are used as often on cloudy and overcast days as they are on sunny days. Polarizers are so critical to good landscape images that photographers should use them routinely unless, for some particular image, they can articulate a specific reason for not polarizing.

Four Important Polarizer Tips

1. Polarizers are in the optical path of the lens, so buy high-quality ones and keep them clean and scratch-free.
2. Polarizers must be rotated to get the proper effect. After mounting has been completed, rotate the polarizer while looking through the viewfinder to see the effect. Rotate it only counter-clockwise (while looking from the rear of the camera) to avoid inadvertently unscrewing it from the lens and having it crash to the rocks below.
3. Polarizers add glass surfaces into the optical path, and are likely to exacerbate flare problems. Always use a lens hood to shade the filter. The short hoods of wide-angle lenses may allow

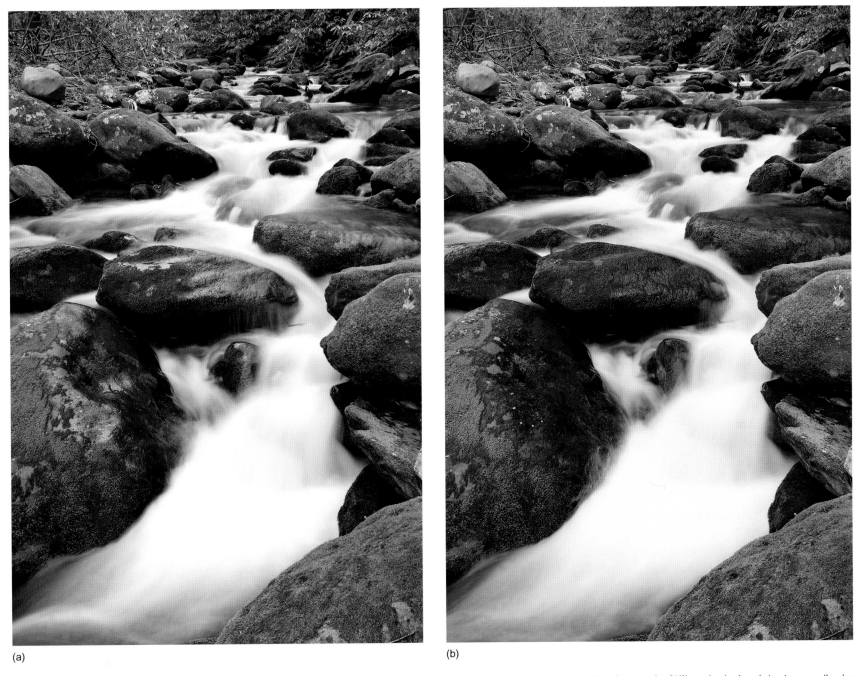

(a) This small creek in Great Smoky Mountains National Park offers many compositions. Although the day was cloudy and quite dark, plenty of glare reflected from the wet rocks. (b) We used a circular polarizer to remove the glare, revealing colors and details that were hidden.

rotation of the polarizer by reaching in with a single finger. The deeper hoods of longer lenses may have to be removed to rotate the polarizer. Be sure to replace it before shooting. If bright sun is near your shooting direction, don't hesitate to augment the lens hood with your hand or your hat. Your images will love you!

4. Polarizers must be readjusted when changing between horizontal and vertical compositions. Forgetting this step is a common mistake, even for pros, so try to remember!

COLOR OF LIGHT

White light is composed by combining the light of the individual visible colors. A color is determined by the *wavelength* of its light, and all the colors lie in a spectrum of light in the specific order of red, orange, yellow, green, blue, indigo, and violet. Science students may remember Roy G. Biv, a memory device to help remember the sequence of colors. They may also remember that wavelength is a measurable characteristic of several phenomena, including sound waves, radio waves, microwaves, X-rays, light, and others. Red light has the longest wavelengths in the visible light spectrum, violet light has the shortest. The longer wavelengths penetrate the atmosphere easier than shorter ones. This plays a key role in the color of light illuminating the landscape. For example, daylight has a pronounced reddish hue at the beginning and end of a clear day because the sun is lower and its light must travel a greater distance through the atmosphere. The greater distance causes shorter wavelength violet and blue light to be absorbed more

than the longer wavelength red and yellow light, which better penetrate the atmosphere.

The sky turns blue shortly after sunrise because the shorter wavelength blue light is more easily scattered in the upper atmosphere and reflected down to earth. As the sun rises higher, its light travels through less and less atmosphere, allowing the light to contain more blue. The increased blue content reduces the warm red glow of early morning.

THE RED LIGHT AT DAWN AND DUSK

The sun is low in the sky at dawn and dusk, and the prevailing red light makes this a special time for photographing the landscape. Additionally, the early and late golden light of a clear day accentuates the colors in most landscapes. In fact, odds are that more gorgeous landscape images are made an hour or so before and after sunrise and sunset than at all other times of the day combined.

Even though color in a digital image is easily adjusted with software, you should still take advantage of the exquisite light that nature so readily offers. Shooting around dawn and dusk makes it hard to join the breakfast and dinner crowd, but there are many photographic rewards to eating and socializing at unconventional times.

The golden light of dawn and dusk is superb for mountains, sand dunes, old barns, ghost towns, and rocky outcrops. Autumn colors reflect beautifully in still water. In many places, dawn and dusk tend to be calm periods, so the wind doesn't stir foliage in the scene. Golden light isn't effective for everything,

though. Water and blue wildflowers may not appear natural in color in golden light and, in other light, such as that of the direct sun, the very high contrast can be a problem for many scenes.

A camera's automatic white balance (AWB) feature can easily wash out the attractive red and gold colors of dawn and dusk, so AWB should be disabled when shooting at those times. Instead of using AWB, set the camera's white balance control to the Cloudy or Shade settings, and you'll ensure a good rendition of the attractive early and late light. That suggestion is most appropriate for JPEG images. The white balance setting is less critical for RAW images because white balance is so easily adjusted in post-capture editing.

If you want a really magenta sky, and if your camera permits, manually set the white balance to 10,000 K and shoot away. You have thus told the camera that the light is very blue, which is a lie, but the camera dutifully adds a lot of red to the picture to counteract the imaginary blue light. The result is a vivid magenta sky that might be just what you wanted. Don't forget to reset the white balance, or your next portrait subject will look very peculiar indeed!

THE BLUE LIGHT IN OPEN SHADE

The sky is blue on a clear sunny day because air molecules in the upper atmosphere scatter a large percentage of the shorter wavelength blue light. The longer red and yellow wavelength aren't scattered much, and most pass straight through. The scattered blue light is reflected toward earth, so when one looks at the sky, it appears blue.

High winds are blowing the snow off the mountain peaks in the Sierras. The sky is blue on a sunny day because it scatters primarily the blue portion of the visible light spectrum.

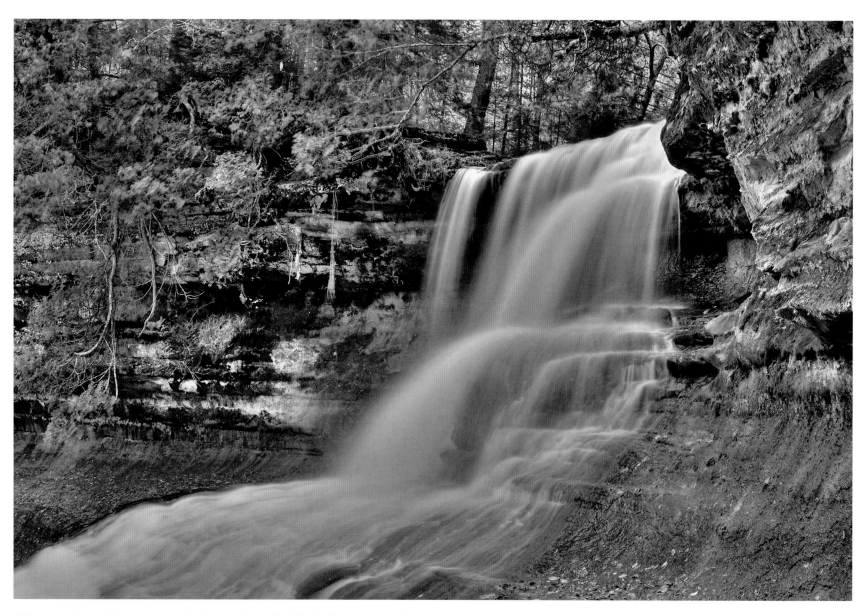

A blue color cast is useful for enhancing the color of a waterfall. Laughing Whitefish Falls is a northern Michigan waterfall that photographs well on cloudy days when the light has a natural blue cast. Two images were combined using high dynamic range (HDR) techniques to capture more detail in the dark objects.

Now, let's define *open shade* as a shaded area that, on a sunny day, has blue sky above but is shaded from the direct sun by some intervening object like a tree, a building, or a mountain. The blue light of open shade is very helpful for river and waterfall images, among other subjects. Many of these scenes look best when the water has a slight blue cast, and if your foreground includes large patches of blue wildflowers, the blue light can improve their color. However, the intense blue light of open shade is usually harmful to landscape images because other colors, such as green, orange, red, and yellow, look muted and seriously off-color when illuminated by blue light. As an example, the red rocks of Bryce Canyon aren't nearly as attractive in blue light, so steps must be taken to modify the light. Fortunately, digital capture makes this easy to do. Simply set the camera's white balance control to its Shade position, and the resulting image will have a pleasing, more yellowish, warmer, tone. This color control is particularly important for obtaining nice JPEG images, and it makes good sense to get close even when shooting RAW images. If *close* isn't quite good enough, it's easy to later refine your RAW image with your RAW conversion software.

CLOUDY LIGHT

The light of a cloudy day has a slight blue cast. This blue cast can be desirable for some images, like those of water or blue wildflowers, but it's undesirable for nearly everything else. JPEG shooters will benefit from using the camera's Cloudy white balance setting to remove the blue cast, and RAW shooters can use AWB or Cloudy white balance settings, and later refine the image in the RAW converter.

Don't miss this important point: Light is less blue on a cloudy day than in the shade with blue sky overhead. That's why your camera offers the choice of Shade or Cloudy white balance settings.

MIXED COLORS

Experienced photographers are well aware of the extra blue light found on overcast days or in open shade. However, some scenes add a second color-cast to the mix. The green leaves of a thick forest give a green tint to the light, which in turn, gives a green cast to your images. So, if you're shooting in the thick forest on an overcast day or in the shade of the mountain, you must deal with a compound color-cast that's both green and blue. You can easily use either of the Shade or Cloudy white balance choices to neutralize the excess blue, but that obnoxious green cast is still there. There are two good ways to handle mixed light situations.

Color Adjustment of RAW Images

Digital capture handles a blue-green color mix quite easily with proper techniques. With the camera set to generate RAW images, we set our white balance to Cloudy to remove much of the blue color-cast of our digital file. Later, during post-capture RAW conversion, we use the converter's Green-Magenta control to remove the green cast and the Blue-Yellow control to remove any residual blue cast. Voilà! Blue taboo and green unseen!

JPEG Color Adjustments

Color-cast correction of JPEG files is somewhat more difficult in post-capture editing, so it's more important to exercise good control in the camera. Yes, image-editing software is improving but, in the meantime, the astute photographer takes charge when shooting.

Compound color-cast problems are solved for JPEG files, first by employing the camera's custom white balance feature. Every camera model seems to have its own method, so consult your camera manual for the details. In brief, using custom white balance requires you to shoot a test subject that's either pure white or neutral gray — a gray card is just fine — in the *same light* as your scene. Be sure to properly expose the test target and to fill the entire frame with the test target. Set the camera to custom white balance. Then, select the image of your test target to instruct the camera that this image should have no color bias. The camera applies whatever white balance correction is needed to neutralize the color-cast — any color-cast — whether single or compound.

Leaving the camera on custom white balance, shoot the actual scene, remembering that the scene must be in the same light as the test target! If you go to a new area, having a different but also objectionable color-cast, you can repeat the process. For example, if you leave the forest to shoot in a nearby open meadow under the same cloud cover, you should select a new target and shoot the test shot again. Although the light in both forest and meadow has a strong blue component, there is much less green light in the meadow, so using the test target shot in the greenish light of the forest might make images shot in the field too magenta.

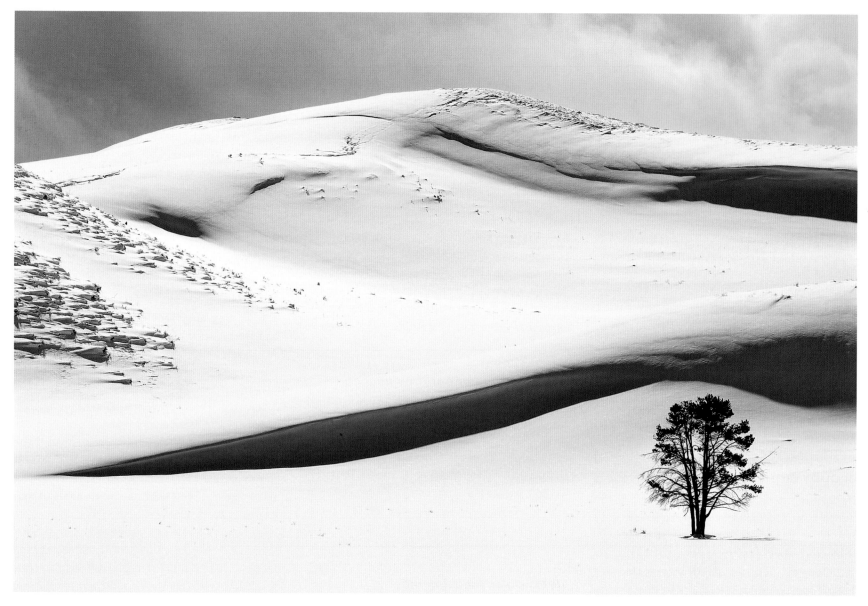

We never use AWB because it may remove a favorable color-cast like blue in the shadows as you see here or the red light in a dawn sky. This is Yellowstone's second most famous tree because it's photographed a lot. It's located in the rolling hills of Hayden Valley. The most famous tree grows near Old Faithful geyser.

If no color-cast correction is needed in the new area, remember to take the camera off of its Custom white balance setting.

WHITE BALANCE SELECTIONS

Your camera offers many white balance choices, which may include AWB, Sun, Cloudy, Shade, Custom, White Fluorescent, Tungsten, Color Temperature (K), and Flash. Some are frequently used for landscape images while others have limited landscape use. Let's explore their uses.

AWB

Use AWB when you don't want to bother setting a specific white balance to compensate for the color of the prevailing light. It works quite well for most outdoor scenes. Usually it'll get you close, which is satisfactory for most JPEGs. It's also satisfactory for RAW images because of the ease of changing color balance during post-capture RAW conversion, as we've said before.

Auto white balance doesn't work well if you wish to keep a strong color-cast. Perhaps you want a strong blue cast in the shadows of a snowy landscape to suggest cold temperatures. Letting AWB take away the blue may be detrimental to the feeling you intend to evoke with the image. You're better off using the Sunny white balance choice. AWB also drains the red from sunrises and sunsets, so don't use it for them, either.

Daylight

Daylight white balance is a logical choice anytime your landscape is illuminated by sunlight. Use Daylight white balance unless there's a compelling reason to do otherwise.

Shade

Shade white balance works well to remove excess blue light when photographing in open shade with a blue sky overhead.

Cloudy

Many successful landscape images are captured on cloudy days because of the low contrast. Use Cloudy to remove the slight blue color-cast so typical of those conditions. Cloudy white balance produces a slightly warmer image by adding a little yellow. Many photographers, including us, prefer a very slight yellow cast to their images, so this choice is suitable for both cloudy and sunny days.

Tungsten

The Tungsten white balance choice reduces the red color-cast found under tungsten lighting. This lighting is typical of ordinary incandescent bulbs. We don't think Tungsten white balance will be a factor in your landscape work, but it could be useful for other subjects when photographing indoors. Perhaps you could use Tungsten white balance to add a strong blue color-cast to your outdoor images for creative reasons.

White Fluorescent

This one takes out the excess green light found under fluorescent lamps. It's another white balance setting that you won't often use in landscape photography, but you might use it for photographing people under white fluorescent lights or, perhaps,

This intimate landscape of a red maple leaf lying on a white birch log is illuminated with blue light on this cloudy day and green light from several nearby white pine trees. This unappealing mixture of color is easy to control with a digital camera. If you shoot RAW, set the camera to Cloudy to take out the excess blue light and use the RAW converter to reduce the excess green light. If you shoot JPEG, photograph a gray card, select the image, and set the camera to Custom white balance to neutralize both the blue and the green color-casts.

city scenes at night if the setting is under fluorescent lighting. Note, though, that other cityscape lighting, such as incandescent lighting, can produce other color-casts.

Flash

Most flashes produce a light that is slightly blue. Cameras set to Flash white balance will attempt to compensate for the blue light. A word of caution, though: Some flashes are made with built-in yellow filtering to compensate for their own blue light. If the camera is also compensating, one could end up with an overcompensated, too warm image. Canon flashes are in that category, so if you're using one and don't want overly warm images, leave the camera on AWB or Daylight.

Mt. Sheridan is beautifully reflected in the calm waters of Heart Lake in the Yellowstone wilderness. A bit of flash nicely highlights the beach stones in the foreground. Mixing natural light and flash together is a powerful technique that's highly effective and easy to do with modern equipment.

Custom

This choice requires some effort to learn how to use it, but the results are worthwhile if you shoot JPEGs in mixed light sources. The proper use of the Custom white balance setting will ensure excellent color fidelity in your images when shooting in difficult lighting situations.

Color Temperature (K or Kelvin)

A photographer uses this setting to precisely instruct the camera how to compensate for the color of the light. The color temperature of the prevailing light is entered, and the camera then knows exactly how to compensate to produce a color-neutral image. Few photographers use this setting, largely because accurate use of it theoretically requires an expensive color-temperature meter.

Even without a color-temperature meter, however, this white balance setting can be used to substantially punch-up the magenta colors in sunrises and sunsets. Set the camera on K, dial in a value of 10,000 K, and shoot the scene. You lied to the camera by telling it you're shooting in extremely blue light. The camera adds a lot of warm-toned compensation to counteract the blue light. But the light in the sunrise or sunset is already warm, not blue, and here the *incorrect* compensation produces an overabundance of orange and red — just what you wanted!

CONTRAST

Contrast is the term used to describe the brightness differences between various parts of a scene.

Bright sun produces more contrast than other types of daylight, because the sun is such a small light source and so far away. If the sun isn't directly behind the camera, those attributes create very bright highlights and very deep shadows, so much so that the sensor may be unable to properly record both. The photographer is compelled to make a choice and, as has been previously said, and said, and said, he should probably favor the highlights.

DYNAMIC RANGE

The luminance range of a scene is the range of brightness levels of subjects within that scene, which is another way of saying brightness range or contrast. *Dynamic range*, as used in photography, is yet another term describing the luminance range of a scene (the contrast of the scene) or describing the capability of a processing component to faithfully process a given luminance range. A digital processing component is an image-forming device like a camera, a part of a camera, a scanner, or it may be an image-reproducing medium such as a computer monitor, a projector, or a printer and its printing paper. Like the proverbial weak link of a chain, the dynamic range of any digital system, from camera to output, is no greater than the dynamic range of its weakest component. Every component has its own limitations in how white its whites are and how black its blacks are. The resulting limited range of brightness is called that component's dynamic range.

If the dynamic range of a scene exceeds the dynamic range of the processing system, then the fidelity of the finished image is compromised, which can be a problem for the photographer. An example of such a scene is our notorious waterfall in the harsh light of the noon-day sun. Another and subtler example is a pretty white birch with its pale yellow leaves growing in front of some very dark green pines. That can be a wide dynamic range scene, even in soft light. A wide dynamic range scene, processed by a system of only limited dynamic range, gives images with ugly blown-out highlights or with blocked shadow areas lacking detail or, in extreme cases, both. Today, the innovative digital-darkroom worker can apply HDR computer techniques to help compensate for her system's dynamic range limitations. We'll say more on this in Chapter 9. But, short of that remedy, the photographer has the option of either accepting the limits of the dynamic range available to her and carefully engineering the exposure of her image or, which is the better option, of coming back tomorrow when the light is better.

YOUR EYES VS. DIGITAL CAPTURE

We are truly blessed to be able to see such a wide variety of color in both bright and dim light. The ability of our eyes to process scenes of extreme contrast and the dynamic range of our body's vision system far exceeds that of film or digital photography systems. The human eye can process somewhere around 13 or 14 stops of light, and ordinary digital cameras are limited to about 7 to 9 stops. Keeping in mind the definition of a one-stop difference as a doubling or halving of the light, it's clear that the dynamic range of human vision vastly exceeds that of our cameras.

We sometimes use the Color Temperature (K) white balance choice to enhance the sky at dawn or dusk. These wildebeest were marching along the skyline at dawn one morning, but the sky was only slightly red. Setting the camera to K and dialing in 10,000 K made the camera add plenty of extra color to the sky.

CONTRASTY SCENES

Many landscape images suffer from too little detail in important highlights and shadows, which is the direct result of excessively contrasty scenes. Making images when the scene is too high in contrast is a major mistake for many photographers, unless steps are taken to deal with it. Often, which has been said previously, it's best to come back at another time when the light is more suitable for the scene. Even though excessive contrast is generally detrimental to our images, occasionally more contrast is just what's needed. For example, sand dunes can often benefit from the contrast of direct sunlight (albeit preferably at a lower angle, such as early morning or later evening) because sunlight can be used to accentuate the texture and shape of the dunes. And the higher contrast of side-light or back-light on a wave crashing into a rock is frequently helpful. Certain silhouetted landscape subjects, like a tree isolated against the rising sun, can produce beautiful images of extreme contrast. Still, for many and perhaps most landscape images, low-contrast light is more effective.

CONTROLLING EXCESSIVE CONTRAST

Wait!

Sometimes the harsh sun makes contrast far too high, but a short wait for a friendly transient cloud may solve the problem by lowering the offending contrast. If no cloud cover is forthcoming — and yes, we'll say it again — coming back tomorrow can be a good solution. This effective strategy is one of searching out good landscape spots and planning your schedule to coincide with better shooting conditions. The opposite strategy is used by one amateur shooter we know. He keeps a notebook in his car in which he records the locations and problems of potentially good scenes that he sees, but were seen in the wrong light, at the wrong time of day, in the wrong weather, in the wrong season, or when he was just too busy to deal with it. Then, rather than planning his schedule to fit the scene, he can often use his notes to find a scene that fits his schedule.

Fill Flash

If a small portion of the image, such as the foreground, is in deep shadow, one might use flash to brighten the dark shadow areas. Recently, we photographed Grotto Falls in Great Smoky Mountain National Park. Grotto Falls is special because you can easily hike behind it to make images from that unusual vantage point. Of course, from the inside, the top of the ledge from which the water drops is completely black. An electronic flash worked perfectly to illuminate the dark rocks while the natural light properly exposed the cascading water.

HDR

High dynamic range describes a digital technique for preserving detail in both the highlights and shadows of high-contrast scenes. HDR works well with static landscapes in which nothing is moving. The photographer uses his tripod-mounted camera to shoot several images that are identical except for exposure. First, shoot an image in which the highlights are about one-stop underexposed. Then make additional shots, increasing the exposure by at least one stop and no more than two stops each time. Do this until the darkest shadows are about two stops overexposed. Finally, use Photoshop, Photomatix Pro, or some other HDR tone-mapping software to merge several shots into a single image. It'll show excellent detail throughout the brightness range. We'll cover HDR techniques in much greater detail in Chapter 9.

Double Process an Image

It's possible to produce an HDR image by double-processing a single image. This procedure is generally more effective when shooting RAW images. In RAW conversion, process an image to optimize the highlight detail while ignoring the shadow areas. Save the converted file. Then, process the same RAW image and this time adjust the RAW converter to maximize the detail and quality of the dark tones while ignoring the highlights. Use noise reduction software to improve shadow detail and color. Save that image, too. Now use HDR software to merge the two saved images into one final image. The tone-mapped final image you save will show good detail throughout its entire brightness range. This procedure is more convenient than shooting multiple images with varying exposures, but it's less effective because of noise in the shadow areas.

Split Neutral-Density (ND) Filters

Split ND filters are an old-fashioned but highly effective way to lower the contrast of many landscape scenes. The most common application is for scenes having a very bright sky and a dark foreground, where the contrast of the scene exceeds the dynamic range of the digital system. The filters

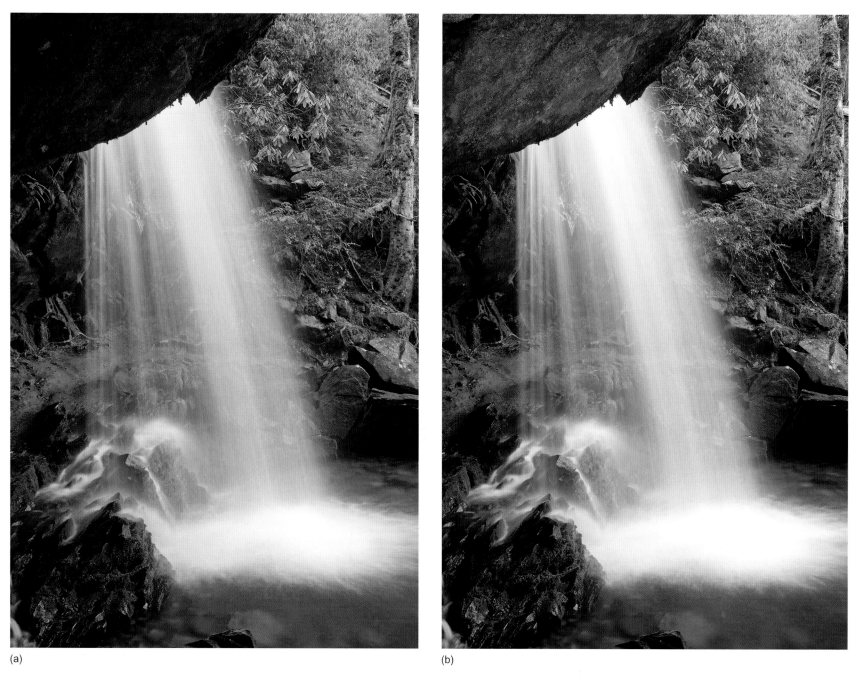

(a) (b)

(a) Grotto Falls in Great Smoky Mountains National Park is unique because you can walk behind the falls, offering an unusual vantage point. (b) Unlike the other image, we used flash to light up the upper rock to reveal some detail in the foreground.

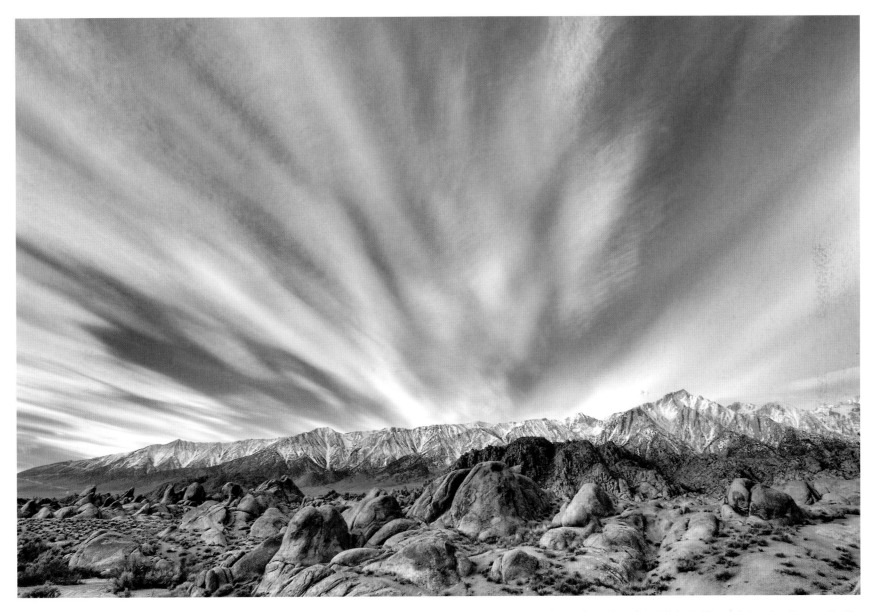

The contrast between the dark Alabama Hills and the light sky is far too much for traditional photographic techniques to successfully capture. Rather than fuss with a split neutral-density filter, we shot a series of images with different exposures and merged them together with Photomatix Pro — a dedicated HDR software program.

are usually rectangular pieces of plastic. They're available in various sizes to fit specific filter holders, but a typical size is $3'' \times 4'' \times 1/8''$ thick. The sheets are tinted over a portion of their area. From the top down to the middle, they're dark and from the middle to the bottom they're clear. The filters are available in different strengths — the darkened segment may have an attenuation of 1, 2, or 3 stops — and the transition region may be either *hard* (abrupt) or *soft* (gradual).

The filters are inserted into a proper holder and, in the typical application, slid up or down until the dark portion of the filter just covers the bright sky and the clear portion of the filter is over the darker foreground. By darkening the bright sky, the contrast between sky and foreground is greatly reduced. Split ND filters with a gradual transition are most useful when there's no sharply defined straight line in the scene between the highlights and the shadows. Here, the gradual transition in light attenuation makes it easier to hide any telltale sign of the filter in the resulting image. If, on the other hand, the scene abruptly changes from light to dark with a clear straight line, such as a bright sky meeting the surface of a dark sea, then the hard ND filters work better. All of the foregoing notwithstanding, the recent advances in HDR techniques offer such a vast improvement over ND filters that we no longer use them.

LIGHT DIRECTION

FRONT-LIGHT

The direction of the natural light is critical to the success of many landscape images. A scene is considered front-lit when the sun is directly or nearly directly behind the camera. This is the light that many photographers use much of the time. Direct frontal lighting produces a low-contrast scene because the shadows created by the sun fall behind the subject and are largely invisible to the camera. The camera, therefore, can easily record the entire brightness range of the scene. Frontal lighting does a good job of revealing the colors of a scene, but the absence of shadows tends to produce an image lacking in depth. Direct frontal lighting can produce fine images, especially in the red light of the early or late sun, but after a while they can get boring. Some shadows are often beneficial to reveal texture and to imply depth, so perhaps direct frontal light should be used less than it is.

OVERCAST LIGHT

Cloudy days and overcast days produce low-contrast scenes easily dealt with by the camera's sensor. It's somewhat like frontal lighting in that shadows are minimal, but the color of the light is cooler (more blue). Although the scene appears as if front-lit, the sun may be any place in the sky if the cloud cover is thick enough. Overcast light is especially suited for fields of wildflowers, provided one very carefully composes to disallow any bland sky from appearing in the image. We use this light for nearly all of our waterfall images, especially for those waterfalls surrounded by dark forest, because the high-contrast scene demands a low-contrast light. Contrast considerations aside, the dim light of an overcast day, especially early and late, makes it easy to use long exposure times to get that smooth silky running water in our waterfalls or to depict

This intimate landscape of paintbrush wildflowers photographs well on this calm cloudy morning. The clouds act as a huge soft box to eliminate harsh shadows.

wildflowers swaying in the wind. And, if the exposure time is still too short, consider a light-reducing ND filter, not to be confused with the split ND filter previously discussed. These filters are a uniform gray color and come in different densities. We sometimes use a .9 ND filter that blocks three stops of light so we can use longer shutter times to blur the water more.

SIDE-LIGHT

Side-lighting can produce few or many shadows, light or dark, depending on the lighting. If the angle between the camera-to-subject line is less that 20 degrees from the camera-to-light line, then the shadows are minimal. As the sun's angle moves toward 90 degrees, the shadows get longer. In all cases, side-light easily reveals texture and suggests depth in a two-dimensional image. The side-light of early morning and late evening is wonderful for many landscapes such as seashores, sand dunes, rock formations, and a forest of cacti. All of us could and should use side-lighting more than we do. Spending a few days shooting only side-lit images is a fine way to teach yourself the benefits and joys of side-lighting. You'll soon discover those numerous situations where side-lighting works best and a few where it doesn't work at all.

Side-lighting produces more shadows than front-lighting or overcast lighting, so side-lit scenes have more contrast. However, high contrast can be difficult or impossible for the digital system to properly handle, so do be careful. Extremely bright sun may create too much contrast for side-light to be successful for some landscapes. Generally, the softer sunshine and warmer colors of dawn and dusk work far better for making nice side-lit landscape images. Always use the first and last two hours of a sunny day to shoot your images. Your success rate will be much higher.

BACK-LIGHT

Back-light comes from behind the subject. It tends to create extreme contrast because shadows face

This acacia tree in Kenya is a fine example of being on location well before sunrise, which is still 20 minutes away. To capture this image, choose a low viewpoint to get the tree above the horizon as much as possible. Focus on the tree, stop down to f/16, and expose for the bright background using the histogram to guide you.

the camera. You can expect dark shadows with bright highlights. It's the most difficult light to successfully use, but the most dramatic when everything works. Photographing a gorgeous acacia tree in Kenya against the rising sun isn't only appealing, but a good way to use soft back-lighting.

When the sun has risen high in the sky, back-lighting is higher in contrast. It's effective to include the sun in the image at those times, particularly when using a wide-angle lens. This is especially true if you stop the wide-angle lens down to f/22 and underexpose the sky a bit, which turns the sun into a star shining in a very dark blue sky background! Once again, early and late in the day are terrific times to use back-light. Look for instances where the back-light can rim the subject. The spines of a field of cacti, a prairie full of grasses, or an exploding milkweed pod are typical subjects that glow when back-lit.

Both side-light and back-light are higher in contrast, so RAW images work best here. During the RAW conversion process, exposing to the right (ETTR) without clipping important highlights, if not done fully in the camera, increases your chances of getting sufficient detail and reducing noise in the shadows. Finally, HDR techniques are very effective for back-lit images.

REFLECTED LIGHT

One of the great joys of shooting in mountainous or rocky regions is working with reflected light. A splendid example is the light reflected by a rock wall and bounced around within the depths of a canyon. The slot canyons near Page, Arizona, are wonderful subjects for reflected light. A creek or pool of water illuminated by light reflected from colorful rock walls or by the light reflected by autumn maple trees offers a perfect opportunity to shoot many wonderful and unusual landscape images.

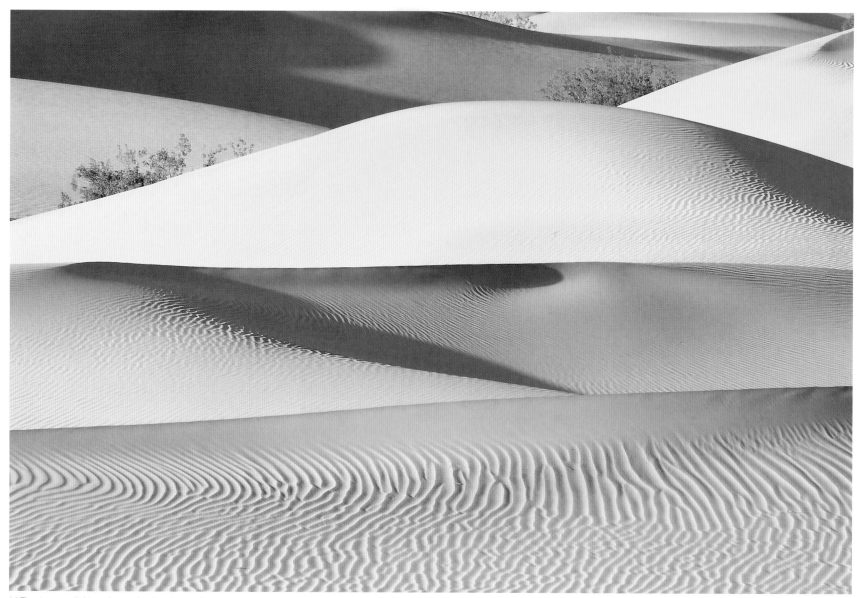

(a) The strong sunlight comiae overlapping dunes in Death Valley National Park. At times, you need bright light to create the shadows that suggest depth in the image.

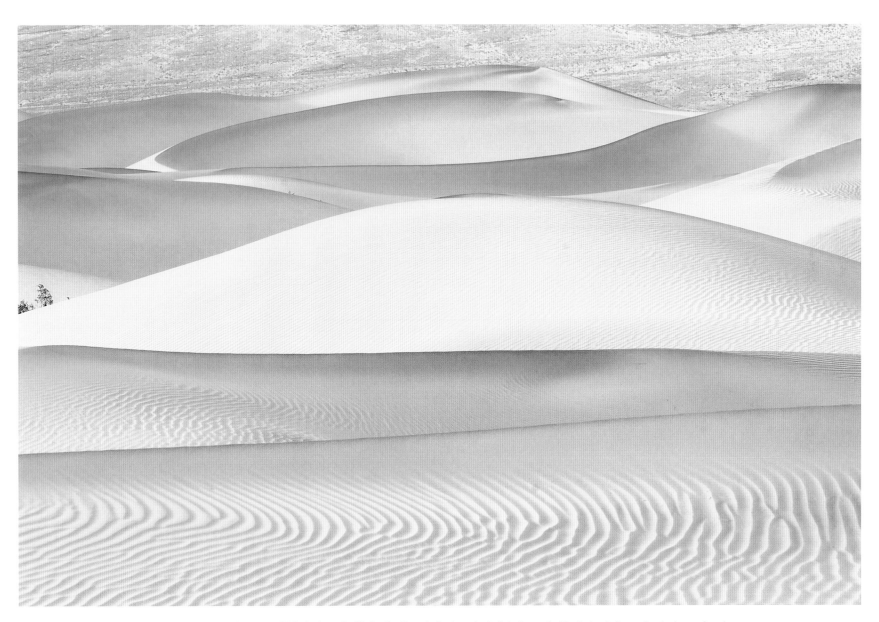

(b) An unruly cloud covered the sun momentarily reducing the contrast. While the image is still pleasing, the reduction in contrast eliminates much of the texture in the overlapping layers of sand.

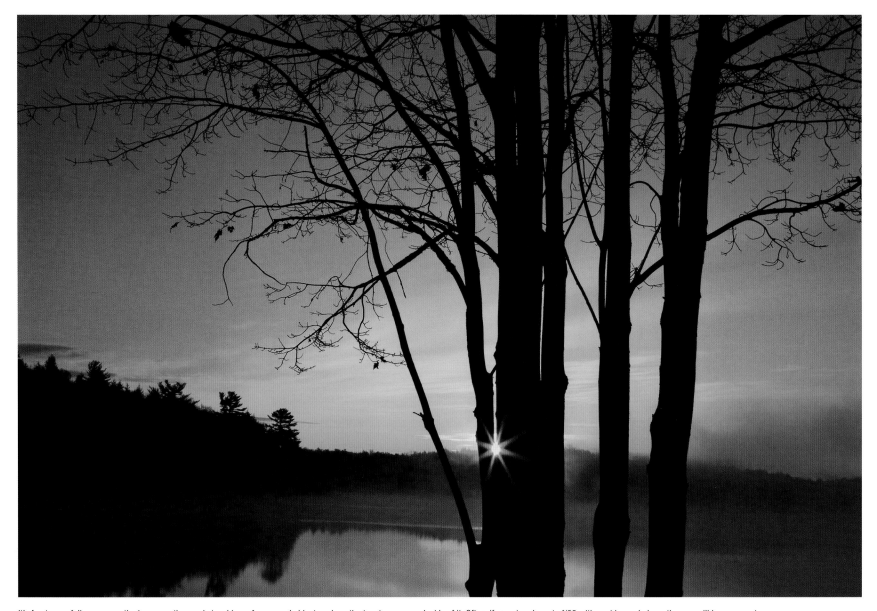

It's fun to carefully compose the image so the sun is touching a foreground object such as the two trees on each side of it. Often, if you stop down to f/22 with a wide-angle lens, the sun will become a star.

IT'S ONLY DIGITAL

Your landscape images will improve if you use more side- and back-lighting early and late in the day, when the color of the light is most favorable. Always remember that there's no film cost and no processing cost when shooting digital images. Take lots of chances and play extensively with the light, even when you think it may not work. You're certain to expand your knowledge of the role of light, which you'll be able to apply it to your landscape shooting, and you'll most assuredly capture many remarkable images to cherish. *It's quite routine for the serious photographer to delete many more images than she keeps!* A *National Geographic* shooter once remarked during an interview that he had shot about 15,000 images for one article, and only a half-dozen or so were ultimately used. That's about one-half of one-tenth of one percent! Oh yes, he's a very successful photographer. Even your authors might be just a bit chagrined by throwing away that many, but we'd bet that his *keepers* were potential Pulitzer winners!

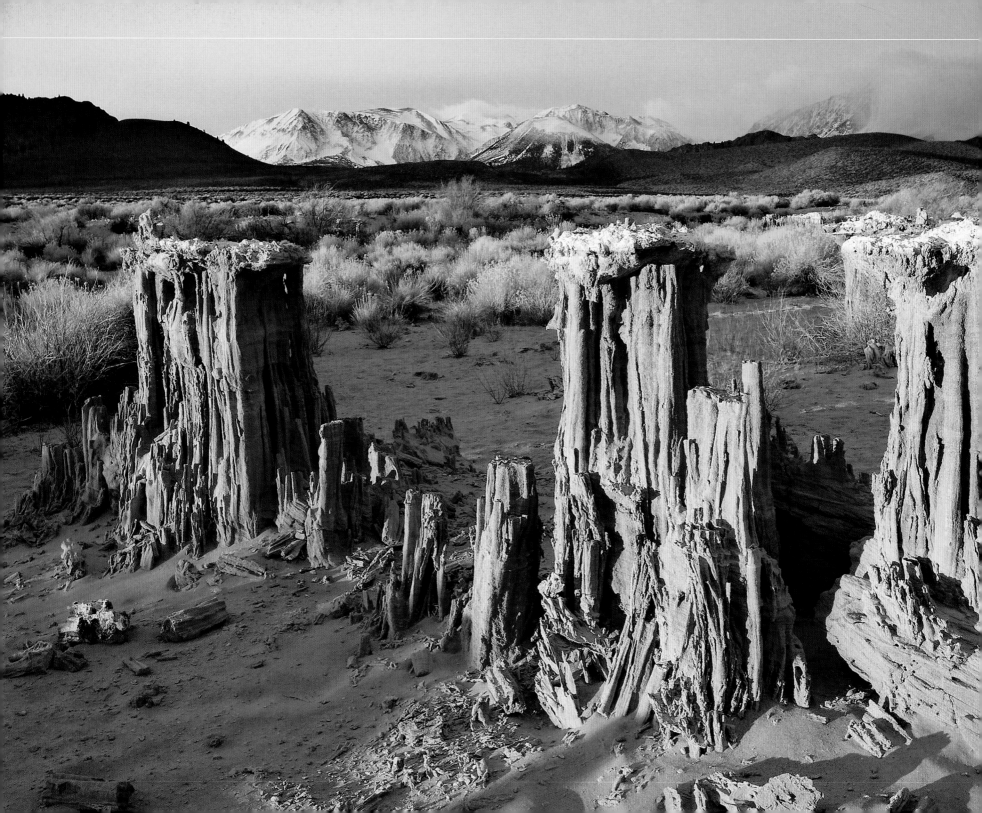

Composing Pleasing Images

WHAT IS COMPOSITION?

Composition is the thoughtful and meaningful placement of carefully chosen elements of a scene into an image of that scene. Good composition uses the effective selection and arrangement of the elements of a scene to present a visually pleasing image that tells a strong story. Composition combines several important elements: subject selection, object placement, camera viewpoint, perspective, leading lines, pattern, line, form, and image orientation.

Most photographers naturally concentrate on how to include and arrange the key elements of a subject, but the more experienced shooter never forgets that the exclusion of certain elements can be equally important. Beginners tend to include too much in the image, which often produces cluttered and chaotic scenes that aren't pleasing to view. An effective guideline (but not a rule) is to simplify the scene. When in doubt, try framing the scene tighter.

WHY IS COMPOSITION SO CHALLENGING?

The decades of our long photographic careers have allowed us to develop certain compositional skills, and we've been privileged to teach them to more than 4000 field workshop students. From this teaching experience, it's clear that everyone can learn to compose more effective images, and some of our students are naturally more gifted at it than others. Many of our students make an early error by thinking they have an inherent ability to see wonderful images and that composition is easy. They believe the hard parts of photography are getting excellent exposures and sharp images. Those students are convinced that if they could only learn the mysterious science of photography, the artistic considerations are so simple that they'll rapidly transform into the complete photographer they long to be.

We wish that learning to make good compositions was easy, but it isn't. In our case, we long ago mastered exposure, how to shoot sharp images, and how to use the camera effectively

These sand tufas at Mono Lake grab your attention immediately. Eventually, you look past them to the sagebrush desert and finally travel all the way to the snow-capped Sierra Nevada Mountains in the background. This is a good use of foreground, middle ground, and background to complete the composition.

to handle any subject. We've learned, though, that technical skills are the easy part of nature photography because our abilities to recognize memorable image opportunities and our compositional skills steadily continue to develop and will most likely do so for the rest of our photographic careers.

So, how can we help you develop your eye to see wonderful images in the scene in front of you and for composing them into effective and pleasing photographs? Our first request is that you don't assume you're already sufficiently gifted at seeing or composing good landscape images. You probably can still learn a lot and so can we, but we can hopefully help you to easily and swiftly improve your skills and expand them over the years to come.

Composition is challenging because it's highly subjective and the typical scene is filled with related and unrelated elements. There are so many ways a scene can be composed. Who can really say what makes the best composition? It depends on the photographer and eventually the viewer. There are no compositional rules that work all of the time and no recipes to follow. In our opinion that's what makes composition more difficult than exposure or sharpness. An image is either well exposed or not. An image is either sharp or not. Sure, you can like a soft image and even shoot some on purpose as we sometimes do, but we all agree they're not sharp. We almost always agree on those things and there's little room for personal preferences — either it is or it ain't.

Not so with composition. Composition offers endless possibilities. A few simple rules of thumb can help here and there, but there are no bright-line rules defining right or wrong. We must individually strive to please ourselves by finding our own way of selecting scenes and composing them out of the seeming chaos of nature.

TIPS FOR MAKING PLEASING COMPOSITIONS

Let's agree right now that there's no formula for consistently shooting good compositions. But there are several guidelines that can steer you away from mistakes and help you obtain well-composed images. Please notice that our suggestions are only guidelines and not rules. All composition *rules* can be broken from time to time with pleasing results.

DECIDE WHAT'S APPEALING ABOUT THE SCENE

As you observe the landscape before you, decide what attracts you to the scene. Is it the reflections of autumn maple trees in a still pond? The repeating curves of sand dunes? The flow of the water as it cascades down a rocky slope? The solitude of a lone person kayaking on a foggy lake in the light of dawn? Or is it, perhaps, the loneliness of a weathered old cabin surrounded by snow-covered mountains?

Your mission is to mercilessly eliminate each and every extraneous object that is unnecessary to the story you want your image to convey. In a word — simplify! Your first task is to decide just what parts of the scene appeal to you. Then compose those parts into your image while ruthlessly rejecting every non-essential or distracting element from the edges of the frame. Seek a slight improvement by pointing your camera a little to the left. Or to the right. Move your tripod a bit sideways, even a little bit. Move it the other way. Raise it. Lower it. Zoom in. Out. Use a larger aperture to defocus those ugly dead leaves on the tree in the background. Hide that obnoxious fence post in the middle of the scene behind a convenient tree. If you don't gotta have it, get rid of it!

AVOID CLUTTER

Photographers weak at composition tend to shoot cluttered images that include too many non-essential or distracting objects. A careful selection of the shooting angle, zooming more tightly, and moving closer will all help to avoid clutter. As an example, a fine image of a forest might require you to zoom in a bit tighter to eliminate a road or ugly wire fence from the image. Sometimes it's necessary to eliminate ugly light, too. Photographers know that a viewer's eye is first attracted to the brightest areas of an image, so we could wisely elect to deliberately exclude a small part of a forest waterfall too brightly lit by an intruding ray of sunlight. It's not only a compositional concern, but eliminating the bright part of the waterfall may also help ensure that the scene's contrast doesn't exceed the dynamic range of the camera.

Some photographers refuse to compose tightly, because they can subsequently crop the image during post-capture editing. This is easy to do, and we often do a small amount where necessary. Cropping can produce a fine image, but it has a potential drawback. If the cropping discards a large quantity of pixels, there may not be enough remaining for

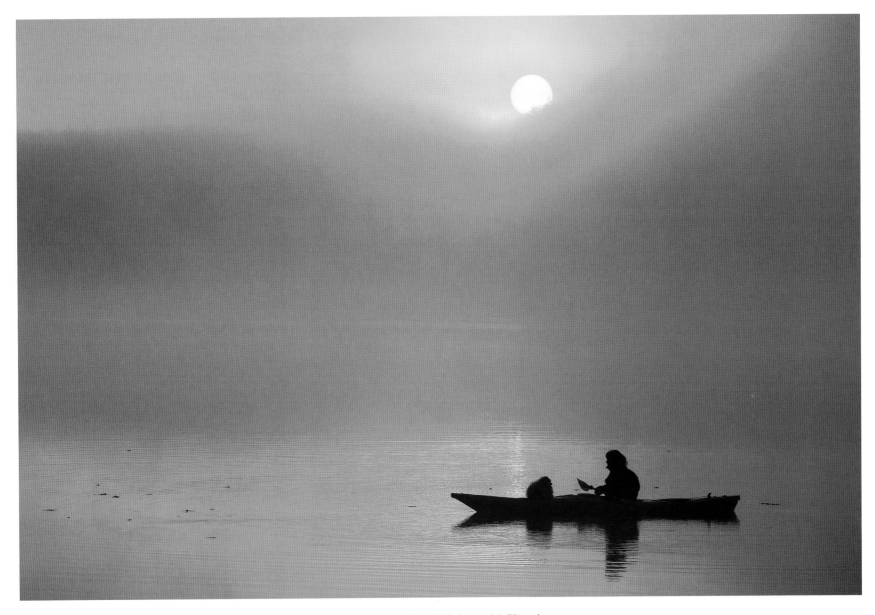

Many fine landscape images are simple in design, but they work beautifully. Barbara and her dog (Yogi Bear) immediately draw you into this sunrise scene.

a high-quality print. However, for smaller prints, or for Web applications, moderate cropping is generally acceptable. It's your choice. Our choice? We believe that the best procedure is to compose tightly and carefully in the camera so that little further cropping is needed.

COMBINE ELEMENTS THAT WORK TOGETHER

This is another guideline that helps you avoid clutter. Concentrate on and compose only those elements of the scene that really go together. Compose a section of an autumn maple forest so that the colorful leaves hanging on their branches are supported by a nice tree trunk. Avoid distractions like sky hotspots peeking through the leaves, roads, trails, fences, and telephone wires. We're not saying that it isn't possible to make a nice autumn image that includes a fence; just make sure it's a truly photogenic fence and one that leads your eye through the scene. One example may be a weathered old split-rail fence that starts in a lower corner of your image and extends diagonally through the image to an important element of the scene in the upper opposite corner.

Otherwise, compose the image so the fence is excluded. However, we realize some distracting elements can't be removed from the scene because of their location. We have a mountain near our home that we refused to photograph for years, because an air traffic control radar station is perched on the very peak. Today radar stations are easily obliterated (from photographic images!) by the power of the digital darkroom. Jet contrails streaking across the sky are also easily eliminated, so a photographer can take small liberties from time to time, knowing things can later be fixed with editing software. Still, it's wise (and always our goal) to shoot the finest possible image with the best

The trunk and branches of this red maple tree support all of the beautiful leaves. To capture this sort of image, you need terrific autumn colors, bright overcast light, and absolutely no wind. We didn't know it at the time, but we should have shot another image that had two stops of additional exposure. Then we could have run it through HDR to get more color and detail in the nearly black tree trunks.

composition in the camera so little must be done after the fact.

HOW BIG SHOULD THE MAIN SUBJECT BE?

There's no rule here, either. It all depends on the subject matter and what story the image should tell. Perhaps you're photographing the famous old Methodist church in the ghost town of Bodie, which lies north of Mono Lake in eastern California. You could fill the frame with the church to show off the detail in the old wood or you could make the church much smaller in the image to show it in context with the other buildings of Bodie. Either choice can make a fine composition.

Most of us do fill the frame with a waterfall because it's the dominant feature of the scene. It's effective to show a close-up of the waterfall so you can easily see how the water so splendidly tumbles over the rocky outcrop. But it's equally effective to compose a waterfall small in the image. One can use a wide-angle lens to shoot from 10 to 30 yards downstream, letting the river lead the viewer's eye up to the waterfall in the background.

HORIZONTAL OR VERTICAL ORIENTATION

Decide whether your selected scene will work better as a horizontal or vertical image. It isn't always an easy decision. Some scenes suggest a horizontal treatment. Reflections along the opposite bank of a lake work well as horizontal images and so does a sweeping expanse of undulating dunes. Most waterfalls and tall buildings suggest vertical compositions.

As a rough guideline, consider main objects that are much taller than wide to suggest vertical images and subjects that are much wider than tall to suggest horizontal images. Beginners (including us in our earlier years) tend to shoot too many horizontal images because they think that it's easier to work the camera horizontally and forget about vertical possibilities. In fact, cameras are designed to be equally effective horizontally and vertically and should always be oriented to best accommodate the important elements of the scene. Most of us, however, must work hard at breaking that bad horizontal-only habit. The skilled photographer can compose the majority of scenes either horizontally or vertically, and with equal success.

Let's consider an autumn reflection scene. The opposite side of a small lake, in dawn's unruffled waters, showcases the reflections of gorgeous autumn foliage. The more interesting part of the reflections is wider than tall, so a horizontal image is suggested. Maybe, though, you also notice an attractive area of the lake filled with pretty reflections of extra bright leaves or perhaps with the crisp reflection of an outstanding birch tree, either of which can nicely fill a vertical frame. Don't hesitate to change your camera to a vertical orientation. (And don't forget to re-polarize.)

Nothing, we repeat, is cast in stone, and many expansive horizontal landscapes can be successfully composed using tight vertical sections. Conversely, oftentimes very tall objects that scream for a vertical composition can work well as a loose horizontal. Explore the opportunities by attempting to find effective compositions both ways.

LEVEL THE HORIZON

Too many landscape images are marred by a tilted horizon. A lake is flat and its surface doesn't slope down in either direction. Images with tilted water horizons always suggest that the water is about to flow out! With or without water, it's good practice to pay extra attention to keeping the horizon level. We both use grid screens in the viewfinder (they replace the original screens in our high-end cameras) to assist in keeping horizontal lines horizontal and vertical lines vertical. If you can't replace

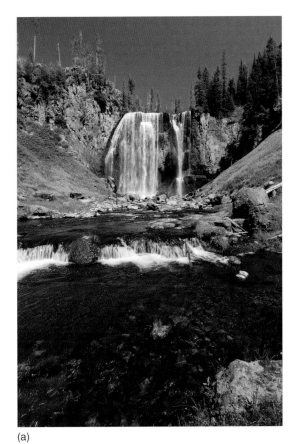

(a)

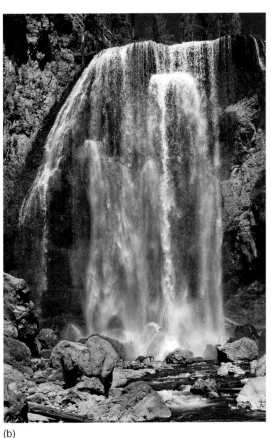

(b)

(a) Most subjects like Dunanda Falls can be photographed well from the same spot with different lenses. This wide-angle shot was taken with a Nikon 12–24 mm zoom at the 12 mm setting to include plenty of foreground. The crop factor for the Nikon D300 is 1.5×, so it's equivalent to an 18 mm lens on a camera with a full-frame sensor. (b) Here's Dunanda Falls shot from the same spot with a Canon 24–70 mm lens set at 65 mm and a Canon 1Ds Mark II. This camera has a full-frame sensor. These images show the differences in lens coverage you get between an 18 and a 65 mm focal length.

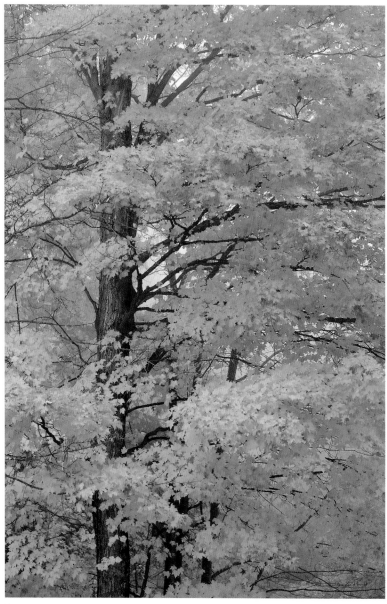

(a)

(b)

(a, b) Always look for a horizontal composition in an obvious vertical and vice versa. Many scenes can be successfully framed both ways! Notice how we use the tree trunks and branches in each image to support the leaves in this foggy autumn maple forest. We like both compositions and our favorite varies from day to day.

distractions near the edges and, if so, compose more tightly to remove them or plan to edit them out later.

YOU NEED A STRONG CENTER OF INTEREST

All fine images have a center of interest, which could be a waterfall, an old barn, a natural rock arch, or perhaps reflections of autumn foliage. It's easy to think of the center of interest as the one dominant object in the image, but you could also have several dominant objects together, forming a repeating pattern. Shooting a landscape image of overlapping lines on the sand dunes actually fills the entire frame with the center of interest. In practice, most scenes have an obvious center of interest but, as demonstrated, there are exceptions.

CHOOSE THE BACKGROUND

Once you find that gorgeous scene and decide on the center of interest, consider what the background will be. Poor backgrounds ruin many images, so carefully choose how you frame the scene. For example, we enjoy photographing Michigan's beautiful beech-maple forests during autumn. We prefer overcast days for shooting sections of those very colorful trees since the soft lighting will give a low-contrast scene that doesn't exceed the dynamic range of the camera. Now, though, we must be concerned with keeping any sign of a bright and featureless white or gray sky completely out of the background. It would appear as an ugly blob with no detail. We're also careful to not allow any little patches of that bright sky to sneak in between the

This silhouetted conifer tree is carefully composed to be isolated from other nearby trees. Its shape makes a strong center of interest. The mountain background is chosen so plenty of dawn's reddest rays light the background. Back-button focus on the tree and expose for the mountain to capture this scene.

leaves, since the hotspots quickly kidnap a viewer's eye and become an unwanted center of interest.

RULE OF THIRDS

This rule as been around for centuries and was used before photography by painters and architects.

It was one of the first rules ning of our careers. We t while, but let's call it a gui Here's how it works. Imag into thirds, both horizont like a tic-tac-toe grid. The intersection, which some c *spots*, and this guideline the center of interest of yo of the four points.

This *rule of thirds* help ing the center of interest in the middle of the fram *bull's-eye* shots that so q Keep in mind, though, th guideline, or any guidelin boring if the technique is ony by occasionally stretc mechanically rely on nu Compose the image in a to you, and not necessar decide that the composit least it didn't cost anythi tion takes but a second.

PLACING THE HO

Conventional wisdom st should not exactly bis bull's-eye composition zon line that's always i gets dull. Here, though, horizons. If the sky is foreground, place the occupies more than hal

your viewing screen with a grid screen, use an inexpensive accessory level that attaches to the flash hot-shoe on the top of your camera. At least one camera, the Nikon D3, has a built-in *virtual horizon*, a firmware feature to help level the camera. Airplane pilots enjoy it because it looks just like a traditional flight instrument!

If your camera has live view capability, be sure to activate it. Live view lets you see your intended image on the LCD monitor before you shoot. Many cameras let you activate grid lines that overlay the live view image. One can line up a horizontal line of the scene with a camera grid line and be comfortable that everything is level. No matter how careful we are, sometimes horizons are tilted despite our best efforts. Most image-editing programs offer an easy method for post-capture leveling of horizons and alignment of verticals, so the forgetful shooter can relax a bit.

VIEWPOINT

Viewpoint refers to the camera's location with respect to a scene, so it's your selection of shooting position that defines the viewpoint. Unfortunately, most of us shoot standing up with the camera at eye level, so the viewpoint tends to be monotonous and, what's more, may not produce the best images. If shooting from eye level works best, then that's the viewpoint to use. However, another viewpoint often works better. Many successful photographers like to use wide-angle lenses and get very close to — or even lie on — the ground. These viewpoints can be excellent for subjects where you want to emphasize the foreground. For example,

they permit filling the foreground with wildflowers that form leading lines to the mountains in the background. A prominent, near foreground gives a sense of depth to an image.

Viewpoints above the subject can be good, too. Shooting down at a scene from a mountain ridge, a hill, or any other elevated vantage point frequently shows an unusual but pleasing angle to an image. You don't have to get very high for a good aerial viewpoint. At times, we use only a tall stepladder to achieve our aerial perspective. If you do that, clamp a ball head to the top of the ladder for camera mounting, and be sure to hold still when shooting.

PERSPECTIVE

Perspective is the visual effect of depth caused by the difference in the apparent sizes of foreground objects and background objects. Consider a scene with a flower in the foreground and a tree in the background. The perspective is determined by the ratio of tree size to flower size or, speaking more clearly, how large the flower appears compared to the tree, and it's determined only by the distance between the subjects and the camera. This effect is absolutely critical to establishing where the emphasis lies in an image. Many photographers wrongly think that viewpoint and perspective are the same. Definitely untrue. Viewpoint can be changed by raising or lowering the camera, or by side-to-side movement. *Perspective can be changed only by changing the distance from camera to subject.* (Geometricians will please ignore the insignificant perspective change caused by slight side-to-side movement!) Moreover, some photographers believe

that perspective is varied by changing lens focal length. Also untrue. Changing focal length will change what is or isn't included in the image, but the relative apparent sizes of foreground objects and background objects remains the same, so the perspective is unchanged.

Let's photograph a decaying home from the past century with mountains behind it. To illustrate perspective, we'll start by photographing the house in the foreground from a long distance and using a long lens. For our second shot, we use a slightly shorter lens and we keep the house the same size by moving closer. The shorter lens makes the distant mountains look a little smaller. We take a third shot with an even shorter lens, maintaining the same house size by moving closer still. Again, the apparent size of the mountains diminishes. We keep shooting, moving closer and closer and using shorter and shorter lenses to hold the house size constant. The old saying says that if you keep doing what you always did, you'll keep getting what you always got. To the contrary, in our case, we kept going closer, kept using shorter lenses, kept the same house size and, beyond, we kept getting smaller mountains. The changes to the relative size of the foreground house and background mountains are changes in perspective. This example shows that, for a more dominant background, you stay far from the foreground and use a longer lens and, for a more dominant foreground, get closer to the foreground and use a shorter lens.

It's the perspective of an image that produces the pleasing effect of a large foreground element visually leading the viewer's eye right to the main

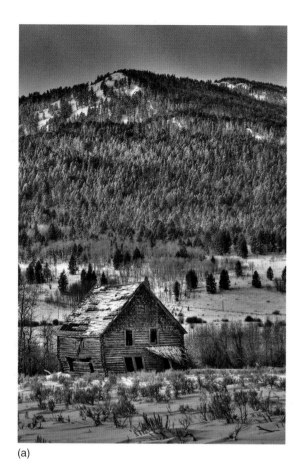

(a)

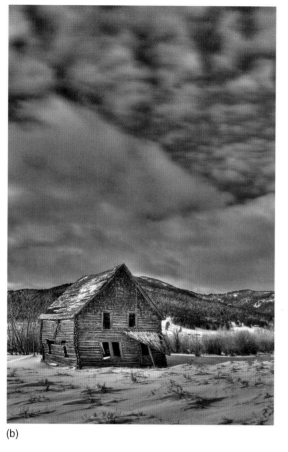

(b)

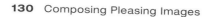
(a, b) This charming old cabin fr
defy gravity. We began photogra
focal length and slowly snowshe
In each image, we kept the cabi
position in the composition. Lo
Did you notice how these mo
cabin, which doesn't? What you'
important concept that's widely
who falsely assume viewpoint
Viewpoint is determined by whe
viewpoint without changing the
movement, for example. Perspe
the size of the foreground to tl
can only be changed by physic
closer or farther away from the
dominate the image, such as tl
a longer focal-length lens. If yc
close to the foreground and use
images carefully. This is an im
these cabin images were made

you completely unders
that changing your sh
relative sizes of the for

FRAMING THE

Decide, as you view th
the horizontal or vert
sense. Carefully choo
from which to shoot tl
edges of the frame fc
able objects or hotspo
elements by changi
length, or distance. T
fessional DSLRs displ
but the viewfinders
unfortunately show c
image. With those car
edges of the scene ma
tions appearing in th
ing your camera arou

subject in the background. Our cliché scene is the beautiful flower prominent in the foreground, with a small but pretty waterfall way in background. Get that image by getting close to the flower with your short lens. It's likewise the effect of perspective that gives us the ominous image of the helpless little prey animal in the foreground visually overwhelmed by the massive and snarling grizzly looming in the

background. Get that one by moving a long way from the scene with your long lens. Come to think of it, maybe you should be even farther from that scene and not worrying about perspective!

Consider reading this section on perspective again. It's vitally important to the success of your images and in developing your creative eye that

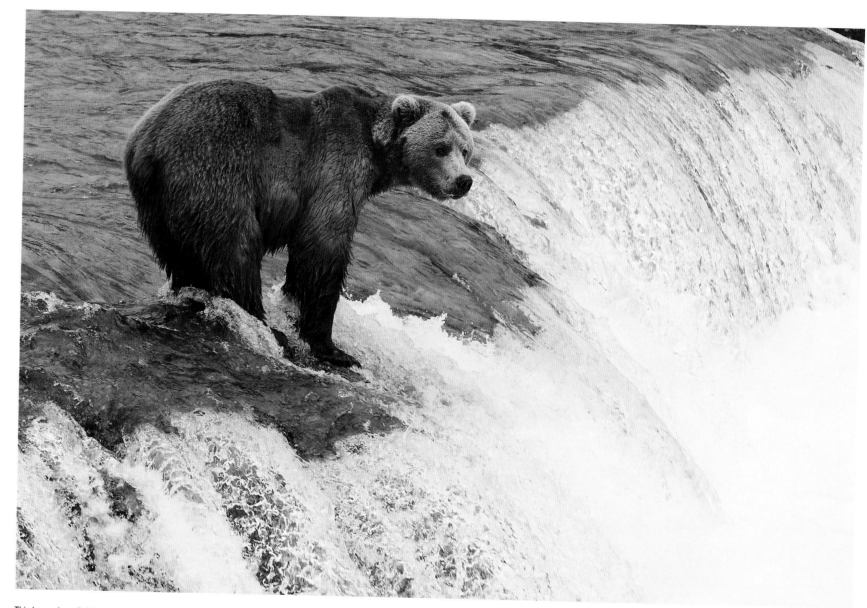

This brown bear fishing for salmon atop Brooks Falls at Katmai National park in Alaska is composed using the "rule of thirds." We prefer to think of this "rule" as a guideline, although it does work often and well. The bear is placed at the top left power point because this position gives it more room to look into the frame toward the lower right power point. We like how the falls makes a diagonal that flows the opposite way.

foreground is more interesting than the sky, place the horizon line so the sky occupies less than half of the image. In both cases, avoid precise bisection. Place the horizon line so that the amount of sky is proportionate to its visual attractiveness. In the case of a particularly dramatic sky, include as much as possible, leaving only a little foreground, perhaps less than one-quarter of the image.

Remember, too, that not all images must include a horizon. And when overcast skies prevail, compose the image to completely eliminate that featureless bright blob, because it grabs the viewer's eye and belittles the intended center of interest. As the great movie producer Sam Goldwyn might have said, exclude it out!

In spite of our previous admonitions, occasionally a mid-image horizon does work nicely. Perfect mirror reflections of landscapes bathed in golden light can be very appealing with the horizon in the center of the image. Panoramas are another case. Here, the horizon is best placed in the middle when shooting multiple images of a scene to make a single panoramic image. By doing this, there's less chance of inadvertently cutting off important elements, so the stitching process is simplified. One can always crop the top or bottom of the final panorama to deliberately move the horizon to a more photogenic position.

SHOWING DEPTH IN THE IMAGE

The images you view on your LCD screen or your computer monitor or project with a digital projector or showcase as a fine print all have height and width but no depth. The images are two-dimensional representations of a three-dimensional scene. You can't record the scene in three dimensions without very specialized photography gear, but it's quite possible to compose images that give a very strong feeling of depth.

USE THE GROUND

An easy technique to suggest depth in an image is to shoot a scene having a strong foreground, an interesting middle ground, and a helpful background. The foreground grabs your attention first and your eye then moves through the middle ground and finally works its way to the background. The different *grounds* lead your eye through the image suggesting depth. It's easier than you think to find scenes that meet these criteria, and it gets even easier with practice. Many people photograph mountains or interesting old buildings with nice skies in the background. These images, occasionally eye-catching as described, can often be enhanced by including a nice foreground object, such as a lush patch of wildflowers, a pretty pond with a frog, or perhaps a weathered old split-rail fence. You can move in close to the new foreground, emphasizing elements that draw you into the image and lead your eye to the middle ground, which is the mountain or building. Your eye then naturally moves to the background's distant sky, the last element contributing to the sense of depth. The image is surely two-dimensional, but its sense of depth is very strong.

USE WIDE-ANGLE LENSES

An effective way to suggest depth is to use a wide-angle lens close to the foreground. This method creates a very prominent foreground that grabs a viewer's eye and leads it farther into the image. Early in our careers we seldom used wide-angle lenses, much to the detriment of our images. Don't make the same mistake. Use your wide-angle lenses often. These days we frequently use lenses between 15 and 20mm close to the main subject to capture that wonderful foreground that so insistently invites us farther into the image.

The close-in-and-wide-angle technique for implying depth works particularly well when the elements of the scene are similarly sized. Think of a wide expanse of flowers in a large field, or of a long stretch of white-capped waves crashing onto a beach. The flower image will show apparently large flowers prominently in the foreground and seemingly much smaller flowers way in the background. The wave image likewise has the apparent disparity of sizes.

SHADOWS

The effective use of shadows does wonders for suggesting depth. Light is critical to the use of shadows, as exemplified conversely by the flatness caused by scarcity of shadows under a heavy overcast. If the light comes from directly behind or nearly directly behind the photographer, there will be few and smaller shadows, because the bulk of the shadows will be invisibly behind the objects that cast them. Some subjects, such as sand dunes, snowy landscapes, and foggy scenes enjoy an enhanced sense of depth from the texture and the shadows brought out by side- and back-lighting.

We especially enjoy photographing the patterns of the sand dunes found in Death Valley National

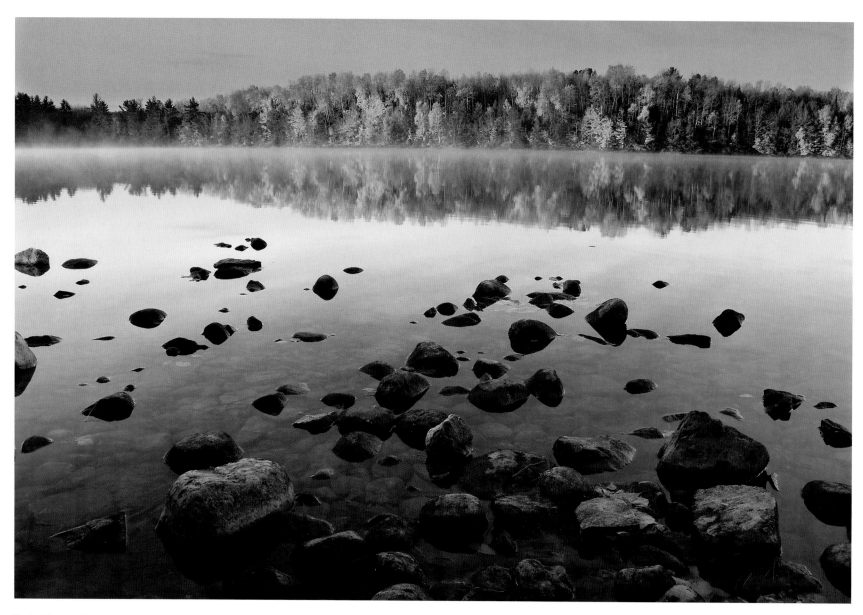

You feel the great depth right away in this scene, even though the image itself has no depth at all. Place the horizon of Moccasin Lake near the top of the image. Use the prominent stones in the foreground to draw you into the scene on a visual journey that leads to the exquisite colors in the background. This perspective is easily achieved by using a wide-angle lens only a few feet away from the foreground.

Park. The flat light of a cloudy day, though, makes it difficult or impossible to depict the depth and texture of the dunes, so we always plan to shoot the dunes when they're bathed in the warm sunlight of early or late day.

CONVERGING LINES

In any scene, approximately parallel lines that originate in the foreground and flow toward the background will converge like the rails of a receding railroad track, thus suggesting depth. Examples include roads, trails, the aforementioned railroad tracks, rivers, and shorelines that lead away from the camera. All of these subjects are opportunities to use converging lines to suggest depth in an image.

LEADING LINES

Some landscapes have a single dominant leading line that begins in the foreground and leads your eye to a center of interest in the background. Look for and use any strong lines that lead the viewer's eye toward the image's center of interest whenever you can. Fences and streams are often used as leading lines.

CURVES AND PATTERNS

The famous "S" curve of a meandering creek is frequently used to make pleasing compositions. S curves are a bit of a cliché, but they frequently work well, so don't hesitate to use them in your landscapes.

Many scenes present the observant photographer with several curves that might be included in an image, rather than the common single S curve. Here we'd suggest that the shooter move in closely or zoom tightly to assess the visual merits of including lots of curves or even all of them. It may be difficult, when shooting a series of curves, to strictly apply our foreground-to-midground-to-background guideline, but filling the image with a series of curves makes a pleasing image and can be thought of as an intimate landscape.

WORK THE SUBJECT

When you've found a potentially pleasing subject, be sure to spend plenty of time working all of its possibilities. There may be many. Explore multiple variations of every shooting parameter: different viewpoints, different perspectives, varying apertures to manipulate depth of field and selective focus, faster and slower shutter speeds for depicting movement, changes in polarization of glare and skies, and vertical and horizontal orientations. It goes on and on. Moreover, if you come back tomorrow when the light has changed, there'll be an equally large and uniquely different collection. Somewhere in that unbounded array of possibilities lies an image to make you proud!

In our opinion, this tip is unarguably the most important that we can offer for making memorable images, so please take your time to absorb what we say here. Let's use an example to illustrate this crucial point about working the subject. For more than 20 years we have taught nature photography field workshops in our beloved northern Michigan. We take every workshop to Au Train Falls, which means we have guided nearly 3000 people to this *underwhelming* waterfall. That's not a typo, and an image of the overall falls is true to the subject — underwhelming — except during spring runoff when the water is high. When we visit the falls with our summer or fall workshop participants, the river is always low, with only a few inches of water in the deeper parts, and the edges are bone dry.

Au Train falls is actually a long series of small cascades. It's fun to photograph because, when wearing rubber boots, it's easy and safe to walk on the sandstone river bed searching for attractive compositions. This way you can get in close to the small cascades with a wide-angle lens. Shooting from right in the river makes it easy to capture images of the water flowing directly toward the camera. Several of the small cascades can be shot at close ranges, as close as 2 feet, and from many angles it presents endless compositional choices in an otherwise unexciting waterfall.

We're going to temporarily abandon any attempt at diplomacy and come right out and tell you that, in our experience, amateur photographers don't extract anywhere near the actual potential of a subject. They remain rooted in whatever spot they started in and, for whatever reason, just don't move around. Setting up the tripod in some spot and doing all of your shooting in that one place is a major mistake! It's a huge mistake! It's a stupendous mistake! It's a … well, you get the idea. You have to move frequently to work most subjects well.

We probably won't be shooting much at Au Train Falls, having been there so many times, but if we were shooting at a less familiar waterfall, we'd be moving around more than a hungry weasel

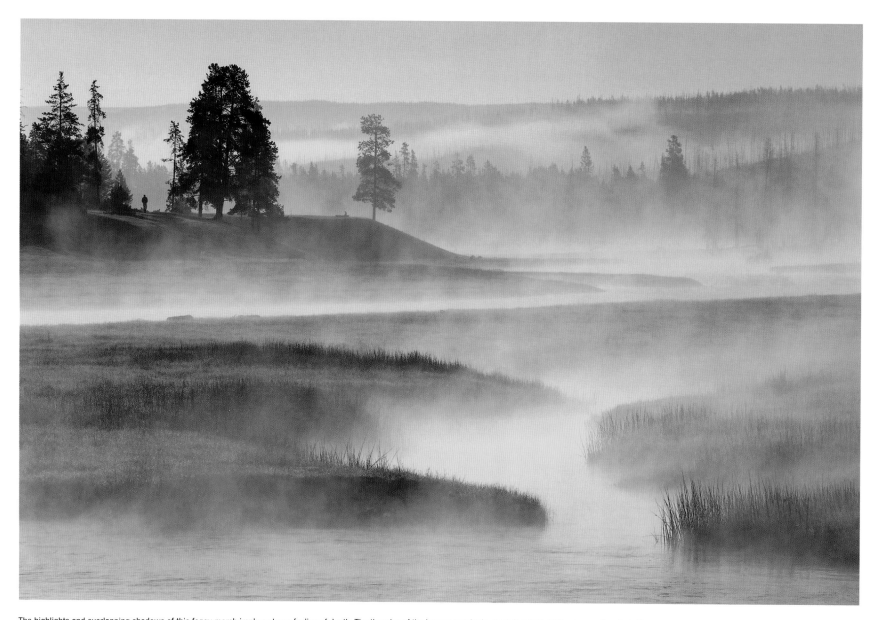

The highlights and overlapping shadows of this foggy marsh imply a strong feeling of depth. The tiny size of the lone person in the top left corner adds a sense of scale to the scene.

These railroad tracks wander through miles of remote northern Michigan forest. From a highway bridge, we shot down on the tracks for an aerial viewpoint. The converging tracks in the distance impart a strong sense of depth.

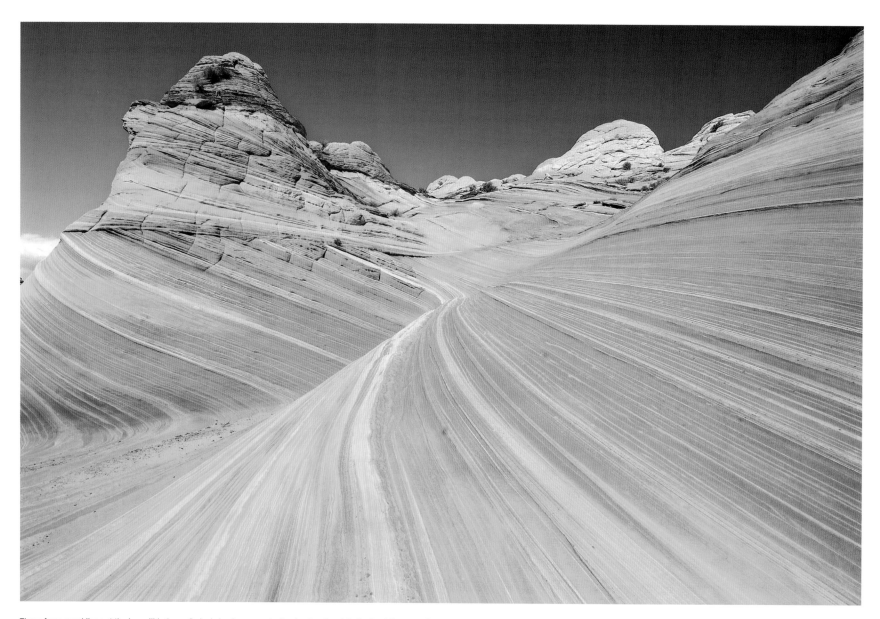

These foreground lines at the incredible "wave" nicely lead your eye to the dominant rock in the top left corner. Once again, we used a wide-angle lens to produce this wonderful perspective.

This fine image by Dan Pater, one of our "editing commandos," was taken during a Michigan autumn color workshop. We're always inspired by our talented students, and love his exquisite use of a wide-angle lens and careful composition to include a sunstar in the scene. It's an unexpected image — in a fall color workshop — because there's no fall color in the scene. Leave it to Dan to find a terrific image at the peak of autumn color that has no color.

the restaurant — prematurely abandon high-value photographic targets long before they discover the best compositions.

ALWAYS STRIVE TO IMPROVE YOUR COMPOSITION SKILLS

An effective composition is an essential component of every successful image. It doesn't come easily for most, but everyone can improve their skills if they don't assume to already know enough and constantly work at it. Developing your eye to recognize good image possibilities is an ongoing process that you can practice year after year. In our case, we don't get much better at shooting sharp images or exposing the scene, but we continue to improve at seeing and composing images. Even after working a subject as completely as we know how, we still wonder what incredible images were present that we failed to see. Every year we have a few students make a composition that is totally unique at a location previously visited by 3000 students, so we know it can be done. The key is to slow down, take lots of time, and carefully study every scene for its photo opportunities.

Some good image possibilities just can't be seen. Consider, for example, foam floating down a river or autumn leaves swirling in a small whirlpool on the surface of the stream. We can see that those subjects are moving but, no matter how experienced we are, we can't see what neatly intricate patterns they might make with a long exposure, say two seconds or more. Why not? Because we can't see the patterns they make over time, but our cameras can capture the path of this motion with long exposures.

chasing mice in a woodpile. We'd shoot it from the river, from the right side, the left, from the top, the bottom, and maybe even from the back. We'd spend hours, not minutes, photographing it from this angle and that, from this height and that, and we'd make dozens and dozens of compositions. We'd use several different lenses and we'd shoot different shutter speeds in each composition to vary the look of the flowing water. We'd polarize a little and we'd polarize a lot. We'd try vertical and

horizontal compositions. Can it be a panorama? We would shoot some HDR sets of images and use fill flash to freeze water drops. We'd leave little untried and most likely walk out in the dark!

We just can't stress it enough. Far too many potentially good photographers — sometimes technically sharp but artistically still-learning photographers, sometimes photographers anxious to get to the *better* place just down the road a piece, sometimes photographers anxious to meet their pals at

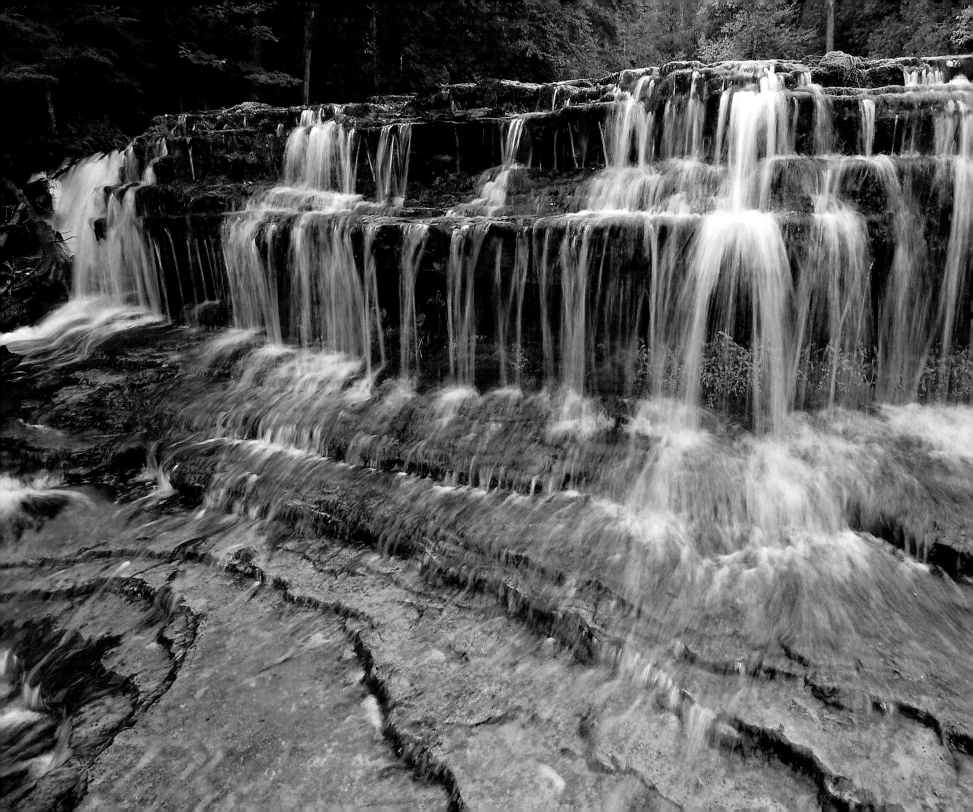

8

Special Subjects

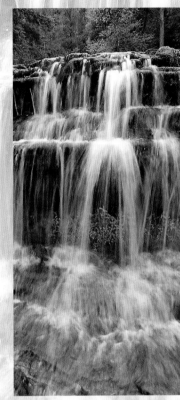

We're fortunate to have spent decades photographing our favorite subjects year after year. We have photographed the gorgeous autumn color of Michigan's Upper Peninsula every year since 1985. Waterfalls are always appealing to photographers, and snow offers its own special magic to the landscape. Kayaks work exceedingly well for photographing many wetland habitats and everyone loves the red light of sunrise and sunset. These topics are all specialties for which we have developed numerous shooting strategies to ensure photographic success. Let's cover each subject in more detail so we can share some of our observations and strategies to help you capture dazzling images.

USE BOATS TO PHOTOGRAPH THE LANDSCAPE

Let's face it, some spectacular landscapes just can't be photographed from land. The incredible colors and patterns of the sheer rocky cliffs along Michigan's Pictured Rocks National Lakeshore are a perfect example. The cliffs face northwest and they can't be shot from the nearest land, Grand Island, because it's miles away. The water abutting the cliff face is more than 12 feet deep, so setting up a tripod in the water is out of the question. This colorful shoreline must be photographed from a helicopter or from the water, and shooting from the water is much less expensive when you're accompanied by 18 students!

Au Train Falls is superb for giving our students the opportunity to practice their compositional skills. The water flow is low during the summer, so it's easy to walk on the sandstone in the shallow river, making it possible to photograph the cascading water from the middle of the river. We used a wide-angle lens to properly frame the leading lines in the foreground and were careful to eliminate all white sky above the falls.

Let's cover the strategies for successfully photographing this colorful shoreline, which can easily be adapted to your own situation. First, consider the light. The most colorful sections of Pictured Rocks National Lakeshore face the northwest, so at dawn the cliff face is in shadow and the colors are muted and dull. Early afternoon sun begins to light the face of the cliffs, but the small overhead sun causes high contrast, glare on the wet rocks, and washed-out colors. It ends up that the only good time to photograph those exquisite colors is the last 2 hours of a sunny day, in the low-contrast golden light. The time of the year matters, too. Remember that the cliffs face northwest. The sun sets farthest north during late June, so more of the cliffs are illuminated by the sun from early June through mid-August. Then, from September through early

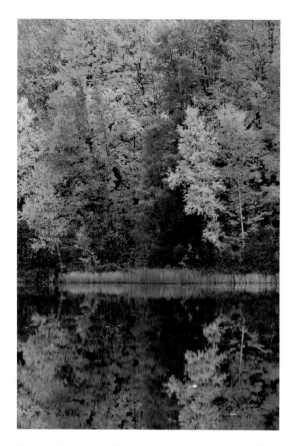

Some kayaks are designed to be exceedingly stable. They're terrific for photographing autumn color reflections and other nature subjects that can only be captured from the water. Use short lenses, use a bit higher ISO such as ISO 200 or 400, turn on vibration reduction if you have it, use more intermediate f/stops such as f/11, and brace your elbows on your knees to ensure sharp images.

May, much of the cliff face is in shadow during the late day because, in those months, the sun is setting farther to the south.

To shoot the cliffs you have to be there at the right time of year and at the right time of day, in the right weather, and on the water. Use your own boat, canoe, or kayak, rent a private pontoon boat in the nearby town of Munising or, alternatively, take a Pictured Rocks cruise ship. The cruise ships depart Munising several times each day, so enjoy the best light by taking one that runs during the last hours of the day. Don't attempt to photograph the cliffs if there's a north wind, because the lake is too rough. Even if you've long had your sea legs, you'll still want calm water to help get sharp images. Many summer days have light winds, so there's a good chance you'll get lucky. A gentle breeze out of the south, east, or southeast is no problem, because the cliffs block the wind along the shoreline and the water is reasonably calm.

There's no reason to use a tripod from a boat. It hinders your ability to shoot sharp images unless the boat is perfectly still, which is rare, because a camera on a tripod moves as much as the boat is bobbing up and down on the waves. You'll get sharper images if you hand-hold the camera, letting your body damp some of the motion of the rocking boat.

(a)

(a) Pictured Rocks National Lakeshore offers a multitude of fine images along the cliffs. Use your best boat shooting techniques and work the subject. Here we used a wide-angle lens to capture the grand landscape.

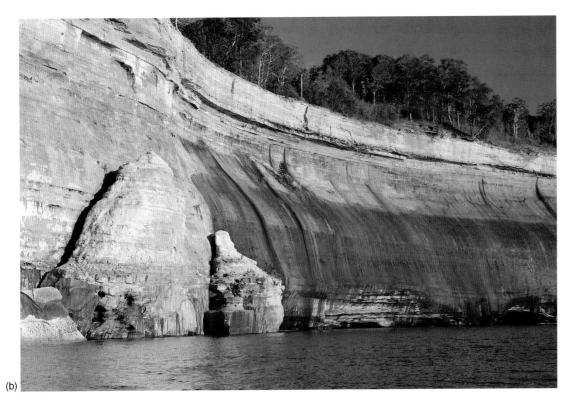

(b)

(b) We paddled closer to these two eroded rocks, using them as points of interest. We composed the scene so plenty of colorful stains from the minerals in the spring water trickling down the face of the cliff appear to the right of the rocks. At this oblique angle to the face of the cliff, we had to stop down to at least f/16 to cover the extended depth of the scene.

We always photograph the colorful face of the cliffs from our own kayaks when we're by ourselves, or from rented pontoon boats when we're leading a workshop. This gives us the control necessary to pick our distance from the cliffs and to stop in the most beautiful locations. We like to get within 20 yards of the cliffs so we can use a short zoom, such as a 24–105 mm or a 70–200 mm lens. The cliffs are colorful but very wet, so it's wise to use a polarizing filter. The polarizer will remove the glare from the rocks and enhance the rock details and the colors. However, the polarizer also absorbs about two stops of light and increases the difficulty of maintaining a high enough shutter speed to arrest the motion of the boat. The light loss also increases the difficulty of using a small enough aperture for the desired depth of field. Fortunately, the cliff faces are fairly flat, so the conventional shot doesn't require great depth of field. Many other shots do, however. The challenge to the photographer here is much like the challenge to a design engineer — how to juggle all the trade-offs to reach an acceptable result. A kayaking photographer shooting hand-held with a light-losing polarizer while he swings and sways in choppy bays is compelled to use every technological advantage he can squeeze out of his digital camera. Yes, he knows that the finest quality image comes from using his camera's native ISO speed, but that's just not in the cards right now. Now he makes a compromise. He trades off a tiny bit of quality by raising the ISO from its native speed up to 400, or 800, or maybe even 1600 or higher. He sacrifices a little quality and accepts a slightly noisier image, but he gains precious light sensitivity, which he can use for a higher shutter speed or a smaller aperture, or maybe both. He may consider this an easy trade-off, though. His modern DSLR allows higher and higher ISO speeds while still offering improvements in noise performance and overall image quality compared to the digital camera of only a generation ago.

Hand-held shooting is certainly the time for your vibration-reduction technology to pay for itself. Whether in the lens or in the camera body, it'll help considerably in getting sharp images. Your authors both use short zooms with image-stabilization. We try to maintain a shutter speed of at least 1/100 second, and prefer to use 1/200 second to be safe. As mentioned before, Pictured Rocks has a fairly flat face, so great depths of field aren't often required. Consequently, f/11 is adequately small most of the time, especially with short focal-length lenses.

If the water's rough offshore from the bluff, be sure to shoot enough. Shoot lots, and statistically

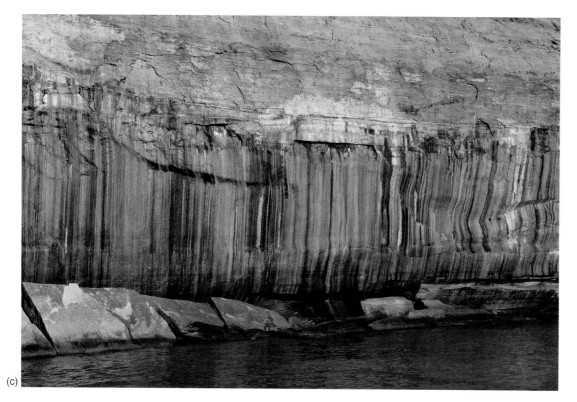

(c) Our kayak is gently rocking only a dozen feet from these vertical stripes on the stained rock. The rocks are wet, so we used a polarizer to reduce the glare, revealing the color and details underneath.

you'll get a few sharp images. Try to shoot right at the top or bottom of a swell, when the vertical motion of the boat is momentarily arrested. Increase your chances of a pleasing image by using your camera's *continuous* shooting mode, and fire rapid but short bursts at the tops and bottoms of the swells.

We use manual metering, the RGB histogram, and *blinkies*, all in the usual fashion, to arrive at the best exposure. Back-button (thumb) focusing and the continuous focus mode work quite well here. A boat is bound to be moving as you're photographing. Continuous focus mode will help ensure sharp focusing on the cliff face as the boat drifts to and fro. If your camera doesn't offer back-button focusing (nearly all Nikons and Canons do), then use continuous autofocus and use the shutter button.

We often use kayaks that are designed more for stability than speed. They're wider than the skinny sea kayaks, they aren't so tippy, and can float in very shallow water. Kayaks let you reach photogenic subjects easily when nothing else works. If the water is completely calm, as it often is on ponds and small lakes, we hand-hold as usual, but support one or two elbows on our knees to reduce camera shake. The features of modern equipment make it easy to shoot quality images from boats. We use our kayaks at every opportunity. The images obtained from the kayaks are unique and rewarding, and kayaks are just plain fun, too! Try it, you'll like it!

WATERFALLS

There's something special about watching and photographing waterfalls. We especially like the small woodland waterfalls that are a bit off the beaten track. We enjoy listening to their music and we wonder about the people who paused there centuries before us. We feel privileged to view nature's handiwork that has taken eons to carve itself into what it is today.

First, you must find the waterfalls. Many are on ordinary maps, and topographic maps often reveal others. Waterfall locations are frequently promoted by local governments to attract visitors and are easy to find. Indeed, there are many waterfall guidebooks. An Internet search for *waterfalls* and *state name* will surely bring forth the guidebooks and direct information on specific falls. Many national parks, such as Yellowstone and Grand Teton, have guidebooks just on the park's waterfalls.

It's irritating that some waterfall guidebooks are illustrated with such poor images of the waterfalls. Seemingly, their authors are good writers and love waterfalls, but many are inexperienced

Notice Barbara's technique of bracing both elbows on the kayak while she shoots on a calm lake. This reduces the problem of shooting unsharp images enormously. No matter how short the focal length or how high the shutter speed, always brace the camera on a solid object whenever possible. Sadly, most photographers we see who are shooting without a tripod fail to use objects when they're readily available to reduce camera shake, and their images often suffer terribly from this oversight. Of course, there are always exceptions. Sometimes it helps to let your body absorb some of the motion. If you must shoot from a boat in choppy water when the boat is bobbing considerably, then don't brace the camera on anything, shoot hand-held, use the fastest shutter speed you can, and hope for the best.

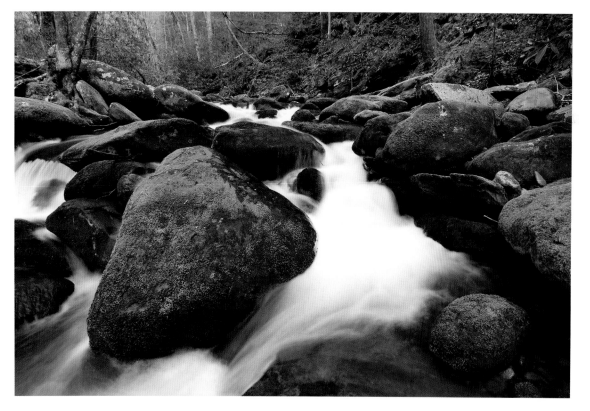

These tiny cascades in Great Smoky Mountains National Park photograph well in the soft light of a cloudy day. Use back-button focusing techniques (of course) to focus on the foreground rock, stop down to f/16 or f/22, and use the histogram to expose as far to the right as possible without clipping any white water that has detail.

it's possible for sunshine to light the entire waterfall. A case in point is Iris Falls along the Bechler River in Yellowstone National Park. Photograph this waterfall in the early afternoon of a sunny day and you'll have a wonderful rainbow, adding interest to your images.

Waterfalls mean water and wet rocks. Use polarizing filters to remove the always present glare from the wet surfaces to reveal the underlying color and texture. Our students tend to have trouble adjusting the polarizing filter when photographing waterfalls, because they have difficulty seeing the effect on the plunging water. Don't look at the water. Instead, look at the wet rocks along the margins of the waterfall. Turn the polarizer until the wet rocks are at their darkest. Wet rocks darken when polarized because reducing the glare permits their natural tones to predominate. The polarizer can also be easily adjusted at a waterfall by minimizing the glare of the water at the top of the falls, just as it spills over the edge.

Full-frame shots of waterfalls are the most common images, some suggesting vertical shots, and some suggesting horizontals. Whichever seems obvious, be sure to diligently look for the other. Zillions of photographers have already done the obvious. Be different!

Look for a way to legally and safely get close to the river, or actually into it, just downstream from a waterfall. From there a wide-angle lens and a low viewpoint will emphasize foreground water, logs, and rocks, while the river is a strong leading line taking the viewer's eye right up to the falls in the

photographers. They think that waterfalls photograph best in bright sunshine. Usually waterfalls bordered by trees and bushes require cloudy days to be photographed well. Trees and bushes cast harsh shadows when the falls are illuminated by direct sun, which can cause far too much contrast for a digital sensor to faithfully capture. Conversely, the soft light of an overcast day provides a far lower

and more favorable contrast. If you're traveling and can't wait for a cloudy day, maybe you can just wait for a friendly cloud to drift by and obscure the sun, or perhaps you can just visit the waterfall very early or late in the day before the bright sun shines on the waterfall and its surrounding vegetation.

Bright sun does work well on some waterfalls, though. In arid environments that lack vegetation,

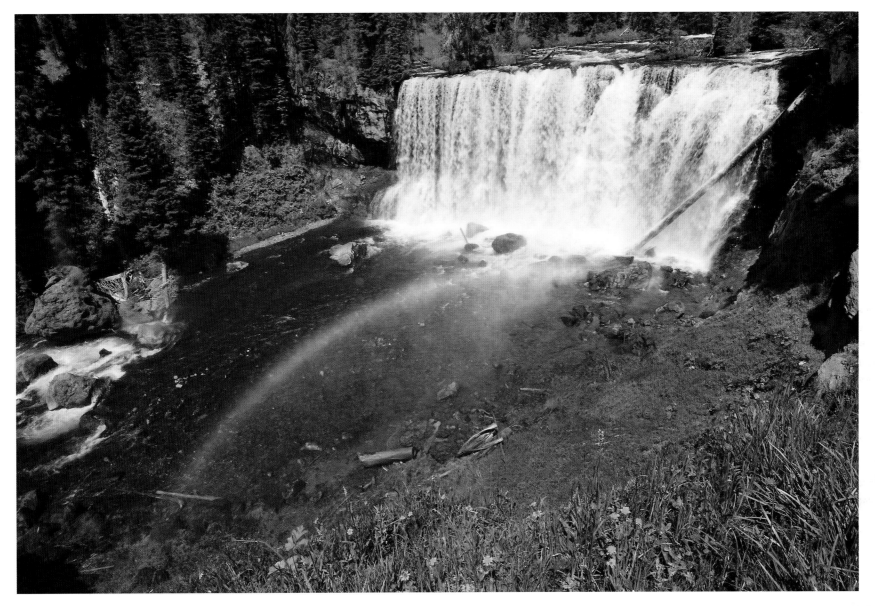

Iris Falls is a thundering waterfall along the Bechler River. Photograph it in late morning when an enchanting rainbow dances in the spray. While we find it's best to photograph most waterfalls in shade or on cloudy days, use sunlight when you can capture a rainbow in the mist.

background. Compose carefully to eliminate any white or gray sky from the background or peeking through the trees forming hotspots. Those bland skies record as bright distractions that can seriously damage an image.

At some waterfalls it's possible to walk deeper into the woods and frame the waterfall with trees, which can evoke a feeling of approaching the waterfall through the forest. Composing the waterfall so it's a center of interest, but still small in the image, is often effective and unexpected to most viewers in a pleasing way.

Most waterfall shots need plenty of depth of field, so we start by setting the aperture to f/16 and manually selecting a shutter speed to zero the exposure meter scale. We take a preliminary shot and check the RGB histogram to see which of the three color channels has data, no matter how little, farther to the right than the other channels. Then we readjust the shutter speed and shoot again to make the data closely approach, but not touch, the right edge of the graph. This technique ensures that the white water, normally the brightest part of the waterfall, isn't overexposed.

Sometimes, though, waterfalls have areas of white water without any highlight detail that needs to be preserved. We'll occasionally expose to deliberately clip such areas. The idea is that by giving up any attempt to get detail in those unimportant white areas, we move the entire histogram farther to the right, therefore improving the shadow areas by increasing detail and reducing noise.

Some scenes in some light have a contrast that exceeds the dynamic range of the camera, but we

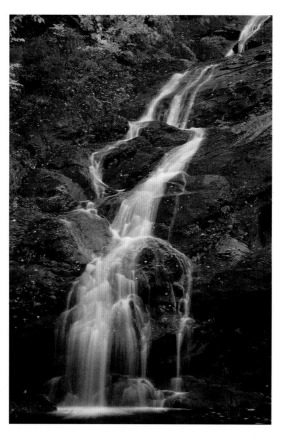

Waterfalls that make a series of plunges over a rocky cliff are often the most photogenic. This fine image is made by Al Hart, who helped tremendously in making this book more comprehensive and easier for you to read.

want to preserve both highlight and shadow detail. Waiting a few years for a later generation camera of higher dynamic range is generally not a good option, so instead we'll use HDR techniques. We shoot a series of exposures in one-stop increments. The first exposure has the highlight areas about one stop underexposed, and the last shot has the shadow

areas about two stops overexposed. All the images are merged into one final high-contrast image by the HDR software. Much more is said about the fabulous capabilities of HDR software in Chapter 9.

Waterfalls are little affected by reasonable winds, but the surrounding foliage can dance about in a most annoying manner, so it's better to shoot in windless conditions. The erosion of eons has caused some waterfalls to create their own canyons, and sometimes those canyons can be advantageous to the photographer. For example, a north-facing waterfall might block, or partially block, a south wind and thus render that wind photographically harmless. That's a point to consider on a windy day when deciding whether to travel to a particular waterfall. Also consider, that if a north-facing waterfall is facing a north wind, the so-called *Venturi effect* may actually increase the wind speed as it shoots up the canyon to the falls. That kind of wind can irritate even well-tempered waterfall photographers.

You probably want the rocks and surrounding vegetation to be as sharp as possible. Use a sturdy tripod and be sure to trip the shutter with a remote triggering device or cable release so your quivering body doesn't impart vibrations to the camera and cause soft images. Camera vibration can also be reduced by using the self-timer. A 2-second delay works well. We usually use our self-timer, rather than a cable release, when photographing waterfalls. Remember that a tripod in fast-moving water can tremble more than a soggy doggy. Try to set the tripod legs into calm water or, better yet, get them

(a)

(b)

(a, b) Rock River Falls is one of our favorites, especially after the peak of autumn color, when hundreds of leaves whirl about in the pool at its base. Always look for both vertical and horizontal compositions!

completely out of the water by placing them on protruding rocks or logs. A motionless tripod will help ensure the maximum sharpness from your lenses.

Don't forget about seasonal variations. Many waterfalls are most photogenic when the first heavy snowfall of the year covers the rocks, logs, and vegetation with fresh snow. Waterfalls surrounded by deciduous plants that turn bright colors in autumn are wonderful to behold and photograph. Spring can bring huge volumes of water cascading over the edge, and the low water of late summer may actually showcase a more delicate and intimate nature of the falls.

Waterfalls are excellent subjects for showing motion. Different shutter speeds can impart a wholly different look to the moving water. If you love the look and feel of smooth and silky water, be sure to use exposure times of at least 1 second. We remember one waterfall shot in which the low light of the overcast day, the shielding canopy of the forest, the light lost to the polarizer, the tiny aperture needed for a large depth of field, and the low ISO needed for best quality all conspired to require a shutter speed of 64 seconds!

If you want the water frozen in motion, then use faster shutter speeds, of course. Always remember: It doesn't cost anything to shoot additional digital images, and this is a good time to vary the shutter speed to get different looks to the water. You can select the ones you like best later. Give this a try: Set ISO 100 or ISO 200, whichever is the camera's lowest ISO. Attach a polarizing filter and set the exposure mode to aperture priority. Start with the fastest f/stop on your lens, such as f/2.8. Adjust the polarizer, focus, and compose. Use the eyepiece shutter or cover or your hand or hat to prevent stray light from entering the eyepiece and causing serious underexposure. Don't touch the camera. Shoot and then check the exposure, not by looking at the LCD monitor, but by using the RGB histogram in the conventional way. Then shoot again, if necessary, using the exposure compensation dial to arrive at the best exposure, as determined by the histogram. Once you have arrived at the best exposure, shoot the same composition using all of the full stop apertures on your lens. If your lens covers f/2.8 to f/22, then shoot an image at f/2.8, f/4, f/5.6, f/8, f/11, f/16 and, finally, f/22. The camera automatically changes to longer shutter speeds as you stop down from f/2.8 to f/22.

Well, you ask, why use aperture priority if I want to vary shutter speed? Why not use shutter priority? The reason, briefly, is this. A typical lens, such as an f/2.8 to f/22 lens, offers only seven different full-stop apertures that can be used — not counting intermediate 1/2 or 1/3 stops, of course. Yet, most cameras have shutter speeds from at least 1/2000 second to 30 seconds, giving 17 different

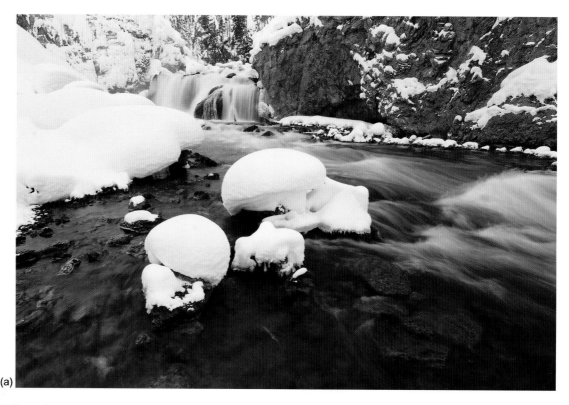

(a)

(a) Use a wide-angle lens downstream from the waterfall any time you can stand in or next to the river below the fall. This shooting position produces a giant foreground that invites you into the scene. The gradually diminishing river leads you to Firehole Falls in the background.

shutter speeds that might be used. So, using aperture priority, for any given f/stop we have 17 different shutter speeds available to accommodate differences in the subject, the light, and the ISO setting. If, however, we use shutter priority, then we have only seven different apertures available for any given shutter speed we set to accommodate the differences in the subject, the light, and the ISO setting. Consequently, in shutter priority there's a greater chance that the camera couldn't produce a

correct exposure. For example, say you are shooting a 100 mm f/4 lens during a dark evening. If the best exposure is 4 seconds at f/4, and you're using shutter priority, setting the shutter speed to 1 second won't work because the lens can't open up any farther.

If you really want to, you can use the *poor man's* form of shutter priority: Put the camera in manual exposure mode, set whatever shutter speed

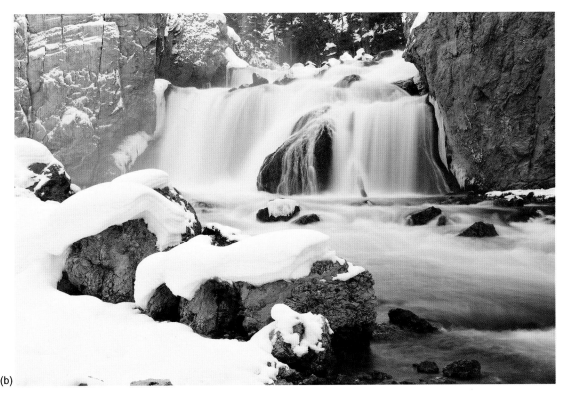

(b)

(b) This version of Firehole Falls was taken at the base of the fall, so it dominates the scene. Snow and white water are easy to expose. Use the histogram to make sure no important highlights with detail are overexposed (clipped). In this case, focus on the rocks in the foreground and stop down to f/16.

tickles your fancy, and set the aperture for a correct exposure. If no such aperture is available, change the ISO.

Focusing on a waterfall is straightforward. You may focus manually, perhaps even using a live view mode to more precisely focus or just help out old eyes. You may focus automatically, using an autofocus point on the place in the scene that you want in sharpest focus. Our highly preferred auto-focus method uses the back-button focusing that we described in Chapter 5. We activate the middle autofocus sensor and point it wherever we want the image to be the sharpest, typically a rock along the edge of the waterfall. We push the back-button to focus, release to lock focus, recompose, and shoot using the 2-second self-timer. This method is precise, quick, and simple!

AUTUMN COLOR

Autumn is our favorite time of the year for shooting landscape images. The intense and spellbinding colors found throughout Michigan's Upper Peninsula (called *the UP* by the native *Yoopers*) are world-class, but the generally spectacular color show is far too short. The beech-maple forests change from their all-green state to a veritable riot of yellows, oranges, reds, and browns; then to bare deciduous trees, all in a period of 3 weeks. Indeed, once the leaves begin to turn, each day brings changes that offer new photographic opportunities.

Every year for the past 20 we've enjoyed those 3 weeks amid the glorious colors of this special season, and we've learned a great deal about autumn photography that we'll share with you now. These tips apply specifically to northern Michigan, but most of our observations and shooting strategies apply to fall color everywhere.

From year to year the date of peak autumn color varies a bit according to weather conditions. Over the past 20 years of teaching autumn color workshops near Munising, Michigan, the color has peaked as early as October 4 and as late as October 13 — a spread of 10 days. Everyone has their own idea about why those dates vary from year to year, but we notice that the colors peak earlier during dry years and later during wet ones. Sunny days during the color season speed up color development, while rainy days slow it down considerably. The maple trees that turn first are generally those growing in open fields, along the edges of a forest, and along the north side of east–west roadways. Trees growing in the interior of the forest are the

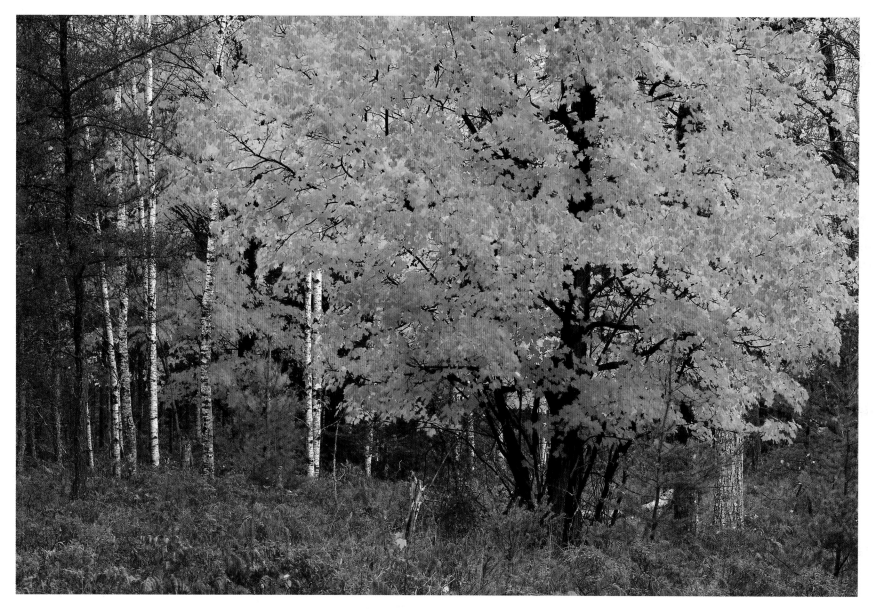

Before the autumn colors peak, some early turning solitary maple trees explode into magnificent fiery red displays of intense color. Set against a foreground of brown bracken ferns and a background of green, this tree makes an appealing subject. Windless, bright overcast conditions are superb for capturing this tree. Be sure to compose so no (or little) white sky intrudes into the image.

The clear sky near the horizon allows the reddest rays of sunlight to light up the bottoms of these clouds hovering above the dunes at White Sands National Monument. The extreme contrast between the magenta clouds and the dimly lit dunes is easily captured by varying the shutter speed while using manual exposure to record several different exposures, so the entire range of brightness levels is covered. These images are processed with Photomatix Pro, a dedicated HDR software.

Enclose your camera in a protective plastic bag to protect it from heavily falling snow. This is an ideal time to photograph any dark object because the snow will show up against the dark background if you use shutter speeds of 1/30 second and faster. Warning: Autofocus usually has difficulty focusing on the correct spot when the snow is vigorously falling, so switch to manual focus. Barbara loves her two spotted horses. If she had her way, every image in this book would have a horse in it somewhere. By the way, we live on "Spotted Pony Trail." Guess who named it?

We use snowmobiles, cross-country skis, and snowshoes to move around when shooting winter landscapes, but we live in big-snow country where snow 4 to 8 feet deep or more is commonplace. Chances are, though, that you live in a region with more modest snow, so you can get around with less dramatic winter footgear.

Photographing while the snow is heavily falling leads to many outstanding images. You can record the streaks of the falling snow by using shutter speeds of 1/15 to 1/60 second, depending somewhat on the wind speed. Find dark subjects so the falling snow streaks show up easily. Most cameras don't like moisture, so if the temperatures are causing the falling snow to be wet, put your camera in a plastic bag with only the lens protruding through a hole in the bag. If the temperatures are well below freezing, then snow drops off camera gear without getting it wet so no cover is necessary. Obviously, your camera, just brought out of a warm car or warm house, is in peril until it gets cold. No matter the condition of the snow, always use a lens hood to keep snowflakes off the front glass. Otherwise you may discover out-of-focus blobs in your images where an inconvenient snowflake or water drop interfered with focusing a few rays of light.

Digital camera gear that gets too wet can temporarily refuse to work or, worse, can be expensively or irreparably damaged. Very cold camera gear coming in from outdoors will soon be drenched, inside and out, by condensation from the warm indoor air. Prevent this by inserting your cold gear into plastic bags and sealing them before bringing them indoors. Let them gradually rise to room temperature before opening the bags so the condensation is constrained to the outside of the bags. *Be patient* — it can take hours (yes, hours) for things to warm up adequately. If you need access to your batteries for recharging, or your memory cards for downloading, put them into a separate small plastic bag before coming indoors!

SUNRISE AND SUNSET

All landscape photographers love to photograph during these magical times of the day. We have all seen and photographed magnificent sunsets and sunrises, but we think you'll agree that the vast majority are unexciting. What attributes are shared by terrific sunrises and sunsets? Most of all, you need the right combination of clouds. Even if no clouds are present, the sun will surely rise and set, but the amount of red sky is underwhelming. We want clear sky right at the horizon, but lots of clouds floating just above the horizon. That situation promises outstanding image opportunities. The warm light of the rising or setting sun can travel unimpeded through the clear area and then brightly illuminate the bottoms of the clouds, causing the sky to turn into a riot of red, yellow, gold, and magenta.

Sometimes the clouds are so thick that you think there may be no color at all, but if luck prevails, you'll enjoy a special treat of exquisite colors in the sky. Fog, smoke, and dust (especially in the desert) are other conditions that can improve your chances for incredible colors.

Photographs of the sky alone are okay, but can generally be improved by an attractive foreground subject silhouetted against the colorful sky. Good subjects include a gnarled old tree with a lot of character, a barn, a windmill, a lighthouse, a natural arch, overlapping sand dunes, or even a geyser. Focus on the foreground object, stop down to f/16, and use the histogram to properly expose the bright sky. Don't forget you can also use a strong flashlight or an electronic flash to paint light onto the foreground.

The colors and details of a sunrise or sunset can be nicely reflected in the calm surface of a pond or a lake, thereby doubling the area of nice color in a scene. The calm water also imparts a feeling of solitude and quiet that the image is sure to convey.

Many photographers arrive too late at sunrise and leave far too soon after sunset. (I was once told that a certain photographer always eats shoots and leaves, but I've never known whether that described his hectic schedule or his dining habits.)

And speaking of leaving too early, sunrise and sunset often give three separate color shows. You may get a beautiful red glow about one-half hour before sunrise, when the first rays of sunlight strike the air molecules high in the eastern sky and create intense magenta colors — a pre-glow, if you will. This period doesn't last long, so you must be at your selected location with your gear ready and prepared to shoot. The colors then fade until the sun rises a bit more. While the sun is still below the horizon, the red rays of light illuminate any clouds floating in the eastern sky. When the sun climbs above the horizon, you may get a beautiful red sun that can be composed with a foreground subject or captured as a reflection in calm waters. To be safe, it's wise

2 1/3 stops greater than the meter's recommendation to compensate for the reflectance of the white snow. He polarizes, meters, focuses, composes, and shoots. Then he checks the histogram to make sure the exposure is right on. If not, he adjusts the exposure slightly, changing only shutter speed when shooting landscapes, and tries again. This exposure is usually correct.

Whether we've metered by matrix methods or spot methods, once we've arrived at a satisfactory exposure, there's no need for further metering as long as the light doesn't change. However, it's prudent to periodically check the histogram to assure ourselves that the exposure data are falling where they should.

Very brilliant sunlight can be reflected from parts of a snow-covered landscape, and some of those parts may have substantial glare. Use a polarizer to minimize the glare and to darken the blue sky. Be aware that it's possible to overly darken the sky, but you can adjust your polarizer to allow the sky to retain some color. Back-lighting works well for winter landscapes because the snow has lowered the high contrast normally encountered with back-lit subjects. F/16 is a good choice for the depth of field wanted in most landscapes. We know most lenses can be stopped down to f/22 or even more, but we avoid using f/22 and f/32 because of the image-softening effects of diffraction. We consider that the slight sharpness loss caused by diffraction becomes serious at f/22, although the starting f/stop is debated by various writers. When worrying about such disputes, always remember that the optical lab

scientist and the field photographer may have entirely different interests and goals. So, don't hesitate to shoot some additional images at f/22 if your scene truly requires an extreme depth of field to ensure sharpness in both the foreground and background.

Cloudy winter days are terrific for waterfalls, creeks and rivers, rocky outcrops, old buildings, snow-caked evergreen branches, and other subjects where the sky can easily be cropped out of the image. However, white sky isn't nearly as offensive against a white snowy foreground as it is against the colorful landscapes during other times of the year. Take advantage of dark gray storm clouds in your winter scenes. A foreboding dark sky adds a strong sense of an approaching storm, and it can set the mood for the image.

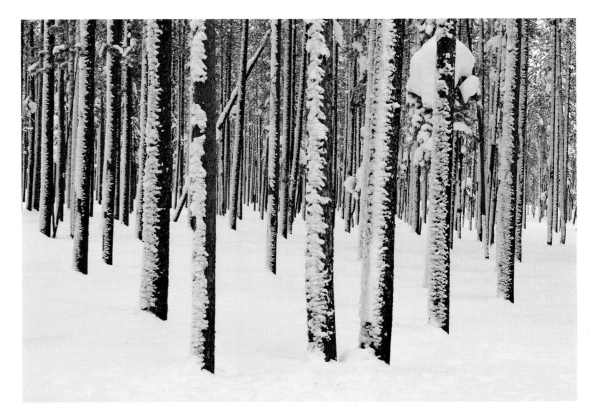

A howling winter storm pounded this lodgepole pine forest for two days. When the snow and winds subsided, we found these tree trunks with snow plastered to them on one side especially appealing, so we slowly waddled through the deep snow shooting various compositions along the way. We like the "V" shape arrangement of the trees in the foreground.

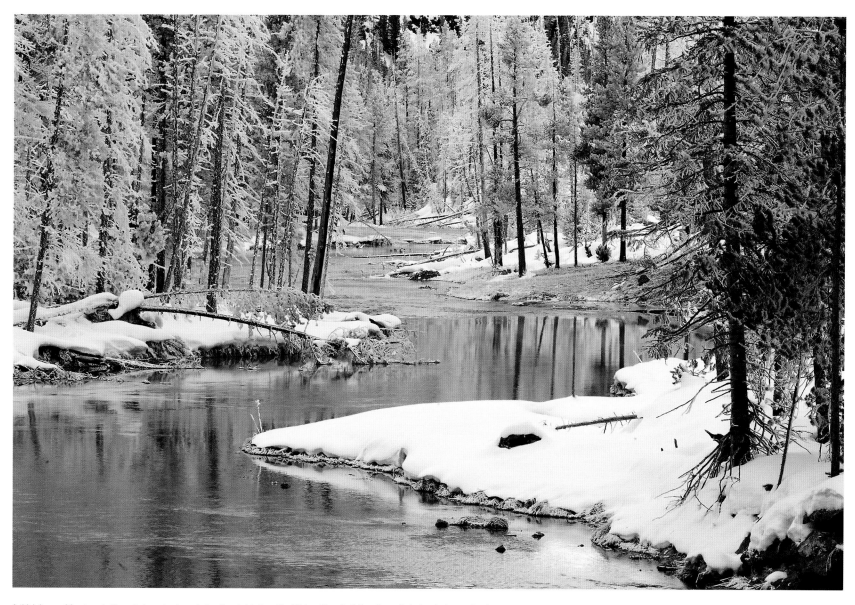

A thick layer of frost coats these lodgepole pines during the night along the Gibbon River in Yellowstone. At daybreak, heavy cloud cover rolls in preventing the warm rays of sunshine from melting the frost. The low-contrast light is perfect for capturing this river with the distinctive "S" curve that's so widely and pleasingly used in composition. Although this is a color image, the scene is really a study of black and white. Use the histogram to expose to the right without clipping the brightest snow.

same scene and compare sharpness later on in the computer with the image blown up to 100%. Use *live view*, a feature found on some newer DSLRs, which allows you to compose via the LCD instead of the viewfinder to detect slight subject motion such as trembling leaves. We activate the live view feature and the grid lines that overlay it. Now the actual scene being photographed appears on the camera's LCD. Our Nikon and Canon cameras let us magnify a section of the image by 10×, so it's easy to see if the leaves are motionless. We simply watch the magnified leaves on the LCD closely. When the leaves are completely and finally motionless, we quickly press the cable release to trip the shutter. This tactic works wonderfully! It's awesome! While there are other uses for live view, this one trick alone compels you to get live view with your next camera if your current one doesn't have it.

Autumn color is such a very special time of the year! We all wish it might last longer, so spend as much time as you can photographing its splendor. Remember to work the subject, use excellent shooting techniques, and most of all, enjoy the season.

SNOWY LANDSCAPES

Snow does a lot of terrific things for your landscape images. If it's deep enough, it covers many distractions such as litter, stumps, trails, logs, and bare soil. Snow cleans up the landscape. It also reduces contrast considerably. Imagine a woodland waterfall cascading over a ledge surrounded by black rocks and very dark logs. Without the snow, your camera's sensor has trouble dealing with the highlights, the extreme whites of the cascading water, the shadows, and the deep blacks of the logs and rocks. A covering of fresh snow hides the dark areas of the scene and substantially reduces the contrast, making it easier for the sensor to record excellent detail in all parts of the scene.

We live at 7000 feet elevation in the rugged Idaho mountains near Yellowstone National Park. In most years we have permanent snow on the ground from late October through late April so we get plenty of chances to photograph snow. This is a superb time to photograph the mountains, waterfalls, icy creeks, isolated old buildings, snow shadows in the forest on a sunny day, trees covered with fresh white snow, and *ghost trees* that are totally encased in snow. Dress warmly, keep fresh batteries in your camera, have another set staying warm inside your winter coat and close to your body, and enjoy the magic of winter. Your digital camera, not having the mechanical burdens of sluggish motors struggling to transport cold-stiffened film, is surprisingly tough and should work fine even in below-zero temperatures.

Many photographers believe snow is difficult to expose, but we don't agree. The histogram makes it easy to properly expose snow. Again, don't use your LCD monitor to judge exposure. Use only your RGB histogram or, lacking that, your luminance histogram. Ensure that the edge of the histogram is as close as possible to the right edge of the graph without actually touching it. This simple method of managing exposure results in a digital image that preserves detail in the highlights while increasing the exposure of the shadow areas, thereby optimizing detail and reducing noise.

We both use the manual exposure mode, but in different ways that both work. Barbara prefers to use her Nikon's *color matrix* metering mode. This metering scheme evaluates the entire scene and considers its brightness, contrast, color, and even how those factors are arranged in the scene. It then compares the measured data to a vast bank of internally stored image information, and in mere microseconds, reaches a recommended exposure. Except in unusual circumstances it'll be correct or very close. Barbara then uses the metering scale in her Nikon's viewfinder to manually adjust the aperture, shutter speed and, perhaps, even the ISO so that the intended exposure exactly balances the meter's recommendation. She shoots her image and immediately checks the histogram. The matrix meter often satisfies her critical artist's eye but, if necessary, she'll readjust aperture, shutter speed, or ISO or some combination of the three using small increments of 1/3 or 2/3 stops to get her desired histogram and the best exposure for the image.

Barbara's strategy works well for most shots, because it's easy once you do it a few times, and it eliminates evaluating scene reflectance. John, though, is sometimes stuck in his old ways (his own opinion of himself), and he's quite efficient at dealing with scene reflectance. He points his Canon's spot meter at an area of pure white snow. Then he uses the metering scale in the viewfinder to adjust shutter speed, aperture, ISO, or some combination of these, so that the camera's exposure will be

(a)

(b)

From the peak of fall color to the end, brilliant red is less common while orange and yellow tend to predominate. (a) The branches and leaves were carefully composed to create this colorful maple tree close-up. (b) Zooming a 70–200 mm lens ◀ the exposure makes the leaves explode from the branches. This effect is easier to manage with a zoom that uses a collar to zoom the lens rather than a push–pull zoom because it's smoother.

are a few things you can do to help get images, though. The obvious solution is to forget about trying to shoot sharp images and deliberately use long shutter speeds to let the leaves blur during the exposure. This works quite well, and for a while, can make images that are fun to look at. But it gets old after a while. Another technique is to zoom the lens during the exposure. We often find a nice tree with a lot of surrounding color, set the aperture to f/16 or f/22 to reach a shutter speed of one second or so, and zoom the lens during the exposure. This makes the colors explode out of the image. The faster you zoom the lens, the more dramatic the explosion of color. If you tire of this, then photograph waterfalls, leaves floating down creeks, or

leaves lying on the ground, because wind doesn't affect these subjects too much. Remember that wind can vibrate your tripod too, making it impossible to shoot truly sharp images. Avoid using your tripod in high wind, if you can.

If a light wind comes and goes and you really won't be happy until you capture this great composition you've found, try using what we call *wind technique*. Set a higher ISO such as ISO 400, ISO 800, or even higher if necessary. Don't use a polarizer, and use an intermediate aperture like f/11. Doing these things allows faster shutter speeds, hopefully in the range of 1/30 to 1/125 second. Use a cable or remote release to trip the shutter when

the leaves look like they're perfectly still. A self-timer won't work because there's no way to know if the leaves will be motionless when the shutter trips at a future time. Autumn breezes are fickle that way. By waiting for lulls in the breeze and firing immediately when the leaves hold still, your chances of getting sharp images improve dramatically. Of course, you have to be patient. It may take several minutes of alert concentration before you get to shoot an image.

However, if you're photographing a single tree or forest scene that's more than 20 yards away, it's difficult to see whether the leaves are moving ever so slightly, so take multiple images of the

Far too many photographers move on when the peak color passes. We understand the interest in following the peak color, but so many wonderful images exist only after the peak. Here the ground is littered with newly fallen leaves. John used a 17 mm focal length to capture this intimate color scene. Barbara said with a devilish smile, "next time, turn-over all the leaves that don't have the pretty side facing up." Considering how many leaves had the "wrong" side up, I told her I prefer natural leaf arrangements.

time of the color season, so stay around to work the last act in this incredible show. As a bonus, you're more likely to get frosty mornings later in the color season, which offer exquisite macro images.

Don't worry too much about any specific date for the actual peak of color. Different plants peak at different times. Moccasin and Thornton Lakes are two lakes we photograph every year. Their western shorelines are lined primarily with maples and aspens. When the maple trees turn brilliant red and orange, the aspens are fading but still mostly green. A week later, the maples have discarded their leaves for their long winter slumber and the aspens turn brilliant yellow, so there is a second *peak* color at these lakes. Indeed, on lakes that are lined with tamarack, these unusual deciduous conifers turn brilliant yellow 10 days after the aspens drop their leaves. We're stressing this idea of peak color as an indeterminate and drawn-out concept, because a majority of photographers give up and head south long before northern Michigan's terrific photographic opportunities have expired.

A challenge to photographing autumn color is that weather tends to misbehave. Winter is trying to exert its dominance over summer, and steady breezes are typical. Colorful trees are difficult to photograph well when the leaves are trembling in the breeze and may be impossible to shoot on a truly windy day. The perfect conditions for photographing along the margins of the forests are the soft light of a bright cloudy day when the winds are usually short-lived, leaving *dead calm* conditions. Clouds lower the contrast in the forest, reducing the problems of burned-out highlights and blocked black shadows lacking detail and full of noise. Help ensure attractive images by composing so that the ugly hit-you-in-the-face white sky doesn't appear in the image.

Try a polarizer to see if it helps. Depending on light angles, leaf shapes, and surface moisture, the polarizer may remove some glare or may do nothing. If it's doing nothing, then get rid of it to recover the two stops or so of light that it absorbs. You might welcome that extra light to sharpen the image by increasing your depth of field or by raising the shutter speed to better arrest the motion of leaves trembling in the breeze.

It's unusual to have cloudy skies with no breeze, so never quit shooting while you still have such perfect conditions. Think ahead by always carrying a few snacks with you so you can delay a meal when excellent shooting conditions prevail.

You can photograph autumn on a sunny day, too. A single colorful tree or clump of them can be very nicely composed against a blue sky, especially if some interesting cloud formations are drifting by. Use a polarizer to remove glare from the shiny leaves and to darken the sky so the clouds separate better. Bright sun in the forest doesn't work well because of the extremely high contrast caused by the deep shadows. Yet, even in the presence of that ugly contrast, there are good shots of single back-lit leaves or groups of leaves. Nice shots of leaves against a pretty blue sky background can often be found by lying on your back and shooting straight up.

You'll find that wind is a tough problem during autumn. Capturing sharp images of leaves hanging on a branch is nearly impossible if they're even slightly moving, especially with shutter speeds of 1/60 second and slower, and chances are you'll be using shutter speeds closer to 1/8 second. There

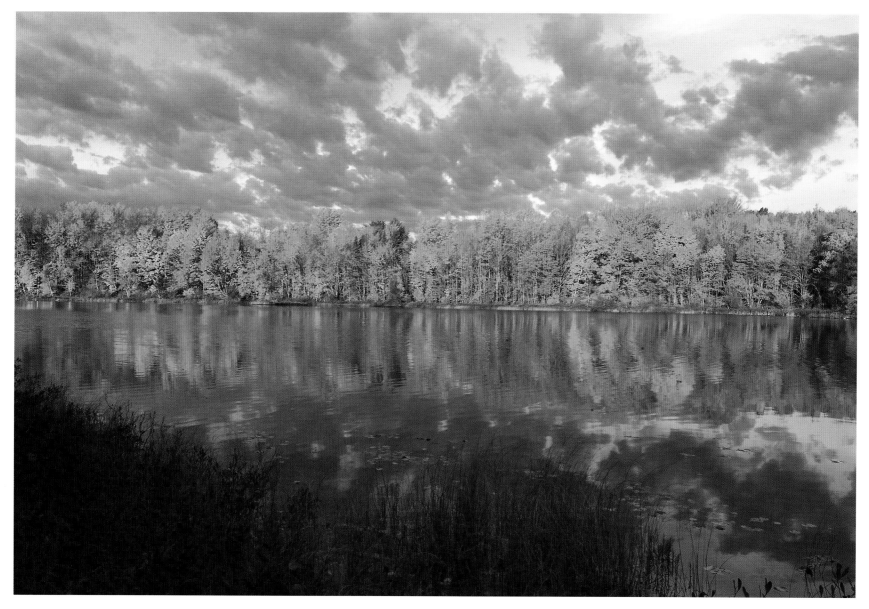

The first golden rays of sun light up the maples at Thornton Lake while a squadron of dark gray clouds drift overhead. Being at small woodland lakes on a calm morning when the opposite shore is crowded with deciduous trees in full autumn color is a highly successful strategy.

last to turn colors. Leaves turn color because they're stressed. Apparently, leaves that are directly lit by sunshine much of the time dry out quickly, which stresses them so their colors turn early. Leaves in the shaded forest are able to retain more moisture, so they turn a bit later.

Although the exact date of peak color does vary, the sequence doesn't change. Colors don't peak everywhere in the same area at exactly the same time. We know the forest around some lakes peak first, while the colors at other nearby lakes peak a week later. On a broader scale, the trees several miles inland from Lake Superior peak about a week earlier than the trees within a mile or two of the lake.

Apparently, proximity to such a large lake delays color development a bit. Perhaps this is due to the slightly warmer night temperatures or higher humidity levels along the shoreline. We use this sequence to plan how to photograph the entire color season. If you photograph autumn colors in the same area year after year, be sure to keep notes that record the sequences of peak dates for different areas, or even for single trees.

Most of our students and other photographers working the area seem to be unduly worried about catching the exact peak of the color change. The many variables affecting its date in a given year can make this an elusive moving target, and we feel that it gets far too much emphasis. Each year the color season offers a nearly infinite variety of wonderful scenes to make into even more wonderful images. Hmmmm — does *even more wonderful images*

mean images that are even *more wonderful*, or does it mean even *more images* that are wonderful? Luckily for us photographers, the magnificent UP autumn makes it right both ways!

The date of peak color gets too much play because each part of the color season offers its own unique images to capture. For example, the beginning of the color season offers innumerable opportunities for nice images of an *early turner* single tree in all its autumn glory, surrounded by neighboring green trees. In fact, the entire first half of the color season features an abundance of exquisite bright red and orange leaves, especially on the trees around and about the small lakes and ponds in the nearby Hiawatha National Forest. Those trees and leaves are wonderful subjects for photographers in the Upper Peninsula of Michigan.

Peak color, of course, is spellbinding. On some roads the trees form a canopy over the top of the road, making driving seem like traveling through a tunnel of flaming color. This is a good time to find small lakes where the west side of the lake is lined with deciduous trees turning beautiful colors. There, in the golden light of the early morning sun, when the air is still and the water like glass, it's easy to capture gorgeous images of exquisite color reflections.

These superb conditions don't happen often enough during peak color, so scout out the best locations ahead of time, and don't be late when the good light occurs. We generally get only one chance during each fall color season to have the conditions just mentioned and also have ominous

dark gray and black storm clouds to the west. This really sets off the colors. It's just awesome! When this happens, we change compositions and shoot as fast as possible, because the conditions are rare and spectacular but usually fleeting. The wind often begins to blow, creating ripples on the water and destroying the mirror-like reflections, or an unruly cloud covers the sun at just the wrong moment. We sometimes get superb conditions right before sunset, too, but it's more likely to be windier then, and it's rare to have fog on the lake, so mornings tend to be best.

Sadly, peak color lasts only a day or two at any given spot. Once the overall forest is clearly a bit past peak color, many photographers move on, following the peak color then developing farther to the south. But in their haste they waste. They waste many opportunities for superb images: images of patterns of colorful leaves lying on ferns or on the ground; images of creeks choked with leaves, perhaps swirling in a small whirlpool; or images of mushrooms emerging among the brightly colored leaves. Those opportunities only happen after peak color. The post-peak fall of the leaves opens up the forest canopy, and is a superb time to use that wide-angle lens to shoot straight up in the forest at the leaves remaining on the trees. The forest isn't quite so thick, when a quarter of the leaves have fallen, so it's a wonderful time to capture those now-visible and very photogenic tree trunks and branches beautifully engulfed in a sea of leafy color.

Our favorite time is from peak color to the end of the color season when nearly all color has faded to brown. We believe this is the most productive

This Defassa waterbuck standing along a ridge line in the rolling hills of Kenya's Maasai Mara makes a fine silhouette against the dawn sky. We call these "wildlife scenes." Using a long lens, we used 1/250 second while shooting on a bean bag from a vehicle. We back-button focused on the head, making sure the single activated focus point was partly on the dark animal and partly on the bright sky to get accurate focus. Then we composed and exposed for the bright background.

to be ready about an hour before sunrise to catch all of the opportunities. Expect the opposite at sunset. You start with the sun hovering over the western horizon, then the red light (hopefully) lights up the clouds and, finally, you get a colorful afterglow. Sometimes the most magical light happens a full 45 minutes or even more after the sun sinks below the horizon, so don't be too quick to leave.

A lot of haze, dust, or humidity in the air is likely to cause the sun to appear as a large red ball that photographs quite nicely. If the air is clean, however, then the sun comes up tiny and bright, making it more difficult to photograph well.

Caution: Don't ever look at the sun for an extended period, and *never* look at it through any optical device not specifically designed for sun observation!

While stopped way down and using your depth-of-field preview button, compose a bright sun by looking in the viewfinder, but don't look at the sun. Look away from the part of the image where the sun resides. You'll know when it's in the image so just look at the darker side of the viewfinder.

A small aperture such as f/22 may cause the sun to appear in the image as a star, especially with a wide-angle lens. This can be a pleasing effect. Composing so that the sun overlaps a foreground element such as a tree branch tends to improve the star effect. If the sun is very bright, consider putting it directly behind a foreground object so little or none of the sun can be seen from the camera position. Now you have an interesting halo of bright sky around your subject.

The red clouds at sunset conveniently light up this Lake Superior beach. Although the north wind has subsided, waves are still splashing onto the sandy beach. John used Canon's 90 mm T/S lens to make the plane of focus align with the plane on the beach. This makes it possible to use a higher shutter speed to freeze the waves more in the dim light while still sharply focusing the entire beach.

You never know when you're going to get that truly spectacular sunrise or sunset. Keep trying, even if it means repeatedly returning to the same location. During our fall color workshops, we often take our groups to a local lake for sunrise.

At the lake, sunrise on the first morning might be good, mediocre on the second morning because of clear skies and no fog, and not much better on the third morning. We hike about 300 yards to the lake, so invariably, on the fourth morning, someone thinks that the sunrise possibilities have been exhausted and doesn't bother to carry camera gear to the lake. This frequently fallacious failure of faith forms a fraudulent folly guaranteeing that the clouds are just right, the winds are calm, a soft wafting fog gently caresses the surface of the still lake, and the spectacular sunrise isn't only unusually spellbinding, but lasts much longer than anyone could have imagined. Always be prepared and never give up!

USING FLASH AT DAWN AND DUSK

Everyone loves to silhouette photogenic objects against the red sky of dawn and dusk. It's easy enough to do. Select a low shooting viewpoint so the subject is nicely isolated against the sky. Focus on the subject and meter for the red sky behind it, using the histogram to guide you. This produces an image where the subject is nicely silhouetted against the colorful sky. The subject has little or no detail and no color because it's in silhouette. Many fine images are made that way.

However, it's also very effective — and fun — to properly expose a bright and colorful sky and use an electronic flash to illuminate an otherwise too dark foreground. As an example, we shot at Mono Lake in the autumn of 2008. Mono Lake has an area of 66 square miles, and lies in the Great Basin Desert

just east of Lee Vining, California. It's famous for incredible numbers of birds, strange tufa towers, brine shrimp, delicate sand tufas, and no fish. We especially enjoy the wonderful sand tufa formations. We used flash to illuminate the sand tufas and isolate them against the red sky at dawn. First, we found an attractive sand tufa that could be isolated against the dawn sky by shooting only a foot above the ground. Using back-button focusing, we pointed our single activated autofocus sensor at the edge of the sand tufa so part of the sensor was on the black edge of the tufa and the other part was on the red sky. (The considerable contrast allowed the camera to easily focus, even on the dark tufa.) Then we manually metered the sky and used the histogram to get the red channel (in this case due to the red sky background) close to but not touching the right edge of the graph.

We attached our wireless flash controllers (ST-E2 for Canon and SU-800 Speedlight Commander) to the hot-shoes on our cameras. Barbara then used her SB-800, and I used my Canon 580 II to illuminate the sand tufa. We set the flash compensation to about +1 stop to properly expose the sand tufa. (Notice that we said *flash compensation*, not *exposure compensation*.) The final images had well-exposed red skies and a well-exposed sand tufa in the foreground. We admit the light is a bit unnatural because nobody expects to have bright light in the foreground with the red sky in the background, but they're still compelling images. It really is an easy and effective technique that's well worth learning. Just determine the background exposure first. Then use automatic flash and the flash compensation control to expose the foreground.

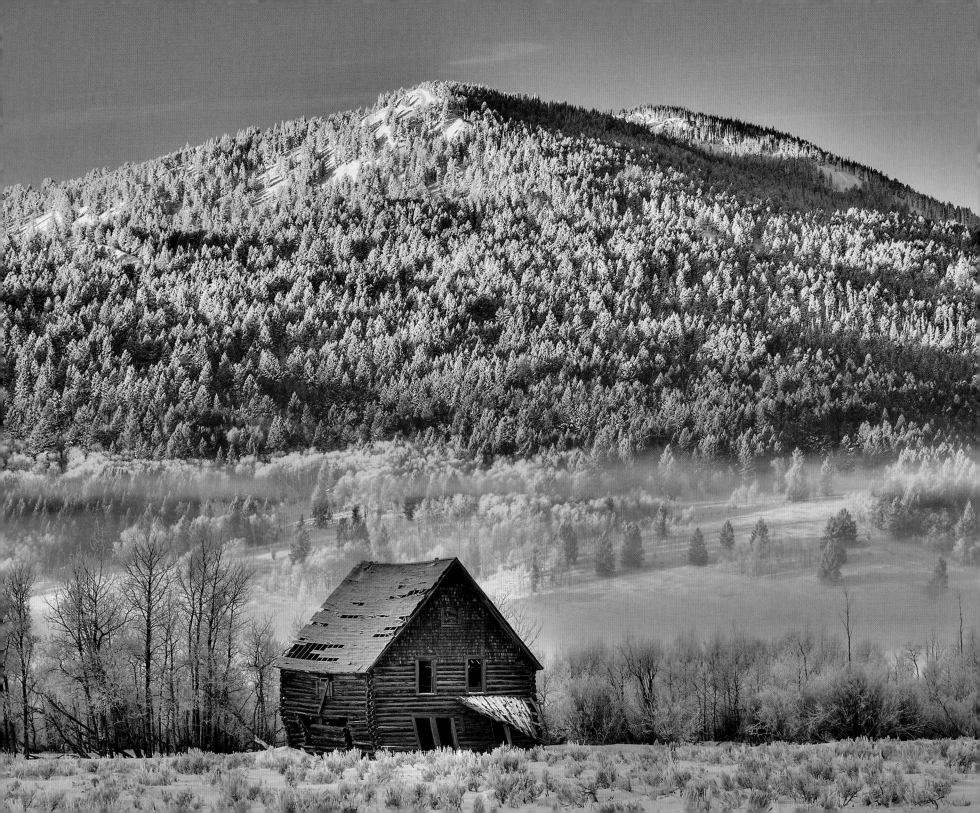

High Dynamic Range
Images

Photographers once hindered by the inability of film to faithfully capture the wide range from brightness to darkness, i.e., the contrast or the dynamic range found in many scenes, are now hindered by the same limitation of digital sensors. Imagine that the red light of dawn is illuminating the distant mountain peaks, but the foreground remains in shadow. The scene's contrast is the difference in brightness levels between the darkest portion of the shadowed foreground and the brightest spot on the sunlit mountain. We measure this contrast in *stops* of light; each stop is a halving or a doubling of the light. If you correctly expose that scene for the brightest mountain peaks, the shadows are underexposed, so you lose detail and may suffer unattractive levels of digital noise. If you properly expose for the darkest shadows in the foreground, you overexpose the mountains so they lack detail. Since the beginning of photography, photographers have had to make choices due to limitations of technology. We have had to accept this limitation even though our eyes can easily see detail in the darkest and lightest portions of most scenes.

The problem of too much contrast has been greatly reduced by a new shooting strategy that produces images designed to be processed by special software. These special images easily render fine detail throughout the entire range of brightness levels found in the scene. It's a simple process. Shoot a series of images in one- or two-stop exposure increments so that some of the images contain well-exposed highlights, and others contain well-exposed shadows. The HDR software processes all of the images, combining them into a single 32-bit image that features a very wide dynamic range that's too great to be properly viewed on your computer monitor. This image is then tone-mapped or processed back into a 16- or 8-bit file so we can properly view it with the limitations of our current technology. This final tone-mapped image preserves the color and detail of all parts of the original scene.

(a) This lonely, decaying cabin, though badly twisted and bent, continues to hold out against Idaho's brutal mountain winters. The dynamic range between the sunlit snow on the mountain and the shaded wood under the roof is far too wide to be successfully recorded in a single image. Five images were shot to fully capture the dynamic range. These included the standard exposure, +2, +4, −2, and −4 stops of light. These images were merged into one single tone-mapped image using Photomatix Pro. Final image adjustments were done with Photoshop CS3.

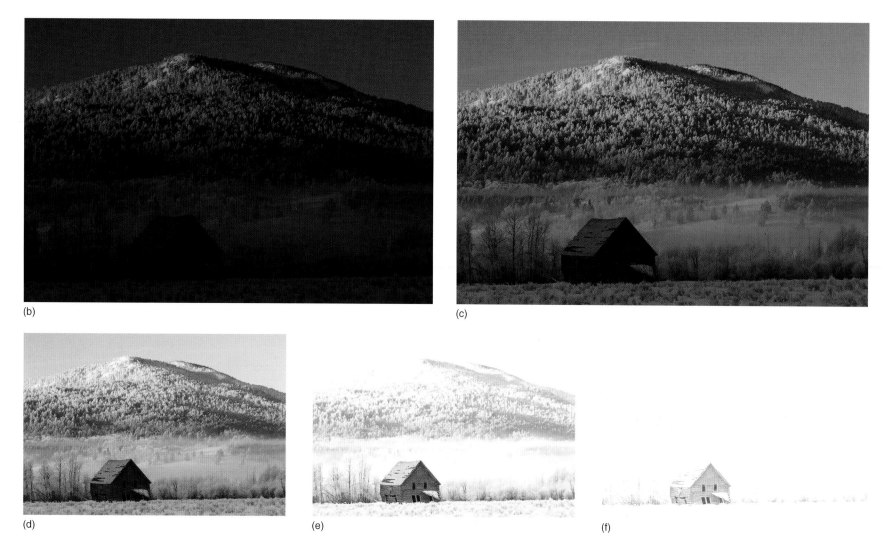

(b) The cabin scene is underexposed by four stops of light from the camera's suggested exposure. The brightest highlights at the top of the mountain have excellent detail, but everything else is far too dark. (c) This image is two stops darker than the camera's suggested exposure. The sunlit portions of the scene are looking better, but everything else is too dark. (d) This is the camera's suggested exposure. The highlights on top of the mountain are significantly overexposed, but the cabin is underexposed. This image clearly shows the camera's sensor can't cover the dynamic range of the scene. (e) All sunlit objects and white snow are overexposed, but the dark wood on the cabin is much better. (f) Everything looks overexposed except the cabin's black windows. As you can see, none of the individual images can adequately record the wide range of brightness levels in this scene. High dynamic range (HDR) software takes the best exposed parts of each image and assembles them into the chapter-opening photograph on page 164.

CONTROLLING HIGH CONTRAST

Before exploring the details of HDR photography, let's look at how extreme contrast was dealt with prior to the widespread use of today's HDR techniques. Many of these tactics are still quite useful and therefore well worth learning.

PHOTOGRAPH IN LOW-CONTRAST LIGHT

The best color landscape photographers learned early to photograph in the soft, low-contrast light of a cloudy day. Soft light is superb for photographing waterfalls, autumn color, large patches of wildflowers, patterns in the rock, and many other landscapes where the white sky can be eliminated from the image by careful composition.

The golden light of dawn and dusk is also exceptionally good for many photogenic subjects, and is widely sought by landscape photographers wanting to capture beautiful colors in their images. This light also has lower contrast than the harsh sun of midday. Yes, our digital darkrooms do allow considerable manipulation of colors in digital images, and HDR software techniques do accommodate many high-contrast scenes, but dawn and dusk rightly remain the favorite times for most landscape photographers, not only for the enhanced colors, but also for the narrower dynamic range of light.

Your landscape images are far more likely to be rewarding if you photograph early and late in the day instead of prematurely rushing off to join the breakfast and dinner crowd. Serious photographers know that this beautiful light is transient and woefully short lived, so they shoot now and eat later or before.

COMPOSE TO AVOID EXCESSIVE CONTRAST

A carefully engineered composition can often help avoid too much contrast. One simple example that's regularly employed by astute shooters is making a photographic silk purse out of the sow's ear of lousy light by composing a brilliantly colored maple forest so that an ugly white sky is excluded from the frame. However, if excessive contrast arises not from bright overcast, but from the harsh light of midday sun, then composing to reduce contrast can be harder and sometimes impossible.

REDUCE CONTRAST WITH FLASH, REFLECTORS, AND DIFFUSERS

When a scene's contrast is too high to successfully record, photographers either wait for better light or they apply various techniques to modify the ambient light. Reflectors are used to bounce light into the shadows of a scene, which lowers the contrast. Flash can easily accomplish the same thing. These methods can work well for close-up images, but most landscape scenes are far too large for reflectors or flash to effectively change the lighting ratios. There are exceptions. In the last chapter we discussed how we used electronic flash at Mono Lake to illuminate silhouetted sand tufas in the foreground and how the additional light effectively reduced the contrast between the foreground and the bright red light of the dawn sky.

SPLIT NEUTRAL-DENSITY FILTERS

These filters worked wonders to reduce contrast in many scenes, and are still widely used by many landscape photographers. But split neutral-density (ND) filters are expensive and, more important, they place another layer of glass or plastic in front of the lens, raising the risk of increased flare and loss of sharpness.

Although split ND filters are still used today, the emerging HDR techniques are vastly easier to use and superior in flexibility and quality. Rather than using precious space telling you how to use the split ND filters and how to deal with their numerous problems, we'll go out on the proverbial limb and predict the future. We predict that split ND filters will rapidly fade from the scene as more photographers discover the gratifying capabilities of HDR techniques. Indeed, we won't be surprised if future cameras actually process HDR images right in the camera without need for additional processing or software.

HDR PHOTOGRAPHY VS. SPLIT ND FILTERS

The advantages of HDR imagery are huge! HDR photography can capture an extremely wide contrast range. Certain scene configurations necessary to hide the split of an ND filter aren't needed in HDR shooting and processing. A single high-quality ND filter might cost over $100, which is more than the cost of most HDR software, and it's relatively easy to shoot the series of exposures required by HDR software. Also, with HDR the extra glass or plastic, which reduces sharpness or might increase flare problems, is removed from the optical path. We struggled with split ND filters for years. Today we value the freedom in expressing our creativity

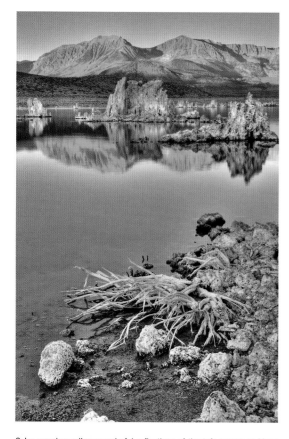

Calm mornings allow wonderful reflections of the tufa towers at Mono lake to occur as the sun first illuminates the Sierra Nevada Mountains to the west. Five exposures capture this early dawn view quite easily. This is a tough scene for split ND filters because the bright golden light surrounds the shadowed tufa towers in the upper part of the image. It's difficult to hide where the filter changes from dark, to light, but it's no problem for HDR!

that's offered by HDR photography, and we know that you will, too. Looking back, the split ND filters did work, sort of, but they seem primitive when compared to HDR techniques. The biggest drawback to HDR is that the scene and camera must be motionless or nearly so. Camera or subject movement, such as clouds scooting across the heavens, or branches swaying in the breeze, can cause ghosting. Try to avoid subjects that are moving a lot, even though at least some ghosting can actually be removed. Photomatix Pro, FDRTools, and Dynamic Photo HDR all permit some ghost removal, so at least moderate subject or camera movement isn't a hopeless situation.

HDR SOFTWARE CHOICES

Software is certain to evolve quickly as more photographers begin their journey into this wonderful new world of photographic opportunity and use the necessary software. They'll send feedback to the publishers, which helps improve the product. Some of the leading software packages include Photomatix Pro (www.hdrsoft.com), FDRTools (www.fdrtools.com), Artizen HDR, and Dynamic Photo HDR (http://www.mediachance.com/hdri/index.html). Even Photoshop CS4 has HDR capability, but it's slightly more limited compared to dedicated programs. As of early 2009, we had been shooting HDR images and using HDR software for only 6 months. Our research of many HDR software reviews showed that Photomatix Pro was particularly well liked, so we used this application for the images you see in this book. However, HDR experts (we're novices) tell us that each software package has special strengths and all render the same set of images in different ways, so don't be afraid to experiment with different software.

CAPTURING HDR IMAGES
USE A TRIPOD

It's best to use the native speed of your digital sensor, normally ISO 100 or ISO 200, to ensure the best quality of digital capture and the lowest noise. Landscape images usually require lots of depth of field, demanding small apertures like f/16 and f/22 and, as a result, your shutter speeds will be correspondingly slow. A solid tripod always helps ensure sharp images, and the elimination of camera motion reduces the chances of HDR ghosting. For best results, make sure the scene aligns perfectly in each image of the HDR series. However, it's possible to hand-hold a series of images for HDR processing if you brace yourself solidly and shoot the series quickly by using high-speed shooting and autobracketing.

RAW VS. JPEG

We shoot nearly all of our images as RAW files. We convert the images later when we have a need for them. Lately, we have been shooting each image as RAW + JPEG, so we have a choice of either. Most HDR enthusiasts shoot RAW images because of the increased ability to edit and change white balance, sharpness, exposure, color space, and other factors. However, JPEGs work just fine too. It's true that JPEGs offer less adjustability than RAW images, but HDR comes to the rescue because the presence of the multiple exposures means that all of the brightness levels in the scene are captured perfectly in at least one of the JPEG images when the series is shot properly. Simply bracket each exposure by at least one stop and no more than two. Then it

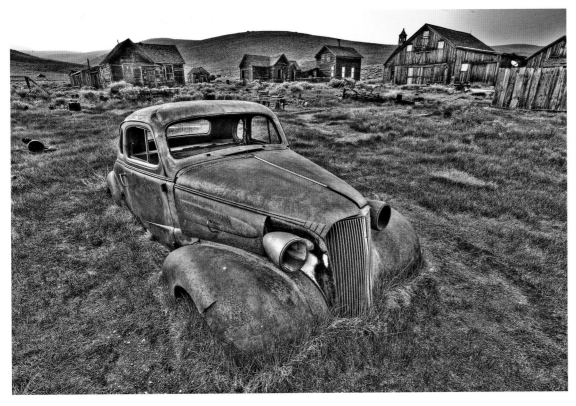

Be creative in your landscape photography. We see nothing wrong with shooting double exposures, mixing natural light with flash, zooming or shaking the camera during the exposure, or using HDR software to make fun, but unnatural looking images. Barbara adjusted her sliders in Photomatix Pro to deliberately create this surreal scene of a car in the fabulous ghost town of Bodie.

that dynamic range in stops. For example, suppose at some arbitrary ISO the scene's highlights were measured as f/4 and 1/1000 second. Also suppose that the darkest shadow was measured as f/4 at 1/15 second. The difference is six stops. No? Count 'em yourself in the series of 1/2000, 1/1000, 1/500, 1/250, 1/125, 1/60, 1/30, 1/15, 1/8, 1/4, and 1/2 seconds. Well, a scene having a contrast or dynamic range of six stops or fewer fits within the dynamic range of many modern digital cameras, so HDR techniques may be quite unnecessary. What if the highlights were 1/2000 and the shadows measured 1/2 second? Now the scene's contrast is 10 stops, more than likely well beyond the camera's dynamic range, so a resulting image would have either overexposed and lack detailed highlights or would have little details and noisy shadows, or even both.

The HDR scheme starts out by making a series of exposures, the brightest one producing a histogram with its right edge at least one stop below the clipping level on the right edge of the graph. The darkest exposure should have its left edge near the middle of the graph to capture detail in the darkest portions of the scene without noise.

Let's do it step by step for the example above that has a contrast range of 10 stops.

doesn't matter that you don't have as much leeway for adjusting JPEG exposure.

VARY THE SHUTTER SPEED ONLY

Allow only the shutter speed to change through a series of exposures destined for a single HDR image. Changes in aperture cause changes in depth of field…changes in ISO cause changes in noise… changes in white balance cause changes in color…

and all of these changes are unwanted! Change only shutter speed! Your HDR software will more easily align the multiple images and will thank you!

COVER THE DYNAMIC RANGE COMPLETELY

Consider a landscape. It has a dynamic range that you could measure by spot-metering the brightest and darkest areas of the scene. You can express

1. We start by using our favorite metering scheme (the spot meter works well) and our histogram to produce the first image, the one where the histogram's right edge is about one stop below clipping (one stop underexposed). The shadows are badly clipped, but we'll ignore that. In this

image we have guaranteed that no highlight detail is lost because of overexposure. Underexpose by two stops if the scene has a few small very bright spots to prevent overexposing them. Normally, only the bright sun is allowed to be overexposed if it's in the scene or perhaps specular highlights that have no detail anyway.

2. Then we change the shutter speed (only) to increase the exposure by one stop and make the second image. The right edge of the histogram moves right and is about at the edge. The shadow areas have also moved slightly right but are still badly clipped. It's still okay!

3. We repeat step 2 and make our third image. Now the right side of the histogram is noticeably clipped and the shadows have moved even more to the right, but are still clipped.

4. We continue making images and increasing the exposure by one stop each time until the left side of the histogram coincides with the middle of the histogram graph. In this image the shadows are definitely not blocked by underexposure, and they contain all available detail and minimal noise.

Aha! We can stop now, because we have a series of images where one image or another portrays every brightness of the scene, from brightest to darkest, in a manner that every brightness of the scene lies well within the dynamic range of the camera.

Two questions arise. First, how many images will be needed? Secondly, is a one-stop exposure increment between images optimum? Well, as the lawyer says, it all depends. The answers are interdependent. Here are the factors:

1. The more contrasty the scene, the more images needed to cover it with a given exposure increment.

2. The greater the exposure increment, the fewer images needed to cover a scene of a given contrast.

3. Larger exposure increments, say, two stops, may be necessary to cover extremely contrasty scenes. Some brightly lit outdoor scenes can have a contrast of 16 stops. That takes 17 images with 1-stop exposure increments, but only 8 images with a 2-stop increment. Fortunately, most scenes have less contrast.

4. One may want to manipulate the number of images and the exposure increment to accommodate the automatic exposure bracketing abilities of her camera.

AUTOBRACKETING

Manually bracketing exposure does work nicely, and all cameras with manual exposure can do it. Most cameras are also capable of autobracketing even when using manual exposure, although many have a limited autobracketing range. If your camera can only shoot a three-frame bracket comprising the nominal exposure and +1 and −1 stop, your 2-stop bracketing range isn't enough for most scenes. But don't give up too quickly. Many cameras offer bracketing choices you may be unaware of. For example, the Canon 1D Mark III's default autobracketing shoots a three-frame exposure bracket. Both the bracketing range (up to +3 and −3 stops) and the exposure increments (1, 1/2, or 1/3 stop) can be selected by the user. Let's use a bracketing range of +1 and −1 stop. The default autobracketing (AEB) setting only shoots three exposures. The first is the standard exposure, the second is the exposure reduced by −1 stop, and the third is the exposure increased by +1 stop. This doesn't help you much if you must shoot five exposures to cover the dynamic range of the typical landscape.

Read the Camera Manual

It helps to read the fine print. Many if not most DSLR cameras have custom functions or menu choices that offer additional ways to use autobracketing. Custom function 1–6 turns the Canon 1D Mark III into a convenient HDR shooting machine. This custom function lets you choose bracketing of two, three, five, or seven images. Choice #2 in CF 1–6 changes the bracketing from three images to a more effective five images. A 5-stop bracket in 1-stop increments covers the range of −2, −1, metered exposure, +1, and +2 stops of light. If you set the bracketing increment for 2 stops of light, as many HDR enthusiasts do, the 5-exposure bracketing sequence covers a range of −4, −2, metered exposure, +2, and +4 stops of light. This bracketing range should cover most natural landscapes with the exception of some scenes with very bright highlights, very deep shadows, and also scenes in harsh light.

We should mention that some cameras have even wider bracketing ranges. For example, our Canons offer brackets of seven images and our Nikons can be set for nine-image brackets. With the bracketing increment set at 2 stops, a series of seven

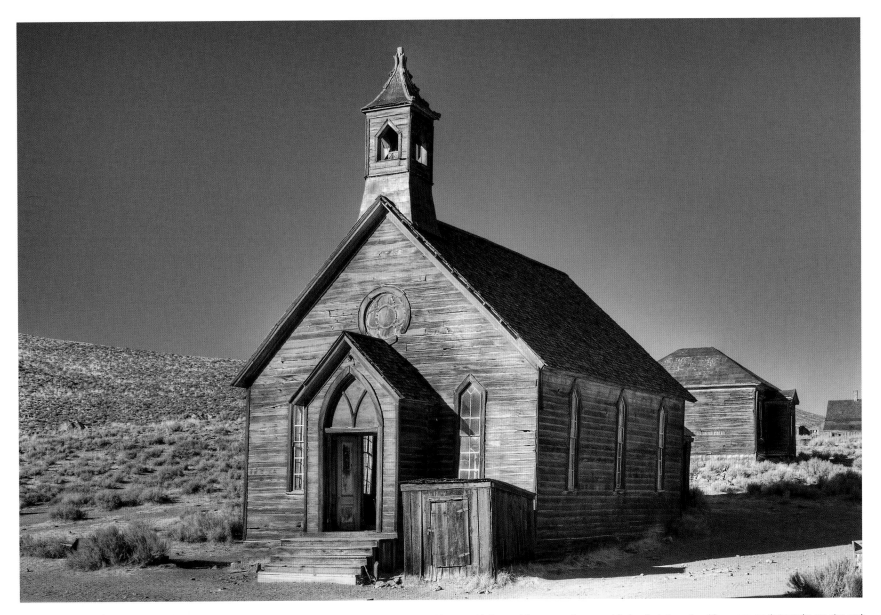

The harsh sun creates deep and dark shadows in the late afternoon on the Methodist church in Bodie. Normally this contrast is too much for a sensor to successfully handle, but a series of five exposures that vary by one stop each handles the contrast nicely when tone-mapped.

images that are bracketed in 2-stop increments covers the range of −6, −4, −2, metered exposures, +2, +4, and +6 stops of light. This range should adequately cover the vast majority of high-contrast scenes. In this case, leave the camera set on automatic using aperture priority (so the aperture doesn't vary) and shoot the seven-image series. When you look at the images with editing software, examine the histograms and discard any unneeded images. For example, if you have one image where the brightest highlights are at least one stop underexposed, you probably don't need an image that has the highlights three stops underexposed. So remove any unnecessary images from the group to be processed by the HDR software, although you may want to just set the removed images aside for later deletion. If your camera is able to do what we just described, then this is the easiest way to successfully shoot a set of images covering the entire dynamic range of the scene.

We realize this whole procedure might sound complicated or involved, but we assure you it rapidly becomes quick and easy. We can compose the image, focus, determine the exposure starting point, and shoot the entire five-image series of bracketed exposures in less than 30 seconds. As we have stressed throughout this book, it's a matter of knowing your equipment and developing an efficient shooting flow.

Autoexposure and Exposure Compensation

It's quite feasible to shoot a bracketed exposure series that works perfectly for HDR by using autoexposure and exposure compensation. Every camera we have

seen offers exposure compensation when using autoexposure. Indeed, many cameras offer exposure compensation for flash, too. The flash compensation exposure control won't affect your natural light images, so make sure you find and use your camera's control for natural-light exposure compensation.

As we have said, the controls used for autoexposure bracketing vary from camera to camera, so we can describe their use only in general terms. If your camera can shoot a three-image bracket in one-stop increments, try this procedure. Set the camera to matrix or dynamic metering and set the exposure compensation to +1. Shoot the three-image exposure bracket. Now set the exposure compensation to −1 and shoot another three-image bracket. You now have six images that include −2, −1, 0, 0, +1, and +2 exposure stops. Delete one of the two identical standard (0) exposures. This leaves five exposures that cover a range of −2 to +2 stops in 1-stop increments. This works for many scenes where the dynamic range isn't too extreme. If your camera offers 2-stop autobracketing increments, set the camera's exposure compensation control to +2 and shoot three exposures which include 0, +2, and +4. Now set the camera to −2 exposure compensation and shoot three more exposures which are 0, −2, and −4 stops. The six images now cover the range of −4, −2, 0, 0, +2, and +4 stops. Delete the duplicate (0 compensation) exposure and your five images cover the exposure range of −4 stops to +4 stops in 2-stop increments. This should satisfactorily cover the dynamic range of most scenes you'll photograph. The key here is to find out how your camera autobrackets and also check for any

adjustments that can be made through menu or custom function choices.

HDR IMAGE SET GOALS

Here's the key to creating the perfect series of exposures to make an excellent HDR image. The darkest (most underexposed) image must provide excellent detail and color in the highlights. The lightest image must capture detail without significant noise in the darkest shadows. The exposures of the series should be no more than two stops apart and no less than one stop. Maintain the same ISO, focus, aperture, white balance, and composition throughout the series. You want everything to be identical except the exposure, which is varied by changing the shutter speed.

MARK YOUR HDR IMAGES

A series of images shot in one- or two-stop increments is easy to recognize in your image browser because the compositions are identical and the exposures vary widely from image to image. View the images displayed by the browser to locate the HDR exposure sets. Once a set of images is located, highlight all of the images and label them. For example, we recently made a five-image exposure bracket in 1-stop increments of the amazing tufa formations that emerge from the salty waters of Mono Lake. We labeled the entire set of images as Tufa-HDR-5-SI. We also add the frame number so each image has a unique name. The camera adds an extension to the file. The official name of the first image of this set is Tufa-HDR-5-SI-41880. CR2 + JPEG. The second image differs only in the

HDR techniques work best with subjects that don't move. Even clouds drifting across the sky or branches blowing in the wind can leave "ghost images." Most HDR software can reduce or effectively eliminate some ghosting. Photographers new to HDR tend to think of only static landscapes as suitable for this treatment. However, we frequently use HDR to help photograph wildlife that hold still some of the time. We have trouble with dark bison and moose amid white snow, the white heads of mostly dark bald eagles, and these Canada geese. HDR solves these high-contrast subject problems. Using HDR on wildlife is effective and easy to do if you can set your camera to a two-image bracket. Use manual metering and set the exposure using the histogram to guide you so the lightest tones are nearly touching the right edge of the histogram. Set the camera so the second autobracketed image is two stops brighter than the first one. Shoot as many frames per second as possible to reduce the chance of the animal moving during the two exposures. The darkest image captures the detail and color in the brightest highlights. The lightest image captures the shadows and dark portions of the image. Create the final image by tone-mapping the two images.

frame number, which is 41881 and so on. Tufa identifies the subject. HDR means this series is intended for HDR processing. The number 5 tells us five images make up the series. The letters SI stands for the original *Source Image*. The frame number is 41880. CR2 + JPEG indicates there is a Canon RAW image and a JPEG with the same frame number. By the way, always archive the original source images. HDR software continues to improve and someday, as it breaks new boundaries, you'll be able to re-process your images for even better results.

PROCESSING HDR IMAGES

It doesn't take long to shoot numerous HDR groups of images. Now the images must be merged together so highlights, mid-tones, and deep shadows all appear in one image with terrific detail and color. HDR software is specially designed to make this feat fairly simple and straightforward. Our goal is to make natural-looking images (some prefer surreal) that have a huge dynamic range. It's a goal that only recently became achievable, and was naught but a photographer's dream in the bygone days of film and the early days of digital photography.

Before exploring some basic processing details, let's discuss natural-looking images. HDR images actually don't look natural when projected, when viewed on a monitor, or made into prints because we aren't accustomed to seeing high contrast handled so well by those media. Some argue that HDR images are inherently unnatural because of their extremely wide range of detail. Yet, when viewing the scene with our own eyes, it's easy to see detail throughout

the scene, as our eyes adjust for varying brightness levels. Our own belief is that HDR techniques produce images that indeed do look natural, because they reveal the detail that we see while directly viewing the scene with our eyes. For too many years the limitations of film and sensors have produced images with low dynamic range and we accepted them as natural. Now, though, we think it's time we all learn and accept a new definition of *natural* and fully embrace the new-found powers of HDR photography.

LOAD THE HDR SOFTWARE

To be honest, we began our journey into HDR photography fairly recently. We haven't had time to try every software package or learn the details of everything that can be done. We've shot hundreds of sets of images for HDR processing and, working on most of them, we're rapidly learning new details as we continue to gain experience.

We bought a few books on HDR photography and we read the software reviews carefully. Many writers spoke favorably of Photomatix Pro so we bought the $99 download. In our limited time with it we found the program to be easy to use and we've discovered several features that will surely accommodate the needs developed as our experience grows. Besides, it produces terrific results. All of the HDR images in this book were processed with Photomatix Pro.

Go ahead and load Photomatix Pro onto your computer so we can lead you step by step into producing your first natural-looking HDR image.

Caution: We used version 3.1 so the following work flow may be slightly different in later versions.

SELECT THE IMAGES

When the software window opens, click on GENERATE HDR IMAGE. When the next window opens, click on BROWSE and navigate your folders to find the images you want to combine into one HDR image. Select the images and click on OPEN. Make sure you have selected the correct images. (You can also drag and drop the RAW files from the desktop directly onto the Photomatix desktop icon.) Now click on OK to open the Generate HDR-Options window.

REDUCE OR ELIMINATE GHOSTING ARTIFACTS

With the GENERATE HDR-Options window open, make sure the ALIGN SOURCE IMAGES box is checked. Even when shooting on a tripod, it's possible for the camera to move slightly between images. That step helps to align the images, if necessary. Check either the BY CORRECTING HORIZONTAL AND VERTICAL SHIFTS or The MATCHING FEATURES button. The BY CORRECTING HORIZONTAL AND VERTICAL SHIFTS option is normally best for landscapes.

Sometimes, unavoidable subject movement occurs while shooting an HDR series. Clouds and blowing branches are common culprits. If you know that such movement has indeed happened, check the ATTEMPT TO REDUCE GHOSTING ARTIFACTS box and the BACKGROUND MOVEMENTS (e.g., water or foliage) radio button.

Caveat: Unnecessary use of this feature can reduce image quality!

On the other hand, if you have flowing water, you might decide not to check the ATTEMPT TO REDUCE GHOSTING ARTIFACTS box to let the water movement overlap, producing a surreal flowing water appearance.

TONE CURVE, WHITE BALANCE, AND COLOR SPACE CHOICES

There are a few more check boxes, but leave them at their default selections unless you have a reason to change them. We use RAW images, so the NO TONE CURVE APPLIED box is checked because RAW images don't have a tone curve. We then select the AS SHOT white balance although you do, at this point, have the choice of changing the white balance. Then we select the Adobe RGB color space. You also have the choice of sRGB or ProPhoto RGB color space.

GENERATE THE 32-BIT HDR IMAGE

Now click OK to generate the 32-bit HDR image. It takes a minute or two for the image to appear on the computer screen and your first look will certainly be underwhelming. The image may have blocked-up shadows and burned-out highlights, so it looks slightly worse than horrible. It has such a huge dynamic range that it can't be properly displayed by the far more limited dynamic range of a

computer monitor. The image must undergo further processing called *tone-mapping*. Since it takes time to generate this 32-bit file, be patient and do save it at this point so you can easily tone-map it again at some later date.

TONE-MAPPING WITH TONE COMPRESSOR

Photomatix Pro offers two mapping methods called Details Enhancer and Tone Compressor. Both methods can produce natural-looking images, but Details Enhancer is the more complicated because it has more choices. It can produce images that look natural or just the opposite. We generally choose Tone Compressor, because its fewer choices make it easier to understand, and because it does make natural-looking images. Furthermore, we find that Tone Compressor is the better of the two at producing the colorful and detailed shadows that we so dearly love.

Our preference for Tone Compressor notwithstanding, we've lately been processing every series of HDR images through Details Enhancer and Exposure Blending. Then we pick the look we like the best. It's amazing how different the images look with the different methods, so experiment.

Click on TONE MAPPING to start this tool for the open HDR image. From the Tone Mapping window, click on TONE COMPRESSOR, which opens up a window with seven sliders on the left side of the screen. The first is the BRIGHTNESS slider. This slider globally changes the tones of all pixels. Move it left to darken the image, or right to lighten

it. Make sure you don't overexpose the highlights by monitoring the histogram for clipping on the right. The slider below the BRIGHTNESS slider is the TONAL RANGE COMPRESSION slider. Moving this to the right compresses the tonal range while moving it to the left expands the tonal range. Adjust it so everything looks good to you. Usually, the TONAL RANGE COMPRESSION slider ends up at a value or two lower than that of the BRIGHTNESS slider. Finally, the CONTRAST ADAPTATION slider changes the contrast in the image. Move it left to increase contrast or right to reduce contrast. Adjust the slider until you find the setting you like the best.

FOUR MORE SLIDERS

The next two adjustment sliders are the WHITE POINT and BLACK POINT controls. Adjust each until you like the look of it. We find 0.25% works well for most of our images, but we still make a few other small adjustments from time to time. Now move the TEMPERATURE slider to the right to add yellow or to the left to add blue. Finally, move the SATURATION slider right to increase color saturation or left to reduce it. Adjust each of these sliders until you're pleased with the image. Now click on PROCESS.

SAVE THE IMAGE

Save the newly tone-mapped image by going to the (File > Save As...) menu at the top of the window. Save it with the name it already has or rename it. You can save the file as a JPEG, 16-bit TIFF, or 8-bit TIFF. We usually save it as a 16-bit TIFF to retain maximum detail and flexibility.

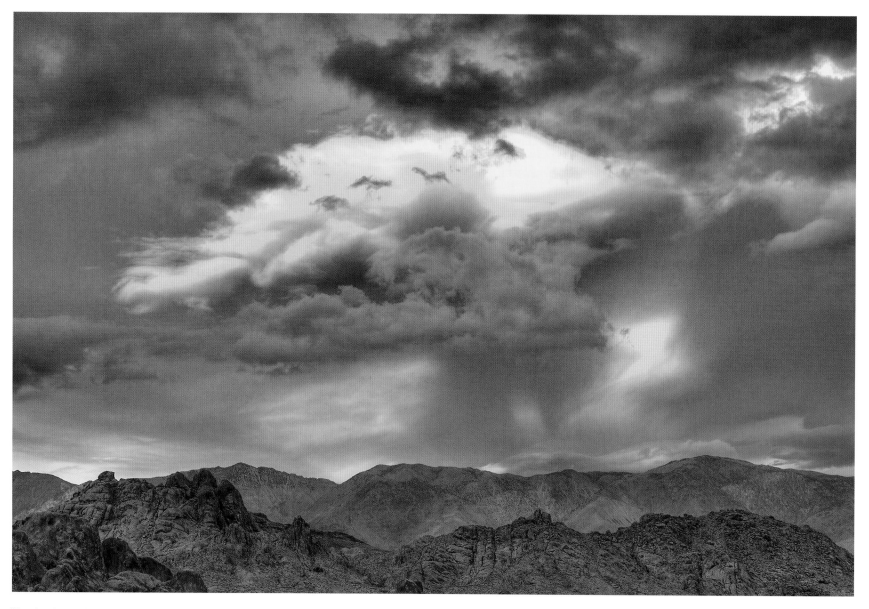

We enjoy photographing clouds lit by fabulous light. This desert scene is tremendously high in contrast. The rocks in the foreground are dimly lit, while some clouds are lit by bright sun. Not only is there a huge contrast range between the dark brown rocks and the white clouds, but the distribution of light makes it even worse. The foreground is in the shade while some of the clouds are illuminated by sun. No color film or digital sensor that we know of can handle this contrast range in a single image. We shot five images that cover the range of −4, −2, 0, +2, and +4 stops of light. They were combined with software to make a 32-bit image, tone-mapped, and final adjustments were done with Photoshop.

Now you can use regular processing software such as Photoshop or Adobe Lightroom to tweak the image. Perhaps you need to eliminate spots from sensor dirt, adjust a color, or sharpen the image, so proceed with the rest of your workflow. Tone Compressor is quite simple and effective, so don't be afraid to try it. The results are wonderful!

CONCLUSION

HDR software is quickly evolving and improving. The ability to tone-map images offers incredible freedom to portray scenes far too contrasty to have been successfully captured by traditional photographic and darkroom techniques. This exciting new HDR capability, now available to everyone, radically changes the look of images and will eventually change our perception of what a fine image looks like. Do embrace HDR technology and its power to overcome the limitations of old technology and create a new generation of HDR images.

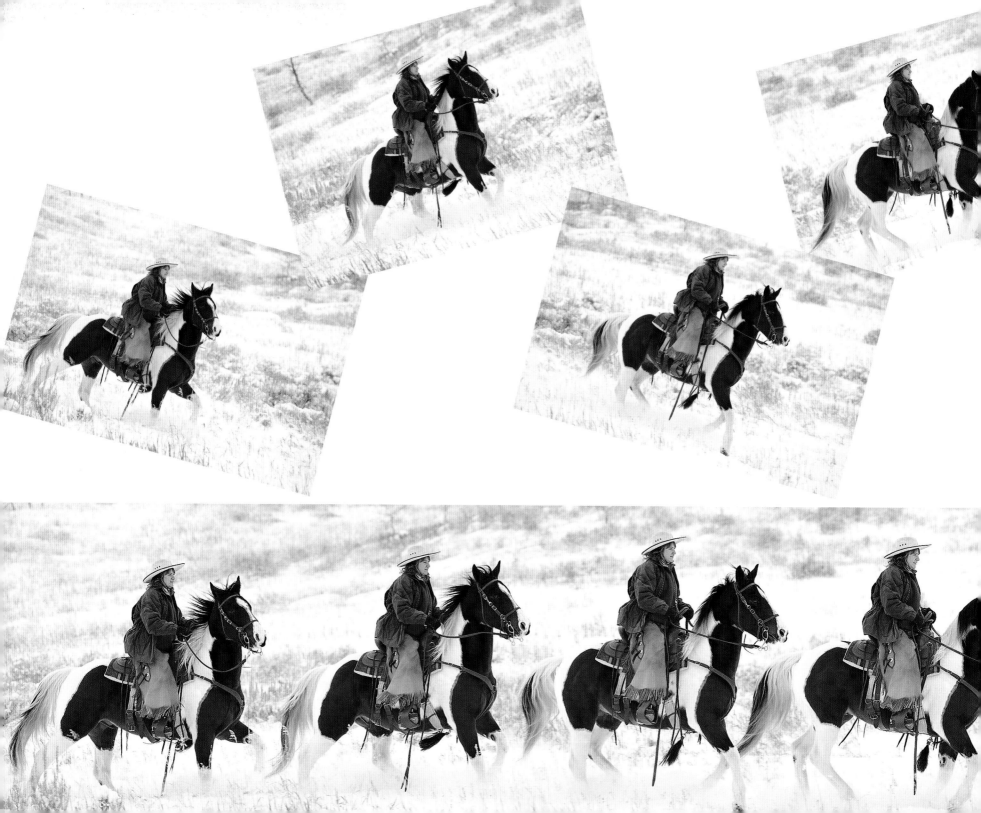

Panoramas

(a–e) Barbara is highly skilled with Photoshop, so she easily put four individual images of her riding Joker on a single canvas and manually merged them together into a long panorama. This technique does require a good bit of skill with Photoshop. Fortunately, plenty of programs are available that do all of the work for you automatically.

Digital photography has made techniques available that allow everyone to easily shoot mesmerizing panoramic images. No longer must you spend thousands of dollars to buy expensive equipment that's specialized for making these images. You don't have to be a computer whiz either, because plenty of software programs are available that easily stitch together the two or more images made for combining into a panorama. The panoramic images included in your portfolio or made into prints for your wall draw attention to your images because they're unusual and captivating to view.

SCENES THAT MAKE A FINE PANORAMA

Look for scenes having very wide or tall subject matter. Often these scenes include strong patterns such as the sand dunes in Death Valley, trees packed in snow and ice on the high mountains, or autumn color reflections along the opposite side of a wilderness lake. A panorama can depict more than strong patterns, too. It can be a single dominating point of interest such as a waterfall where the rest of the panorama is filled in with the river downstream from the falls. And though we're concentrating on landscapes in this book, we must note that a splendid panorama can depict a huge colony of penguins, a thundering herd of wildebeest, or flocks of shorebirds lined up along the beach.

Until the advent of digital photography, most photographers never shot panoramas and didn't develop an eye for seeing the possibilities. We were not exceptions. We're all learning now to expand our vision to see exciting panoramic possibilities. And although we tend to think of panoramas as horizontal images, it's just as easy to create exciting verticals.

PHOTOGRAPHING PANORAMAS

It's quite possible to photograph a scene loosely and then crop the image to make a vertical, or more likely a horizontal, image. However, severely cropping an image to make a panoramic format

eliminates a significant percentage of the information captured by the sensor and greatly reduces your ability to make a large and high-quality panoramic print. Shooting two or more (sometimes many more) overlapping images that can be stitched together later is a far more effective way to make panoramas. It isn't hard, but you must adopt a fairly precise procedure for optimum results, so follow along carefully as we describe how to do it.

LEVEL THE TRIPOD

Use a sturdy tripod to keep your series of images level. That isn't to say nice panoramas can't be done hand-held, but the images shot that way are harder to stitch together, although stitching software is continually improving. Hopefully, your tripod has a built-in level. Adjust the legs so the level's bubble is centered. If your tripod doesn't have a built-in level, try attaching a bubble level to any tripod part that's flat and intended to be horizontal in the erected tripod. A leveling head can be purchased for many tripods. This makes it quick and easy to level the head, which you must do anyway.

LEVEL THE CAMERA

It isn't enough to level only the tripod. The camera must also be level side to side and front to back. The easiest way to do this is to attach a double-bubble spirit level, such as those made by Hama and other manufacturers, to the flash hot-shoe on top of the camera. Be sure to level the camera in both directions or, as a pilot would say, "wings level and nose on the horizon." Properly leveling everything makes the images much easier to stitch together. If you don't level the tripod and camera, the series of images will surely slope downward on one side or the other. Your goal is to make your images as level as possible across the entire series.

FINDING THE NODAL POINT

Today's software is amazing at combining images without showing the seam. You can get superb results by merely leveling the tripod and the camera and properly shooting the series of images. However, if you're a perfectionist, you would ease the software task by ensuring that the camera is mounted in a manner that puts the nodal point of the lens directly over the camera's axis of rotation. Good grief! What does all that mean? Well, the nodal point of a lens is the point along its length, within the lens, where the light rays converge and cross on their journey from subject to camera sensor. The nodal point is also known as the "optical center" of the lens. The term "axis of rotation" is the hinge on which the camera turns, as it does on the head of a tripod, when it's rotated or "panned." As the artilleryman would say, the camera changes its azimuth. (Hmmmm — is

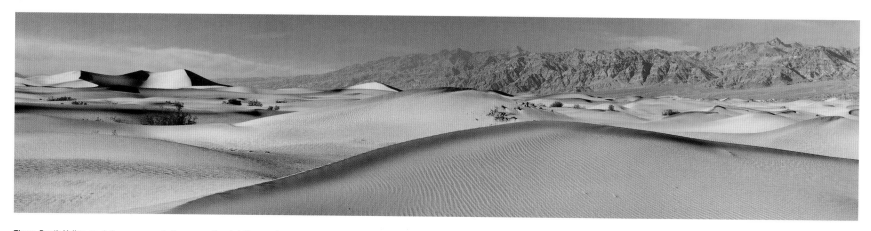

These Death Valley sand dunes appear to be a sea of undulating overlapping lines that spread far and wide. This is the perfect subject for panoramic treatment. We shot a series of overlapping images and put them together automatically using Photoshop's Photomerge.

the artilleryman the only cannon shooter that uses a Nikon?)

One seeking to achieve this mounting, where the lens' nodal point lies on the camera's axis of rotation, would mount her camera on a tripod with a gadget that allows the camera to be moved forward and backward along the longitudinal axis of the lens (closer to and farther from the photographer). Simply, the lens' nodal point would then be over the head of the tripod! How do you set this up? Either of two gadgets is presently used. There's a special bracket offered by at least one manufacturer (Really Right Stuff) to allow easy adjustment of nodal point location. In the absence of such a gizmo, a conventional macro focusing rail, or "slider," can be used for the same purpose. Oh yes, it's a good idea, once having found the nodal point, to place a visible mark on the lens so the point is easily found next time.

Mounting your camera with proper placement of the nodal point guarantees that a series of images can be perfectly aligned. Of course, the dastardly devil is in the details.

To find the nodal point, mount your camera on a leveled tripod and then level the camera both horizontally and vertically. Find an object in the scene having a vertical line, such as fence post, in the near foreground. Find another vertical line, such as another fence post or the edge of a building, in the distant background. Align the camera so the two vertical edges are very close to each other, but not exactly overlapping. Notice the distance between the two vertical lines. Now pan the camera, that is, rotate

the camera horizontally, and watch the two lines. If the apparent distance between the lines doesn't seem to vary, the camera is properly mounted through the lens's nodal point. More likely you won't be so lucky at first and the relative distance between the two lines will vary. If so, it means the nodal point isn't centered over the axis of rotation of the tripod; that is, the axis upon which the camera rotates when it's panned. Use your focusing rail or the aforementioned special pan head to move the camera back or forward a bit and pan horizontally again. When the nodal point is exactly over the axis of rotation, the two vertical lines will appear to remain a constant distance apart as you pan left and right. Now, use a grease pencil or a little piece of tape, to place a mark on the lens so its nodal point is easy to find next time. It all sounds very complicated, but with the proper equipment and a little experience it's really easy to do (see http://archive.bigben.id.au/tutorials/360/photo/tripod.html). Remember, though, you can shoot superb panoramas without even being able to spell "nodal point," so don't let this procedure deter you!

START PANNING ON THE LEFT SIDE

Make your first shot on the left side of the scene, which simplifies lining up your images properly for the stitching software. The first image on the far left has the smallest image file number, while the last image on the far right has the largest image file number. When you use your browser to select the images, they'll be lined up in the proper orientation. If you start on the far right side and shoot to the left, you'll have to re-number the images.

MARK THE PANORAMIC SERIES

A single image intended to be part of a panorama is seldom well composed, so often we mistakenly delete it before realizing that the goofy looking composition is only part of a series. Then we have to recover the image from the digital trash can (which real computer geeks call the "bit bucket") and restore the image. To keep things simple, we stick our hand in front of the camera and shoot an image of it. After shooting our series, we photograph our hand one more time to mark the end. When we view the images hours or days later, the hand images remind us what we've done. We rename the images of each series with a unique prefix. The images of a panorama series shot at Moccasin Lake might be named "Moccasin Lake #1_pan_4_nnnn.nef," where the "#1" indicates the first panoramic series shot at Moccasin Lake, the "4" indicates there are four images in the series, and the "nnnn" is a unique numeric file name, or part thereof, assigned by the camera. The next panoramic series done at Moccasin lake, perhaps of three shots, would have names of "Moccasin Lake #2_pan_3_nnnn.nef," and so on. Then we move them to appropriately named folders in the computer for eventual incorporation into the final panoramic images.

KEEP SOME SETTINGS THE SAME

WHITE BALANCE

Never use auto white balance for images intended for a panorama. You don't want the camera to change the white balance between images, and it

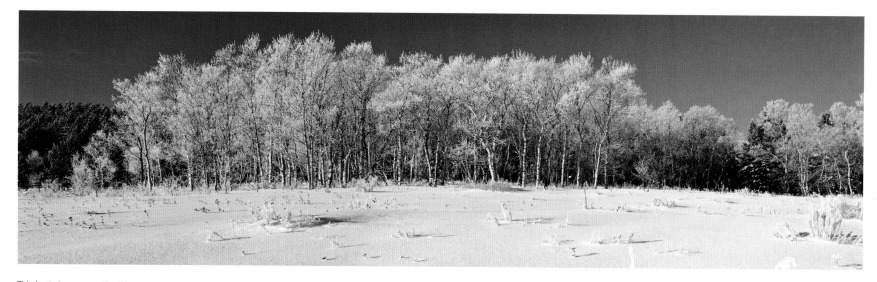

This frosted aspen woodland is very wide, but not very tall. In this case, we easily covered the important parts by shooting four overlapping horizontal images to completely cover the grove of trees. Always begin the series of images on the left and shoot to the right so the images line up properly in your browsing software.

will happen if the scene colors radically change from one side to the other. Always use a preset white balance, such as Cloudy, Sun, or Shade, or, if you have the option, use the K option to enter a specific color temperature choice.

FOCUS

It's very important that the camera doesn't change focus between the shots of a panorama series! Use manual focus and keep your paws off the lens's focusing ring. Alternatively, leave the camera in autofocus, but only if you've changed to the back-button focus scheme that we so highly recommend and you keep your thumb far from the focus button! Finally, if you really prefer having the shutter button control autofocus — we don't understand why you still would, but if you really do — go

ahead and push the shutter button down half-way to make the camera focus the lens on the scene, and then turn off autofocusing. The autofocus switch might be on the lens itself or on the camera body.

ISO

Always use the same setting for all of the images shot for any one panorama.

EXPOSURE

Use manual exposure so that the exposure remains the same for all of the images of a single panorama. Any change to either aperture or shutter speed between those images would make the sky segments difficult to match when the images are stitched together.

DON'T ZOOM THE LENS

Don't change focal length between the images of a single panorama. Changing a zoom setting would cause the same object in adjacent images to be different sizes, and the stitching software would be unable to properly align the images.

EXPOSING THE IMAGES

Use manual exposure and your histogram. First, set the aperture, perhaps to f/16, for a landscape with a near foreground and a distant background. Point the camera at the brightest area to be included in the panoramic image, and adjust the shutter speed so the important highlights are well exposed. This means that the right side of the histogram data approaches as closely as possible, but doesn't actually touch, the right edge of the graph. Use that

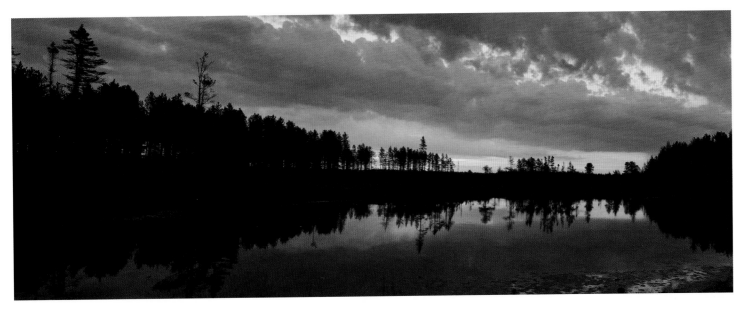

This quiet sunrise along a northern Michigan lake is perfect for panoramic treatment.

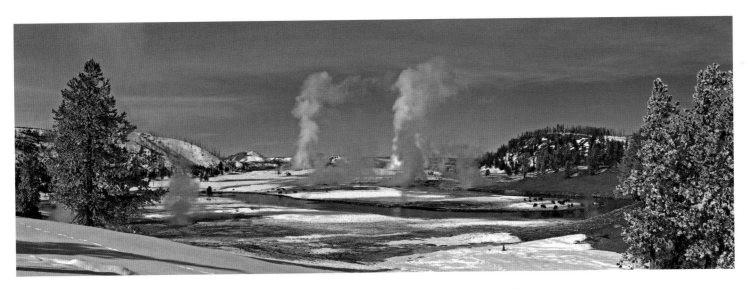

The rising thermal features of Midway Geyser Basin on this calm winter day nicely accent this scene of the Firehole River through the valley.

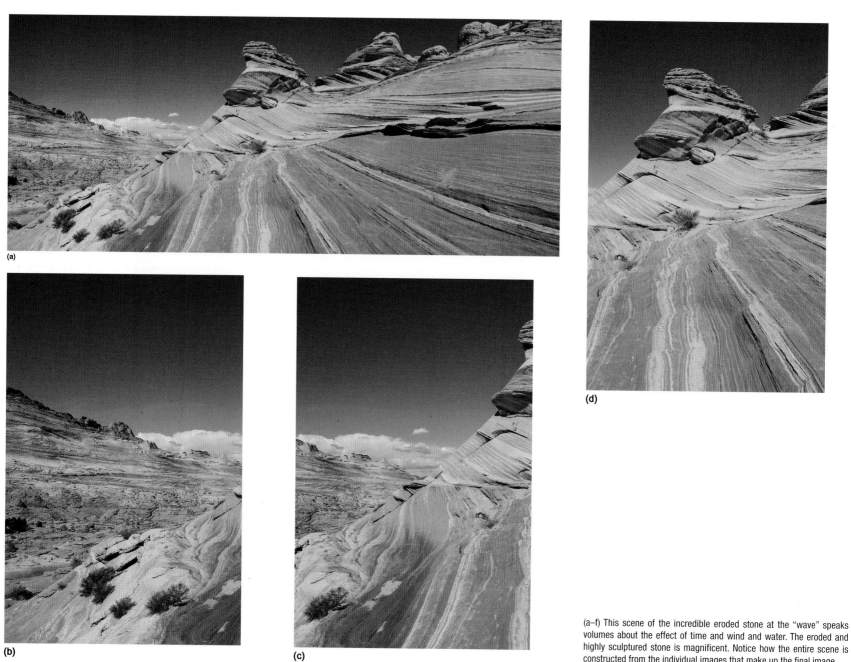

(a)

(b)

(c)

(d)

(a–f) This scene of the incredible eroded stone at the "wave" speaks volumes about the effect of time and wind and water. The eroded and highly sculptured stone is magnificent. Notice how the entire scene is constructed from the individual images that make up the final image.

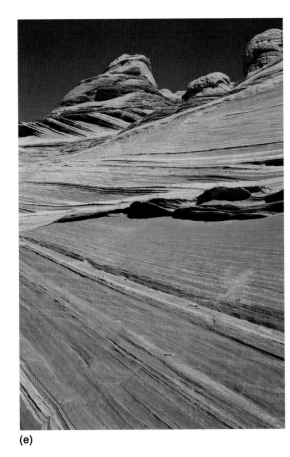

(e)

Continued

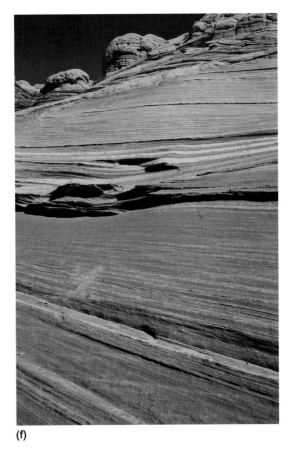

(f)

exposure for the entire series, and take care that the prevailing light doesn't change during the series. If it does change, you must re-shoot the entire series so that every image is shot under the very same light.

HDR PANORAMAS

The light illuminating a long horizontal scene may vary greatly from one side of the scene to the other.

Traditionally, you look for a panorama where the light is similar across the scene. However, it's possible to successfully photograph a high-contrast panorama by shooting an HDR series of images for each individual image that makes up the panorama. Once each series of images is merged and tone-mapped, then all of the images that make up the panorama can be stitched together. Strategies

for doing this are covered in detail in the HDR book entitled *Complete Guide to High Dynamic Range Digital Photography* by Ferrell McCollough, mentioned in the references.

POLARIZING FILTERS

Many advise to avoid using polarizing filters when shooting a series of images for a panoramic image. If the angle between your line to the subject and your line to the sun is changing, then the sky would appear to unnaturally change intensities from one image to the next. This is so often true that you could do well by remembering it. However, there are times when the effects of a polarizer are so profound that we use it anyway for a series and deal with uneven sky density later. For example, polarizers are so good at removing glare on wet foreground rocks to reveal texture and color that we still use them, even if the sky doesn't appear uniformly blue in the final panoramic image. After all, the sky isn't uniformly blue anyway. Often it's lighter near the horizon and darker above.

OVERLAP THE IMAGES

As you shoot the series of images, make sure each image overlaps the previous one by about 30%. The software requires having identical objects in adjacent images to line them up precisely.

PORTRAIT OR LANDSCAPE ORIENTATION?

It seems obvious that the best way to shoot a horizontal landscape for panoramic treatment is to

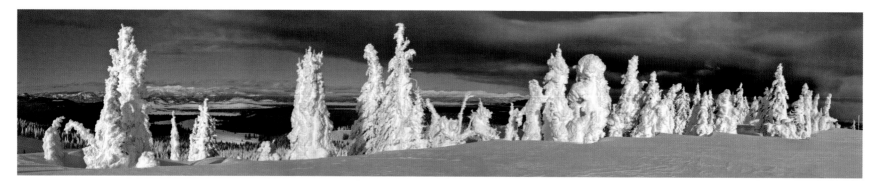

To keep the sky as uniformly bright as possible, no polarizing filter is used to capture these "ghost trees" on top of Two Top Mountain near West Yellowstone, Montana.

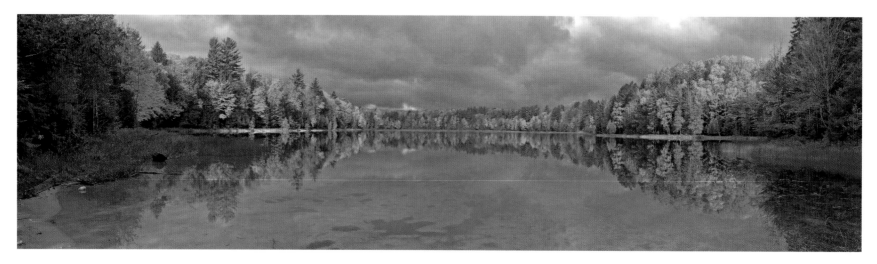

Autumn color reflections on small inland lakes are perfect panoramas since these scenes tend to be extremely wide. We determined the manual exposure by pointing the camera at the brightest portion of the scene. Then we panned the camera from left to right, overlapping each image by 30%.

shoot horizontal images to cover the expanse of the scene in the fewest number of images. Therefore, it's counterintuitive to think that shooting vertical images of a horizontal scene, or horizontal images of a vertical scene, can work much better. This is true because you may have tall objects in a horizontal scene that might get cropped if you shoot horizontal images. Here, shooting vertical images captures more space above and below the subject, so there is less chance of accidently cropping part of the scene. When the images are stitched together, you can use the crop tool to eliminate unwanted elements at the top or bottom of the image, assuming none of your main subject is too close to the edge.

FOCAL LENGTH CONSIDERATIONS

You'll have the best luck with lenses in the 40 mm focal-length range and up. Wide-angle lenses like a 20 mm tend to introduce a lot of distortion, so avoid them, at least at first. And also be careful with longer lenses, such as a 300 mm. The magnification of longer focal lengths causes limited depths of field, which can cause noticeable changes to foreground focus between the images of a series.

STITCHING PANORAMAS TOGETHER

This can be done using Photoshop manually, but a stitching capability that specializes in doing the job will save labor and grief. Later versions of Adobe Photoshop and Adobe Photoshop Elements each have a splendid feature to do just that. It's called "Photomerge" and it does all the grunt work for you. Give it a try. Once you process the proper images through the program, you'll have a good final image that can be edited by any image-editing software for color, contrast, sharpness, dust spotting, and more.

If you shoot Canon, you probably already have Canon software that stitches images together. Load the Canon Utilities disk and load Zoombrowser EX. Open this program and click on Tools > Stitch photos. Now follow the simple instructions and you will soon have a nice panoramic image to view. Other dedicated panorama stitching programs include Autopano Pro, PTGui, Panorama Factory, and Stitcher.

Resources

EQUIPMENT

Giotto Rocket Blower
HP Marketing Corp.
www.hpmarketingcorp.com

This device blows air when you squeeze it, and comes in different sizes. Bigger means more air, so we conclude that size does matter and we prefer the larger one. It is terrific for blowing dust off lenses and the sensor in the camera too. It is generally a great blower, but do be aware that the models with an articulating nozzle are not recommended. Cases have been reported where vigorous squeezes of the bulb have briskly ejected the nozzles from the bulb, which could easily enter an open camera and do substantial damage.

Hoodman USA
800-818-3946
www.HoodmanUSA.com

The HoodLoupe is worn around your neck and used to easily view the LCD monitor without the distractions of bright ambient light. It works well and is much more convenient than the devices that snap onto the back of the camera.

Kirk Enterprises
333 Hoosier Drive
Angola, IN 46703-9336
800-626-5074
www.kirkphoto.com

Kirk offers excellent ball heads, L-brackets, custom quick release plates for cameras, and many other specialized products invaluable to a landscape photographer.

Really Right Stuff
205 Higuera
San Luis Obispo, CA 93401
1-888-777-5557
www.ReallyRightStuff.com

RRS makes terrific ball heads, flash brackets, quick release plates, L-plates (ideal for landscape photos), lens and camera body plates, and some specialized devices for shooting panoramas. Ask for their excellent catalog!

Wimberley
974 Baker Lane
Winchester, VA 22603
540-665-2744
www.tripodhead.com

They make the famous Wimberley head that is ideal for action wildlife (but of limited value to landscape photography) plus many other devices that could help you shoot better images. Ask for their catalog.

TOURS AND WORKSHOPS

Gerlach Nature Photography
PO Box 642
Ashton, ID 83420
(208) 652-4444
www.gerlachnaturephoto.com
michele@gerlachnaturephoto.com

This is our home office that is managed by Michele Smith. We offer several products and lead many photo workshops and tours. Go to our website for all of the details.

International Expeditions
One Environs Park
Helena, AL 35080
800-633-4734
E-mail: nature@ietravel.com
www.IEtravel.com

This fine company is our partner in managing our very successful photo tours to Kenya and other exotic destinations.

PHOTOSHOP INSTRUCTION

Let's be honest here. Of the two of us, John's speciality is making camera equipment work efficiently to capture fine images in the field. Barbara does that too, but she is also a borderline computer nerd who deftly makes Photoshop dance to her commands. She is an advanced printer, thanks to the help of Charles Cramer. If you are looking for a heavy duty fine-art printing class, look no farther than www.charlescramer.com. However, the classes are not for beginners. You must be able to navigate Photoshop easily to keep up during the classes.

BOOKS

Thom Hogan Nikon E-books: You will find your camera manual doesn't tell you everything you want to know about the camera. The manufacturer's manual generally covers all the features, but tends to omit the all-important "how and why" regarding the features that help you shoot excellent images. Thom Hogan produces superb and detailed E-books covering many of the advanced Nikon cameras that give you the answers. Contact: www.bythom.com for his latest offerings. Unfortunately,

we don't know of any similar E-books on other camera systems, but many "real" books are now published on various camera models, so search the web to find out what is available.

The Photoshop Lightroom Workbook: Resnick and Spritzer, Focal Press, 2009. This fine book clearly explains why many photographers prefer to shoot RAW images. Then it covers the end-to-end workflow for storing, finding, and processing images using Photoshop Lightroom 2.

National Audubon Society Guide to Nature Photography: (Digital Edition), Tim Fitzharris, Firefly Books, 2008. This book is loaded with terrific images and superb advice about working with weather and wildlife, to capture stunning images.

Complete Guide to High Dynamic Range Digital Photography: Ferrell McCollough, 2008. This book helped us enormously in getting started with HDR. The advice is excellent and so are the images.

Photoshop for Nature Photographers: A Workshop in a Book, Tim Grey and Ellen Anon, Sybex. Thiswell-written and beautifully illustrated book is a nice blend of shooting images and working on them in Photoshop. It is revised as new versions of Photoshop appear, so be sure to get the latest version.

Digital Nature Photography: The Art and the Science, John and Barbara Gerlach, Focal Press, 2007. This is our introductory book on nature photography. It covers many

crucial strategies you must master to capture outstanding nature images quickly and easily.

CAMERAS AND ACCESSORIES

Canon: www.usa.canon.com

Nikon: www.nikonusa.com

Olympus: www.getolympus.com

Sony: www.sony.com

3RD PARTY LENSES

Sigma: www.sigma-photo.com

Tamron: www.tamron.com

PRINTERS

Epson: www.epson.com

MEMORY

Lexar: www.lexar.com

SanDisk www.sandisk.com

WEBSITES

We spend little time browsing the internet because we are nearly always in the field shooting new images or teaching workshops. However, we have visited some sites, and our students tell us about others, so here is a short list you might consider visiting.

Gerlach Nature Photography (www.gerlachnaturephoto.com) This is our home web site. It contains details about each of our instructional nature photography programs and much more. Many of our most helpful instructional magazine articles are posted here for your reading and learning enjoyment so please come and visit.

Outdoor Photographer (www.outdoorphotographer.com) This is an online collection of the articles that have been published in the magazine. It is full of terrific information.

Nature Photographer (www.naturephotographermag.com) This site contains numerous articles. We are long-time columnists for this fine magazine.

NANPA (www.nanpa.org) The North American Nature Photographer's Association is a fine organization that promotes and helps the nature photography community. They conduct an annual NANPA Summit each year that is fun and informative. Consider joining this organization and do attend the summit.

PSA (www.psa-photo.org) The Photographic Society of America is a fine organization that is comprised of dedicated amateur and professional photographers who share photo information through the *PSA Journal*, photo clubs, workshops, seminars, and conventions. They help each other develop their photographic skills and conduct numerous photo competitions.

INSTRUCTIONAL DVDS

Photographing Yellowstone National Park, John and Barbara Gerlach, TalkStory Media, 2007. This is our in-depth video shot on location showing how to photograph the magnificent landscapes and wildlife of Yellowstone National Park.

Photographing California's Eastern Sierra, John and Barbara Gerlach, TalkStory Media, 2009. This video shows where and how to photograph the splendid landscapes between the ghost town of Bodie to the ancient Fossil falls. Instruction includes photographing Mono Lake's tufa towers, Tioga Pass, June Lake loop, Manzanar National Historic Site, the ancient Bristlecone Pine Forest, Rainbow Falls, Devil's Postpile National Monument, Minaret Falls, Mt. Whitney, Alabama Hills, and the Bishop petroglyphs sites.

Index